The Business
of Being an
artist

Sixth Edition

Daniel Grant

ALLWORTH PRESS
NEW YORK

Allworth Press books may be purchased in bulk at special discounts for sales promotion, corporate gifts, fund-raising, or educational purposes. Special editions can also be created to specifications. For details, contact the Special Sales Department, Allworth Press, 307 West 36th Street, 11th Floor, New York, NY 10018 or info@skyhorsepublishing.com.

26 25 24 23 22 5 4 3 2 1

Published by Allworth Press, an imprint of Skyhorse Publishing, Inc. 307 West 36th Street, 11th Floor, New York, NY 10018. Allworth Press® is a registered trademark of Skyhorse Publishing, Inc.®, a Delaware corporation.

www.allworth.com

Cover design by Mary Belibasakis

Library of Congress Cataloging-in-Publication Data is available on file.

Print ISBN: 978-1-62153-813-4
eBook ISBN: 978-1-62153-816-5

Printed in the United States of America

Table of Contents

1

The Goal of Earning a Living through One's Art

Artists aren't people who simply create art and then drift off into oblivion; they want their work to be seen and to receive some sort of reaction from those who see it. Putting art in front of the public establishes an artist as a professional and, for many, the quest for a show is the first goal. Fortunately, there are many venues for exhibitions available.

For the past 130 or so years, art dealers and galleries have been the principal route to success in the art world—for a couple of centuries before that, salons or group shows of establishment-picked artists predominated. Some artists have been very closely identified with their dealers, such as Renoir and Picasso with Ambroise Vollard, Jasper Johns with Leo Castelli, and Richard Serra with Larry Gagosian. Dealers frequently have a select clientele, often including one or more principal backers, who do the bulk of the buying, and it is the ability to steer these important collectors to certain artists' work that establishes a dealer's prestige. Few long-term successful art dealers survive without this clientele, and gallery owners who rely on walk-in traffic for their sales tend to go in and out of business in short order. The main exception to that are galleries in resort and tourist towns, where buyers may want something by which to remember their vacation.

Galleries come in all types, and many storefronts with "gallery" in their names do not support themselves from the sale of artwork. Frame and gift shops

often have art objects on hand, but it is unlikely that the volume of sales would support any of the artists whose work is displayed. Even galleries whose principal business is the sale of original art rarely can support their artists, requiring those artists to place their artwork with a number of galleries in the hope that the cumulative sales will add up to a livelihood. One lesson in this book that I hope to impart is that artists cannot just place their work with one or more dealers and hope that sales take place, relieving them of the need to do anything other than create more artworks. The more galleries that have your work in their inventory, the better your record-keeping and communications need to be. Who has which pieces, and what efforts are being made to show and sell that work? Should pieces be swapped out to keep the inventory fresh? Have sales taken place, what is the artist owed, and when will the artist receive payment?

Finding the right dealer who will lead the artist's work to major collections is a challenge, and few generalizations can be made. Dealers become interested in potentially representing artists largely in two ways: The first is when dealers personally know the artist (meeting him or her at an art opening or on a studio visit), as well as hearing about the artist from people they trust, such as other artists they represent, curators, critics, collectors, and other dealers.

The second way is through the strength of an artist's work and market. Artists usually send dealers images of their work and some indication that there is a market for it. To that end, artists who are starting out need to build a track record of group and one-person exhibitions and, along with that, develop a group of consistent buyers. Dealers don't like to try to build a market for an artist but, instead, look for artists who already have a market that can be expanded. The reason is, operating a gallery in a major market such as New York City is very expensive, and artists whose work does not sell right away and in sufficient quantity puts the dealer in a financial hole. In 2017, Jill Weinberg Adams, co-owner of the Manhattan art gallery Lennon, Weinberg Gallery, said that "rent is my highest single expense, thirty-three percent of my budget," with total monthly costs for the gallery generally ranging from $80,000 to $100,000. Valerie McKenzie, owner of New York's McKenzie Fine Art, lowered some of her overhead by moving from a space in the

high-rent Chelsea district to a less expensive if somewhat smaller site on the Lower East Side. Reducing overhead helps, but pressure is still on to sell, sell. "I have to sell 50–70 percent of the works in the shows in order to break even," she said. "If you have one poor-selling show, you feel it for months."

The pressure to sell moves down the food chain to the artist, whose tenure at a gallery becomes increasingly reliant on regular sales, especially when the gallery needs between half and three-quarters of works in a given exhibition to find buyers in order to break even. "Galleries can only afford to carry X number of artists whose sales don't cover the cost of their promotions," said a Manhattan gallery owner who asked not to be identified. "The operating costs can also begin to impact which new artists you can afford to take on."

The prices for artworks in galleries in major markets often strike visitors as absurdly high, and artists sometimes refer to art dealers as greedy bloodsuckers for seeming to live lavishly while they go hungry, but this is a tough business for everyone. A question arises for artists: Is your primary goal to get into a gallery or to sell works? Accomplishing the first doesn't always result in achieving the second.

ALTERNATIVES TO GALLERIES

Art galleries and dealers are but one, if a highly publicized, means for artists to exhibit and sell their work. Success in the art world may lead to critical acclaim and financial rewards, but many artists find the process of currying favor with dealers and even spending so much of their time in the large cities where the major art dealers are located to be grating on their nerves, contrary to why they sought to be artists in the first place.

There are alternatives, opportunities for artists to sell their work outside the gallery structure, and many artists have been able to gain exposure or make a living this way. The French Impressionist exhibitions in Paris of the 1870s and 1880s were all organized by the artists involved (one of Mary Cassatt's main values to this group was in convincing wealthy American collectors to come take a look). The German Expressionists of the 1910s staged exhibits and published the

Blue Rider almanac to promote their work; a sprawling group of American artists put together the 1913 Armory Show, which is credited with establishing Modernism to the United States; Dadaist artists in the 1920s created "Manifestations," and Pop artists of the early 1960s put on "Happenings." The group of art students at Goldsmiths College in London, interested in conceptual and installation art, who became known as the Young British Artists, gained notoriety through a 1988 exhibition titled "Freeze," which was put together by the group's leader, Damien Hirst, at the Saatchi Gallery. Eventually, those artists found their way into mainstream galleries, but they made their start outside them, and they did it by uniting themselves for a common effort. These days, such exhibitions are called artist-curated shows, and they often take place in nonprofit art spaces, but the intent of today's artists is the same as it was for the Impressionists, Expressionists, Dadaists, and Pops: Artists with similar interests and artistic ideas band together to promote themselves as a group and individually. Hey, art world, something new has arrived! Being an artist is a business, requiring artists to act entrepreneurially, being as creative in efforts to generate attention for themselves and their work as they are in their own art.

The first step on this path starts with putting work before the public.

SO, WHERE CAN I SHOW MY WORK?

There is a wide variety of exhibition spaces available for the starting-out artist. Banks, libraries, corporate headquarters, community centers, hospitals, real estate offices, and cafés and restaurants, for example, are frequently willing to allow artists to hang up their works on the walls where the public may see them. The likelihood of sales is often low, and the possibility of damage to the work (fingerprints, coffee splashes, cigarette smoke) is considerable, but this type of show is a chance for feedback and for the artist to circulate press releases, announcements, and exhibition cards, and be remembered the next time their work is on display.

Many towns and smaller cities have arts centers where exhibits can be seen in an actual gallery setting. A notch above the art show in the bank or library, the arts center is likely to have its own means of promoting activities, increasing the

number of people who may come to view the artwork. This may be a first opportunity for a write-up in a local newspaper, again increasing the number of people who know about the exhibit and the artist.

One might also look outside the usual sites where art is displayed to places where people with money and thoughts of making a purchase are going, such as furniture, wine stores, and jewelry shops. The clientele is a bit more select, and the connection between artwork and furniture, for instance, is reasonably close; buyers are apt to think about one in relation to the other. Real estate companies cater to people shopping for a home (they will want to decorate it), while social clubs and country clubs have dues-paying members who have demonstrated that they have discretionary income.

ROUNDING UP VISITORS

Who will come to an artist's early shows? The answer is, any number of people, but first artists must start out with their own network of friends, families, and associates, all of whom are predisposed to think well of the work. Artists have friends who might come; those friends have friends and business associates, some of whom may be persuaded to come. An artist who works in an office has coworkers, supervisors, a boss, clients, and suppliers who may be willing to come to a show. Family members, such as parents, may also have friends, business colleagues, clients, and suppliers. Out of all these people, there may be some who buy a piece because they like it or just as a show of support. A more informal style of exhibiting work that frequently results in sales is for friends or relatives to host a private showing in their homes, inviting ten people they know to meet the artist and examine the work close-up.

Everyone is a potential client, but it is important to let people know that you are an artist—you never know who might become a collector. For that reason, artists need to develop a client list, one that changes and (it is hoped) grows over the years, which will be used to contact people about art exhibitions or an open studio event. That list can grow with the help of some of those friends and family members who suggest other people to be contacted (their friends and business

acquaintances, for instance), and those friends and family members may be persuaded to write or call on the artist's behalf. Using people the artist knows to locate new prospects is a pyramid approach that ensures that more than the same group of potential collectors shows up at each exhibit.

Barbara Ernst Prey, a watercolor artist in Long Island, New York, began selling work by finding buyers through people she knew. Her mother's friends were some of the first collectors, quickly followed by the friends and associates of her husband's parents, and later, friends from college became buyers. Her brother, who lives in Manhattan, also set up a show of her work in his apartment, and other friends in Massachusetts and Pennsylvania did the same—all of which resulted in sales. Word-of-mouth advertisement and people she met at art openings and other social get-togethers also increased her client base. Eventually, her work came to the attention of art galleries, which became a principal venue for sales, although she continues to sell directly to buyers.

MARKETING

The business term for making the public aware of what one has to offer is marketing, which simply means finding an audience. Who are the people most likely to understand and appreciate the type of artwork I create? Not everyone will get it or like it, and it shouldn't be assumed that everyone should; more people have seen and not purchased a work by renowned painter Chuck Close, for instance, than have bought pieces, and it isn't just because of the high prices. His paintings are too large for some would-be buyers; other collectors may appreciate his techniques but aren't interested in his self-portraits or portraits of his artist-friends. Yet other collectors of postwar contemporary art prefer abstraction or sculpture. And then there is the price. The universe of prospective art collectors gets whittled down more and more until we come to a very small number of people who actually buy the work of this famous artist.

All artists who have achieved success—defined as the ability to sell their work, particularly being able to live off the sales—have needed to find that audience. Which people are most likely to appreciate the art? In some cases, geography

offers some help: Artists of the western landscape are more likely to find buyers in the western half of the country than in the East, while marine artists are apt to interest collectors along the Atlantic and Pacific coastlines. Practitioners of performance art, installation art, social practice art, and conceptual art have narrower avenues to pursue within a few cities and some college campuses. Artwork that contains references to contemporary pop culture is more likely to be enjoyed by younger people, while those who own or ride horses favor equine images, and avid golfers frequently are interested in paintings of the thirteenth hole at Augusta. There is no one "art world" but just an assortment of niches.

Exhibiting artwork and eliciting reactions is how artists begin and, over time, refine the process of marketing. First and foremost, artists want to know if people understand and like what they are doing. A negative reaction may indicate that the wrong people are looking at one's work, or it may mean that the art still needs improvement and isn't ready for general exhibitions and sales. It is wise to solicit the responses of professional artists in the area, perhaps faculty from art schools, who can evaluate the artwork and offer suggestions for the art or, perhaps, where else it might be shown.

Exhibitions often have guest comment books in which visitors are invited to record their reactions, and it is a good idea for artists to have someone else at an art show—friend, relative, spouse—who directs people to these books, asking them also to leave contact information in order that they may be notified of future exhibits, lectures, demonstrations, and open studio events. As valuable as the comments may be, artists will want to know something about these people: Are they homeowners or renters, city dwellers or suburbanites? Do they regularly go to art exhibits and, if so, do they collect? Do they belong to any clubs or associations? The income level (take a guess), age, gender, nationality, and race of the visitors who offer the most positive responses to the artwork will enable artists to better determine where future exhibitions might be planned and who should be invited. If there are any sales, it is advisable for the artist to personally deliver the piece to the collectors' homes in order to learn more about them: What is their color scheme? What rooms in their home might be suitable for art?

Artists always should be on the lookout for potential buyers, attending the kinds of social and civic activities where these people would be found, such as art exhibition and performing arts openings, charity events, and parties. Jot down names and contact information for one's client list, following up with a letter, email, or telephone call inviting that person to an upcoming exhibition or to visit one's studio. If that seems a bit pushy, a get-together could be at a museum or art gallery, or just a café.

MARKETING IN THE ETHER

Social media—Twitter, Facebook, TikTok, Instagram, Pinterest, LinkedIn, YouTube, and various other sites—also allows artists to promote themselves and their work at virtually no cost other than their time and energy. Posting content (images, comments, videos, blogs, retweets and likes, and links to one's own or others' websites) allows artists to create an ever-expanding community that includes other artists, collectors, curators, dealers, and whomever else might share the same interests and tastes. Social media, according to Shannon Wilkinson, chief executive officer of the New York City-based Reputation Communications, is a career-building and career-sustaining tool. "First and foremost, it is about connecting and sharing. It is not about endless self-promotion, although many people misuse it in that way."

Facebook offers the greatest opportunity to provide information about oneself to the larger world through the About section, which may include links to a website and an artist statement, and Facebook groups allow artists to pick up tips from others regarding sales and marketing. Additionally, site users may obtain insights about those in one's community and how well one's posts are received.

To be effective, however, social media cannot be a one-shot endeavor, such as creating a Facebook page and posting some photographs on it, then leaving it stagnant for weeks, months, or longer, but needs to be regularly updated and augmented. When people comment on or respond to a post, tweet, or image (assuming the response is not just mean-spirited, vulgar, or insulting), artists should respond back, as that helps to build a sense of community. It also is just polite to do so, as those in the growing community feel heard.

Also to be effective, the content needs to be brief—social media users tend to have short attention spans—and well thought out. Interesting is more important than being clever or catchy. Social media is not just a platform on which to make a sales pitch but a means of gaining followers and earning their trust. Eliciting feedback and responding to it often increases that trust. Written material (who I am, the type of art I create, the technique I use, the theme of my work, where my work is on display) should be to the point. Images should not be blurry nor videos bouncing.

The first step to building an online community involves researching the audience that matters to the particular artist. For instance, a sculptor might conduct a hashtag search for #sculpture, which will offer a sense of what is currently on Twitter and Instagram in that space. More specific hashtags, such as #DUMBOsculpture or #reliefsculpture, will make the search more targeted.

Next, artists should conduct searches for the magazines, writers, institutions, and organizations that are most active in supporting their particular type of art, following those that interest them and are relevant to their careers. After that, artists might start examining who those people and institutions follow, and following the ones who interest them. One might look for what are called "influencers," gallery owners, museum staff, grant-making and awards organizations, journalists, critics, collectors, and sponsors, as well as other artists; in effect, people who play active roles in making decisions, policies, and statements that impact the art world—in particular, the art world that is most relevant to an artist. Comment on, or like, their posts, with the idea that as you follow them they will come to follow you.

It also makes sense to conduct a search outside the more narrow confines of the art world. If science is a theme in one's work, or nature, artists should research the journalists in those areas, including bloggers, starting with the same #hashtag search. "Bloggers are more accessible than magazine editors and often freelance for them," Wilkinson said. Even better, bloggers generally respond before mainstream editors and writers do, as there is less competition for their time. "When they publish posts about art or other topics, it provides instant online forums for it that can be built upon and expanded."

Print publications are on the decline, being reborn as digital publications. However, all digital magazines and bloggers have social media platforms. Artists who are not aware of them, much less following and engaging with them, are restricting their opportunities. Much publicity is now being done digitally, and publicists are connecting with writers online because so many are independent; they are freelancing more and are less likely to be a full-time staffer. Often, these writers also write for other online publications, ones that curators read. Being active on social media enables artists to see who those writers are and where they are publishing.

Social media should be used to support, rather than replace, other forms of marketing and public relations. For example, an artist preparing a mailing of printed promotional material for art consultants and editors at art publications to announce a recently installed commission might look to maximize the marketing opportunities by researching all of those individuals on Twitter and other social media platforms and connecting with the ones he or she finds. Begin sharing their posts (with the goal that they will notice and follow the artist back). That can lead to what is called "engagement" on social media—also known as a "conversation." If that occurs, the artist might send a private message letting the contact know to look for his or her announcement. If it does not occur, the artist can still include the person's Twitter handle or Instagram address on future posts with pictures of new commissions.

Similarly, when artists have an exhibition and know there is a critic who is likely to respond to their work (based on the reviews the critic writes about other artists with commonalities), they can follow the critic on social media and ensure that this person's Twitter/Instagram handles are included in posts with images from the upcoming show. That is a very easy way to increase awareness about the upcoming exhibition, reinforcing the message that is being sent on other channels, such as direct mail, perhaps in advertising, as well as from a gallery or public relations consultant.

Different social media platforms should be used in different ways. Facebook, for instance, should serve as a portfolio, while Twitter should be used to gather

information and to build an audience, and Instagram can showcase one's work. Using #hashtags on posts helps to reach new audiences. For instance, when an artist has finished a painting in Sedona or the Hudson Valley, make sure an Instagram post about it includes #Sedona or #Hudson Valley. Otherwise, the artist might be missing exactly the type of audience that wouldn't otherwise know about it, and that may respond to it.

We live in a world of people seemingly glued to their phones and tablets for hours every day, following So-and-So and posting images from their drive home (or whatever strikes their fancy). Social media might seem to fine artists like an enormous time-suck, the rewards of which are only theoretical, while the requirements only guarantee distraction and time away from work in the studio. However, Wilkinson said that two or three hours per week would be sufficient, using that time "to scan the posts and tweets made by the community they have built, which provides them with marketing insight about news, reviews and opportunities within their sphere, and to compose and schedule periodic posts for the coming week. That may be as little as three posts in a week, two of which may be just sharing someone else's content." She recommended several free and low-cost social media management systems—such as Hootsuite (https://hootsuite.com), Buffer (https://buffer.com) and Sprout Social (http://sproutsocial.com)—that enable users to read the social media posts of anyone they want to follow, as well as schedule and publish one's posts on social media platforms. That enables artists to participate within that community, and the alternative is to be invisible to it "at least in the digital space."

A caveat or two. Social media does not come without some potential problems beyond the amount of time it takes to stay current. Social media represents "an opportunity and a risk for artists, depending upon the business model of the artist," said New York University School of Law professor Christopher Jon Sprigman. For artists, too, who "want people to share their images, pass them around, social media allows people to interact with their artwork in a number of ways."

On the other hand, for artists whose business model relies on wanting to reserve all rights to their artwork, posting images of their art on social media may be tantamount to flashing expensive jewelry while walking at night in a bad neighborhood. Laws—in this case, copyright law—exist to protect people from harm, but the risk of some harm taking place is high. Posting an image online, for instance on an artist's own website, does not necessarily imply the hope or expectation that the image will be passed around from one interested person to another, but posting within the social media environment likely implies that its owner is licensing it for some form of distribution by other site users, for instance through the Share function at Facebook or retweeting at Twitter, and that the image will go viral.

The risks are relative, less for sculptors, since images are imperfect replacements for three-dimensional pieces, and painters than for photographers, because a downloaded high-resolution image of a photograph will look largely identical to the original. The customary solutions for artists are to post low-resolution images of their work, which displays the art very well at a small size on the screen but does not look good when enlarged and reproduced, and to embed metadata (information about whether the image is copyrighted and to whom, who owns the particular image, the camera that took the image, and the exposure used) in the image. "I always advise artists never to post high-resolution images online and to embed images with copyright management information or watermarks," said New York art lawyer Barbara Hoffman. A problem arises when certain social media websites automatically strip out any and all identifying metadata when images are uploaded to their sites, making it more difficult to learn if an image is copyrighted and by whom.

The Terms and Conditions pages of social media sites indicate what the site operators and users may do with posted material. Instagram, for instance, claims no ownership of this material. However, "By displaying or publishing ("posting") any Content on or through the Instagram Services, you hereby grant to Instagram a non-exclusive, fully paid and royalty-free, worldwide, limited license to use, modify, delete from, add to, publicly perform, publicly display, reproduce and

translate such Content, including without limitation distributing part or all of the Site in any media formats through any media channels, except Content not shared publicly ("private") will not be distributed outside the Instagram Services." This language would appear to give Instagram—and by extension, its users—the unfettered right to use, display, perform, and modify the content of an image without the permission of the work's creator, which vitiates the copyright. This is the price someone pays for the ability to use this free service, and undoubtedly many users consider that the potential drawbacks are greatly outweighed by the benefits.

PRICING ARTWORK

What a work of art should cost and whether or not an artist ever should offer, or accept, a discounted price are among the most difficult decisions an artist may face. The problem of pricing has long puzzled artists. There have been some efforts to devise a system in the manner of a building contractor, totting up the cost of materials plus a margin of profit and then adding in the number of hours the artist worked on a piece multiplied by some hourly wage, but the final amount may have no relationship to the market for that artist's work. This is particularly true for lesser-known or emerging artists who are less concerned with getting the right price for their work than with getting someone to look at and purchase their art. (Artists who have had a history of sales, on the other hand, will have a better idea of prices that are more suitable for particular buyers.)

How much to charge? First, there is no formula to determining this. In the building trades, for instance, contractors charge hourly rates, as well as the cost of materials plus an average 15 percent markup, but artists cannot do the same. Some artists simply work more slowly than others, for one thing. More important, the final price may have no relationship to the market for the artist's work, especially if the artist is relatively unknown and has little to no history of sales.

The building trades are not completely irrelevant, however, because a completed house and a completed work of art can be priced in similar ways, through comparables. A three-bedroom, two-story house in a neighborhood of similar-size

homes is appraised based on the sale prices of those in its immediate vicinity: If the others have sold in recent years for $300,000, that is the starting point. In a more affluent neighborhood or town, where such houses sell for $800,000 and up, that is the starting point.

Artists, too, need to find comparables—work of the same size, with similar subject matter, in the same medium, produced by artists in the same stage of their careers—in order to set prices. As a result, artists need to visit art fairs, art galleries, and other places where artworks of comparable size, imagery, and quality by artists of similar standing in the art world are sold. A comparable cannot be a well-known artist whose work fetches high prices and looks quite a lot like yours.

It is frequently the case that the work created by quite celebrated artists went for very little early in their careers, and some of them look at high secondary market sales of those pieces and think that they were cheated. Perhaps they were cheated, but at the time most of those artists probably were happy that someone would buy their work. However, back to the subject of lesser-known artists trying to determine what to charge for their work: one should never ask prospective buyers what they would pay for art; that is the artist's decision.

As sales take place and the number of buyers increase, raising prices may become justified. Consider the case of Scott Fraser, for example, a painter in Longmont, Colorado. His paintings were first shown in an art gallery in Denver and sold for $300 in the early 1980s. Some sales took place and, the following year, his prices went up to $900. The value of his work continued to rise, to $1,500, then $7,000, later priced at $20,000 and up. "Each time you make a jump in pricing, you have to get a new set of buyers," he said.

For other artists, raising prices may require finding another gallery or dealer, where opportunities for having works purchased by collectors who will pay more or lend enhanced prestige to the work are greater. Some dealers may only be able to work with emerging artists and not have the contacts to help an artist who is selling work steadily. Changing galleries may be a difficult decision for an artist who got their first big break with a particular dealer, and it can be doubly hard in the

art world because the relationships between artists and dealers are often on a personal, friendship level.

Discounts is the other side of pricing, customary to the point of expected in the gallery world ("Every work is discounted," said Manhattan art dealer Debra Force. "I can't think of an instance in a long time where someone paid the asking price") but often jarring to artists who sell their work independently. Artists come up against bargain hunters in their studios and at art fairs where prospective buyers offer to pay as little as 50 cents on the dollar for one or more pieces. At art fairs, many artists claim that these buyers come in an hour before the event is over, just as the artist is preparing to pack up, offering to take work off the artist's hands but at some substantial discount. It is easy to feel insulted, but the issue isn't so clear-cut. On the side of accepting the payment is getting ready cash, which may be welcome if the fair was not as profitable as might have been hoped, and reducing the expenses and risks of crating and transporting artworks back to one's own studio. Too, if the artist's work had been consigned to a gallery, any sales would have meant paying a sales commission to the gallery owner, which is often half. The artist still may feel insulted, but some reasons can point to taking the money.

On the downside, allowing a discount once is apt to mean that an artist will be asked again and again for markdowns. Buyers cannot be trusted to be discreet and may well boast to other prospective collectors that they talked you down 10, 20, 25 percent or more, and those people will now have reason to think themselves insulted if they aren't allowed the same (or better) discount as So-and-So.

It is not at all clear that lowering prices increases demand. Economists refer to this in terms of the "elasticity of demand"—demand shrinks or expands with higher or lower prices –but "demand for art is probably not elastic," according to John Silvia, former chief economist for Wells Fargo. He noted that lowering the price for less-expensive consumer items "brings people into the store, but if you have a product that is fairly unique or distinct, like art or jewelry, the answer is, no, you don't lower the price." In a prestige realm such as art, cutting prices—"a painting that last week was selling for $40,000 is now for sale for $30,000," he speculated—could have an adverse effect. Artists who do slash prices risk "alienating

two customers: You alienate anyone who bought from you in the past and now thinks he was cheated, and you create a doubt in the minds of future buyers about any work of art you sell. They wonder, Am I being cheated now."

Discounts blur the question of the actual price, and value, of the work involved and potentially make those who pay full price feel like chumps. The process of selling artworks does not want to be likened to car buying, in which dickering and mistrust have taken on greater importance than the actual thing being sold. Being a car dealer is synonymous with shadiness, and artists want to be viewed in a different way. More and more, collectors on all levels of buying are taking the view that the stated price is not the real price and beginning a process of haggling. Barbara Krakow, a dealer in Boston, noted that many galleries "raise prices for works in order to accommodate requests for discounts," adding that "it all becomes a game. Some people seem more interested in the discount than in the artwork. Some people ask for discounts, because their friend got one. The discount seems to have a meaning in itself."

The cleanest arrangement, and the one that does not require artists to remember who got what discount, is simply to declare to prospective collectors that the stated price is the actual price. Some buyers may be lost as a result, but it may also generate a sense of respect for the artists that they truly believe in their work and have priced it fairly. Some modest discounts may be easier to swallow, such as 5 or 10 percent off when a collector purchases more than one, or the artist will throw in framing and shipping. As fraught with perils as discounting may be, I don't mean to condemn artists for allowing it. As noted earlier, gallery owners and private dealers allow discounts all the time. What is most essential for artists is that they develop a price list for their work and a policy on discounts before they put artwork up for sale. You don't want to come up with a discount policy on the spot.

SALES

Marketing and sales are often spoken of in the same breath, but the two are distinct, if related, concepts. While marketing involves identifying one's audience of potential buyers, sales concern the steps leading up to an actual transaction.

Selling art without intermediaries takes some getting used to. Most artists are happy to talk about what inspires them, where and with whom they studied, the subjects they pursue, the medium in which they work, the techniques they employ. They tend to be a bit more reticent about money—what their work costs, how and when they want to be paid and if they allow discounts (and how much of a discount). The subject of money knocks artists off a lofty perch, turning them (so many believe) into car salesmen, and who really thinks well of car salesmen? The answer is, you can conduct sales without becoming the caricatured car salesperson.

First, the artist needs to take the initiative in closing the deal, although it may be easier to proceed by focusing attention on which piece(s) the collector seemed to prefer as well as how, when, and where the art should be delivered. The payment question can be brought up in the form of "Do you want to pay me now or upon delivery?" Other possibilities include being paid half now, half later or some form of barter.

When artists sell their work directly, rather than through a third party, they need to use many of the same sales techniques as gallery owners. For example, artists should have brochures, postcard images, and other written materials (such as a bio and a price list) readily at hand. Fumbling in a desk or file cabinet for an exhibition history takes away from the impression of the artist as a professional prepared to sell work, and prices that are not committed to paper may suggest to potential buyers that they are being made up on the spot with the amounts dependent upon the artist sizing up the collector's financial resources and whether the artist likes the buyer or not.

If would-be collectors are expected to purchase works from the artist's studio, there should be some area within the studio set up for displaying art. Artists should follow a collector's interests, determining an individual's preferences in media, size, colors, and subject matter and showing additional works that correspond with those tastes, rather than attempt to direct a potential buyer to particular works they would like to sell. Artists may offer to bring a selection of works to the collector's home or office so that the buyer can choose the piece(s) that work best in the

environment. In most cases, the delivery of the sold work of art should be at no additional charge to the collector.

Delicately, artists should try to discern the buyer's budget, leading that person to pieces that are priced in that category, rather than attempt to urge the collector to spend more than they find comfortable. Artists may also offer a returns policy, allow a buyer to change their mind about the piece within a week or two, or permit collectors to take the object home on a trial basis (again, a week or two) before paying. Collectors may want to pay over time or pay through trade (other artwork or goods and services), which is taxable income but not the hard cash with which to pay the sales tax. A measure of flexibility in price and the manner of payment entails increased risk for the artist, but it may also inspire greater confidence on the part of the collector.

Some written document should accompany the transaction, either a straight bill of sale or a sales agreement. The bill of sale will indicate all relevant facts about the transaction, such as the artist's name, the name of the artwork, the work's medium and size, the year the work was created and if it is signed (and where), the price of the piece, and the date of sale. A sales agreement will include all those facts as well as add some points that are advantageous to the artist, such as reminding the buyer of the artist's rights under the copyright law as well as allowing the artist to borrow the work (at their own expense) for up to sixty days once every five years in the event of a gallery or museum exhibition and permitting the artist access to the work in order to photograph it for their portfolio.

Artists who sell directly to customers should obtain a sales tax number through the state department of taxation (the number usually is one's Social Security number, and there is rarely any charge for this) and add a sales tax to the price of the artwork they are selling. Every state has its own percentage tax for sales. An added benefit of having a sales tax number is being able to either deduct the sales tax that one pays for art materials or not pay sales tax at all if the materials are incorporated into a work for resale. The artist should contact the sales tax bureau in their own state concerning the sales tax.

ACCEPTING PAYMENT

How to get paid would seem to be obvious. I mean, you know, like, just pay me. But the question arises, in what form are you willing to accept payment? Each form has its own benefits and drawbacks. At Sam's Club, members have a range of options to pay for their purchases, from cash and checks to (selected) credit and debit cards, and EBT and SNAP. Walmart adds PayPal to the mix, and the California Department of Motor Vehicles notes its willingness to accept money orders and e-checks. A buyer comes into your studio or booth ready to make a purchase: What are you willing to accept?

Perhaps the best answer is most of the above, because you want to make it as easy as possible for people to pay you.

CASH

Cash has obvious advantages, since it doesn't need any time to "clear," as do checks and credit card payments, and there is no service fee of between 2 and 4 percent for the vendor to pay to a middleman, as exists with credit cards and PayPal. In fact, vendors might have reason to encourage prospective buyers to pay in cash by offering a small discount. Still, as a practical matter, most people do not carry large amounts of cash on them for the same reason that vendors might be reluctant to be paid with large amounts of cash—they make themselves a potential target of thieves.

Money orders and certified checks are as close to actual cash as one may get, and some people use them to pay for purchases through the mail. A benefit of these types of payment for the buyer is that they do not contain any personal information (home address or telephone number). For the vendor, the benefit is a type of check that cannot bounce. Both money orders and certified checks are available through post offices and banks, and the principal difference between them is that money orders are written for specific amounts—say, $200 or $1,000—while certified checks may be for any amount (for instance, $126.27). There have been rare instances of counterfeit postal money orders, and they may not be accepted if damaged in the mail, for instance if the routing number on the bottom of the money

order cannot be read by a processing machine. (The process of getting the bank or post office to issue a replacement is neither quick nor assured.) It is very unlikely that someone entering your booth or studio, however, will pay for anything in this way.

Personal Checks. Personal checks continue to be an option, although a declining number of people these days pay for their purchases this way, due to the ubiquity of credit cards. The benefit of a personal check is that, just like cash, they do not require the vendor to concede some percent of the payment to a middleman. Handing over a check, however, has the potential that the buyer's bank account has insufficient funds, which would be discovered only after the purchased object has been taken and the check has been returned (five to ten business days later). There are other recourses for artists and craftspeople, including requiring those wishing to pay with a check to provide a telephone number (if it isn't preprinted on the check) and present a driver's license (write down the license number on the back of the check) in order to confirm their address and identity. If the check is returned, you will have a means of contacting the buyer to explain the problem and getting it resolved amicably. (If a telephone call doesn't work, artists might send a certified letter that restates what was requested over the phone, contacting the customer's bank to see if their account now has sufficient funds to cover the check—the bank may agree to collect the amount from that person's account following the next deposit, transferring the money to you—and, finally, taking the individual to court or hiring a collection agency.) Another pair of options is to delay delivering the purchased item until the check has cleared—this might suggest to the buyers that you do not believe they are honest or reputable—or not taking checks at all.

DEBIT CARDS AND E-CHECKS

Debit cards tend to be accepted at most of the same places that take credit cards, and the main difference between them and credit cards is where the money comes from. Using a credit card is a form of borrowing money, while debit cards draw directly from one's bank account. Vendors who receive authorization to accept debit

cards can find out immediately if the buyer has the money to pay for the purchase, and the bank would put a hold on that amount of money in the account. Presumably, that should protect buyers and sellers, since no one would be able to spend money they don't have in the bank. The only problem in the system is that the process of transferring money from one bank account to the other may take a few days, during which time the "hold" has elapsed and the buyer no longer has sufficient funds to cover the purchase. That doesn't happen often, but it has occurred.

E-checks, which are a paperless form of payment made online or over the telephone, are becoming more popular among people who don't have credit cards or are reluctant to use them. Similar to a debit card, the e-check taps one's checking account directly—buyers would need to supply the name of their bank, the name on their account, the account number, and the routing number, as well as the amount of the purchase—and the advantage for vendors is that payment is assured (otherwise, the check bounces immediately). The only drawback for vendors is that, similar to accepting credit cards, they must apply to and be accepted by an e-check processing service, paying an initial setup fee ($100 is standard), monthly user fees ($20), and transaction fees, and there may be other optional or required fees, such as fraud detection and a chargeback fund. Vendors also may be required to purchase special payment processors.

CREDIT CARDS

There are many different types of credit cards—among which are MasterCard and Visa, which are bank-issued and underwritten by these companies, Discover and Capital One, as well as Diners Club and American Express, which refer to theirs as charge cards—and to accept them as payment vendors must obtain a merchant services account, which involves a range of setup fees, the acquisition of a credit card terminal or a card processing app for a mobile device, transaction fees (the percentage of the purchase price tat the company takes, plus a flat per purchase cost), authorization fees (a charge for each time the company authorizes a transaction), statement fees, annual or monthly fees (the cost of having an account), monthly minimum fees (an additional cost if the amount of charges does not reach

a certain amount), and chargeback fees (for reimbursing the buyer if there is a return).

American Express and Discover tend to be accepted by fewer businesses than MasterCard and Visa, because the transaction fees are higher, sometimes as much as 4 percent as compared to the 1 to 2 1/2 percent that the bank-issued cards generally charge, which cuts down on a vendor's profits. Those merchants simply have to hope that the buyer has more than one type of card or some other way of paying.

ONLINE PAYMENTS

PayPal (and there are other, similar companies) is often a way for consumers to make purchases online although, just as with every other option, there are benefits and drawbacks. The largest benefit is that it is easy for buyers to use, paying for items with their credit cards or e-checks, and setting up a PayPal payment option on a vendor's website (with buttons for single purchases or a shopping cart) is quick and uncomplicated. What's more, customers may be familiar with PayPal already through purchases from eBay or Amazon, which adds to their comfort level.

There are no setup fees for vendors setting up merchant accounts with PayPal, but it takes four business days for funds to be deposited into one's account, which is a bit slow. Vendors still may find the costs of being a PayPal merchant to be high, with monthly fees of up to $30 and transaction fees of 2.9 percent in addition to 30 cents for debit and credit card purchases. Even more costly are chargeback fees of $20, and PayPal will still retain its 2.9 percent transaction fee. As with many other online services, contacting an actual person at PayPal's customer service department about problems you may be experiencing is not easy.

With both e-checks and PayPal, the monthly costs of being able to use these payment systems may begin to bite if buyers don't want to make purchases in this way, or they do so rarely. Spending hundreds of dollars per year to enable just a few small sales may make the convenience unprofitable.

There is more. Venmo and Zelle are popular, although buyers using Venmo have the option of retrieving money sent to a vendor's account, leaving that vendor

in the lurch, whereas Zelle directly transfers money to and from FDIC-insured banks. Cryptocurrencies such as Bitcoin and Ethereum also are used increasingly although, unlike government-issued currencies, they may fluctuate wildly in value and have been the targets of hackers.

In short, every system of payment involves costs and risk, and artists who sell their work directly have to determine which fees they are willing to accept and how much uncertainty they can live with.

A WORD ABOUT TAXES

Artists and craftspeople may receive money in a variety of ways, including awards and prizes at shows, project grants, scholarships, and fellowships. The prize money or the monetary value of an award (the cash value of a gift certificate, for instance) that a craftsperson receives at a show is taxable at normal state and federal rates. The same taxability is true for money received through project grants from a private or governmental agency. On the other hand, there is no tax on fellowships and scholarships if the craftsperson is studying for a degree at an educational institution (including tuition, lodging, equipment, and travel expenses), nor is an award taxable if it comes from a governmental agency or school. If the award is contingent on the recipient teaching or offering demonstrations or some other part-time service, however, a portion of the fellowship or scholarship will be taxed.

The sale of one's work, of course, also occasions the payment of taxes to state and federal agencies on either a monthly, quarterly, or annual basis. Those artists and craftspeople who sell their work at retail or wholesale shows in the state where they live or out of state are required to apply for a resale tax number both in their home state and where the shows will be held. Usually, one applies with a state's department of revenue, and the cost of registering to sell work is in the area of $10, although some states have no charge. In some cases, registration is for one year, although some states permit applicants to receive a two-day or weekend resale tax number. Most show promoters require a state resale tax number as a condition of taking part in the event. The artist or craftsperson will receive from the state

information about how much sales tax to collect (generally, between 3 and 8 percent) and how to pay it—often, a coupon book is enclosed (the coupons are to be mailed back with sales tax receipts). Usually, applicants receive their number and paperwork from the state in a couple of days.

2

Finding Other Venues for Display

For many artists, selling art is an improvisational affair, trying things out to see what works. How about a commercial gallery, an arts fair, a sidewalk show, a pop-up gallery, an open studio event, posting images on Instagram, showing artworks at a café or bookshop or winery or a bank, announcing that you will accept Bitcoin? There is something to learn from every success (do it again, go bigger) and every failure (wrong venue, wrong date, wrong clientele, wrong prices, wrong colors, wrong art).

Erin Ashley, an artist in Boca Raton, Florida, who creates moderately priced ($300–$6,000) abstract paintings, has done a lot of the standard things that artists do—exhibiting in galleries here and there, as well as soliciting commissions from private buyers and corporate clients—but from time to time she also ventures a bit outside the norm, holding what might be considered online open studio events. Her emailed announcements and promotion on social media and other website resemble those of Bed, Bath & Beyond, MyPillow, and other retailers (TAKE 25% OFF ON ALL ORIGINAL ART! Offer ends Midnight Sunday, Enter Promo Code: VIPSALE), and she usually sells between two and eight paintings in these time-limited offerings, generally in the $600–$700 price range.

Perhaps the most important element to making Ashley's event a success is her email communications. She uses Mailchimp, one of the top brands of email

tracking programs, which counts and identifies the recipients who opened the email and downloaded the message (rather than just hit the "delete" button), as well as how many recipients clicked on the link to her website, where they could see more of her artwork. That enables her to know which of the people receiving her announcement are showing real interest, which helps determine who might get more targeted offerings at another time. (Mailchimp, Constant Contact, and other email marketing services do not, however, provide information on how long someone who clicks onto one's website stays there or what they look at on the website. Other programs, such as Google Analytics, https://analytics.google.com, help with that.) The cost of Mailchimp ranges from free to $199 per month, although most subscribers go with the $10 per month plan, based on the tools they seek for their online marketing.

Email, which has been available for several decades, may strike some as old school, replaced as a form of communication by the seemingly more direct social media, such as Facebook, Instagram, tweets, and texts, but Ken Mahar, chief executive officer of Email Broadcast, a West Coast design and marketing firm that focuses solely on email campaigns, noted that "emails are forty times more likely to lead to a customer than social media. The cool kids are on social media, but they look at social media for entertainment. People look to emails for information that they can absorb." Email Broadcast, and other firms like it, work with individuals and with larger companies to craft marketing campaigns that determine how often email announcements should be sent out, the content and design of the messages, and who in an email address database should receive specific messages. That last area is referred to as "segmented campaigns," in which recipients are sent different announcements based on what is known about them. Mailchimp provides some information to subscribers, but it may take more experienced marketers to turn what one knows about the people in a database into an actionable plan.

"Say, one-third of the people on an email list have bought your work, but two-thirds haven't," he said. "Why message all those people the same?" He added that other ways of segmenting one's database may be on the basis of location or gender or the price levels at which they have made purchases in the past.

The cost of Email Broadcast's services range from $500 per month to $10,000, but Mahar said that clients "should earn three times what they're paying us." The automated tools provided by Mailchimp and others like it make it possible for subscribers to save some time. However, he said, email marketing "is really hard to do effectively, and the likelihood of an accomplished artist being a professional designer, copywriter, developer, manager, and strategist is very low. Bottom line, use Mailchimp, save a little time, get a little bump in results, hire an expert to use Mailchimp for you, save a ton of time, and get big time results."

DEMONSTRATIONS

Every artist has heard it. Masonville, Colorado, sculptor Daniel B. Glanz certainly has heard it. Someone looks at one of his small bronze pieces of animals or human figures, sees the price, and asks, "Why does this little sculpture cost so much?" He has an answer to this, but sometimes it is easier to show people, and for that reason he offers demonstrations of the process of making a sculpture several times a year at the galleries that represent his work (there are three in Colorado and one in Texas) and, occasionally, at a museum.

The demonstrations last a couple of hours each. Some visitors stay for the entire time, while others go in and out. Talking through each stage of the process, Glanz brings a lump of clay, a wax figure, an armature, a mold, the bronze piece, and the bronze after it has been smoothed and patinated in its final version. He will do something with each of the stages to reveal what is involved. "People have no idea how labor-intensive the process of producing a bronze is," he said, and his demonstrations usually elicit lots of questions: "Why do you do it this way? Why did you make that decision?" By the end of the demonstration, he noted, the why-does-it-cost-so-much question "often becomes, 'There is so much work involved. How can you afford to do it?'"

Chalk up the modest expense of setting up a demonstration, and his time doing it, to the cost of marketing. "I do it for promotional reasons, to educate people about what goes into making a sculpture," Glanz said, "and get them to thinking about buying one." These demonstrations have resulted in purchases right at the

site of the demonstration—he brings a number of fully made artworks to sell—as well as commissions to create other works down the road, in addition to visits to his website, where other pieces are on constant view. (He also makes sure to bring flyers, postcards, and other promotional material that lists his website and studio address in Loveland, Colorado, for visitors to take with them.)

Hunting up prospective buyers is not the only benefit for artists to demonstrate how they work. Karen Nastuk, a watercolorist in Danvers, Massachusetts, has been asked by a number of art associations to present demonstrations of between two and five hours for their members (she has been paid between $75 and $250 per demonstration), and it is from these gatherings that she has found private students. "In a lot of these associations, you may have one or two people with advanced skills," she said, "but most of them are more like Sunday painters, and they really appreciate someone showing them how to do certain things and explaining how to do it at the same time."

Opportunities to hold a demonstration are abundant, at art galleries, arts and community centers, and at many art museums. The Museum of Fine Arts in Boston and the J. Paul Getty Museum in Los Angeles are just two institutions around the country that offer regular series of artists' lectures and demonstrations for the public.

OPEN STUDIO EVENTS

An artist's studio may also do double duty as a showroom, affording an opportunity for visitors to see unsold work, preliminary sketches and designs, and works in progress and generally how an artist goes about the process of creating new pieces. To many artists, visitors may seem to be an intrusion, but many of those visitors find the experience thrilling, because this workroom looks so different than what they are used to and since it brings them closer to the act of creation. Unless an artist's studio is always open to the public, for instance if the artist runs a gallery out of their home and studio or if the artist works in an open-to-the-public venue such as the Torpedo Factory in Alexandria, Virginia, or the Columbia Pike Artist Studios in Arlington, Virginia, these events tend to be limited to one or two days per year at most, if the artist even wants them.

Open studio events tend to come in two types, a community activity in which a number of artists agree to open their studios to the public on a certain day (such as the St. Paul Art Crawl in Minnesota or Somerville Open Studios in Massachusetts) or by-invitation showings for a more select group (usually, past collectors and others who have shown interest in the artist's work).

Community events tend to be less for the purpose of generating sales and more to create opportunities for artists to display their work and for area restaurants and shops to do some extra business. "For a lot of the artists, the only place that people can see their work is at the Crawl," said Craig Thiesen, coordinator of and participant in the St. Paul Art Crawl, which has taken place over two days (Friday evening, 6–10 p.m., and Saturday afternoon, 1–6 p.m.) in the spring and fall since 1991. The Crawl encompasses over 180 artists in thirteen downtown buildings, and the seven thousand estimated visitors may get to one-third or less of the studios. There is no jurying of artists who wish to participate, and their principal obligation to the event is the payment of a $40 fee. Few of the artists earn a living solely from their artwork; Thiesen, himself a web designer who also paints landscapes, said that "I generally don't sell anything at the Crawl. I do make some good contacts, and occasionally that results in a sale sometime later."

Nancy Fulton's own experience in Somerville has been similar. She is a photographer and architectural consultant who has participated in a number of the open studio events, rarely selling anything. "I've sold a few small pieces," she said. "Nothing much."

Tallying up how many sales artists chalked up, and how much money they earned, during these open studio events is never easy. Thiesen noted he sent out a questionnaire one year and only a handful of artists sent them back. Both the St. Paul Art Crawl and the Somerville Open Studios receive grants from the state arts agencies and their city governments to pay for advertisements, maps, brochures, and other promotional materials, because these events are seen principally as increasing tourism—shopping and eating in restaurants—in less-used areas of town. The Art Crawl takes place in the Lower Town section of St. Paul, an abandoned railroad district that artists began to use as loft space for studios and living

quarters beginning in the 1970s. However, it still is "a pretty sleepy area that twice a year is transformed when thousands of people come for the Art Crawl," said Jeff Nelson, director for cultural development for the City of St. Paul. "That's very good for shops and restaurants in the area."

By-invitation events are more focused on sales, but both types of open studio activities require similar setup procedures by the artists. Artists should notify their friends, family members, collectors, and acquaintances about the open studio, rather than relying on an organization to spread the word effectively. The studio should be visitor-friendly, with easily obtainable information (biographical material about the artist, postcard images, perhaps a portfolio, artist's statement, and price list) at the entrance, and the artist should be accessible to talk with visitors about the work or him- or herself. The event should have a range of media and price points. The studio should not pose any safety hazards, such as open containers of turpentine or jagged pieces of scrap metal, and prescription medications should be removed from the bathroom and anywhere else. (The same goes for alcohol.) Close doors of rooms where visitors are not to enter, such as bedrooms, and hide jewelry and other valuables. Visitors should sign in, so that artists know who has shown interest in their artwork. By-invitation events might include refreshments (finger foods, wine, soda or other nonalcoholic beverages), and sending a thank-you note or email afterward to visitors is a way to keep one's name and the entire experience memorable a bit longer.

JURIED ART COMPETITIONS

The closest events we have nowadays to the old-style salon is juried art competitions, which are often organized by membership organizations of artists, such as American Watercolor Society or the National Watercolor Society or the numerous state watercolor societies, pastel societies, sculpture societies, western art societies, miniature art societies, and many others as well. Juried art competitions are large-scale group exhibitions that offer the public the chance to see artwork in a particular medium, style, or with a specific content (landscapes, maritime or equine images, Christian themes, the figure, or something else), while others are more

general, in the manner of the Art in the Village show. Of greatest interest to participating artists is that these shows attract potential and actual buyers who may only purchase art at these exhibitions and never go into commercial art galleries.

We tend to think about the life and careers of artists in certain specific ways: They retreat into their studios to do battle with the muse, emerging with artworks that their dealers and critics praise to the heavens, and for which collectors pay heavenly prices. Museum exhibitions and coffee table monographs to follow. (Maybe that goes a little too far.) Still, our portrait of the artist generally does not include driving their work around to outdoor weekend art festivals, battling the elements while setting up a ten-by-ten-foot metal and canvas booth to display that work, keeping one eye on the cashbox in the booth and the other on the van in the parking lot, negotiating with neighboring exhibitors to watch their booths while they take a bathroom break. Real artists—*real artists*—don't have careers like that, right?

Perhaps the experience of Richard Wilson, a painter and pastel artist in Greenville, North Carolina, might upset some people's expectations. By the numbers, Wilson has been very successful over the years, participating in fifteen to eighteen fairs and festivals annually and earning close to $140,000 per year against annual expenditures of just under $50,000. He judges an event's success as making sales of between three and five times the cost of getting and being there. There are an awful lot of artists represented by New York City galleries who wish they had sales of $140,000. Plus, Wilson said, "galleries charge a 50 percent commission" on sales—which means that his net earnings would only be $70,000 rather than $90,000 if he were relying on gallery sales—"and you have to wait for them to send you your money." Plenty of artists complain about how long it takes their dealers to pay them after a sale. "At shows, you get your money right there and then."

Wilson also has the type of personality that works well in a festival setting: He likes to talk, and he does it easily and without jargon or obvious salesmanship. At the fairs and festivals, visitors expect to see and talk to the actual artists, and the rules of these events require the artists to be there for this purpose. (The prospectus of the Coconut Grove Art Festival in Florida states clearly: "Artists MUST

be present all three days of the Festival. No commercial dealers or agents are permitted to represent the artist. The Festival reserves the right to close down or remove any booth in which the artist is not present.") Talking to strangers and knowing what to talk about are learned skills that are not taught in art colleges, and those on the fairs and festivals circuit who are successful need to figure this out. (More on that in the next chapter.)

Within the realm of juried art competitions and art fairs—shows in which selected artists will set up a booth to display their work—there is a hierarchical range of prestige. The more renowned shows have strong visitor attendance and generally more sales, usually at higher price points. Most juried art competitions take place indoors, while a large percentage of the art fairs are held outside, but the setting tends not to be determinant of status. Some of the larger outdoor events are coordinated with agencies of the particular cities and local businesses in order to turn an art show into a community-wide festival, drawing in more visitors than ordinarily might come just to see the art.

Many of the art fairs are sponsored by private companies that run a number of events throughout the year in different cities. Participating in these shows is dependent on being selected by a judge or jury, and it is also not free. Most shows require a jurying or application or administration fee that may range from $5 to $50, and that's just where the costs begin. For juried competitions, artists are responsible for crating and shipping their work to and from the exhibition site, and the only insurance that the sponsoring organization is apt to offer is for the artworks while they are on view. Art fair sponsors often require artists to send in payment for the booth fee, which may go as high as several thousand dollars, along with their applications. Artists who are accepted to participate in the fair have made a significant commitment, because if they choose or need to withdraw they may not get all or even part of their money back, depending on the reason for not taking part and when the sponsor is notified. Additional costs for art fair participants are travel, lodging, food, and insurance.

Because the investment is often significant, artists should have as much information about the shows in which they might enter as possible. The number of

arts fairs and festivals taking place across the United States and throughout the year runs into the thousands, requiring prospective applicants to do some research. There are some online sources of information on which fairs and festivals are taking place and where, including Fairsandfestivals.net, Artfaircalendar.com, and Festivalnet.com. None of them are complete listings, nor are they rated in any way. The first questions artists want answered are how long has this fair or festival been in existence, how many visitors came in prior years, and what volume of sales has taken place. In a more subjective vein, prospective applicants will be interested in character of the show's sponsors (did they do everything they promised? how did they treat the artists?). Again, these websites won't answer all one's questions, but they will help link artists to the show sponsors' websites where more information is available.

The primary source of information about a show, at least the sponsor's intentions, is found in the prospectus, and artists should never submit an application or any money for an event without first carefully reading this document. The prospectus may be online and downloadable or will be sent to artists who are considering whether or not to apply, but they all must answer basic questions:

- Who is the show sponsor, for which there should be a physical address (rather than a post office box or only a website) and landline telephone number, because prospective applicants might want to check with a local Better Business Bureau. It also is advisable to know the names of the people who run the sponsoring organization.
- Where and when the show is taking place. Does the sponsor have permission, or a signed agreement, to hold the event in a particular site on a specific date?
- If the event is to take place outdoors, are there contingencies for rain? What if it is an indoor show and there is a power black- or brownout? Under what circumstances might artist-participants receive their money back?
- Whether or not there is an application fee and the amount of it.

- Has this event taken place in the past and with the same sponsors? Artists will want to know that the sponsors have a track record (ask for visitor totals and any sales information—perhaps there were articles in a local newspaper); if this is a first-time event, it is important to feel confident that the sponsors have the wherewithal to stage a successful show.

- For artists setting up booths, how much electrical power is provided? Is there cell phone reception?

- Who is assigned responsibility in the event of damage, fire, loss, or theft?

- How art is to be shipped and insured (and who pays for shipping and insurance). Will artists be charged a "recrating" fee when their work is sent back from a juried competition? The show organizers should assume curatorial and financial responsibility for the artworks in their care. As an example of what should be done everywhere, the loan agreement between participating artists and the National Trust for Historic Preservation for the annual "Contemporary Sculpture at Chesterwood" exhibition in Stockbridge, Massachusetts, stipulates that "Works selected for exhibition will be insured for 80% of their established retail value while installed on the Chesterwood grounds. Additional restrictions will also apply. A condition report will be completed upon installation."

- Will prizes be offered to the artists (and in which categories)?

- Will the show sponsor take commissions on sale of artwork (will the artist report sales to the sponsor or route sales through the sponsor)?

- Whether or not every item must be for sale (or within a certain price range).

- Are artists obliged to provide "door prizes" or other donations for visitors to the sponsor?

- How many artists are to be selected, as well as the names and affiliations of the judges who will be making the determination. In general, it is the prestige of the juror(s) that gives importance and validity to the event. Also, artists may better gauge their chances for being selected if they know something about the person making the decisions. A juror who is an

artist known for sculptural installations may seem like a long shot for a potential applicant painter of traditional realism, but maybe not. The people picked as judges might have a wide range of knowledge, interests, and discernment, but more information helps would-be applicants make their decision.

- The type of art (subject matter and media) that will be featured. If only original art, does that allow for reproductions of an exhibitor's original art, such as an offset lithograph or digital print?

- Will the show have a catalog available (free or for sale) to visitors? Catalogs with images and contact information of the participating artists permit visitors to refresh their memories and perhaps make purchases after the event has concluded.

- Does the show sponsor charge admission, and what is the amount? Are there corporate sponsors of the event, and will they have booths, too? What types of concessions will be run at the event? Will there be music (live musicians or piped in by loudspeakers)? Some artists may balk at having a cell phone company or hot dog stand or loudspeaker placed right next to their booths.

- What type of marketing (to potential visitors and collectors) and promotion (to the media) are planned to ensure strong attendance and media coverage? Is there a budget for advertising?

The prospectus may not answer every question, and artists ought to make inquiries, which is one of the reasons that reliable contact information should be available. Also valuable is asking other artists who may have participated in a previous fair or festival to see how well they did and how they liked the experience.

NONPROFIT ART SPACES

To many artists, art gallery owners and dealers are the gatekeepers of the art world, leading to exposure, sales, a seat at the table. Will anyone come to see my artwork, will any critic write about it or any collector buy it—will it have any

stature as art—if it isn't exhibited in a commercial gallery? Getting into, and being represented by, a gallery becomes their highest career objective. Galleries, of course, are businesses that don't exhibit artwork just because it is good but, rather, because there is an audience and buyers for it. So, what of the artists who don't have a long and active client list?

"Our aim is to show work by underrepresented artists," said Ed Shalala, assistant director of New York City's The Painting Center, defining "underrepresented" as "not represented by a gallery." That, and being painters, are the only specific criteria for having artwork exhibited, and there are two ways in which that may happen: Painters may submit images of their work to the center, and twice a year a committee will select artists for an invitational show that takes place in the main gallery; the second possibility is being part of a group of artists that an outside curator proposes to exhibit, usually based on a particular theme involving content or style. There are eleven of those four-week-long exhibitions that take place throughout the year. Shalala stated that the organizers of these shows are often art historians, critics, and independent curators, but it is not at all uncommon that artists themselves take on the role of curator, assembling the work of artists who are united by some type of shared interest ("as long as it pertains to painting").

Being a nonprofit organization, The Painting Center is dependent on funding from one source or another to maintain its operation. Those who curate an exhibition agree to raise money by applying for grants from a foundation, corporation, or state agency, and if that doesn't materialize, the individual artists in the show will "split the cost to pay the rent," Shalala said. Sales of artists' work sometimes take place at these shows, and the Center receives a commission of 25 percent for those, but the aim is not sales as much as presenting art that is largely unknown to the public. "We have gotten some reviews over the years in the *New York Times* and *Art in America*," he said, which may be the larger goal.

The Painting Center is not the customary nonprofit arts organization; it is actually a cooperative gallery, with sixteen dues-paying members who exhibit their work in one- and two-person shows throughout the year in a project room gallery, but they formed as a nonprofit group to serve a larger realm of artists. However,

there is no prototypical nonprofit arts organization. The hundreds of these organizations that exist around the country—the best source of information is in *Art in America's* summertime issue, *The Art in America Guide to Museums, Galleries, Artists* (the digital version is https://artinamericaguide.com/)—range widely in their goals and target audiences, some acting as educational centers, where art classes and workshops are taught to young and old, or as venues for performing arts events. Many nonprofit arts organizations are focused on the local or regional community (the degree to which an artist could be classified as a "professional" may or may not matter), while others look to exhibit the work of artists from elsewhere in the country or even from other nations. Some offer artist residencies and have grant programs. Uniting them all is the aim to show work by up-and-coming artists who haven't received wide exposure.

The public is probably the largest beneficiary, as it receives a first look at emerging artists, and that public includes many people who don't regularly visit commercial art galleries or museums and feel less intimidated in an arts center. The artists, however, gain experience in showing their work, sometimes making sales and otherwise developing their credentials as exhibiting artists. "My show was hugely helpful to my career," said Jennifer Mattingly of Baltimore, Maryland, who exhibited her miniature dioramas at the Arlington Arts Center in Virginia in 2007. Seven works were sold to visitors to that show but, more importantly, her artwork was seen by curators at two Washington, DC, nonprofit arts organizations—Washington Project for the Arts and the Civilian Arts Project gallery—who both invited her to participate in group exhibitions.

Something that leads to something else is the goal of artists who show work at nonprofit arts organizations. Jesse Bransford, an artist of large-scale drawings and paintings and the director of undergraduate studies at New York University, had been invited to exhibit at Locust Projects in Miami, Florida, in 2003 by Locust's director, who had seen his work online and at shows at other nonprofit arts centers. Unlike many other nonprofit arts groups, Locust brings in artists specifically to create site-specific installations. Perhaps not unexpectedly, none of Bransford's works sold at the Locust Projects exhibit, but "I met a lot of people with

whom I'm still in contact," including Miami gallery owner Kevin Bruk, who began to show Bransford's work and currently represents him.

POP-UP GALLERIES

The term "pop-up" gallery has come into use to describe impromptu exhibition sites, such as vacant storefronts or empty buildings, where the owners may be willing to allow a temporary art display if certain conditions are met. Those conditions involve keeping the premises clean and protected from theft and damage, and leaving the owner free from any liability claims if someone is hurt. Many insurance companies carry event coverage, short-term protection, which has a wide price range, based on the size of the space, the expected number of visitors, the nature and location of the event, and whether or not alcohol and security staff will be provided. Individual artists may contact building owners about their willingness to allow the space to be used for an art exhibit, arranging the security requirements on their own, or work through a nonprofit arts organization that would negotiate and sign an agreement with the owners for the event. One organization that does this on a regular basis is the Lower Manhattan Cultural Council in New York City, which works with area real estate developers to develop short-term exhibition venues for artists in its residency program, but other nonprofits around the country have done the same for artists who have come to them with a request and a plan.

An even more informal exhibition setup is apartment galleries, in which artists turn their own living rooms into display areas to which the general public or just specific guests are invited.

COLLEGE ART GALLERIES

Yet another type of nonprofit exhibition site is art galleries at colleges and universities, many of which welcome inquiries from artists looking to show their work. Often, schools express greatest interest in local and regional artists, as well as alumni, but they will set up exhibits of artists who live and work farther away and have no association with the institution, simply because the artwork appeals to the gallery director. "You'll find a fairly positive attitude toward exhibiting regional

artists in the art galleries of colleges and universities, because these galleries are these schools' main portal, main form of outreach, to the larger community," said Brent Tharp, former museum director at Georgia Southern University and vice president of the Association of College and University Galleries and Museums. "The galleries' role and purpose are to connect with both the campus and the community."

Not all college and university galleries hold that view—Stephanie Snyder, curator and director of the Cooley Memorial Art Gallery of Reed College in Portland, Oregon, noted that "it's not in our mission to show regional artists' work. Our mission is to bring in exceptional work and significant artists from around the world"—and some schools use their galleries only to display student or faculty work. However, of the more than three thousand schools offering baccalaureate degrees and the 1,100-plus community colleges around the country, the majority have exhibition spaces, and a high percentage of them will show work by contemporary artists. Actually, many schools have more than one exhibition gallery, such as one exhibition space for student shows, another for a permanent collection, and a third for mixed programming that may include traveling exhibitions, faculty shows, and shows of contemporary artists within the region.

Interested artists should look at the type of exhibitions that the gallery has staged in order to obtain a sense of the desired aesthetic and media, which is likely to be found online, as well as whether or not there is a prescribed method of submitting a proposal. For example, the art gallery at Saginaw Valley State University in Michigan solicits on its website submissions of a completed entry form, résumé, and portfolio of images from "local and regional artists." An exhibition committee of the gallery meets regularly to review artists' proposals, deciding whose work will be shown in one-person or group shows. On occasion, visitors to the gallery express an interest in buying works on display, and gallery staff act as intermediaries, putting the visitors in touch with the artists. However, sales are not the gallery's main function, and the gallery also does not take a commission from any sales.

REGIONAL ART MUSEUMS

A growing number of museums not affiliated with colleges and universities also specialize in contemporary art, which is less expensive to collect than works by more established artists, and some focus exclusively on regional artists. The DeCordova Museum and Sculpture Park in Lincoln, Massachusetts, for instance, largely shows contemporary New England art, while the Louise Wells Cameron Art Museum in Wilmington, North Carolina, is specifically dedicated to North Carolina art, and the Museum of Nebraska Art in Kearney displays contemporary and deceased Nebraska artists, while the Nicolaysen Art Museum in Casper, Wyoming, shows contemporary and traditional western art. There are many others, including the Noyes Museum of Art in Oceanville, New Jersey, which features fine and folk artists from the Garden State, and the Museum of Wisconsin Art in West Bend that shows and collects produced within Wisconsin.

A valuable source of information about museums is the *Official Museum Directory* (www.officialmuseumdirectory.com, $287), which is an annually published directory of museums in the United States, with more than 14,000 entries, listed by state and alphabetically. Many municipal and college libraries have a copy in their reference sections.

GOVERNORS' ART EXHIBITIONS

A number of state governors also sponsor art shows as a means of spotlighting in-state talent. In Michigan, Nebraska, and Oregon, for instance, artwork by artists living in those states is featured in exhibitions at the governor's residence or office. The annual juried exhibition of two-dimensional artwork, titled "Scenes of Rhode Island," is hung throughout the month of January in an atrium gallery in the state's Department of Administration Building. The Governor's Invitational Art Show in Loveland, Colorado, and the Kansas Masters' Invitational Art Exhibit in Manhattan, Kansas, both annual events, are fundraising efforts for non-art causes—the Kansas Park Trust, an 11,000-acre nature preserve, and the Rotary Club of Loveland—that involve the display and sale of in-state artists' work. Both events produce a catalog, with a brief introduction by the respective state's

governor, and participating artists receive half of all proceeds from the sale of their work with most or the entire remaining portion applied to the charitable cause.

Often, a governor creates partnerships with non- or for-profit organizations, using those groups' wherewithal and the governor's office's imprimatur to produce a noteworthy event. For instance, the governor of South Dakota teams up with the State Historical Society, the Dahl Arts Center in Rapid City, the South Dakota Art Museum, the University of South Dakota, and the South Dakota Arts Council to create the Governor's Biennial Art Exhibition to highlight artists of two- and three-dimensional work living and working within the state. The resulting exhibit travels to five museums and arts centers around South Dakota.

Similarly, the Governor's Capitol Arts Exhibit in Wyoming, a juried show for in-state artists taking place each summer at the Wyoming State Museum in Cheyenne, is sponsored by the state museum, the Wyoming Arts Council, and a number of area businesses. The pooled money is used to purchase works from the exhibit for the state's art collection, and a 25 percent commission on any other sales from that show goes to buy yet more pieces from the exhibition n for the collection.

ART IN EMBASSIES

At a more global level, the Art in Embassies initiative (begun in 1964) of the US State Department seeks to bridge the cultural divide between the United States and other countries through displays of American art in American embassies abroad. It is a relatively low-cost program for the American public, since the artists who are brought overseas are not paid for their time and efforts (their travel and lodging—usually in the ambassador's own residence—costs are picked up by the State Department) and almost all of the artworks displayed in the embassies are three-year loans (the State Department handles the crating and shipping). "We look to spread the best of American culture with the rest of the world," said Anne Johnson, former director of the Art in Embassies program. "We want to share it and give a positive image of the US" Exhibiting American art in the embassies or bringing in American artists for short-term teaching stints outside the embassies helps people

around the world better understand the United States and gain a better opinion of our country. Interested artists should register at the State Department's website (http://aieregistry.org).

The benefits of participating in the Art in Embassies or the American Artists Abroad programs are limited. A party and exhibition will be arranged when the artworks are first installed, often coinciding with the advent of a new ambassador, and local cultural bigwigs (artists, collectors, dealers, museum directors) are invited. However, most visitors to US embassies are students, professors, and businesspeople seeking visas, rather than buyers of art. The poverty in many or most of the countries in which the United States has embassies would severely limit the number of people who could pay American-type prices for art. On occasion, lightning strikes. Paraguayan ambassador John F. Keane bought a painting by Virginia artist Margaret Huddy. On the downside, the Art in Embassies program takes an artwork out of circulation for a few years, which may limit other opportunities during that period of time.

The obvious benefit of any exhibition is exposure. A small catalog for each embassy exhibition is prepared by the Art in Embassies curators, which is sent to the participating artists—although specific benefits may be difficult to predict. "It gives me credibility to collectors," said Evergreen, Colorado, painter Don Stinson, whose Texas landscape painting *Cisco No Services* had been displayed in the American embassy in Saudi Arabia from 2001 to 2004. "When I'm introduced at a talk, or when I'm having an exhibition, the fact that I was in the Art in Embassies program is always mentioned. I don't pick what is said about me; someone just looks down the list of things on my résumé and picks it out, and that one is picked out every time."

MUSEUM SALES AND RENTAL GALLERIES

Yet another option are museum sales and rental galleries, which provide an opportunity for local and regional artists to exhibit their work. "There is a different pool of buyers—especially, corporate collectors—at the Seattle Art Museum than you find at" commercial art venues, said Kim Osgood, a painter in Portland, Oregon,

who also exhibits her work at galleries in Portland and Seattle, Washington. "I get another chance to make a sale."

The Seattle Art Museum's sales and rental gallery was established in 1970 for the twin purposes of helping to create opportunities for artists and create additional revenue for the institution. It has accomplished the second by achieving the first, since the gallery takes a 40 percent commission on sales (more than three hundred artworks are sold annually) and rentals, generating over $100,000 in income for the museum. The sales and rental gallery serves as a perquisite for museum membership, because only members may rent artworks or purchase them on a yearlong installment plan (one needn't join the museum to purchase a work outright).

The price range for works in museum sales and rental galleries is generally on the lower side—$600–$3,000 at Seattle, $500–$5,000 at the Delaware Art Museum, and $200–$600 at the Charles MacNider Museum of Art in Mason City, Iowa—and the majority of sales tend to be in the lower to middle area. A higher price point may work against an artist whose market is strong, making sales and rental galleries a more appropriate jumping-off place for emerging artists.

There are a number of benefits and a few drawbacks for artists in showing their work at a museum sales and rental gallery. Certainly, there is the opportunity for considerable exposure, since far more people visit art museums than art galleries, and a certain percentage may stop by the museum's gallery to see what's on view. Museums tend to be less intimidating to the general public than commercial art galleries, which attract a more select group of visitors. Additionally, although there is rarely any curatorial involvement in the selection of artists or the operation of sales and rental galleries (they are usually started and run by a museum volunteer committee with, perhaps, one paid employee), artists recognize the value of being associated with an art museum.

On the downside, museum sales and rental galleries suffer from neglect from the media, and their shows—some galleries create thematic exhibitions and do not just place artwork on the walls or in bins—are rarely reviewed, perhaps also reflecting their lower status. The quality of the operation of the sales and rental gallery is often uneven, reflecting the fact that some groups of volunteers may be

very committed to the endeavor while others lose interest or do not follow through. Sales and rental galleries at the Fort Wayne Museum of Art in Indiana and the Springfield Museum of Fine Arts in Massachusetts never generated any revenues and were closed down; in both instances, it was difficult to find volunteers just to sit in the gallery during the hours it was open.

Among the sales and rental galleries at museums are:

CALIFORNIA
Laguna Art Museum
307 Cliff Drive
Laguna Beach, CA 92651–1530
(949) 494–8971, ext. 213
The museum no longer has a sales and rental gallery but continues to arrange rentals and sales for artists

Los Angeles County Museum of Art
5905 Wilshire Boulevard
Los Angeles, CA 90028
(323) 857–6000

San Francisco Museum of Modern Art
151 Third Street
San Francisco, CA 94103
(415) 614–3206

DELAWARE
Delaware Art Museum
2301 Kentmere Parkway
Wilmington, DE 19806
(302) 571–9590, ext. 550

IOWA
Charles H. MacNider Museum
303 Second Street, S.E.
Mason City, IA 50401–3925
(641) 421–3666

MICHIGAN
Flint Institute of Arts
1120 East Kearsley Street
Flint, MI 48503–1915
(810) 234–1695

NEW YORK
Albright-Knox Art Gallery
1285 Elmwood Avenue
Buffalo, NY 14222
(716) 882–8700

OREGON
Coos Art Museum
235 Anderson Avenue
Coos Bay, OR 97420
(541) 267–3901

Portland Art Museum
1219 S.W. Park
Portland, OR 97205
(503) 226–2811

PENNSYLVANIA
Philadelphia Museum of Art
Benjamin Franklin Parkway and 26th
Street
Philadelphia, PA 19130
(215) 684–7965/7966

WASHINGTON
Northwest Museum of Arts & Culture
2316 West First Avenue
Spokane, WA 99201
(509) 363–5317

Seattle Art Museum
Rental/Sales Gallery
1334 First Avenue
Seattle, WA 98101
(206) 748–9282

REGIONAL MUSEUM BIENNIALS

Museums would seem to be an end stage for a successful art career, not a jumping-off point for the artist looking to get some attention. The fact is, however, that a great many museums view exhibiting the work of emerging, often regional artists as part of their mission. These museums support contemporary artists in a number of ways.

One of those ways is by maintaining sales and rental galleries. Other museums—the Hammer Museum, Laguna Art Museum, Phake Museum of Contemporary Art (Del Lago, Texas), the University of California at Berkeley Art Museum, University of Iowa Museum of Art, and the Wadsworth Atheneum (Hartford, Connecticut)—hold exhibitions ("matrix" or "Projects" or some other term) that highlight the work of emerging, contemporary artists and often are the first opportunities for these artists to have their work in a museum setting.

Yet a third way in which a number of regional museums around the United States bring attention to the work of artists in their area is through holding biennial exhibitions, which display contemporary work by primarily younger artists. The model for biennials undoubtedly is the Whitney Biennial, which began in 1930 actually as an annual show that featured painting one year, sculpture the next, later becoming a biennial but always having a national focus in terms of the artists

represented. The Whitney Museum of American Art sees its Biennial as document-ing the present as "a key moment in which we take the temperature of the art world," said Jay Sanders, one of the museum's full-time curators and before that a guest curator of the 2012 Biennial. "The biennials are a way for people to see what's going on now. It's a summation of new tendencies, revealing what artists are think-ing about, the dialogues and arguments they are having, and it is a judgment by the curators of the most important work being done at that moment."

Regional museums similarly look to provide "a snapshot of what's happening now," exhibiting "artists who are doing interesting work," said Dina Deitsch, cura-tor at the deCordova Museum and Sculpture Park in Lincoln, Massachusetts, which created its first biennial in 2010. Similar to the Whitney Biennial, the deCor-dova strives to "be at the forefront of contemporary art. At times, we try to push the conversation," she said. "Interesting work" means New York–centric. Unlike the Whitney Biennial, however, most of the artists in the deCordova exhibition are apt to be characterized as "emerging" in terms of selling their work. "Maybe two or three of them earn all their income from their art alone. A lot of the artists teach." Because of this, Deitsch claimed, "we try to make the biennial a show people strive to be in as a career marker."

Alexi Antoniadis, who creates sculptural installations with fellow artist Nico Stone, noted that the deCordova's 2010 biennial "helped us certainly in the Boston area, maybe more than just Boston. A lot of people have come up to me and said, 'I know your work from the biennial.'" Shortly before that biennial opened, the Boston Museum of Fine Arts purchased a work by the two artists from a show at their Boston gallery, Samson Projects, and the combination of that success and their inclusion in the deCordova "helped us line up a couple of shows. It also has given us more confidence in our portfolio."

Also trying to operate in the frontiers of contemporary art are the Wiregrass Museum of Art in Dothan, Alabama, and the Appleton Museum of Art in Ocala, Florida. "We try to show regional [Alabama, Florida, Georgia, Louisiana, and Mississippi] artists working in a contemporary way"—with contemporary defined as the use of new media and other "experimentation"—which is "not what our

audience is most familiar with," said Wiregrass curator Dana-Marie Lemmer. She noted that the Wiregrass is the only art museum in a hundred-mile radius. The museum makes purchases of works in its biennial for the permanent collection, which helps to give cutting-edge artwork more exposure for visitors. The biennial of the Appleton Museum, which is part of the College of Central Florida, exclusively displays works of installation art. "Installation art is not commercial and gets slighted in many small regional art museums," said the Appleton's chief curator Ruth Grim. "A nice painting will always win out" if the general public were given its druthers. She noted that the Appleton is the only art museum for quite a distance in central Florida, and her aim is to "expose the public to art they don't normally see. My view has been that the community would get used to it, and it has become open to it." The museum could not "make a steady diet" of installation art, but an every-other-year biennial presentation of this type of art has been received well.

There are an estimated three hundred art biennials taking place around the world, and perhaps a third of them are in the United States. The Whitney Biennial and the Venice Biennale are among the top events, drawing many of the most notable collectors, critics, curators, and dealers in the world, but a number of the regional biennials also draw their share of attention from people interested in spotting the next trends and stars. "I go to a number of regional museum biennials," Jay Sanders said, "because I want to know what's going on. I want to find out what other museum curators are seeing and how they put together these things. Even if I'm not all that interested in something, someone else might be."

CO-OPS AND ARTIST-OWNED GALLERIES

The benefits of being represented by a dealer or exhibited in a nonprofit space or institution are many, and they include the cost of overhead—the utilities, the fresh paint on the walls, the salaries of the staff, the insurance, the rent—being covered by someone else. The artist gets to be the artist and not the underwriter. There are, however, situations in which the artist has to be both.

Cooperative galleries exist in small towns and large cities, in small towns because there may be nowhere else for artists to show their work and in large cities

because there are too many artists for the existing commercial galleries to show. Or, maybe those galleries aren't interested in exhibiting those artists. Artists band together, contributing money on a monthly basis to rent a gallery space, buy paint for the walls, and turn on the lights, then work out a schedule by which they may display their work in group or solo exhibitions. "Back when we started, in 1966, there wasn't hardly anywhere in Reno to show your work," Marge Means, past president of the Nevada-based Artists CO-Operative Gallery, said. "Now, there are a lot of galleries where you can show your work in Reno, but a lot of people just like being part of a co-op."

Co-ops solve the where-can-I-show-my-work problem for artists, although they are less likely to lead to substantial sales. The cost of joining a co-op and paying monthly dues may prove a drain on some artists' bank accounts, and a stigma is occasionally attached to co-op artists for not being good enough to get a dealer to represent them.

For some artists, however, co-ops are places where careers may begin, although advancement frequently means that the artist moves on to a commercial gallery. The A.I.R. (Artist-in-Residence) Gallery in New York City, which was founded in 1972 as a feminist cooperative, has given rise to a number of noted and successful artists. For some, the co-op was a clear starting point in their success, attracting the attention of collectors and commercial art dealers, while others found success coming in spite of their association with A.I.R.

Nancy Spero, one of A.I.R.'s founding members, who left the co-op in 1983 to be represented by a commercial gallery, stated that her work "didn't really sell much there, but it was seen by a lot of people, including dealers who later asked me to show at their galleries." Among the benefits to her of being in a co-op, she found, were "learning how the art world worked and understanding how to pursue my own interests, not being pushed around" as well as creating art without having to keep an eye on the market.

"The work I did at A.I.R. was crucial to my artistic development," Spero said. "I wasn't worrying about sales; I was supporting myself in other ways. Being able to create and exhibit noncommercial art, and get feedback from people on it, gave me a lot of confidence when I finally went to a commercial gallery."

For Dotty Attie and Barbara Zucker, who were members of A.I.R. from 1972 to 1987 and 1972 to 1974, respectively, the opportunity to have their art exhibited, especially in the context of a politically oriented artistic cooperative, was vital to their careers. "A.I.R. gave me the opportunity to show my work," Zucker, a sculptor, stated. "Once you've shown, that's a rite of passage. You have a different view of yourself once you've had a one-person exhibition, and what I also learned was how to show my work."

As with Spero, dealers came to Zucker, having either seen her work at shows at the co-op or through hearing about her from those who had been to her exhibitions. Dealers also told Attie that they admired her work at the co-op ("I always remembered those dealers and had a warm feeling for their galleries," she said), which proved encouraging when she decided to move to a commercial gallery. "Through years of being at A.I.R., I was able to build up a reputation," she noted.

Another option that involves an even greater outlay of up-front cash is to create a gallery that exclusively, or largely, displays an artist's own work. For Provincetown, Massachusetts, photographer Julie Tremblay, the options were stark: either come up with another way to make a living or be her own dealer. "None of the galleries I approached would take my work," she said. "I was told my work won't sell or photography won't sell." Dipping her toe in the water, she rented a ten-by-ten-foot shed on the edge of town where a number of other artists and craftspeople in similar circumstances brought their wares during the summer season, displaying and selling smaller works for four years. Sensing that she could do this on a larger scale, Tremblay rented a storefront on Provincetown's main thoroughfare, Commercial Street, in 2013, selling more works and larger pieces. "It's hard to get people to take you seriously when you're in a ten-by-ten-foot shed."

Tremblay is not alone in this, nor was she the first. Another Provincetown artist, painter Hilda Neily, took a flyer on being her own dealer in 1969, trading a painting to a building landlord for the first year's rent. Unlike Tremblay, Neily had exhibited her work in other, commercial galleries, but the experience was not fully satisfying. "Dealers are businesspeople, and they want to represent as many artists as they can in order to have something that someone will want to buy," she said.

Being just another face in the crowd was not to her liking, nor was not knowing when or if her works would be shown in the gallery (a group show, a solo show), or where or how her paintings would be hung. Then, there is the matter of a 50 percent commission that the gallery owner receives. Being her own gallery, Neily gets to keep the whole sales price, although that gets whittled down as a result of overhead and probably works out to the same net profit or even less.

HOSPITALS, HOTELS, AND SPORTS ARENAS

Art means different things to different people. For individual collectors, a work of art may be a signifier of their good taste or wealth, while institutions that own or display art reflect corporate goals. Real estate developers, for instance, frequently place works of art—sculptures, frequently, but sometimes murals—in the lobbies of the buildings in which they are looking to attract tenants, and interior designers often hang paintings in the homes and condominiums they are "staging" to lure buyers. For the artists involved, it is an opportunity for a little rental income, exposure (perhaps someone will take an interest after seeing the work in situ), and future sales. Beyond real estate brokers and developers, there are others whom artists might approach to get their work seen and even purchased.

Some of the most prominent exhibitors of art in the United States are hospitals, where artworks are not only thought of as good for the soul but as good for one's health. "Studies have shown that artwork helps to reduce stress and boredom, reduces blood pressure and increases white blood cell count, all of which are factors in the healing process," said Jessica R. Finch, art program manager at Boston Children's Hospital in Massachusetts, which has been building a collection, now reaching five thousand pieces, since 1996. A growing number of hospitals have created art galleries in their public areas, purchased artworks for a permanent collection, and employed artists to hold regular workshops with patients. "For patients, art is a diversion and a resource to deal with their affliction or problem," said John Graham-Pole, a pediatrician and founder of the Arts in Medicine department at Shands Hospital of the University of Florida at Gainesville. "It is also a way in which we rehumanize the connection between patient and caregiver."

Shands Hospital has two art galleries, offering a changing series of exhibits of the work of patients as well as of professional artists in the area, and an artist-in-residence program that employs up to eighty artists per year (part- and full-time). These artists work with patients individually or in groups on art projects; on occasion, they work with the families of patients.

The largest number of arts in medicine programs is found in university medical centers, which have taken the lead in advancing the arts in healthcare, promoting a holistic approach to healing. Duke University Medical Center, for example, has a cultural affairs department with a five-person staff. On the other hand, a private institution, Trumbull Memorial Hospital in Warren, Ohio, has exhibition spaces, musical events, artworks for children, and an "open studio" in which "artists work with both patients and hospital staff," according to Marianne Nissen, the institution's art director. "They're all facing a lot of stress."

When a hospital does not have an arts program, artists who look to work within or exhibit in or to sell work to the institution should contact the president or chief executive officer. Many hospitals also have volunteer auxiliary groups, one of which may be involved in decoration or cultural activities. In most cases, hospitals, especially those that are municipal or state facilities, work with local artists.

Individual hotels and hotel chains around the country, particularly at the higher-price end, also have come to see artworks as important to their brand. Hotels always have had some form of décor, of which artwork is a small or large part, but luxury hotels have put a premium on higher-value contemporary art by artists with a strong or growing standing. "Artwork is part of how we differentiate ourselves from other hotels," said Stephanie Sonnabend, Sonesta's president and chief executive officer. While acknowledging that no survey has shown that guests come (or come back) to a Sonesta because of the artwork on display in public areas and in guest rooms, she noted that "people make comments that indicate the art has made a difference in their experience." The most expensive art tends to be placed in the more public areas, where security is tightest, but even guest rooms now

feature original artworks that cost more than the frames (in the past, it had been the other way around). Guests appreciate the artwork in their rooms and are respectful of it, and don't steal it, either, Sonnabend said, claiming that flat-screen TVs are more apt to be taken than signed lithographs.

"Being around original art is part of the lifestyle of the people who can afford these room rates," said Alex Attia, general manager of Boston's Charles Hotel, which features original art throughout and whose room rates range from $378 to $859 per night. "These are sophisticated people with discriminating tastes." Many of the guests are either buyers of art already or are in the same income category as art collectors, and it is not unusual for them to ask about buying the artwork that hung in their room. "The art is for sale," Attia said. "You can't just take the work right off the wall, but, if it is part of a series, we will order another one and ship it to the home of the hotel guest."

Buying the artwork that guests have seen on the walls of their room should not come as a surprise, since guests frequently purchase so much else of what they just experienced in the hotel for their own homes. In fact, a growing number of hotels have set up a sideline selling the beds, sheets, shower nozzles, drapes, towels, comforters, and televisions to these very people right on-site or online.

The owner of the Charles Hotel, Richard Friedman, is himself an art collector and has featured artwork in the hotel for over twenty years. However, Attia noted, after a major renovation in 2005, art became part of the hotel's business plan, making the experience unique for guests and establishing "not just a décor but a concept. When people talk about the hotel, they talk about the art, and the art increases the conversation about the hotel."

Original art appearing at hospitals and hotels is not new but is certainly on the rise. One also sees more art at sports venues, and for many of the same reasons that hotels and some hospitals display it. "We believe that the art enhances the visitor experience," said Charlotte Jones Anderson, executive vice president and chief brand officer of the Dallas Cowboys, whose $1.3 billion AT&T Stadium, which opened in 2009, contains sixteen commissioned site-specific artworks, as well as forty-two other works that are on view throughout the facility. The art is not just

for game day—the Cowboys have only eight home games per season, perhaps one or two more if they make the playoffs—and has little to do with sports fans at all.

"It is important to us that our venue be more than just a sports venue, that it would attract people beyond the world of sports," Anderson said. And, in fact, far more than just sports fans come to the stadium in the course of a year. "We have something going on every day," she said, which may include more than one event per day, such as corporate functions, conferences, weddings, high school proms, and bar and bat mitzvahs. The Academy of Country Music held its televised awards show at AT&T Stadium in 2015. "The collection is built for every type of event."

The collection was not acquired in order to justify the high cost of tickets or to turn fans into season ticket-holders or ticket-holders into buyers of luxury suites. As a marketing tool, the artwork makes a facility more attractive to high-end party planners. A spokesman for the Florida Marlins also noted that "art gives the ballpark more polish and definition."

Sports venues are now competing for conventions and party events with hotels, convention centers, and museums. Historic homes and art and natural history museums regularly promote themselves as ideal spots for weddings and other activities, trading on their collections and cultural settings to woo event planners. With the emergence of significant art collections at sports arenas, one sees for-profit enterprises jockeying for the same business with nonprofits, both using artwork as a sales tool. The Cowboys stadium made itself even more like an art museum by creating a free, downloadable app for its art collection, providing information on every work on view and opportunities to hear the artists themselves talking about their art.

The interest on the part of sports venues in art comes as no surprise to Tracie Speca-Ventura, founder of the California-based Sports and the Arts, which acts as an art adviser to sports franchises (including the Los Angeles Lakers, Orlando Magic, New Jersey Devils, and San Francisco 49ers) and professional athletes. "Stadiums are huge spaces with great big walls, ideal for art," she said. "Stadiums are the museums of today. Fans may not go to art galleries and museums, and you

can educate them without hitting them over the head or making them feel stupid. For the franchises, an art collection opens up marketing opportunities and very good press."

She and others at Sports and the Arts attend gallery exhibitions in search of "artists we can work with," and artists contact the company, sending in images of their work. "I have a roster of a couple hundred artists, and I'm always looking for more."

3

Talking to Collectors

At some point in the future, you may have people to talk for you—a gallery owner, a publicist, a museum curator or director, all shouting your praises from the rooftops—but, until then, you the artist will have to do a lot of talking. You will have to talk to gallery owners and prospective collectors, maybe a critic or magazine feature writer, and then to a lot of other people who aren't likely to buy or represent your work but might know someone who will. In an art world that operates on a who-you-know-basis, artists need to think of advancing their careers in terms of coming up with ways to meet people and thinking of something to say when they meet them.

Instead of the word "talk," one might use the larger term "communicate," because artists may provide information and have dialogues with different people in a variety of ways other than in person. For instance, you may send out a press release for an exhibition, a brochure of new work, or post this or that on a blog; in real time, you may text prospective buyers or introduce yourself to them at an open studio event. A website offers information, as does an artist's statement and CV.

Part of promoting and selling their artwork directly to the public requires artists to be able to communicate with people, and they need to be polite and interesting. (Probably, being interesting is more important, since people will be tolerant of artist's rough edges because, well, these are artists.) Communication doesn't

mean having a sales pitch; rather, it refers to having a number of things to say about the work and about who you—the artist—are. Talk is a big part of the process, and the most successful artists are ones who are well practiced. It takes some trial runs to make what some refer to as an "elevator pitch" (speaking concisely and briefly before the elevator door opens and people leave).

It isn't necessary that artists be polished speakers when conversing with prospective buyers, but they should formulate a certain group of topics to bring up on which they feel comfortable speaking. They should not speak in art school critique jargon ("using a post-structuralist analysis . . ."), and it is wise to gauge from the faces of the booth visitors how much information is too much information. It is best to speak positively about other artists and collectors (dishing can be fun, but people wonder what you say about them when their backs are turned), and it is advisable to bring the other person into the conversation by asking questions.

All conversations that one has as an artist with a prospective collector have an element of salesmanship, whether the product is specifically a work of art or more diffusely the artist him- or herself as a serious, knowledgeable, interesting person. Those opportunities to be The Artist may be few—an opening of an art exhibition—or frequent (manning the booth at an art fair, holding an open studio event, giving a public talk or demonstration, introducing oneself professionally at a party), but they all require the same understanding of the need to find something to say.

For instance, This is where I was when I painted that landscape (then I talk about why this place and other places that have interested me).

Or, The particular technique I used involved . . .

Or, The struggle for human rights in the Sudan inspired this series of sculptures.

Or, I have been very influenced or inspired by the work of . . .

Or, How I chose that particular subject to sculpt.

Or, These are the steps I took from conception to final artwork.

At an art fair or open studio event, one might have on hand supporting material, such as photographs or sketches taken of a particular place and used for a

painting, where they see how everything started: A little idea becomes a big paint-ing. The question of where one gets a subject turns into the mechanics of the artistic process, how you get from here to there.

At a gallery opening or open studio event, many people want to meet the artist, who is the celebrity of the occasion, but they, too, don't know what to say. So, it makes sense for artists sometimes to stop talking and draw out their visitors with questions that guide their understanding of the artwork in front of them and give them a sense of the person who created it:

"What do *you* like about this landscape?

Or, Where do you live?

Or, What kind of art do you have in your home?

Or, Who is your favorite artist?

Or, Do you go to museums or galleries often? Which ones? What do you go to see?

Or, Do you paint (or sculpt or are involved in any sort of art or craft activity)? If you were a painter, what would you paint?

Or, What do you see in this painting?

Or, What do you like about where you live?

Or, How do you like the ragged drip edges of my paintings?"

This kind of exchange broadens a discussion that otherwise can easily devolve into rote responses. It also works to engage visitors, and that engagement leads to an investment, first of time and, perhaps later, of money. The conversation gives people a backstory about the artist and the artwork, so they can tell their friends something that makes them feel like insiders.

By asking questions, you are finding out things about them—that's a signifi-cant element of marketing—and they are learning things about you. For instance, you may learn that they are partial to certain colors (perhaps you have a painting with those colors) or that they are interested in buying something but don't have a lot of money to spend (perhaps a drawing or print would be in their price range); you may find out that they frequently vacation at the beach (do you have any sea-scapes?) or that an anniversary or birthday is coming up (how about a framed

painting as a gift?). There is no rule of thumb concerning how much conversation results in sales, but purchases and commissions become more likely when there has been ample communication.

Until you get to know these people better, it is wisest to keep the conversation focused on art: That's the realm in which you are the expert, and visitors will want to hear what you have to say. Once the conversation veers into other, more general subjects—fighting jihadists in the Middle East or health care reform in the United States or some local issue—other people may start to dominate the conversation or require you to take some stand on a divisive issue, generally leading it away from you and your art.

Here are some other topics:

- How I got started as an artist
- Where I have been exhibited
- How long I have been a professional artist
- Famous artists with whom I have studied

This type of talk provides people with biographic information and shows level of commitment, because it indicates that you have been at it for a long time. Talk that is less open-ended and more specific to the artwork on view makes the process of conversing with strangers more manageable. Collectors may respond favorably to stories of where you were when you painted something, the hazards you faced, any dangerous incidents or funny stories. Those anecdotes provide the backstory that leads prospective collectors to see a particular work of art is interesting.

Not all art buyers want to meet the artists—they may feel inhibited about speaking frankly about which works they like or don't like, or about what price seems reasonable or unreasonable—and prefer middlemen who will kowtow to them. However, many others want the experience of meeting the artist, of hearing the artist's voice and getting a sense of the artist's character and ideas about their work.

PERHAPS AN OVERLOOKED FORM OF COMMUNICATION

"I encourage handwritten thank-you notes whenever possible," said Alyson Stanfield, an artist career adviser based in Golden, Colorado, because this type of communication is more personal than an email and is more likely to cause the recipient to remember the artist. She recommended that artists have note cards printed with their art on the front and image credit on the back, and they would be sent to buyers, or "when someone introduces you to a VIP, when someone helps you hang your work or host an event, when someone writes an article about your art."

PRESS RELEASES

There are many reasons to write a press release (the press being identified as radio, TV, newspapers, magazines, online sources of information and blogs), but all of them announce a timely event. For instance, it may be an exhibition, a lecture or demonstration, one's artwork being offered at a charity auction, one's work being purchased by a museum, winning an award at an arts fair, or a fellowship from a foundation.

A press release reads almost exactly like a regular newspaper article, with the most important information at the top ("An exhibition of photographs from the Civil Rights movement of the 1960s will be held . . ."), followed by a statement or two about what makes this event newsworthy ("first time shown," "using a new technique," "marking the anniversary of . . ."). From there, the press release should note where and when the exhibit will take place (address, dates, and time) and mention the artist. The artist may be discussed higher up in the release if the artist figures into the news event of the story ("first one-person exhibition at . . ." or "major retrospective of . . ." or "was chased up a tree and needed to be rescued while sketching a leopard . . .") or if the artist is local to the area or received training there. If the artist has a website, or a page on another site, the address should be listed on every page.

The press release is often part of a press package, which consists of the news release, one or more photographs or a link containing images of the work, information about the artist, and perhaps an artist's statement. The biographical information about the artist may be in the form of a narrative or a CV (curriculum vitae).

POP QUIZ

What is the difference between a résumé and a CV? A résumé is an employment history, indicating the types of jobs the individual has held, the responsibilities of these jobs and the initiative the person has taken, and how long the individual has been employed in one or another job. A CV, on the other hand, is a professional history, listing solo and group exhibitions, commissions, names of collectors, a list of articles or reviews written about the artist (or possibly by the artist), and professional training. The documents are two distinct ways of describing oneself and should be separate in most cases. An art editor or gallery owner, for instance, doesn't need to know that the artist works at Walmart, and the information might actually work against the artist. Some dealers believe an artist is not fully committed to art if they have a full-time job. Conversely, a prospective employer might not be pleased to see that the person applying for a job is putting so much time and energy into getting art exhibitions, because that shows a potential lack of commitment to the actual job at hand.

Additionally, a résumé tends to be brief, no more than a page or two, for most job applicants. Prospective employers want to see quickly if the individual applying for a position has the requisite skills and experience, as well as a commitment to working at a company for a reasonable length of time. Filling up a résumé with lots of different jobs might suggest that the applicant is flighty or doesn't get along with people or something negative. A CV, on the other hand, may go on for pages. The number of group exhibitions in which the artist has participated, the number of awards won, the number of speaking engagements, the number of reviews and articles written about the artist and their work—all of these suggest making a positive presence in the art world.

Another, related document is the bio, which always is written as a narrative in the third person and offers highlights from a CV, such as the most prestigious awards, the most important exhibitions.

ARTIST STATEMENTS

In general, I don't like artist statements, because I've read so many of them that aren't interesting ("My landscapes reflect my interest in painting the natural

world") or that can be said about any artist ("I have been drawing and painting ever since I was a child") or that are poorly written or that say something besides the point. It doesn't seem fair that artists, who excel at expressing themselves artistically, are forced to re-express the same ideas in another form. The problem is, more people like to read, and understand what they read, than enjoy looking at and understanding art. Museum directors and curators often note that long explanatory labels next to artworks dominate the attention of visitors, who spend the same amount of time in the galleries whether there are long labels or not; when the labels are long, they spend more of that time reading than looking. The words become their art experience. The artist statement that doesn't lead directly into a long look at the artworks on display may be detrimental, because visitors may keep the words in mind rather than the images. A poorly conceived or written statement is apt to make visitors think badly of the artist.

Artist statements tend to be used at an early stage of an artist's career—better-known and more established artists don't use or need them, relying on their dealers or published critical essays (often available as handouts to visitors or viewable in a notebook or catalog) to describe who they are and what their art is about—and, as a result, they are associated with not having progressed far in one's career.

However, some exhibition sponsors may require artists to post a statement. As with introductory conversations with potential collectors, a useful artist statement should offer insight into the creative process or the artwork on display in plain-spoken language:

- These paintings were done while on a visit to Morocco.
- I became interested in welded metal sculpture through looking at the work of David Smith.
- Outrage over the genocide in Darfur led me to depict the victims of ethnic violence there and elsewhere.

Artists should ask several people to read their statements before posting them. They should check for spelling, grammar, sense, and how interesting it is. Better

yet, ask people who aren't friends or relatives—maybe people who don't like you very much—to look over the statement in order to determine whether or not it presents the artist in a positive light.

WEBSITES

There is no one type of website, but it should be easy to type in (www.danielgrant. com, rather than www.artisteextraordinaire.com) and easily navigable, with a basic menu of: Who is the artist (there may be both a narrative bio and a CV that lists exhibitions), who has collected the artist's work, what has been written about the artist or their work (perhaps a link to an article or review), images of the artist's work (perhaps including close-ups to offer details), how to contact the artist (or their representative), and how to order and how to pay for artworks—checks, money order, credit card, or PayPal, for instance.

As art brings out a lack of confidence in many people, who fear that they will be making a mistake if they buy something, the website should answer as many of the questions as a visitor to an art gallery might ask: What is the size of the work? What is the artist's background and who has collected their work in the past? How soon could it be delivered? May one pay with a credit card? Does the artist guarantee to take the work back if the textures or colors aren't exactly as seen or described? It is frequently the case that colors vary from screen to screen and, knowing that, artists should reassure potential buyers that they will honor their money-back guarantees.

BLOGS

There is no one type of blog, and there is no one type of artists' blog. Some are focused purely on the artist's own work, providing images, information on what is new, or showing step by step the progress in creating a new work, while others describe the ups and downs of their careers or review regional art exhibits or just sound off on the news of the day. Some writing is far more polished than others, but the blogosphere is a realm in which spelling, grammar, and clean language are optional. It is a most democratic forum—everyone is equal (visitors to your blog or

website judge you by the quality of your ideas or artwork and not by the name on the gallery door) and the words and art are available to anyone with a computer around the world—but that makes it very difficult to conceptualize one's audience. You may picture prospective blog readers as your friends and colleagues, and it may be that these people do read your postings on a regular basis, but others might read it as well. The inside jokes, opinions, and language of a particular clique might be found offensive by someone not in that group: A swipe at Republicans could turn off a potential red state collector. I'm writing here with a lot of "mays" and "mights" and "coulds," because I don't know this for a fact. No one does. It is possible that a collector will read a blog posting that ordinarily would seem objectionable but let it pass, because they like the artist's work and artists are strange cats anyway; it is just as possible that an offended collector will simply decide not to contact the artist, and the artist will never know that an opportunity has been missed because of something written in a blog.

Creating a blog is also a commitment—if you start one and then take a long break from it, some people may be apt to think you died or are doing some other kind of work. There also needs to be some sort of consistency in your postings—if you start out writing about art in general or your art or your art career and then post messages about your friend's love life or your cat (known as "blah-blah blogs"), you give readers less incentive to come back and you may not be seen as so serious.

IS THAT AN INSULT?

Stay positive and be nice: It's easy to take offense at some naive or crudely stated comment, so just answer the questions that may really have been asked

Artists are often asked what seem like insulting questions. For instance: How long did it take you to paint that? Is that an insult? And do you respond in a sarcastic way: "Oh, I just dash it off to make a quick buck?" Or is the question really one about process? If you take that tack, the question can be answered in terms of what is involved in the process of painting (drying paint, layering paint); how many paintings do I work on at the same time? Most people don't understand what is

involved in making art, so you can open up a conversation about what actually takes place.

Here's another: You dress like an artist. An insult? Is someone saying, You're a weirdo? Or is it just an awkward way of saying that someone has a very different type of life?

Here's another: Can you really make a living from this? An insult? How can anyone make a living selling this crap? Or is it a question about what it's like to be a professional artist?

Yet more: Your work reminds me of something else I've seen. An insult? You are a plagiarist? Or is it an opportunity to gauge the viewer's knowledge of art?

It is easy to get testy or punchy at an art fair or exhibition or open studio event—you see a lot of people; you find yourself saying the same things over and over again, and you get asked the stupidest questions repeatedly. However, it is always best to find ways to diffuse the tension. You will want to stay as even-tempered and helpful as the gallery owners, publicists, and museum officials who someday may be doing all the talking on your behalf. Certainly, it is possible that someone enters your art fair booth and really intends to be insulting. No discussion or explanation is apt to save the day in this instance, and it might make sense to recommend to this visitor that they "might want to look at some of the other booths here."

Can you bend without breaking? There are times when what sounds like criticism is criticism, and you will need to decide how or if to respond. For instance, an exhibition may receive a negative review. Artists frequently worry about what is written about them and their exhibitions, fearing the worst: Everyone in the world will read that review and commit it to memory, believing every word. First, it should be stated that the overwhelming number of art reviews are positive. Most newspapers and magazines, most radio and television stations, most websites speak only well of local artists; they want to be supportive, and there is a backlash against those who are critical of local talent. Second, relatively few readers pay much attention to the content of an art review, whether good or bad, and just want to know what is

going on and where: "Oh, there's a new painting exhibit at the So-and-So Gallery. Maybe I'll go on Saturday." Readers are more apt to be influenced in their decisions by a photograph of artwork accompanying the review than by the review itself, which is why any and all press material should include good images.

Still, an occasional negative review is published. There may be a tendency to become defensive, respond by denouncing whomever is making claims with which you disagree, assert your right to be an artist and maintain your own vision. Coping with criticism, both adverse and positive, is one of the most difficult tasks for any artist. They are apt to ask themselves, Is there any truth in what someone else is saying? Does a negative review mean that the work is bad? Do misinterpretations by a critic suggest that the work isn't communicating clearly with the public? One's options are to write an angry response or write an angry response (then tear it up and throw it away).

Artists may be able to hear criticism only from critics, from friends, peers, family members or, perhaps, from no one. Some people respond to criticism in certain ways, regardless of whether they are artists or shoemakers, but the real issue is how confident the creator is in their own work. Criticism can come too early and too hard for some artists, and creators might want to hold off displaying their art until they feel secure in what they have made—secure enough to make it public and, as a child, let it go off into the world. Once a work of art leaves the studio, it no longer belongs exclusively to the artist; rather, it belongs to the world. It is liked and understood according to the tastes and knowledge of the people who see it, and the creator becomes just one more person in this chain. The process becomes even more glaring for those artists who look to put their work into the public domain through public art projects. As opposed to gallery art, where an artist is in charge (mostly) of how everything looks, public art is a process in which the final work is a collaborative effort, involving the artist, the sponsoring organization, public officials, and the larger public. Artists who take the gallery art view of themselves into the public art realm are in for a rude awakening; they need to be prepared for comments and to make changes in the same way that an architect's initial design often will be modified by the time the actual building is put up. Sometimes,

criticism opens an artist's eyes to facets of the work that they hadn't before realized. The artist learns to step back, watch the processes of the art world, pick up what good can be gleaned, and go on to the next creation.

Like it or not, dealing well with other viewpoints is what it means to present yourself as a professional.

MARKETING AND SALES IN A WEAK ECONOMY

Between the third edition of this book and the current edition, the US economy has suffered three serious and prolonged recessions. One might assume reasonably that before the next edition is published, there will be at least another. The US economy is resilient, but knowing that better times will return eventually doesn't help anyone in the middle of a downturn. Some full-time artists may find that they need to get a part-time job, while others will put renewed effort into strengthening ties with current collectors and establishing awareness among prospective ones. In that latter category, artists should become more involved in their communities in a public way, such as giving a talk or writing an article in a local newspaper on some arts-related subject, establishing themselves as experts in their fields. Similarly, taking part in a local charity benefit or community project has the potential of generating free publicity. The local media may be willing to profile a specific artist only once every so often, but teaming with other groups (Chamber of Commerce, Habitat for Humanity, Rotary International, or a local museum or school, for instance) offers additional opportunities for one's name and work to be brought up in a positive way.

Artists should make a greater-than-usual effort to remember the names of the people they meet, following up with a written nice-to-meet-you note and the hope of meeting again. Additionally, responses to emails and telephone calls should be prompt, because a prospective buyer's interest may wane if that person is kept waiting. Creating a lasting and favorable impression can make the difference between finding and losing a possible buyer.

Artists with websites should take a second look at how easily they can be found by someone making a search; if their site doesn't come up high in a search,

they might alter their metadata or improve their links (see chapter 5). Perhaps text messaging and videos might be added to their methods of alerting current and would-be buyers to the completion of new work, exhibitions, or other events.

Of course, when finances are strained, ordinarily enthusiastic buyers may show reluctance to make any purchases, which may prod artists to offer extended payment terms, such as layaway (down payment now, then monthly installments for two or three months until the object is paid for and can be taken by the buyer), just letting the collector take the work (putting down, say, half the purchase price and paying off the rest over a negotiated period of months). This type of flexibility creates potential risks for artists—will the artist need to hire a repossession company if the buyer stops making payments?—but is more likely to generate goodwill and more sales.

On the other side, artists should examine their work and home expenses to determine if there are ways they could reduce spending. For example, artists who rely on professional photographers to produce images of their work may want to learn how to use a camera, or advertising that hasn't produced new buyers over a period of time might be eliminated.

A FINAL WORD ON BECOMING MORE PROFESSIONAL

While the focus of this book is how artists might earn money, rather than how and where to apply for it, there are programs set up across the country by local and regional arts agencies, some private nonprofit organizations and most state arts agencies that offer quick and relatively hassle-free financial aid to individual artists. The grant money, which ranges from $500 to $4,000, is made available to artists seeking help in covering travel costs, paying for materials, attending workshops, working with a mentor, hiring outside professionals (such as accountants or photographers), or other activities designed to advance their careers. The Vermont Arts Council, for instance, awards up to $2,000 for eligible artists living in the state, and the Center for Cultural Innovation in Los Angeles grants up to $600 to California artists seeking to "hone business skills and strengthen the financial sustainability of the grantee's practice," while the St. Paul, Minnesota—based

nonprofit Forecast (which particularly looks to aid "BIPOC and Native artists, LGBTQIA+ artists, womxn artists, immigrant artists, artists from rural communities, and artists with disabilities") provides up to $5,000 for Minnesota artists. There is no single directory of these professional development and sudden opportunity grant programs, but one's state arts agency is a good place to start. Also, organizations such as Americans for the Arts (americansforthearts.org), Creative Capital (creative-capital.org), and New York Foundation for the Arts (nyfa.org) offer workshops and training programs for artists looking to improve their marketing and overall business skills.

4

Expanding the Area of Sales and Income

T he traditional view of what artists do to earn money is create a work, sell it, then create another, and on and on. In this entrepreneurial age, artists have a variety of ways to generate income from their work.

LICENSING

No fine artist begins a career with the thought, "Gee, I'd like to see my work on a throw rug or plate." The idea that one's artwork might have other uses than hanging on a wall somewhere comes later and requires a certain tolerance and maturity on the part of the artist. So it was with Flavia Weedin. In the late 1960s, she was producing two hundred paintings per year, selling most of them for a few hundred dollars apiece at outdoor art fairs, and she had to sell a lot of them to support herself and her family. She might have continued in that way indefinitely, but fate and a greeting card company intervened. A few sales managers from a now-defunct card company (Buzza-Cardoza) saw her work at a gallery she set up with her husband at the Disneyland Hotel, "and they told her that her images belonged on greeting cards," Rick Weedin, president of his mother's company, Portofino Licensing in Santa Barbara, California, said. "She had never thought of doing anything like that—she didn't even know any other artists who did that, either—but they asked to license her work."

After seven years of supplying images to Buzza-Cardoza and then two years of working as a freelancer for Hallmark Cards, Flavia (she didn't use her last name professionally) set up her own company to market a line of greeting cards. Distribution—how to sell the cards—was the initial problem, but retailers at the trade shows where the artist and her husband set up a booth remembered the name "Flavia" from the lines of cards that both Buzza-Cardoza and Hallmark had produced so profitably. Her company was off and running, completing her transformation from an artist who primarily sells canvases to one who licenses images.

Not every artist will want to leave off fine art for licensable images, but opportunities for additional income exist in this area. Their images are licensed to manufacturers of games, calendars, refrigerator magnets, needlepoint sets, beverage holders, wallpaper, place mats, shower curtains, stationery supplies, greeting cards, framed posters, clothing—the list goes on and on.

Many others have done the same, if more as a sideline than as their principal form of income. Cory Carlson, for instance, whose wildlife paintings and drawings have been displayed on the pages of *Wildlife Art Magazine* and in Galerie Kornye West in Fort Worth, Texas, has licensed his work for jigsaw puzzles. About 20 percent of his yearly income is earned through licensing.

Another artist who has discovered the same thing is Mindy Sommers, a painter in Poultney, Vermont, who "never thought that I would see my art on dishes, area rugs, wallpaper, dinnerware, coasters, serving trays, gift boxes, gift bags," but since 2009 she has been earning royalties for licensing images to makers of these and other products. In 2012, it amounted to "30 percent of my income."

The idea of merchandising her art images wasn't as new to her as it was to Carlson, because she already had been selling a line of custom ceramic tiles—for floors, walls, and inlaid on trays—with her artwork on them through her website.

Easy as all this may sound, both Carlson and Sommers needed to learn how to adapt their style of canvas painting to the dimensions of the individual products and to the different audience that may purchase these items. "The art has to work with the product and not just be plopped on," Sommers said. "You have to think

about coordinating patterns and a particular mix of colors, because it's not just about the art anymore, it's about moving product."

Carlson's licensed images are a separate category of his artmaking, with little to no overlap with his canvas works. "Licensed work is different," he said. "It's more realistic, it's more refined—with less heavy impasto that doesn't reproduce well—and more action, more detail." He noted that, in a canvas painting, "you want areas where there isn't anything going on," while in an image to be used for a puzzle "something needs to be going on in all aspects of the painting." From time to time, he exhibits those puzzle paintings, but "the paintings done for licensing purposes don't sell as fast" as the ones he otherwise calls fine art.

As both Carlson and Sommers also have learned, it can take a little while before money starts flowing, possibly a year or two after signing a licensing agreement for an image, along with an advance to the artist of $1,000 or so. Prototypes need to be made, approval from the buyers must be obtained, products need to be manufactured, and then they are marketed and hit the shelves. Then, the 3–10 percent royalty on sales brings in the real money.

Most artists, according to Jack Appelman CEO of Art Licensing International, Inc. (www.artlicensing.com) in Manchester, Vermont, which represents Carlson, Sommers, and over one hundred other artists, are likely to earn advances and royalties closer to the hundreds of dollars and low thousands than the millions. "For a well-selling jigsaw puzzle, an artist could easily receive $1,000," he stated. Perhaps, in the course of a year, for "a card $500, a set of dinnerware $10,000, a T-shirt design $1,000. So you can see how it can add up as each license is an individual source of revenue generation and one good image can be licensed across many product lines."

That assessment was seconded by Maura Regan, president of the New York–based Licensing International, who noted that in the 1980s, art licensing represented "less than 1 percent" of the total revenues of the licensing industry. That has increased to almost 10 percent, or $2.983 billion, of the entire $292 billion licensing industry in the United States as of 2019. Museums and artists are the principal licensors. Artists have caught on to the potential of licensing, she noted.

A painting is sold once, and that is all the money an artist will make from it; however, when the rights to the image are licensed, royalties may be earned for years after the original piece is sold.

Some artists handle their own licensing arrangements with corporations, but most use an agent. An agent will pursue manufacturers and other prospective licensees—looking widely (for instance, games, publishing, furniture-makers, or apparel) or at a niche market, such as baby products—depending upon the type of artwork. They will also ensure that a contract is advantageous to the artist. Among the key elements of a licensing contract are:

- Rights: What is granted to the licensee. The art, referred to as "property," will be defined as a particular image or a collection (for instance, twelve images for a calendar). The specific products (such as a calendar, poster, jigsaw puzzle, T-shirt) on which the images will be used should also be specifically identified. An artist's work should not be used on a variety of products if only T-shirts were agreed upon. The term of the license should also be indicated, limiting the licensee's use of the imagery for a specified period of time, after which the art may be licensed to other manufacturers and other products.
- Territory: Where the products with the licensed imagery will be sold. An artist may license the use of imagery for one or more products to be sold in the United States but license the same imagery for other products elsewhere in the world.
- Distribution channels: In what market the products will be sold. Products may be sold through mail order, at department or discount stores, at gift shops and high-end stores. This matters because the artist may or may not want their name associated with a particular marketplace. For example, artists with a prestigious gallery may not want their work sold at Walmart. Artists may also license images for products sold through one distribution channel, while another licensee sells products at a different channel.

- Royalties: Payment. Licensing royalties are customarily between 5 and 10 percent of the "net sales" or wholesale selling price of the item, which is evenly split between the artist and agent (the division may be 60–40 in favor of the artist when the artist is well known). The contract should not only indicate the percentage but also define the term "net sales" in order that the licensee cannot take numerous deductions that lessen the actual royalty. There is usually an advance against royalties paid to the artist by the licensee, which ensures that an artist needn't wait until the items sell before receiving any remuneration. There may also be a guaranteed royalty, stipulating that over a specified period of time, the artist will receive a specified amount of money. The artist may be paid monthly, quarterly, semiannually, or annually—it needs to be written out, and agreed to, in a contract. There may also be a royalty audit clause, permitting the artist or someone assigned by the artist to audit the manufacturer to ensure that the artist was properly remunerated. Some contracts also describe penalties if the correct royalties are not paid.
- Approval: The artist is allowed to approve or disapprove the final product. The artist may request layouts, pre-product samples, or a copy of the actual object to evaluate.
- Marketing date: When the product is introduced into the market (for instance, at a trade show) and when it will be shipped to retailers.

A variety of factors determine how much an artist will earn. The state of the economy, the market for particular items (what else is competing on store shelves), how effectively the manufacturer sells the product line, and where retailers place items on their shelves all factor into the success and failure of a product. It can be quite difficult to determine, when an object does not sell well, the degree to which the artist's image is or is not the problem.

The world of art licensing, even more than the art world, is also limited by fads and changing tastes: What looks fresh and interesting for a certain period of time becomes stale after a period of time. A gallery artist may receive a

considerable amount of acclaim for their work at one point, which eventually and inevitably recedes as new artists and styles come to the fore, but a group of collectors are still likely to continue buying the artist's work over the years. Manufacturers, on the other hand, make rapid and abrupt shifts.

Sometimes, fine art and art licensing are an easy mix, and sometimes they are not. Manufacturers are likely to have a preference for what is pleasant and quickly comprehended over an image that is intricate and challenging. In one series of landscape paintings, for instance, Stephen Morath of Manitou Springs, Colorado, included roadside crosses, which one sees at various places in the western United States where there has been an automobile accident. However, the representative of a Japanese calendar company told him, "I'm sorry, grave marker not pleasant image for calendar."

Somewhat frustratingly for him, too, the relationship between his fine art and licensing is all one-way: Morath's images may be picked up by a manufacturer for a product, but he hasn't seen any buyers for his originals from those who first encountered his work as a product. "People who have seen the greeting cards have contacted me about the originals," he said, "but when I tell them the price of an original painting"—between $3,000 and $5,000—"they're just flabbergasted. I try to direct them to where they can buy my posters."

PRINTS

Just as with licensing, editions of prints allow artists to get paid for the same image again and again, while a painting will only earn its creator a onetime fee. Art prints clearly sell for less than original works, but, because of their greater numbers, are disseminated more widely. The lower prices of prints may also bring artists an entirely new clientele, some of whom may later purchase the more expensive original pieces, as well as provide money to tide them over until the larger works begin to sell.

SELF-PUBLISH

Producing one's own edition of prints is customary for artists who sell their work directly to buyers at art fairs, shows, and expos or through subscription, and it

requires an extensive knowledge of their collectors. Artists who have a limited track record in terms of showing and selling their work would be unlikely to want to print 3,000 copies of a particular image, because they might never recover their initial costs. Some fine art printers, however, encourage artists to print in large quantities, offering price breaks for each thousand. Early in their career, artists should forgo the price breaks, creating smaller editions that are in keeping with the expected size of the actual number of people likely to purchase a print.

It is rare that an artist starts a career selling prints; instead, the market for original pieces should be tested, with prints following as the number of potential originals buyers exceeds supply or as price increases for originals may leave behind early supporters who now only may be able to afford a print.

Fine art printers can be located in a number of ways. Many of them advertise in art periodicals, and the free online magazine *Decor* (www.decormagazine.com), which sponsors the Décor Expo shows around the United States, has an annual "Sources" issue every July that lists many of the fine art print publishers and distributors in the country. Of course, one may also inquire of other artists, who could report their own experiences and levels of satisfaction. Certainly, artists would want their work printed on archival acid-free, pH-neutral paper with tested inks that will not fade in normal light. Printers that do not specialize in fine art prints are likely to use inks and papers that are not sufficiently durable. Some printers have consultants on staff who will help artists plan for the appropriate publication size and marketing plan (do you have a mailing list? do you want a postcard version of the image to send to potential buyers?).

BRANDING

You may see Bob Timberlake, the eighty-something-year-old artist in Lexington, North Carolina, only as a painter of mostly rural imagery (house in the woods, wicker chair in front of hydrangeas, house surrounded by a snowy field, picked strawberries in a basket, house on an island), but he also is a brand. His name is trademarked, as is his signature and an image of a quill, to identify a variety of products that he has designed or with which he is associated (https://www.

bobtimberlake.com/). There is bedroom furniture, living room furniture, dining room furniture, kitchen furniture, picture frames; wall decor items, namely signs and plaques; mirrors and pillows, colognes and perfumes, dinnerware, decorative pottery, stoneware, and enamelware, namely plates, cups, bowls, platters, teapots, pitchers; ceiling fans, electric lighting fixtures, fabric for upholstery, curtains; and clothing, house paints, and wood stains. "There are close to a dozen trademarks," said his son, Dan Timberlake, a lawyer and adviser to his father.

Perhaps we need to step back a moment to define the term. Trademarks are words, logos, or images (for instance, Jolly Green Giant, Betty Crocker, and Mickey Mouse) that specifically symbolize, or refer, to a company's products and services. They always are used in a commercial context, although some artists have incorporated their designs into usable items, such as Keith Haring's radioactive babies on T-shirts, magnets, stationery, and baseball caps (https://pop-shop.com/) or Donald Judd's home furnishings (https://juddfoundation.org/artist/furniture/). Other artists, including Banksy (https://trademarks.justia.com/851/98/banksy-85198175.html), Jean-Michel Basquiat (https://trademarks.justia.com/769/78/jean-michel-76978977.html), Dale Chihuly (https://trademarks.justia.com/852/77/chihuly-85277584.html), Norman Rockwell (https://trademarks.justia.com/852/33/norman-85233672.html), and Andy Warhol (https://trademarks.justia.com/786/28/andy-78628056.html), also are represented by merchandise that is protected by trademarks.

We usually do not think about artists having nonart items to sell or having a trademark to protect, but a growing number of artists have become brands as a means of increasing their market position. "A trademark creates the presumption that you have a brand, that the government believes your work is distinctive enough to merit a trademark," said Christine Rafin, an intellectual property lawyer in New York City. However, she noted that the use of a trademark, largely for licensing, is appropriate primarily "for artists when they have become successful."

CERTIFICATES OF AUTHENTICITY

Walton Mendelson, an artist in Prescott, Arizona, who creates drawings, collages, and photographs, doesn't have a high opinion of certificates of authenticity—the

documents accompanying digital prints of his work that provide basic information on the edition—but he has come to see that many collectors hold a different point of view. "Just shy of 50 percent of the hits on my website are for the certificate of authenticity page," he said. "People obviously think this is an important thing to have, so I guess I have to, also." Otherwise, Mendelson associates these certificates with commemorative plates and other art-tinged knickknacks. They are "a hoax, a funny way to con somebody into believing that a $7 plate is really worth $50. I'm embarrassed by it, but well . . ."

For potential buyers of his work, which averages $600 a print, however, a certificate of authenticity serves just the opposite purpose, to convince them that the prints aren't knockoffs worth only the price of the paper they are printed on (if that). It was to give consumers greater protection when entering the multiples market that art print disclosure laws were enacted in fourteen states around the country (Arkansas, California, Georgia, Hawaii, Illinois, Iowa, Maryland, Michigan, Minnesota, New York, North Carolina, Oregon, South Carolina, and Wisconsin). These consumer protection laws vary from one state to another, some are more stringent than others, but they all require the sellers of multiples to provide information to buyers, such as the name of the artist, the year in which the work was printed and the printing plate created, the number of prints that are signed and numbered (or signed only, or unsigned and unnumbered), the number of proofs that are signed and numbered (or signed only, or unsigned and unnumbered), and the total size of the edition. These statutes make dealers and gallery owners who sell prints in those states liable for incorrect or absent information.

As a result, galleries throughout the United States regularly provide documents for the art multiples they sell, usually referred to as certificates of authenticity. Artists who sell their own prints directly are responsible for providing this same documentation, although it is far less common to see them offering certificates of authenticity when making sales at exhibitions, in their studios, or through a website.

There is no print disclosure statute in Arizona, but Mendelson is aware that, through the website, his work may be sold to buyers all over the country, some living in any of the fourteen states with these laws. Mendelson's certificate of

authenticity offers a limited amount of information about the prints he sells—their title, medium, size, type of edition, when it was printed, the type of printer and paper used, some care and handling advice, and a statement that "All information and statements contained herein are true and correct" that is signed by Mendelson—which probably reflects his intuitive sense of what collectors want to know rather than what state laws require

Washington, DC, arts lawyer Joshua Kaufman stated that artists should have their certificates comply with the strictest state laws, particularly California and New York, since their work may be sold there. He added that all state laws require information to be provided to "potential purchasers when a print is offered for sale. It is incumbent upon each website to either have this information next to the print or have a link from the image to a certificate of authenticity. A copy must be shipped with the print as well."

Since it is not utilitarian, all art has more a perceived than an intrinsic value, and part of the job of an artist or seller of art is to suggest that this piece of paper, this canvas, this piece of wood or metal (or whatever it is) is worth more than the materials involved. Many artists who offer certificates of authenticity claim that their collectors believe—or hope they believe—these documents both indicate and add value to the prints. Required by law and, generally, a good sales tool, certificates of authenticity offer artists selling their own work an opportunity to display their commitment to their art.

BARTERING, LEASING, AND RENTING ART

More than anything else, artists prefer straight sales of their work and prompt cash payment, but this doesn't always happen. At times, agreements can be made to barter artworks for something else; at other times, works may be leased. Potential problems abound with these situations, but there are also great benefits for artists in both.

BARTERING

One way to make a sale is to accept payment (in whole or in part) in the form of barter, such as goods (appliances, food, furniture, or an automobile, for instance) or

services (such as the preparation of a tax return, legal advice, or dentistry). Some artists trade their art for other things occasionally, while others do it quite a lot. Lindsey Nobel, an artist in Los Angeles, is on the "a lot" side. For instance, an acupuncturist treated her neck and back pains at the rate of three sessions for one smallish (1' × 1') painting. A dentist gave her a checkup, which included X-rays and a cleaning, for a 3' × 5' painting. A doctor arranged for an outpatient surgery for a 6' × 5' painting. A neighbor, a beautician, will give her free facials for life for a painting on the smaller side. Traveling up to Portland, Oregon, to view the solar eclipse, she met a kinesiologist and, what do you know, they struck a deal. People have let her stay rent-free in their hotels and condos. A scuba diving trip to Bonaire, a ski weekend in Telluride, a few paintings to an apartment complex owner in Malibu led to a 75 percent discount in rent for an oceanside residence. One buyer who saw a small work of hers in the trunk of her car asked how much he could have it for. "I told him, '$300, and fill my car up with gas,'" which he did. While in France, another transaction involved some cash and a bottle of Burgundy. Yet another person took a painting in exchange for airline miles that Nobel used to obtain round-trip tickets to New York City. While in New York, Nobel often stays in the guest room of the Upper East Side townhouse of S&P Global portfolio manager Erin Gibbs ("She is a wonderful guest. She keeps to herself, she walks the dog."), who noted that she met the artist through a former boyfriend, "and we clicked right away." That guest room, "we call it the 'Lindsey Room,'" has several of the artist's paintings in it.

Over the years, Nobel has made trades of between fifty and one hundred paintings, allowing her to live healthy and rent-free for periods of time while pursuing her work. Few people advertise that they will trade for art, but Nobel has found that some people just need to be asked.

"I go to a lot of art galleries for fun," said Dr. Michael David Borookhim, an internist in Los Angeles, and it was at a gallery that he first ran into Nobel. "You meet artists there, and I like artists. We get to talking and, one thing leads to another. The artist will ask what kind of medicine I practice and if I might accept their art in trade for medical services." Over the years, he guessed that he has taken

paintings and sculptures ("I don't like prints, only original works") in trade for medical care a dozen times.

Swapping art for medical services has been codified by an organization in Kingston, New York, Opositive (https://opositivefestival.org/), which creates weekend-long arts festivals in which the performers (between fifty and sixty) and exhibiting fine artists (between ten and twenty) receive free treatments at a clinic set up at the site. "Artists gift their talents to the festival and, in exchange, they receive medical care," said Theresa Lyn Widmann, who chairs the organization's board of directors. She noted that "it is very busy in the clinic," as the participating artists meet with dentists, medical doctors, nurses, chiropractors, and acupuncturists. Those who need additional care are given referrals to medical professionals in the area and in other states, such as Massachusetts and Illinois, who have agreed to accept these artists on a sliding-fee scale. More than two hundred artists apply to be in the annual Kingston festival on Columbus Day weekend, and their applications are evaluated by a curatorial team.

Bartering is probably the oldest form of economics—money, on an historical scale, is the new kid on the block—and artists who are rich in canvases if short on cash have kept barter alive. A lot of people have benefited from bartering with artists. Jack Klein was Larry Rivers's landlord for a number of years and was able to retire and move to Paris on the paintings his tenant gave him in lieu of rent. Sidney Lewis, president of Best & Company, built up a collection of paintings by major and lesser-known artists swapped for washers, dryers, and other appliances. Dr. Frank Safford is another. He tended to the health of Willem de Kooning during the 1930s and 1940s, in the years before the artist's works began selling. He was paid in half a dozen paintings, one of which the doctor later gave to the poet and dance critic Edwin Denby, who sold it to buy a house.

In general, it is lawyers who do the biggest bartering business, due, not surprisingly, to the fact that their fees are often beyond the reach of most artists. Of course, many professionals will not accept artwork in exchange for their goods and services, and it is best to discuss methods of payment and how bartered objects will be valued in advance. Bartered property is taxable income and must be declared as

such. For various reasons, the artist may give their work a high value while the recipient, wishing to keep taxes low, might pick a low value. Most artists who exchange their work for goods or services have not sold before, and there are few objective criteria available for valuation. An agreement must be made between the two parties, as discrepancies may pique IRS interest. This can be a testy area for negotiations.

Barter is taxable at the ordinary market rate—a lawyer may charge hundreds of dollars per hour—and must be reported as income to the Internal Revenue Service, so it might be advisable for artists in, say, the 15 percent tax bracket to be paid at least that amount in cash. However, the absence of any actual cash as payment could make sense if a new buyer is a good prospect to become a regular collector. Yet another option is to create a loyalty or rewards program for regular and longtime collectors, which many companies offer to their customers, offering a discount on their fourth purchase after they have bought three, for instance. "Easier terms are better than discounting prices," said William B. Conerly, an economist in Lake Oswego, Oregon, who consults to businesses, "and the best customers are the ones who pay you."

Dealers also from time to time accept something other than money for consigned works in their galleries, such as jewelry or other pieces of art. The artist, of course, should be paid only in cash and at the price level established between artist and dealer—not at whatever the appraised value of the jewelry or artwork is found to be.

LEASING

Over the years, Jenny Laden's paintings been purchased by homeowners, but perhaps even more important than that, "my art looks like something you'd see in someone's home." That may be good enough for the film industry. Several of the Brooklyn, New York, artist's figurative pictures of women have been used as set décor by small-scale moviemakers who have rented the paintings for the few days it took to design a set and film a scene. Her art does more than just look like art, and her work has been exhibited in galleries in the United States and Europe. The big screen is now one more place that people can see her art.

"It's exposure," she said, "and exposure leads to a wider audience of people who might like what you do." However, Laden has no illusions that her paintings as backdrop in a movie, even if it were to have international distribution, will be a big break in her career. For one thing, few moviegoers pay attention to what's on the set (Academy Awards go to set designers, not to the individual makers of props), and the film credits won't list her work. The claim that a particular painting appeared in a movie isn't likely to raise the value of the piece, "although it will make an interesting story when I talk with collectors. It always helps when you have something to say about your work." And it's money in her pocket ($300 per painting), plus she gets to keep—to rent again or sell—the artwork.

Sales of art always seem to get the headlines, but rentals have become a major growth area in the art market, catering to an audience of corporations, film and television producers, Realtors, and homeowners. These groups have their own individual reasons for wanting to rent rather than to buy.

For instance, corporations that may be facing economic uncertainty, take-overs or mergers, and possible relocations want art for office decoration but don't want to invest in a collection that may need to be put into storage or sold; renting is less expensive, less permanent, and tax-deductible. "They're not married to the art," said Barbara Koz Paley, chief executive officer of the Manhattan-based Art Assets, which has leased works of art ("some valued in the six figures") to businesses since 1993. The objects that Art Assets rents out come from a variety of sources, including galleries, museums, and private collectors, but increasingly from individual artists. "It's just so much easier to deal directly with artists than with their dealers," she noted, "and in the age of the internet it's just so much easier to get to artists." Many of Art Assets' almost fifty clients are office building owners and managers who are using art as a tool to sell their properties, upgrade their buildings, and set a "cultural tone." The rental of artwork is 3 percent of the object's value over a negotiated period of time. The cost to the corporate client, she noted, is usually passed along to tenants. In addition, "by renting, they pay a fraction of the cost of buying, and there are distinct tax benefits."

Among the artists who have leased their work through Art Assets is Jill London of New York City, whose art involves gold leaf on paper and other surfaces. She earned "$3,600–$3,800" for the rental of sixteen pieces on two separate occasions, each lasting one month. The income was welcome, as was just getting some artwork out of her studio. The opportunity for having her work seen was also a plus. "People ask if my work is being shown anywhere, and I tell them, 'Yes, you can see my work over there in that building,'" she said.

In a smaller realm, Realtors seek artwork when "staging" houses and apartments, giving a property a more lived-in look that may entice buyers. Shawn McNulty, a painter in Minneapolis, Minnesota, who has sold his artwork at gallery exhibitions and through his website, entered the art rental business in 2007 when "a Realtor working with a stager asked me to lease some paintings" for some properties she was working to sell. Six of his large-scale (3' × 4') abstract paintings were used in a downtown Minneapolis loft, and another five medium-size (2' × 2') works were placed in a house in St. Paul. Both properties sold (maybe the art helped), and he earned $780 and learned a new way to earn money as an artist. "I offer rentals now on my website," he said. "I'm pretty prolific, and I'd be happy if I can move some older work out of the studio this way, at least temporarily."

More and more artists have taken the same direction as McNulty, soliciting rental business and developing art rental agreements that cover the cost (his prices range from 7 to 10 percent of the retail value for a three-month rental), insurance (renter is liable for lost, stolen, or damaged artwork), transportation (renter pays), the manner of payment (credit card, usually, since the rental agreement is automatically renewed at the same terms unless the item is returned), and the process by which a leasing agreement turns into a purchase ("half of the rental money goes toward the purchase price," he said).

Sales haven't taken place for Jill London, who stated that building lobbies "aren't selling spaces, and people who look at art there don't think of it as something to buy." However, the work of Serena Bocchino, a painter in Hoboken, New Jersey, which was rented through Art Assets for the Manhattan headquarters of the tax accounting firm PriceWaterhouseCoopers (for which she earned a leasing

fee of over $4,000), so favorably impressed the company that it purchased twenty of her paintings for its corporate collection. "I got paid for exhibiting my paintings and I got paid for selling my paintings," she said. "All in all, it was a very good experience for me."

Additionally, various museums around the country permit select private and corporate backers to rent pieces for varying lengths of time. The DeCordova Museum and Sculpture Park in Lincoln, Massachusetts, for instance, "will install an exhibition of Museum-owned and artist-loaned artwork in Corporate Member offices for the duration of the membership," according to its website. A number of other institutions (the Coos Museum in Oregon, the Los Angeles County Museum of Art, San Francisco Museum of Modern Art, and the Seattle Art Museum, among them) have volunteer-run sales and rental galleries; however, the pieces for sale or rent are not part of the museum collections.

Another market for art leasing is the entertainment industry, which continually needs props (preferably ones that don't require storage), and the rental of objects frequently fits into a budget better than purchases. Artwork isn't the only cultural objects rented—antiques and crafts items also are used on film sets, in magazine advertising shoots, and as displays in store windows (Bijan Nassi, owner of Bijan Royal antiques shop in New York City, claimed that he rents out between three hundred and four hundred objects per month for use as props)—but it tends to be the largest category in terms of dollar value. Sometimes, homeowners rent artwork on a lease-to-own arrangement that allow them to pay over time while making sure they really like the artworks; if, after a month or six months or a year, they decide the art isn't right for them, they may return it.

Jenny Laden herself did not look for rental business from movie studios but was recruited by a Brooklyn-based company, Art for Film (www.artforfilmnyc. com), which promotes the work of two dozen painters and sculptors to the film industry in New York City and elsewhere. Jessica Heyman, the owner of Art for Film, noted that her pricing is flexible, because "some studios have bigger budgets than others, and you have to work within their budgets rather than have a set price." A rental payment is split evenly between the company and the individual

artist. Frequently, the film studio set decorator doesn't take the physical painting but, rather, a digital image of it, which can be printed out at a size that better fits the actual set. One of Laden's watercolor paintings, a 75" × 40" work titled *Lady*, "needed to be smaller than it was," she said, and was reduced through a computer printer. At the end of the shoot, the digital print was returned to her, "which actually gave me something else I could sell."

In effect, the artist is allowing a studio a onetime right to license the image for a relatively brief period of time. The benefit to the studio of working directly with artists or through a company like Art for Film is that they gain clearance, or permission, to use the image; the failure to acquire those rights when copyrighted artworks are purposefully or inadvertently included in scenes has resulted in lawsuits and judgments against studios.

Film and television studios don't usually have large budgets for set props (Heyman noted that some artworks have been rented but not used on a set, simply because the set designer wants to have a variety of choices), which makes this type of income supplemental rather than primary for most artists. Set designers sometimes find artwork online, but they are more apt to use local artists or local galleries, simply because they don't tend to travel hundreds of miles for a two-day $300 rental; as a result, artists in southern California, New York City, and Vancouver, Canada—the three largest areas of filmmaking in North America—tend to benefit the most. Sculptor Bruce Gray of Los Angeles and painter Susan Manders in Sherman Oaks, California, had their first art rentals to film studios through galleries, but they both moved to represent themselves in rentals, doubling the amount of money they earned. "I started to notice that there was a lot of art in TV shows and movies and thought, 'That could be mine,'" Gray said.

Still, for them, the money doesn't add up to a livelihood; thousands rather than tens of thousands of dollars per year. Art rentals don't "happen all that often, maybe a few times a year," said Gray, whose sculptures have been in the backgrounds of all three *Austin Powers* movies, *Meet the Fockers*, *The Truth about Cats and Dogs*, and *Sleeping with the Enemy*, as well as in over one hundred commercials (Honda and Sprint, among them) and television shows (including *CSI* and *Six*

Feet Under). He has advertised in industry publications and sent postcards to set designers about his work, but "most of my art rentals have come about through word-of-mouth."

There are benefits and drawbacks to renting works of art. Gray had one sculpture stolen off a movie set ("I got paid for it, though maybe not what it was worth") and another scratched ("They actually rented it a second time in order to repaint it. Turned out good as new"); yet a third sculpture was repainted in different colors ("a crappy job") to match the colors on the set. "If you can't bear to see something happen to your work," he said, "you shouldn't rent it out." Manders noted that she has been lucky in terms of no thefts and no damage and even luckier that arrangements that started out as rentals turned into purchases. "Doing business with studios has other benefits," she stated, noting that she has been commissioned each year since 2005 to create an edition of prints that are included in the gift bags for presenters at television's Emmy Awards. "It brings my work to well-known celebrities, and that leads to other sales, because a number of the presenters became buyers."

RENTAL AGREEMENTS

Artwork rentals can be arranged through a variety of sources, starting with artists themselves. One New York City real estate developer, for example, leased a wall sculpture from Jeffrey Brosk for the lobby of the Fifth Avenue apartment building he had erected "in order to give the place cachet for prospective tenants," according to the artist. It seemed to work, as the building filled up and the developer decided to purchase the sculpture.

Art dealers and corporate art advisers also arrange rentals and leases for clients who want to "try works out" for an extended period of time. Dealers often allow prospective buyers to take art home for up to ten days without charge to see if it "works," and may also devise rental agreements for collectors who take longer to decide or whom they would like to cultivate as long-term clients.

Renting a work is usually a short-term event, lasting from one to four months, while leasing may range up to two years with payments applied to the sales price

should the customer decide to buy. Fees for renting or leasing are usually based on the market value of the art, ranging between 2 and 5 percent a month, although it can go as high as 15 percent. Discounts for leasing more than one piece at a time can be negotiated with dealers, and sales and rental galleries frequently have discounts for museum members.

Not all art dealers and advisers are pleased to let work out on a rental basis, however. It can be a bookkeeping, insurance, and inventory headache for dealers who must keep track of lease payments, establish rental agreements, protect these pieces from damage, arrange insurance coverage, and arrange for the work to be returned at the end of the rental period.

"Facilities people" at many companies have no idea of how to care for artwork and may place pieces where they will fade from exposure to direct light or where employees smoke or where there is inadequate ventilation. Vandalism and theft are also concerns. In addition, because they are not buying it, the corporation is more apt to view the art as mere decoration and not shield it from damage in the same way as it would protect something the company owned. Other dealers and art advisers have mentioned that artists aren't as likely to lease their best work.

"There are questions you have to ask," Jeffrey Brosk said. "Who is renting it? Where is it going to go? How will it be protected? You have to be more selective when you're renting a piece but, if you are more selective, you can give better quality work."

Any contract between an artist (or an artist's dealer) and a renter should include specifics about the following:

- the length of the rental arrangement;
- the rental price (which the artist is likely to decide with their dealer, who may know a lot more about going rates);
- how the artist or artist's dealer is to be paid;
- documentation that the art is insured for the entire period of the lease (by the renter or artist's dealer but not by the artist);

- that the artwork is credited to the artist (it also doesn't hurt to have information on the artist noted somewhere);

- that the art not be harmed but, if it is, that the renter must pay for all repairs (the artist should be given first refusal on making any repairs) or cleaning (if a lot of cigarette smoke or coffee splashes have discolored it); and

- that the renter (or the artist's dealer but not the artist) should bear all expenses of packing and shipping the work.

Artists may also wish to have some say over where and how their work is displayed and may want some veto power over certain companies with which they do not wish to be associated. In addition, the work should be available for the artist (or dealer) in the event of an exhibition.

There should also be an affirmative obligation on the part of the renter to return the work after the lease has expired. It should be stipulated on the rental agreement that the renter is obligated to return the work at the end of the rental period. It's not uncommon that no one takes responsibility, and the work just sits there indefinitely. If a long time passes or someone dies or the paperwork is lost, no one quite remembers who owns the work.

When the work is rented through the artist's dealer or gallery (or consigned to a sales and rental gallery by the dealer), the contractual agreement between the artist and their dealer should resolve some of these same points. Specifically, it should indicate that the artist not bear any expenses and that any rental payments to the dealer will be split between the artist and the dealer on the same percentage basis as when a work is sold.

SELLING ART IN OTHER COUNTRIES

Some years ago, Bronx, New York, sculptor Frederick Eversley recalls not being paid by a gallery that exhibited his work. Yeah, yeah, a lot of artists have been in that position, but the difference in this case is that the gallery was in Germany, a country where Eversley doesn't know the laws, doesn't speak the language, and had

no plans to visit. "What was I going to do? Hire a German lawyer? Where would I even find one?" he said. "I decided it wasn't worth it." So, he swallowed his losses and moved on.

That was only once—if we don't count the time another European dealer did pay him, just very, very slowly, or the occasion when some unsold work came back damaged because it hadn't been packed properly—and Eversley has relished the opportunity of broadening his market by exhibiting on another continent.

Seasoned artists know that one needn't travel abroad to experience frustration and disappointment dealing with galleries. Minimalist artist Peter Halley, who lives in Manhattan but makes three-quarters of his sales through galleries in Europe, stated that "it's not any different than sending your work to gallery in the US" Except, he noted, that it can be somewhat more difficult finding out if a dealer in some other country is dependable and trustworthy, and the cost of shipping and insuring works is higher. (In addition, fine art entering any of the twenty-seven European Union nations from an outside country is assessed a 5 percent value added tax.) Those higher costs may lead to other problems. "Consigning works for a show in Europe can be an ordeal," he said. "If pieces don't sell, artists can have trouble—maybe a little trouble, maybe a lot of trouble—getting their works back, because it is so expensive to return works to artists in the US." Dealers make excuses for delays, "saying, 'Let me hold onto it for another year. I'm sure I can sell it.'" Halley's preferred practice is to have his European galleries buy his work outright, reselling it to collectors, which makes "everything cleaner."

Having one's work an ocean away can be nerve-racking enough, especially if there is no plan to visit the gallery while the exhibition is taking place. "Almost all the galleries I have worked with abroad I never visited in person so there is always a question of what do they really look like and how they operate," said Alexandra Pacula, a New York artist who has relationships with a number of foreign dealers. "I feel that every time I decided to start working with a gallery abroad I took a leap of faith but so far I had no major problems."

Just as in the United States, American artists who look to exhibit their work abroad would want to find gallery owners who have a reputation for being

dependable and trustworthy. Halley noted that an artist's "due diligence" in this area largely consists of "talking to other artists who have exhibited there," as well as asking art dealers in the United States about a foreign dealer's standing in the art field. "The art world is small. People know each other."

Getting back unsold works and receiving payment in a timely fashion are the two issues that a number of artists have mentioned. Larry Bell, a painter and sculptor in Taos, New Mexico, had eleven of his painting disappear "when a gallery closed in Switzerland, and the owner died," according to his studio manager Lois Rodin. Some years later, those works "were found in storage and returned to us." His glass sculptures have come back damaged as a result of being "badly packed" or after being left too long in a storage facility. The cost of repairing or remaking these sculptural works is too high, she added. More losses to swallow.

Money is no less an issue when sales do take place. Stephen Schultz, an artist in Idaho, claimed that his dealer in Paris did not pay him for sold pieces "for over a year after my show. He finally paid only because of wanting to participate in another exhibition I was having in Greece." Otherwise, Schultz would have needed to bring a lawsuit, requiring him to hire a lawyer in a country where he barely knew anyone to begin with. It was all "frustrating to be at such a distance and to be unfamiliar with the legal process let alone subtleties of the language."

How artists will be paid for sales is one more adventure that should be worked out in advance. Halley noted that "all business in the international art world is done in English" and that "business in the art world is conducted in dollars," but that may not be the experience for every artist. Portland, Oregon, sculptor Kate MacDowell noted "communication difficulties" she has experienced with a few galleries and museums in Europe that suggest that everyone's English may not be top notch. Additionally, the difference in time zones between Oregon and Europe makes the ability to reach people by telephone in Europe a bit chancier, with email becoming the primary mode of communication. She claimed, "for example, I write to a curator that a collector may be willing to lend a piece for an exhibit but needs more information about how the artwork will be insured and shipped, and

the curator appears to read it as the collector has agreed to the loan and perhaps misses the request for additional info." Speaking directly by phone might have cleared things up more quickly.

One of her communication difficulties involved one gallery in Europe that was "very slow to pay and gave me incorrect information about where a piece was located and if it was sold or not. I'm still unsure about the status of that payment." Over time, she has gotten the impression that European galleries regularly allow buyers more time to pay for their art purchases than takes place in the United States, which could explain why it takes longer for her to receive payment after a gallery reports a sale.

MacDowell noted that she and the European galleries work out the retail price of her sculptures in the local currency, and she is paid based on the exchange at the time "when the payment goes through as opposed to when the price is set or the piece is sold. This plus some small loss in exchange fees makes it difficult to directly predict the eventual price I get back for the piece, although it is usually within an expected range." The most preferable form of payment to the artist is a direct deposit of dollars wired from the gallery's account to the artist's bank account in the United States, with the gallery owner paying any and all conversion costs and transfer fees ("in two cases, galleries paid for the transfer," Schultz said).

European—or Asian or South American, for that matter—art dealers have no better or worse reputation for fairness and honesty than their counterparts in North America. ("I have not had any problems or concerns with my European art dealers who treat me very well," said California artist Mel Ramos, "but this is not to say that I have not had problems with dealers in the USA.") For American artists who show and sell their work both in the United States and abroad, there are more inventory, shipping information, currency exchange rates, and sales receipts to keep track of, requiring that they be organized and attentive to the business side of their art careers. For Ramos, "my daughter Rochelle is my studio manager, and she is incredibly competent when it comes to keeping track of my work." That helps.

ART PARTNERSHIPS

Up until the eighteenth century or so, artists did not have collectors so much as patrons, wealthy people who commissioned new work from them, perhaps providing them housing, possibly protecting them from their enemies, giving them travel money and the materials they needed, and then just money after that. Nowadays, patrons are still wealthy people, but they tend to give their money to nonprofit arts organizations, permitting them to deduct that amount from their earnings when figuring their tax payments. Patrons of individual artists still exist but, in the modern way, they behave more like investors, setting up corporate entities that permit them to deduct any losses or add to their ordinary income.

Often, patrons join in partnerships or limited liability companies with artists for short-term projects that require an up-front infusion of dollars, such as when the artists seek to create an edition of prints or bronzes. On occasion, the relationship is more long-term. "One of my patrons decided to partner with me," said Memphis sculptor Roy Tamboli, and the two formed Roy Tamboli, LLC, in October 2006. "My partner contributes the casting costs, and we share the proceeds of the sales." He added that the two own the bronzes equally.

The artists and their financial backers work out the terms privately, but lawyers frequently are involved in writing up the agreements between artist and patron, as well as setting up these corporate entities through the appropriate state agency. "Someone contributes capital; the other contributes sweat equity," said Mark A. Costello, a lawyer in Rochester, New York, who has set up numerous limited liability companies for visual and performing artists. "You set up an LLC, which is technically the owner of the artwork being created, in order to structure distributions. Then, the artist and the patron have to figure out how the distributions are made." The agreement they reach is part of the partnership or LLC filing with the state, describing the basic setup of the business: how the company will be managed, how profits and losses will be divided, the rights and responsibilities of each member, the ownership percentage of the business by each member, when meetings are to be held, and how votes will be tallied.

In many instances, money earned is split on a 50–50 basis, although Costello stated that the patron may want to receive their return on investment before the artist is paid. Other agreements make a split of 80–20 (favoring the patron) for the first series of sales, changing to 50–50 and finally to 20–80 as the available artworks sell out. At other times, the investor may be repaid in actual artworks (negotiations in advance would determine whether the value is based on wholesale or retail prices), although copyright for the art would remain with the artist.

In addition to the expense of a lawyer or accountant in setting up the company, there are filing fees charged by the individual states, ranging from $100 to $800, as well as business licenses and zoning permits required by the municipality and a federal employer identification number from the federal government.

For the patron, the benefits of setting up an LLC with an artist is that "the business entity acts as a tax shelter, with the flexibility of allocating losses and expenses any way you want, any time you want," said Peter Jason Riley, a certified public accountant in Newburyport, Massachusetts, who has set up numerous limited liability companies for fine artists, writers, and filmmakers. "You can have your basic agreement that all proceeds from sales are split 50–50, or however you want it, but you can also determine when you see how things are selling or not selling that the investor can take 90 or 99 percent of the losses, which he can write off against other income." Additionally, other business-related expenses, such as travel and entertainment, may be tax-deductible.

Without setting up an LLC, he noted, providing money to an artist would only be a loan, which could be written off on tax returns as a personal loss, "but you then might have to prove to the IRS that this really was a loan, with an interest rate and a repayment schedule." The loss may be written off against capital gains (sales of artwork) but, if there are few or no sales, the maximum amount of loss that may be declared would be only $3,000 per year. A loan of $9,000 would take three years to recoup on one's taxes, making the LLC more attractive to wealthy patrons.

For both the artist and patron, the business entity protects their personal assets (such as their homes, cars, and bank accounts) in the event of a lawsuit, although some accountants and lawyers recommend the purchase of a liability

insurance policy for the LLC in the event that a court ignores the limited liability status when making an award.

There are a variety of ways in which artists obtain up-front money with which to pursue their projects. Gallery owners sometimes provide certain artists they represent with loans or monthly stipends, which are recouped from sales. Artists planning to create a print edition, or the print publisher, may "syndicate" the publication costs to collectors who become subscribers or shareholders in the enterprise. A small number of artists have solicited investors for a particular project with a prospectus, selling shares that would be redeemable as cash when the particular artwork is sold.

5

Developing Relationships with Art Dealers

S uccess for an artist is measured over a long period of time, while a big career break is an event. Without some type of break—an important exhibition, a major write-up or sale to a renowned collector, a grant from a foundation, low rent on a studio, a word of encouragement from a well-placed source, among other possibilities—success is less likely to occur. This big break increases the name recognition for an artist among potential buyers, and makes their art seem especially current ("He's hot!").

The most important breaks are those that give artists and their work wide and (one hopes) positive exposure. In a world where there appears to be an oversupply of artists, one needs to stand out from the crowd and receive recognition. But what kind of exposure: Will artwork that shocks the public or blocks traffic do the trick?

It is not always clear at the time, however, which events are the big breaks and which perhaps will be interesting footnotes to a career. An innocuous-seeming encounter may later result in great things, while a presumably significant honor—say, a major museum acquiring one's artwork or receiving some prize—could have no discernible career benefit. And, when it is a big break, how does one take fullest advantage of it?

FINDING REPRESENTATION

For many artists, having a third party (someone other than themselves, such as an agent or dealer) speak on behalf of their work is a major stepping-stone in their careers. Someone not only says that they appreciate the artwork but will make an investment of time, space, and money to promote and sell it. The artist's time is freed to create more work, which now merits the attention of the mainstream art world (artists who sell work on their own are rarely reviewed in art periodicals). For others, a middleman lessens the relationship between artist and buyer, resulting in an increase in prices and fewer sales.

ART CONSULTANTS

That middleman can be an agent or representative, an art consultant, or a dealer (or gallery). At times, art consultants are gallery owners and even museum curators who advise individuals and companies in the area of decorating or building a collection on the side. Those who are free agents, only serving the interests of their clients, generally don't have galleries or represent particular artworks or artists; rather, they tend to work from their offices or homes, maintaining information (bios, slides, press clippings) on a variety of different artists whose work may be of interest to particular clients. Most focus exclusively on contemporary art—works created by living artists—while others will hunt through all styles and periods, depending upon the interests and budgets of their clients. "Our criteria for selection revolves around our clients' tastes," said Josetta Sbeglia, an art consultant in St. Louis, Missouri. "We hope we like it, too."

These clients are a mix of private collectors, corporations, law firms, and health-care facilities. "The healthcare industry is growing, and hospitals see the value of art and creating spaces that are more pleasant," said Talley Fischer, a sculptor in Bellefonte, Pennsylvania, who has been commissioned to create large installations for a variety of health-care facilities through art consultants hired by these institutions, who usually are brought in to help these institutions find artworks when in the process of building new or renovating existing spaces. Fischer noted that she promotes herself directly to art consultants.

Many companies prefer using outside consultants—finding expertise through people who are members of the Association of Professional Art Advisors (www.artadvisors.org), for instance, although quite a few advisers who are not APAA members or work as gallery owners also offer their assistance to private and corporate clients—to hiring their own in-house curators as a cost-savings move. These companies look to acquire artwork, because "art in offices enriches the lives of the people who work there," said Laura Solomon, an art adviser in New York City, who not only helps her clients purchase artwork, but will take charge of framing or installing pieces in the offices, rotating existing artworks around the offices from the collection, and even putting together special exhibitions from it.

Consultants learn of artists in a variety of ways: They attend exhibitions at galleries, as well as at art fairs and juried competitions; they receive recommendations from other artists; they go to open studio events; and they are contacted directly by the artists, through snail mail, telephone, or email. Some consultants encourage artists sending them material, while others do not—it makes sense to inquire by telephone or email what, if anything, a particular consultant is interested in seeing before sending a portfolio. Lorinda Ash, a New York City art dealer and consultant, said that "I get phone calls, faxes and emails from artists all the time, but that's not how I ever become interested in an artist. I find artists through going to galleries."

On the other hand, Jennifer Wood-Patrick, an art consultant at the firm of Art Advisory Boston in Massachusetts, welcomes receiving material from artists but noted that "we have a limited amount of time for telephone conversations and sorting through packages sent by artists." She prefers emails from artists that describe who they are and include images.

"Tom is very busy, so I try not to bother him with things he won't be interested in." The Tom in question is Tom James, executive chairman of Raymond James Financial, an investment and wealth management company, and he and his wife Mary select all of the artwork—2,400 pieces and growing—that adorn the one million square feet of office space at its St. Petersburg, Florida, headquarters. The person trying not to bother him too much is Emily Kapes, curator of the art

collection, who identifies the type of artwork (80 percent two-dimensional and the rest sculptural works in bronze, glass, and stone) that often represent images of the American West and wildlife. She receives telephone calls, postal mail, and email from artists and galleries around the country, all offering their artwork for purchase. "I can filter out the artists that usually wouldn't be collected," she said, "and, otherwise, pass things along to Tom. Tom is known for supporting living artists."

Emily Nixon, a Chicago-based art adviser, also receives numerous communications from artists, but she tends to rely less on submissions from people she has never heard of ("I find that artists may not know what corporations want, and many are unfamiliar with contracts and pricing," she said) and more through visiting art gallery exhibitions, art fairs, and auctions and receiving recommendations from people (artists, dealers, auctioneers) with whom she has had a longtime association. The artists who are of greatest interest to her "should be in a gallery and have had numerous sales." It doesn't hurt if these artists have sold work in the past to other corporations, although that is less significant than the fact that they are represented in a gallery.

ART GALLERIES

The relationship between artists and their dealers is often compared to a marriage, with lots of high hopes at the beginning and plenty of bitterness if things don't work out well at the end, and the process of artist and gallery finding each other and deciding to work together has many of the elements of a courtship. There is a certain amount of asking about this dealer, that artist from others who know these people (other artists, other dealers) in order to determine whether the two are suitable in terms of their expectations (does the artist have a good work ethic, producing a sufficient number of strong pieces for an exhibition every other year? does the dealer promote exhibitions and pay promptly? does this person return your calls? do you admire this person?). Following the analogy, artists and dealers follow a three-date rule—once at my studio, once at your gallery, once at a neutral site, such as a museum or café—in order to learn important things about each other: Am I

being listened to? Is this person answering my questions? Do we have the same tastes?

But perhaps we are getting ahead of ourselves. Before any of that courtship takes place, artists would want to visit the galleries that are of interest to them. Not only do artists want to see that their artwork would fit in stylistically with the other pieces on display, they would be interested in knowing whether or not the space is suitable for their work (tall and spacious enough for sculpture or large-scale paintings), how the other artists' work is displayed (attractively, good lighting, information available about the artist or the pieces on view), and the general price level of the works in the gallery. Dealers and gallery owners look for art that has a specific price range by artists of a certain renown, because that is what their regular buyers seek or can afford. Dealers are very reluctant to represent $2,000 paintings in a gallery where the average is $20,000; they are also not likely to raise the price of a lesser-known artist's work by ten times in order to bring it up to the gallery level of pricing.

Personal contact usually makes a substantial, if not crucial, difference. Knowing the dealer or knowing (or favorably impressing) someone who has the ear of the dealer is likely to turn the tide for a dealer who is unsure about the audience for an artist's work. That is why artists cannot hide away from the world, maintaining some romantic myth of the artist who must be alone, but need to associate with other artists.

Both painter John Hull and sculptor Donna Dennis, for instance, were "discovered" through the intercession of friends who prodded their dealers. Hull worked as a machine operator in a cardboard box-producing factory on the 3:00 p.m. to midnight shift for two years, and he also ran an alternative space gallery in Baltimore, Maryland, for five years. Dennis lived in New York City for seven years before she began to exhibit her art (starting as a painter and gravitating toward sculpture). She worked as a secretary at the Whitney Museum of American Art in New York City for one year ("I was fired because I couldn't type") and as a picture researcher for various publishing houses. Eventually, the two artists found time to make and exhibit their art—she at the cooperative West Broadway Gallery in lower Manhattan,

where she was spotted by the collector Holly Solomon who had just opened her own commercial gallery and invited her to show work there, he at alternative spaces such as W.P.A. in Washington, DC and at P.S. 1 in Long Island City as well as at New York's New Museum, where he caught the eye of Manhattan art dealer Grace Borgenicht. In both cases, friendships paid off. Hull knew one of the artists in Borgenicht's gallery, David Saunders, who spoke on his behalf. "Grace liked my work and she had read reviews of my shows," Hull said. "No one talked her into liking it. But Grace had some questions about me that David could answer: Is Hull a serious artist? Does he do a lot of work? Is he a reasonable person?"

Holly Solomon was led to one of Dennis's shows by Denise Greene, whom she had known from a consciousness-raising group and who was already represented by the collector-turned-dealer. Personal connections served her again when artist Harriet Shorr, whom she had known "from the group of poets I hung around with when I first lived in New York," gave Dennis her first show outside New York, at Swarthmore College where Shorr was then teaching. Later, in 1990, Shorr was teaching at the State University of New York at Purchase and suggested to Dennis that she apply for a faculty position.

Meeting people who can be of help to one's career—call it "making connections" or "networking"—is vital to artists, although this may be a difficult course to plot: Those who obviously are looking to make headway with the "right people" are apt to be seen as opportunists. Sharing ideas and information, attempting to interest others in one's work and showing enthusiasm for theirs, on the other hand, are essential to advancement, as the art world picks winners and losers primarily on the basis of what people say. "I've never lived in New York City," Hull said, "but I go there regularly to meet people and see art. It's as important for me to talk to other artists as it is to see a Goya."

"I didn't think of meeting various women artists as a business thing," Dennis stated. "It was the early years of the women's movement, and we all knew the statistics of how few women were in galleries or in the Whitney Biennial. It just felt good to find people who appreciated my work and what I was trying to do, who understood and faced the same problems I faced."

Connections can be made throughout the art world. For Claire Romano, a printmaker who taught at Pratt Institute in Brooklyn, New York, societies and artist associations were a source of important contacts. Romano was one of the jurors for a show sponsored by the American Society of Graphic Artists in the early 1960s; another juror was Jacob Landau, who was then a teacher at Pratt Institute. "He liked my way of looking at art, the way I articulated my ideas, and he also liked my art," Romano said. "Not long after, he was named chairman of the fine arts department at Pratt and asked me to take over his classes." That Romano was selected to be a juror for this show and there met her future employer was serendipitous. "I never looked for a job," she said. "I was just offered it."

Besides personally knowing people, artists also need to have their work shown as widely as possible—a critic, collector, curator, or dealer may spot it (for instance, as a juror in a competition) and pass the word on about an interesting find—and to make themselves available to potential buyers and gallery owners. Showing art involves more than simply hanging up a picture in front of someone who agrees to look at it. It requires an affirmative effort on the part of artists to, first, place their work in front of people who can be helpful in their careers and, second, be part of the process of marketing their work.

COMING TO TERMS

Landing a dealer, whether or not that person is a major figure in the art world, is not the end of an artist's art business concerns. If art dealers were as trustworthy as so many artists are trusting of them, there would not be a growing body of art law, nor would there be a growing number of lawyers specializing in artist-dealer conflicts. As much as artists want to be "just" artists when they finally find a dealer who will represent them, devoting their attentions solely to creating works of art and leaving the legal and business considerations of their careers entirely to people in other, less-ethereal professions, artists must proceed with caution and a down-to-earth sense of their own rights.

Inquiring about the integrity of a particular dealer helps artists make a critical decision. The Better Business Bureau is an unlikely place for dissatisfied

collectors to go, and the associations to which dealers may belong—even those with codes of ethical conduct—are reluctant to discipline wayward members. For instance, the owner of Harcourts Modern and Contemporary Art Gallery in San Francisco declared bankruptcy and fled the country as a result of improper business practices, yet "none of us had any inkling of the problems," said John Pence, then president of the San Francisco Art Dealers Association. "We don't know the inner workings of each other." Similarly, the Middendorf Gallery in Washington, DC, resigned its membership in the Washington Art Dealers Association in the midst of civil lawsuits over its financial dealings with collectors and other dealers yet never had been called to account by the association. "We hadn't been aware of what was going on before the suits were filed," Christopher Addison, the association's past president, said. Manhattan gallery owner Lawrence Salander had been a longtime member in good standing of the Art Dealers Association of America almost to the day that he was sentenced in 2010 to six to eighteen years for grand larceny.

If insiders claim to have "no inkling" of wrongdoing, how are the rest of us to figure out who's good and who isn't? A little sleuth-work might help answer some questions. The fact that gallery and dealer associations are not quick to act on their problematic members does not mean that scuttlebutt isn't in the air. "There were a lot of people who questioned Larry Salander's lavish lifestyle and wondered if his claims about what he had sold and for how much were really true," said Chicago arts lawyer Scott Hodes. "Getting references from other dealers makes sense." One way to check out the dealer is to find out how long the gallery has been in existence; another is to call a local museum curator for any information about the dealer; a third approach is to ask the dealer for a bank reference. Nothing is foolproof, but, without some sense that the dealer is legitimate and in for the long term, the artist runs a potentially sizable risk.

Hodes also recommended that those considering working with a gallery or dealer as buyer or consignor ask for bank references in order to determine the nature and length of the relationship between the gallery and the bank, as well as if there have been any difficulties, which might include bounced checks. Another

type of search one may make involves reported disputes and litigation in which a gallery or dealer has been involved. Not every lawsuit is relevant or revealing about a gallery's operations, but some are quite telling, according to Jo Backer Laird, legal counsel to the Art Dealers Association of America. "If a gallery is sued by a landlord or vendors, that could indicate it is in financial distress. If you see a pattern of disputes, such as a number of lawsuits by consignors against the gallery after the gallery sold pieces but never paid the consignors, that might also ring warning bells." A regularly used search engine for lawsuits is Lexis-Nexis, which is available by subscription. Most lawyers subscribe to Lexis-Nexis, as do many libraries.

As was the case with Lawrence Salander and Knoedler Gallery, good reputations can go bad quickly, requiring even longtime clients of a gallery to keep tabs on the dealers with whom they have a relationship.

Dealers come in a wide variety. Some have strong contacts with established collectors and are able to sell most everything by artists in whom they believe; others may not sell very much, earning most of their money through framing pictures or consulting with private individuals and corporations on what art to buy and where to hang it; yet others are artists themselves who have set up a gallery for the primary purpose of creating a fixed venue for their own art, exhibiting other artists' work at the same time. Some dealers are personally and professionally supportive of the artists they represent, while others believe in letting artists find their own creative paths. Not all dealers are right for all artists.

Artists and their dealers may not be of the same mind on a variety of practical matters as well. Disagreements may arise over pricing, proper accounting, discounts, assigning of copyright, the frequency of exhibitions, and a host of other legal and business issues. These differences are not necessarily the result of ill intentions on the part of a gallery owner; rather, it is the power imbalance between artists (especially the younger emerging artists) and their dealers that often forces artists to accept otherwise unacceptable arrangements. To a degree, artists can only hope that success in selling their work will provide them with greater leverage for negotiating better deals later on. However, it is useful to have a firm idea from

the start of what one's arrangement with a dealer is and to get that in writing if at all possible.

Written agreements can be broken as easily as verbal ones. Verbal agreements are legally enforceable, although disputes may be settled much more quickly when there is a clear agreement in writing signed by both parties. Certainly, the legal costs would be less, if the dispute reaches that stage, because it takes less time to enter a legal document into evidence in court than gathering hours and hours of conflicting depositions by both sides, disputing what was said when by whom.

A number of artist advocates recommend that artists and their dealers sign explicit consignment contracts as a means of fully clarifying their relationship and avoiding conflict. Written contracts make sense and solve a lot of problems, but dealers frequently make sour faces whenever an artist offers one. There are many instances in which the modern business world and the tradition-bound gallery system are found to work at cross-purposes. Artists tend to be more eager to win the endorsement of a gallery that will represent them than assertive of their legal rights, and it is difficult to fault them. Dealers who profess to scorn contracts are disingenuous—they certainly sign contracts with banks, landlords, and collectors—but the old rhetoric dies hard.

"A lot of the relationship between the artist and the dealer is based on trust, and you can't pin that down in a written contract," one prominent New York City dealer said. "In fact, the written contract may imply a lack of trust."

The threat of "turning off" a dealer may well make an artist reluctant to present any written agreement to their potential agent. However, artists and their dealers should speak with some specificity about how they will work together, and this should be written up by the artist in the form of a letter that the artist asks the gallery owner to approve and sign. Frequently, artists and dealers have a short-term agreement—a sort of trial marriage—to determine whether or not they work well together, and this may be renewed or expanded later on.

It could be a straightforward letter that starts out with, "This letter will confirm our understanding of your representation of me," and ends with "If this is acceptable to you, please sign below and send it back to me."

The letter should address the most pertinent issues, such as:

- The term of the agreement (how long will we be bound by this contractual relationship). Initially, the term should be two or three years, which allows the dealer a reasonable amount of time to promote the artist and to see that investment pays off. An agreement of only six months may make the dealer reluctant to develop the market for an artist's work and may also lead to the dealer dropping the artist if works don't sell immediately. A much longer agreement may keep an artist whose work begins to sell well in a disadvantageous position if the contract is weighted toward the dealer.
- The nature of the relationship (exclusive or nonexclusive representation, for instance). The dealer may have the exclusive rights to sell all of the artist's work, or exclusive rights to sell only prints (another dealer has exclusive rights to the sculpture, yet another has the rights to the canvas paintings); perhaps the dealer has the exclusive rights to market the artist's work in North America or just New York City. The dealer may simply handle an artist's work without any claims to exclusivity. These situations should also be discussed directly with the art dealers involved since, in the very thin-skinned art world, hurt feelings and unhappy artist-dealer relationships may result from surprises. Possibly, dealers for the same artist will work together by coordinating exhibitions (when in the same city) or rotating an artist's works from one gallery to another, which makes it possible to keep artworks from sitting in the same gallery in perpetuity.
- An exact accounting of what is being consigned to the dealer. A paper trail should accompany every work that the dealer or gallery is sent, listing the title of the piece, the medium, and the size, and a signed receipt should be in the artist's possession. Galleries often maintain a large inventory, and works may be misplaced; if the gallery owner cannot locate something that they acknowledged having received, it becomes that person's responsibility to find the work or pay the artist. There is little to be gained from a I-gave-you-that-work, no-you-didn't disagreement.

- Price arrangements (minimum amounts per work or prices for each work, as well as what sorts of discounts may be allowed). It is up to the artist, in consultation with the dealer, to determine the price of artworks. The dealer may have good reason to ask for flexibility in pricing by the artist—certain prestigious museums expect a 50 percent discount, and other prominent collectors may also seek more than the customary 5–10 percent discount—since placing a work well has long-term benefits for an artist. Still, an artist cannot abdicate the responsibility of setting prices.

- The percentage of the dealer's commission (30, 40, 50, 60, 70 percent—the median is 50 percent, but artists and their dealers work out their particular financial arrangements, depending upon the prominence of the artists and the services rendered by the dealers; whatever the percentage, it should not come as a surprise to the artist).

- The responsibilities of both dealer and artist (how promotional efforts for a show will be handled, where advertisements will be placed, who will pay for framing and insurance, whether or not the artist will be compensated for the loss in the event of damage or theft).

- The frequency and nature of the exhibits (one-person exhibits, group shows, once a year or less often, when in the year, how the work will be shown). In some galleries, it is very easy for an artist to get lost, shown only in group exhibitions at nonpeak times of the year. Scheduling shows should be discussed at the outset of the relationship.

- A requirement for periodic accounting (who has purchased the works, how much was paid for them, where and when have works been loaned or sent out on approval). Artists have reason to know who their collectors are, not only to include on their CV but also in the event that a retrospective of their artwork is planned and pieces need to be tracked down. For artists in California, where a state resale royalty law is in effect, subsequent sales of their work would likely result in a royalty payment based on the presumed increased value of the resold pieces.

- Prompt payment by the dealer (sixty to ninety days should be the absolute limit, and thirty days is preferable). Some dealers will pay their artists as soon as the check clears, while others may receive payment from collectors on layaway and not send money to the artist until the last payment is received. (That latter method is patently unfair to the artist; the dealer receives a 50 percent down payment for the work, representing the gallery's commission, leaving little incentive to hurry the buyer toward paying the remainder.)

Some dealers agree to allow prospective buyers to "live with" a work for a period of time in order to ensure that the collectors are satisfied with it before requiring payment (sometime after that, the artist will be paid). The owners of some marginally profitable galleries flat out tell their artists that they need to pay their rent, utility, and telephone bills first—the artists will be paid when money becomes less tight. In general, artists should not subsidize their dealers, allowing them to use the proceeds of sales for other purposes. In thirty-one states around the United States (Alaska, Arizona, Arkansas, California, Colorado, Connecticut, Florida, Georgia, Hawaii, Idaho, Illinois, Iowa, Kentucky, Maryland, Massachusetts, Michigan, Minnesota, Missouri, Montana, New Hampshire, New Jersey, New Mexico, New York, North Carolina, Ohio, Oregon, Pennsylvania, Tennessee, Texas, Washington, and Wisconsin) and the District of Columbia, artist-dealer consignment statutes exist that identify all artwork and proceeds from sales of art consigned to a gallery as trust property and not part of a gallery's assets. If an artist wants to help out a gallery owner financially by deferring payment, that is the artist's right. However, artists should never be in the dark about where their money is and when they will receive it.

While the artist automatically retains copyright (that is, reproduction rights) for their work even after a sale, some artists may want written contracts for the sale of each piece, including, for example, a provision for resale royalties (requiring the buyer of the artwork to pay back some percentage of the profit when that person later sells the work).

Other provisions that might be discussed and formalized in a letter of agreement between artist and dealer include a mechanism for resolving disputes (such as presenting a disagreement before an arbitrator or mediator), protection of the artist's assets in the event that the gallery goes bankrupt in those states where artist-consignment laws do not exist. If the agreement requires that all attorneys' fees be paid by the person who is in breach of the contract, this will encourage the dealer to act ethically.

The issues of bookkeeping and prompt payment are frequently the most troubling in the artist-dealer relationship. If the artist is selling throughout the year, the accounting should probably be monthly; at the very least, it should be quarterly. Artists should also carefully maintain their own records, knowing where their works are consigned or loaned as well as which pieces have sold and to whom.

It is wise to see the sales receipt for any consigned work after it is sold in order to ensure that the dealer has not taken too high a commission or paid the consignor too little. The practice of keeping two sets of books is not unknown, and artists are wise to check every step of the way. Many art galleries are notoriously poorly financed operations that often use today's sale to pay yesterday's debt, and many artists have had to find recourse in the courts when a dealer withheld money owed to them. Those thirty-one state artist-consignment laws protect an artist-consignor's works from being seized by creditors if the gallery should go bankrupt. "A work of art delivered to an art dealer for exhibition or sale and the proceeds from the dealer's sale of the work of art are not subject to a claim, lien, or security interest of a creditor of the dealer," according to the Texas law.

Without that protection, in the event of a lawsuit or bankruptcy of some business that is not a full-time art gallery, an artist's consigned work would be seized and become part of a bankruptcy proceeding. There, the outlook is not favorable to the artist. First in line for repayment are "secured" claims, such as bank loans or mortgages, followed by "priority" claims (taxes owed to the government, for instance), and finally "unsecured, nonpriority" claims, including debts to credit card companies, suppliers, and, in the case of print studios, foundries, restaurants, or any place that may have artwork and artists. John Winter, a bankruptcy

attorney in Philadelphia, estimated the return for unsecured creditors to be seven or eight cents on the dollar, "twenty cents if you're very lucky."

Even artists whose dealers are in other states than these have some protection from creditors seizing art on consignment in galleries. Artists may file a form under the Uniform Commercial Code with the state attorney general's office (the cost is approximately $125) that gives them prior right to repossess consigned pieces should the gallery go bankrupt. An artist (or the artist's lawyer) filing a UCC-1 form or a claim with a bankruptcy court would do so in the state in which the corporation was formed, rather than where the gallery is located. Reports on more than 80 million businesses are available through Dun & Bradstreet, many of which were formed as corporations in the state of Delaware, where corporate taxes are relatively low and the ability to sue individual corporate shareholders for misdeeds is somewhat more difficult than in other states. As businesses, galleries are more likely to be liquidated than file for reorganization under the bankruptcy laws.

Another unfortunate possibility is that the artist's works may have been sold, leaving the artist owed money by a dealer who has disappeared. However, the dealer may still have assets in the state, such as jewelry in a safe-deposit box or a house, which can be attached by the artist.

If there are assets, the artist may have a preferred right to them. The artist would show their consignment form, listing the works that were sent to the dealer, the works that have been sent back or for which the artist has received payment, and the prices for all those pieces. One adds up what is owed and presents that number.

In those instances where dealers have closed shop without returning consigned works to the artist or paying money that is owed and the dealer is still in the same state, the artist has some recourse to the law—contacting the city district attorney's office or the office of the state attorney general, or hiring a lawyer to recapture any works on consignment to the dealer or money owed through past sales. If the dealer has left the state, the legal possibilities become less clear and more difficult for the artist.

Sometimes, however, the reason that an artist has not been paid is quite innocent. Perhaps the artist has moved but neglected to provide a forwarding address to the gallery owner. The dealer, planning to retire and pay all outstanding debts, cannot locate the artist. Artists should always give notice in writing of any moves, even if only for six months.

Knowing what to beware of in dealers is important, but it is equally valuable for artists to develop strong personal and professional relationships with their dealers. The dealer should be aware of which ideas the artist is pursuing, any changes in the work, and other events in the artist's life (such as winning an award or receiving an honorary degree) that may help promote the artist's work. It is often the case that artists who don't communicate with their dealers are the ones who complain that their dealers do nothing for them.

HONESTY IS THE BEST POLICY

"I once was seriously considering taking on a young artist who sent me follow-up material claiming to have shown at the Metropolitan Museum, the Whitney" and other major museums, said Louis Newman, director of Santa Fe's Lewallen Gallery. "When I called to express my astonishment that he did not tell me to begin with about these impressive credentials, he revealed that he actually never showed in these museums but at them," such as on the steps of the Metropolitan, where he would set up a display of his work for tourists, visitors, and other passersby. Newman added that "needless to say," this artist was "out the door as far as we were concerned."

What should we call this? Fib, puffery, white lie, misinformation, half-truth, fairy tale, or just outright lie? It probably doesn't matter, as a prospective dealer lost confidence that he ever could trust this artist to be truthful. Perhaps the moral of this story is that you should always assume a worst-case scenario if you are ever caught not telling the truth.

Certainly, there are a lot of things that you might be reluctant to tell the truth about that don't seem so terrible. For instance, one's age. "I have had a few CVs cross my desk without a birth year or educational dates, although the exhibition

history would suggest they've been around a few decades, so I imagine they were trying to disguise or at least not focus on their age," said former Manhattan gallery owner Edward Winkleman. Actually misrepresenting one's age, however, might make him suspicious of what else isn't quite the case.

It may be embarrassing for some artists to be older and starting out, or to have not ever sold any work or to not have academic degrees in studio art or to not have any real exhibition history. Sins of omission are better than making things up or even feigning ignorance of the truth. Winkleman noted that bothersome to him and other gallery owners "is an artist doing something that is a deal-breaker and then pleading they didn't know it was against the gallery's terms for representation or that this exception was so bad." The most common example of this is an artist selling artwork out of their own studio without informing the dealer and pricing that art below what the gallery charges.

Then there are instances of what might be called "prize inflation," an example of which is the bronze sculptor in New Mexico who told an interviewer for a daily newspaper there that "she won first place—two different times—at the National Sculpture Society in New York City," according to the article, which appeared in the *Daily News* in late March 2013. "One of our board members read that article and emailed it to me," said Gwen Pier, executive director of the National Sculpture Society. "We keep records on our winners," and while that artist did win modest prizes back in 1978 and 1982, "they weren't first prizes." At a distance of thirty-plus years and two thousand miles away from the society's headquarters, this might seem very minor. Still, the society is a national organization with members all over the country, and artists should keep in mind that anything in print also is likely to end up online, shrinking the span between one place and another.

Pier noted that when sculptors apply for membership in the society, they are "juried on the basis of the merit of their work. Jurors aren't very interested in reading the paperwork. They don't care how old you are or what degree you have, or if you don't have any degree."

Various watercolor, pastel, and plein air societies around the country all have their own definitions about what constitutes the acceptable form of their own media.

These definitions become mandatory requirements for those seeking membership or to be included in an exhibition. "You can't always tell from the digital file sent in with the application if opaque or white paint is used, but you can see it when the artwork is in front of you," said Robin Berry, a member of the board of directors of the Transparent Watercolor Society of America. "Those works have to be removed."

"Art is a lie that makes us realize truth," Pablo Picasso told an interviewer in 1923, but artists also need to adhere to a less-lofty form of truthfulness. They must comply with stated rules, offer accurate information about themselves and their artwork, and avoid exaggeration in order that they will be trusted by collectors, dealers, and show sponsors, even when the rules and questions seem unfair and arbitrary.

FOUNDRY FEES AND COMMISSIONS

Few enough artists think that dealers are fully justified in charging a 50 percent commission on gallery sales, but most accept it as just the way things are done. Still, the commission may strike some artists as less fair than others. Sculptors, for instance, especially those who work with foundries to produce bronzes, have far higher production costs than most painters. A $2,000 painting may have cost only $10 in actual materials to create, while a $2,000 bronze may have set back the sculptor $600 or more. The 50 percent sales commission for the painter results in the artist netting $990, while the sculptor's earnings after expenses would be only $400. To break even with the painter, the sculptor could raise the price to $3,220, but that might put off buyers. "Sometimes, you just have to eat it," said sculptor Ann Morris, who lives in Lummi Island, Washington.

But not always. Morris, who works with several West Coast galleries, often is successful in negotiating the commission down to 33 percent, especially when the gallery owner is told that the alternatives are raising the price or not having works by her on consignment. "I have less leverage when I'm the only bronze artist being show, everyone else is a painter," she said. "The dealers tell me, 'Well, I can't make an exception just for one artist.'" When there is more of a mix of media, she added, gallery owners are apt to show more flexibility.

For most of their careers, painters set prices based exclusively on demand, which is why less well-known artists' work is less expensive than that of more established painters. When they are starting out, for instance, artists tend to price their work in the same range as those of similar pieces by artists at a comparable point in their careers, and prices increase with the growth of their collecting audience. On the other hand, the work of bronze sculptors often is priced based on a mathematical formula—three times the foundry cost—for a substantial portion of their careers.

These types of agreements are negotiated individually between artists and gallery owners. The Copley Society of Boston, Massachusetts, actually has a written policy favorable to artists in this realm for its members gallery ("The gallery commission rate is 60% artist and 40% Copley Society for regular gallery sales. For sales of bronze/precious metal sculpture, the artist receives the cost of casting plus 2/3 of the remaining amount"), but gallery manager Carolyn Vokey said she was unaware of anything similar at other galleries.

TO CONSIGN OR SELL?

The consignment arrangement between artists and their galleries is a periodic cause of contention: Artists complain that not owning the work lessens both the commitment of the dealer to the art and the risks of not selling it; dealers respond that they couldn't afford to stay in business if they had to purchase everything they wanted to sell. Gallery owners frequently do better when they own the works outright. In a consignment relationship, the dealer typically keeps half of the sale price; when the gallery owns the work, the artist is paid a net price, and the dealer may sell the artwork for far more than double the artist's take. "Dealers certainly make more money on artworks they own than on those they consign," said Gilbert Edelson, former legal counsel of the Art Dealers Association of America. "The problem is tying up capital."

The association has never tracked what percentage of the works sold by its members involved in the primary art market were owned by the dealers rather than consigned to them. Ideally, the numbers should correspond to the percentage

owned and consigned by the dealers, which would indicate that the galleries worked as hard to sell pieces they did not own as for works they did. Common sense would suggest that the percentage is higher for works the dealers owned. Perhaps for that reason, almost all print publishers require the galleries that represent their work to purchase them outright. "We only sell work, we don't consign," said Kristin Heming, director of Pace Prints in New York City. "We have, on occasion, lent a few works out when a gallery is having a special exhibition, but that's only with galleries we've worked with and only after they've shown a real commitment to the work by buying it."

For both artist and dealer, consigning artwork entails more paperwork. Emerging artists are more likely to face a consignment situation than those creators who are better-known—the dealers of well-established artists are more apt to buy at least some of the works they show or provide a stipend (a monthly payment, which is deducted from later sales) or guarantee minimum sales to the artists, realizing that if they don't they may lose the artists to other dealers who will—and reflects the power differential of the art world. The question for most artists is not if they are going to consign their works but how they will do it, which is why the consignment agreement needs to be fair.

ARTIST-DEALER DISPUTES

There are basic understandings that an artist and a gallery have when they enter into a consignment agreement: The dealer takes a certain percentage as a commission, the artist gets the rest. Well, maybe that's the only basic understanding, because everything else gets contentious (who pays for framing or insurance or advertising, how often will there be exhibits, will there be discounts, among other technicalities) and even getting paid in a timely manner can make everyone testy. But even other points that might seem to be clear-cut turn out to be battles in waiting, even when it involves the win-win situation of artworks being sold. For instance, when a dealer sells an artist's work, doesn't the artist have a right to know who bought it?

"Some dealers make it a practice of telling their artists who bought their work," Gilbert Edelson said, "but other dealers worry that, if they tell their artists,

the artists will go behind their dealers' backs and sell directly, cutting out the dealers." He added that he is aware of no law to support an artist's right to know the names of collectors.

In some instances, gallery owners remove or black out an artist's address and phone number when there is a label on the back of a canvas. More recently, dealers have expressed concern to artists about their websites if the contact information includes anything other than the gallery's address and telephone number. These dealers view artists' websites as an extension of their own marketing; of course, it is rare that dealers offer to pay for the setup and maintenance of these sites. Both the artist's desire for an online presence and the dealer's reluctance to finance it make sense, but it has sometimes led to resentment. There are many ways in which the internet, which would seem to bring people closer together, actually drives them further apart.

The issue of making known the identity of a buyer of art came up for Corlis Carroll, a Lake Luzerne, New York, painter, who had been asked by a gallery owner to participate in a group show of artists who had created paintings on Monhegan Island, Maine. A recent graduate from the University of Albany, Carroll contributed four gouaches to the exhibit, one of which sold—her first ever sale. "I asked who had bought it, and the dealer told me it was a college professor from the Utica area," she said. "I asked who it was, and he said he wouldn't tell me. He said that's how it's done in the gallery world, and he said it in a tone that suggested I was a complete idiot." Adding insult to injury, the dealer noted that, if the buyer wanted to purchase another painting, the sale could take place through him.

The dealer's comments and tone bothered Carroll. "It was like a cancer growing in me," said. "No one gets a 40 percent piece of me for the rest of my life. I didn't have a written agreement with this guy; I should know where my work is." Carroll was not without resources, however. Through the internet, she discovered all of the colleges within one hundred miles of Utica and, by browsing their websites, learned the email addresses for their faculties. She sent a mass emailing to a large number of these professors—telling the story of her frustration with this dealer—and was contacted within a week by the chairwoman of the classics department at

Hamilton College in Clinton, New York, who said she had bought the gouache. Answering the question of who had purchased the painting wasn't simply to satisfy curiosity, since Carroll asked to borrow the painting back so she could make a limited edition print of the image, a request to which the Hamilton College professor agreed.

Quite unsettling to many artists is the sense that there is no protocol in the art trade for accepted practices. That's where the law comes in, particularly those statutes in states around the country that regulate consignment agreements between artists and dealers. Of greatest importance is being paid in a timely fashion (within thirty to ninety days), which requires the artist to be notified that a sale has taken place. As many have discovered, sales would seem to be the end of an artist's troubles, but sometimes they are just the beginning.

BAD DEBTS AND OTHER RECOVERIES

Don't pay the utility company, and your electricity will be cut off. Miss some auto loan payments, and your car will be repossessed. Forget about the credit card charges, and a collection agency will be in touch and your credit rating affected. Don't pay the artist for their painting, and you can keep the artwork and your money. What's wrong with this picture?

When artists go unpaid, they usually have two options: Hire a lawyer whose legal work is likely to cost far more than the value of the artwork itself (lawyers' fees and court costs are rarely included in a settlement), or vent and fume.

In general, artists go unpaid in two different ways: Their dealers sell works but continually find excuses for not turning over the cash (minus sales commission) to the artists, or collectors who buy directly from artists, taking possession of the works with an agreement to pay for them over time, simply stop sending the artists money. In order to determine what to do after artists find themselves owed money, it is useful to examine what they might do before a sale is made.

"You need a clear understanding with the dealer or collector of the terms and conditions of payment," said John Henry Merryman, a professor at Stanford University Law School. "How much are you going to be paid? When are you

supposed to be paid? What is the price of the artwork? Are there any discounts? What is the dealer's commission? If the dealer or buyer has a clear understanding with the artist about payment, that person is more likely to pay the full amount and on time."

There are a variety of ways in which an artist may receive satisfaction that do not necessarily involve the high-priced legal system. Mediation may work in cases where the parties are willing to discuss compromises in the presence of a third party who directs the discussion. A growing number of volunteer lawyers for the arts organizations are offering mediation as a low-cost service, and others may direct artists to mediators elsewhere.

Many dealers and galleries belong to associations, which will set up arbitration (at no cost to the artist or gallery) when complaints are lodged against a member. Another possible approach to getting payment in full or in part is contacting a collection agency. "Debtors know that eventually the creditors are going to get tired of calling and asking for their money, that they will get on with other things in their life, and that's just what they want," said Mike Shoop, president of the Denver-based Professional Finance Company, Inc. "But for us, collecting bad debt is all we do, and we will write to the debtor and telephone the debtor and visit the debtor, in order to convince that person of the benefits of paying the debt and the consequences of not paying the debt, until the debt is paid."

One of the consequences of being pursued by a collection agency is that a negative report is usually placed on one's credit report, which may prove troublesome for the dealer or private collector when that person looks to obtain a loan. Most galleries, as most businesses in general, survive on borrowed money.

There are thousands of collection agencies in the United States, but not all of them take on individual clients. More frequently, agencies serve the big company—such as a department store, with hundreds of potentially lucrative accounts—in their struggle to obtain payment from individuals. Most agencies work on a contingency fee basis, receiving as much as 50 percent of the money received from the debtor. (A source of information and prospective agencies is the American Collectors Association, www.acainternational.org.)

As with everyone else, when artists are wronged, they want justice but may only receive small consolation. The legal system is not predictable in its results, for those willing to invest money and often years in resolving a dispute. Even those who win a lawsuit may still not be able to collect, for people who owe artists money likely also owe money to landlords, utility companies, credit firms, and others— there may be no money there to collect. In that case, artists would have to write off the loss as a bad debt on their taxes and hope to approach their next dealers or buyers with more knowledge about what could go wrong.

SPREADING ONESELF OUT THIN

The problems for artists in maintaining more than one gallery relationship, of course, are significant: The artists must produce enough pieces to keep each dealer satisfied; the works cannot be better for one dealer than for another; the bookkeeping, insurance, and specific consignment agreements with each dealer or gallery require considerable organization on the artist's part; and it may be much more difficult to arrange major shows in one specific location when pieces are spread around the country.

In addition, the artist may be able to sell their works privately, and this should also be discussed with the dealer. Some dealers don't mind, while others do. Dealers who allow their artists to sell privately demand that those prices not fall below what is charged in the gallery. Underpricing one's dealer will sour that relationship as well as diminish the overall value of one's work in collectors' minds.

A GALLERY CLOSES (FOR GOOD)

Art galleries open and close all the time (dealers retire, get sick, die, or go bankrupt), but what seems like the end of an era for the gallery may strike the artists represented there as the end of the world. When Charles Cowles announced the closing of his gallery in New York City in June 2009 and spent the last six months of the year closing down, "all the artists in the gallery called each other. Everyone was asking everyone else, 'What are we going to do? Where are you going to go?'" said Mona Kuhn, a Los Angeles artist whose photographs and drawings had been

represented by the gallery for a number of years. She was one of the lucky ones, since it took her only seven months to find another Manhattan gallery where she could exhibit her work. Shortly after the Cowles Gallery announcement, "I received phone calls from five different galleries, all of whom said they would love to work with me," she said. "I didn't want to waste any time, so I took a red-eye to New York to meet with three of the gallery owners so I could deal with the situation. Two of them weren't right for me, but one was." The director of Manhattan's Flowers Gallery then traveled out to California to make a studio visit, which went well, and arrangements were made to send inventory from the Cowles Gallery to Flowers. Very few of the thirty other artists Cowles represented were able to find another Manhattan gallery as quickly, perhaps, because Cowles wasn't trying very hard to help them or the recession or some other reason. "He cut down the number of people working for him, and the staff that remained was working on closing the business," Kuhn said. Judy Pfaff, a sculptor and installation artist, did not assume that she would be without a New York City gallery for very long after her dealer Andre Emmerich retired in 1997, but the wait proved to be seven years, until she was brought into the Ameringer|McEnery|Yohe gallery in 2004. "A few people talked to some dealers about taking me on, but they didn't want to touch me," she said. "Then, it hit me that the art world has no memory; it doesn't owe me anything; there's no one knocking on the door. I better hold onto my teaching job and figure things out. It was a total reality check."

During that interim, she did continue teaching—she is the codirector of the studio arts department at Bard College—and exhibiting at various galleries and other sites around the country. She also began creating prints (etchings) at Tandem Press, "and they did very well. At the time, I didn't think of these prints in business terms, as a new product line or revenue stream, but that's what they were." Over the years, Pfaff has created approximately one hundred editions of these prints.

At times, galleries just pare the number of artists they choose to work with. "There are many reasons for artists no longer showing with us," said Jane Young, director of Boston's Chase Gallery. "The evolving aesthetic of the gallery; changing tastes of our collectors; the artists' own aesthetic changes, no longer meshing with

what we show in the gallery; sometimes, artists have too many commitments—they are stretched too thin and can't produce enough work for us." Peter Ted Surace, owner of Manhattan's Rare Gallery, noted that a dealer may be supportive of artists and their work but just can't find buyers for it. "There comes a point when you just can't do anything more for an artist," he said. "A glitch develops, and you don't know why that glitch happens. People may not respond to the work anymore." In 2006, New York gallery owner Andrea Rosen dismissed ten of the artists that she had represented, bringing the overall number down to eighteen, claiming that the gallery was being "restructured."

The effect on the downsized artists in these galleries was sizable, both professionally and personally. Not only were they being dropped by a gallery, they were losing their portal to the New York art market. "There's no one there to sell my work," said Brooklyn, New York sculptor Craig Kalpakjian, who had been represented by Andrea Rosen. "It's been really hard on my career."

Exhibition schedules at galleries require artists to assemble a sufficient number of works at regular intervals, such as every other year, which pushes them to work steadily and be productive; without a specific date and place for a show, some artists do not work to full capacity. The process of finding a new gallery may lead to self-doubts on the part of mid-career and older artists, who find themselves competing for attention with much younger artists.

For many artists, a dealer or gallery assumes the business side of being an artist, permitting them to just create while others do the huckster work. The demise of a gallery breaks down that boundary and, perhaps, the artists' idealized vision of themselves. "I have to do my own slides, my résumé, answer phone calls," Pfaff said. "There's no one there now to protect me."

Gilbert Edelson, former administrative vice president of the Art Dealers Association of America, said that "75 percent of all galleries don't last five years. My guess is, the lower down you go in terms of the prestige of the artists represented, the higher the turnover rate." In the wake of periodic recessions and just the ordinary vicissitudes of life, a lot of artists have learned to have a Plan B. Sometimes, it helps to have more than one gallery selling artwork. Two of the artists

represented by Charles Cowles, Los Angeles sculptor Charles Arnoldi and Carbondale, Colorado, sculptor James Surls, worked with a handful of other dealers around the country. Surls had not solely relied on any of these galleries for his livelihood but continued to sell pieces out of his studio even with dealer representation. "I've told my dealers that I would also sell my work directly to collectors," he said. "I've assured them that I won't be competing with them, but this business with Charles Cowles reoriented my head. I'm taking more responsibility for my own survival. You can't blame a dealer or curator or critic."

Dealers going out of business often claim that they will contact other galleries on behalf of their artists, but the assistance that they are able to provide their artists is necessarily limited. They must settle up with creditors, try to sell off inventory, and their staffs are busy looking for new jobs.

SEVERING THE ARTIST-DEALER RELATIONSHIP

The end of the relationship between artist and dealer is often the result of hard feelings on at least one side—the dealer isn't promoting or selling work, the dealer does not pay promptly after sales take place, the dealer isn't showing interest in the artist, the artist made private sales, the artist isn't producing high-quality work—and produces hurt feelings on the part of whomever has been left behind. Often, there is a complicated mix of reasons that an artist and dealer split up.

Sculptor William King left the Zabriskie Gallery in New York in part because "the gallery had a low ceiling, and I expected higher prices and more sales," but the precipitating event was the dealer's "refusal to give my girlfriend a show." He went to dealer Terry Dintenfass, who agreed to exhibit the work of his girlfriend. On the other hand, painter Jacob Lawrence ended his relationship with Terry Dintenfass because "I wasn't getting paid the money I was owed, I didn't get quarterly statements from her, and she was generally hard to work with."

One way in which artists often judge the solidity of their relationship with their dealers is the number of telephone calls from their galleries. "Artists want to hear regularly from their dealers," Curt Marcus, a New York art dealer, said. "It's important that they know they are being thought about." Both Gregory Gillespie,

a painter, and Faith Ringgold, a painter and sculptor, said that they are called by their respective dealers at least once a week, relaying information on prospective buyers, past collectors, a new show, asking how the work is coming along, how's the family—the specific content may not be as important as the ongoing connection.

Painter Richard Haas noted that a sign of how his relationship with a dealer "is fizzling out" is that "the dealer is calling you most of the time when you're in the middle of it; when you find yourself calling the dealer most of the time, you're not in the middle of it anymore. There are not enough phone calls, not enough visits to your studio; you don't get invited to dinner. You know you're at an end."

Many artists approach their relationship with dealers cynically. "You get priority treatment from dealers when your work is selling," said painter and collage artist Nancy Spero, "and dealers have no time for you when sales are slow. In other galleries, the attention you get is based on where you are in the pecking order of artists that the dealer represents."

Haas said that the relationship between artists and dealers is based "on mutual needs, but those needs keep changing, and one is seldom in sync with the other." For Haas, who is best known for his murals, dealers lose interest because they are "object-oriented," whereas his living is based on commissions, which are more difficult to arrange than private sales. Painter and photographer William Christenberry left the Zabriskie Gallery "as a matter of conscience" after he had been awarded a commission from the federal government's General Services Administration in 1979, "and the gallery wanted a substantial part of the fee as their commission. They hadn't help me get the commission, as a lot of other galleries do, and I didn't think they deserved any of it." Painter Peter Halley left dealer Larry Gagosian in New York because of the requirement that Gagosian be his exclusive agent. Dealers elsewhere in the United States and in Europe did not want to share sales commissions with the New York gallery, resulting in lost sales. "Seventy-five percent of my market is in Europe," Halley said. "My collectors are not likely to come to New York to buy. Dealers in Europe chafe under the requirement that they pay half of the commission they earn to my New York

dealer." To his mind, Gagosian would prefer to forgo sales than to lose his commission.

At times, the point of contention is whether or not the artist feels free to develop artistically under the existing relationship. Jacob Lawrence noted that he ended his association with Elan Gallery because the dealer, Charles Allen, "wanted to buy all the work he showed, which put me in the position of creating for him. He didn't come out and say, 'I want you to paint in such-and-such a way,' but it still felt that way to me and I wasn't comfortable with that."

Similarly, Faith Ringgold, who was represented by New York art dealer Bernice Steinbaum from 1985 to 1993 before joining ACA Galleries, said that she "wanted a gallery that was more high-powered, that could get better prices and place my work in better collections. But it wasn't just the money; I wanted my entire career to move forward, and I sensed a tendency on Bernice's part for me to stay where I was."

Ringgold noted a mounting number of suggestions for, and outright criticisms of, her work by Steinbaum. "We weren't agreeing on anything anymore," she said. "It was just a constant aggravation that kept me from concentrating on my work. The only thing I could do was leave her gallery." When she decided to leave, Ringgold had her lawyer contact the dealer and arrange the split-up.

Most artists announce their decision to leave in person, sometimes in a letter, and hope that the breakup with the dealer will be painless and amicable. "I tell my artist clients, 'Don't go away mad. Just go away,'" Jerry Ordover, a lawyer who often represents artists, said. "When you start thinking about leaving a gallery, do it in steps: Start by reducing the size of the inventory; take back works that have been there two or more years to start with, then take more recent pieces. You don't want to leave hostages with a dealer whom you've just told you're leaving. You might find the works get kicked around, or you're told they are lost. Next, you want to get all the money owed to you, little by little if not in a lump sum. You want to settle the money part while the two of you are still on good terms."

Complicating the breakup may be the question of money owed to the dealer for advances against sales (sometimes called stipends) or the costs of advertising,

framing, restoration, the purchase of materials, or the publication of a catalog. An artist may not have the cash to immediately cover the debt and may attempt to repay the dealer through works of art. When Jacob Lawrence left Terry Dintenfass, she had some graphic prints of his and he owed her some money; they agreed to let her keep the prints in exchange for wiping out the debt.

The problem isn't always resolved so easily. Sometimes, spite enters the picture. The artist-dealer consignment laws in most states define consigned artwork to a gallery as "trust property," requiring money generated by the sale of any consigned artwork to be held "in trust" for the artist. However, as a matter of law, there is no fixed period of time by which an art dealer or gallery is required to return consigned artwork to the artist. Most artists don't have written consignment agreements with dealers, and few contracts between artists and galleries include a "termination clause" (identifying how long the agreement will last, how it might be renewed and the steps to be taken by both sides when the relationship is ended), making the issue of when and how to return unsold artwork a matter of negotiation. If a dispute on this issue goes to court, according to William Rattner, executive director of the Chicago-based nonprofit Lawyers for the Creative Arts, "it comes down to common law, and a judge will decide what ought to be done." The basis of a ruling is likely to be reasonableness, but it is not clear what will be viewed as reasonable—thirty days, sixty days, ninety days, longer?

Art dealers may not be in a hurry to return an artist's work, for tactical or other reasons. "If there is a stated end date to the consignment, technically the gallery must make the work available by that date," said former gallery owner Edward Winkleman. However, if there is no such end date, "how long it takes a dealer to return the work is generally negotiated with the artist."

Even if the artist did not agree to share dealer expenses, a gallery may have the right to demand some level of reimbursement if the artist decides to withdraw the consignment too quickly. "A gallery needs time to market the artist's work," Rattner said. If the artist acts too hastily, they "may be depriving the gallery of the opportunity to recover its costs and make a profit." Dealers also may have a right

to compensation on termination even when there is no formal consignment agreement, as it may be claimed that an implied contract existed. Again, that may be left to a judge to determine what might be viewed as reasonable.

There may be other areas of unresolved financial obligations, such as any loans made by the gallery to the artist, stipends that are to be remunerated against future sales or fabrication (at a foundry) or publishing (at a print studio) costs for new works that also were to be reimbursed after sales took place. Manhattan art dealer Renato Danese claimed that these types of outstanding debts are elements in the negotiations that take place while the gallery retains possession of the artist's work. "The matter may be settled by my keeping a couple of artworks to satisfy the debt, for instance," he said.

The next step after this is to negotiate which artworks would remain with the dealer. Does the artist pick? Does the dealer? Do they pick together? When Hirschl & Adler Galleries in New York decided to end its relationship with painter Joe Zucker in 1993, following a private studio sale that the artist had made to a collector, the gallery refused to return twenty-six of his works until $36,000 in advances plus interest had been repaid. Zucker filed a lawsuit and, in 1996, the New York Supreme Court ruled against Hirschl & Adler. The artist and gallery eventually settled the debt by selecting four works (the gallery chose from a sample of works that Zucker selected).

Ending a relationship amicably is important not only since the dealer may be in possession of an artist's work but because "the art world is small," said painter Nancy Hagin, who left Terry Dintenfass in 1980. "It's not like I'm never going to see her again. I see her again and again and again." Within a small art world, an incensed dealer may begin denigrating the reputation of an artist both to other dealers and collectors, adversely affecting the artist's career. Even though their formal relationship has ended, the dealer may still remain a source of future sales and commissions, and some artists may return to a former dealer. William King returned to Terry Dintenfass after his experiment with Virginia Zabriskie, and Gregory Gillespie was invited back by dealer Nina Nielsen in Boston a couple of years after she had "asked me to leave following a big blowup we had."

The experience of ending a relationship is almost always unpleasant, artists and their dealers report, but it is an unpleasantness that everyone tries to get over quickly. Over the course of a career, an artist may change dealers any number of times, and knowing how to make a satisfactory exit must become one more skill to acquire. The dealer Betty Parsons "wouldn't talk to me for a few years when I told her I was going to show my work at the Janis Gallery," said painter Ellsworth Kelly, "but we patched it up and even took a vacation together." When Kelly left dealer Sidney Janis for the Leo Castelli Gallery, "there was some initial bitterness there, too, but that didn't last long and we remained good friends."

The agreements that artists and dealers make when they start a relationship should contain some strong sense of how it might end, according to Joshua Kaufman, a lawyer in Washington, DC, who noted that when he drafts a consignment agreement between an artist and a dealer, "I spend more time on the termination clause than on anything else. You don't want to leave this stuff up to when everyone's feelings are hurt."

Some artist-dealer consignment agreements allow either party to terminate the contract at will if there has been a clear breach (for instance, artist isn't paid, shows don't take place, artist violates the exclusivity) or if either side is simply unhappy with the arrangement. Even if there is no specific termination clause, one cannot be bound by a contract indefinitely. According to Barbara Zucker, Faith Ringgold's attorney, "the contract may be terminable at-will" or, at worst, the statute of limitations will not permit the agreement to be enforced past one year.

Of course, when there is no written agreement between artist and dealer, either side may end their relationship at any time. However, the lack of some formal or informal (an exchange of letters) document may lead to other misunderstandings or even a drawn-out legal action that promises to be expensive and not necessarily conclusive.

Painters David Saunders and Emily Mason both were represented by Grace Borgenicht, who closed her gallery in 1995, six years before the dealer died, and both had to wait four years before other New York galleries agreed to represent their work, and during that period Saunders's savings dropped from $300,000 to

$120,000. Mason was picked up by MB Modern, which was closed down by its owner the following year; however, the gallery's director, Lewis Newman, brought her and several others from MB Modern over to the next gallery where he was hired to work, David Findlay Jr. Fine Art. "Perhaps I'll get a few years to work before the next trauma hits," Mason said at the time.

And traumas of this type will arrive. In 2017, David Findlay Jr. was taken over by another gallery, causing "restructuring" and a loss of representation for most of its artists. While noting that his information is all anecdotal and his "sense of things is pure guesswork," Gilbert Edelson, former administrative vice president of the Art Dealers Association of America, said that "75 percent of all galleries don't last five years. My guess is, the lower down you go in terms of the prestige of the artists represented, the higher the turnover rate."

For most artists, gallery representation means more than just a place to show their work. If there is a lesson in all this, it is that artists cannot just rely on dealers and galleries to do all the business of art for them. Pursuing sales and commissions opportunities, knowing who one's buyers are and maintaining relationships with them, promoting work for exhibitions at nonprofit spaces and museums, maintaining and updating their websites, developing a presence in one's community and elsewhere through talks and demonstrations mean that artists will not be completely blindsided by vicissitudes in the economy and changes in the lives and interests of the people representing them.

6

Artists and the Law

It probably doesn't occur to many art collectors to purposefully alter, mutilate or destroy a work of art that they have purchased, but it has happened occasionally. Among others, it has happened to the creations of sculptors Alexander Calder, Isamu Noguchi, and David Smith, as well as painters Arshile Gorky, Pablo Picasso, and a number of others who aren't quite as well known.

However, because of the Visual Artists Rights Act of 1990, it is less likely to happen in the future. The law, an amendment to the federal copyright law, provides visual artists (narrowly defined as painters and sculptors as well as printmakers and photographers who produce limited editions of two hundred or fewer copies of their work) with the right of attribution (to claim "authorship" of their work and object to false attribution). The law also affords artists the right to prevent the owners of their work from distorting or altering their creations without their consent and, in the case of works of "recognized stature," to prevent their destruction. In the years since then, a number of artists have filed lawsuits under the law—a few successful, most not—largely for works of public art. Laws, of course, are not judged on the basis of guilty verdicts but on how they influence behavior. In this regard, the Visual Artists Rights Act has proven to be a success, because the

owners of outdoor sculptures and murals have learned to their dismay that they cannot do whatever they choose to their artworks.

Artists have become more versed in the law, and the legal profession has become acquainted with the arts. The Visual Artists Rights Act was the outcome of more than a decade of political activism on the part of artists, but it also was the outgrowth of an ongoing international campaign to regulate the art trade and ensure fair treatment for artists. Looking around, one sees a growing body of art law on the state and federal levels over the past thirty years.

Among the main points in this already sizable body of law are:

- Artist-dealer consignment laws in thirty-one states around the country (requiring dealers to whom artists have consigned their work to hold proceeds from sales in trust and out of reach of any claims by gallery creditors);

- Art print disclosure laws for the sale of fine art editions in fourteen states, requiring buyers to be furnished with detailed information about the editions;

- Warranties of authenticity (requiring art dealers to take back works they had sold that had not been created by the artist ascribed to the works at the time of the purchase);

- Requirements for auction houses to indicate by some symbol the lots in which they have a financial interest, such as a guarantee or a loan made to a consignor (New York State), and that art galleries make clear to the public whether or not works on display are actually for sale to the public (New York City);

- Allowance for artwork to be used as payment of an artist's estate taxes (Connecticut, Maine, and New Mexico);

- Passage of the Indian Arts and Crafts Act, a truth-in-advertising statute that punishes the creators and sellers of all objects falsely represented as being the work of a Native American when the creator is not an enrolled member of one of the 557 federally recognized tribes in the United States;

- Passage of the Digital Millenium Copyright Act, which among other things allows copyright holders to identify anonymous online infringers through subpoenas that direct service providers to unmask those infringers' identities;

- The creation of a Copyright Small Claims Court, lowering the cost for artists to protect their rights in the courts when instances of copyright infringement take place;

- Federal labeling requirements for art materials with potentially toxic ingredients;

- State "moral rights" codes similar to the Visual Artists Rights Act and, in California (for several decades), a "resale royalties" statute that requires art collectors to turn over to artists a percentage of the profit when their work is sold again. In addition, two states (Maryland and Rhode Island) have designated art zones in various cities where artists are exempted from paying sales tax on their work, and three states (Massachusetts, New York, and North Carolina) permit artists to deduct the cost of their living-working space for tax purposes. Massachusetts even has a "Schlock Art" law (requiring dealers of low cost, imitative paintings to label these works "nonoriginal").

THE IMPORTANCE OF OBTAINING LEGAL ADVICE

Who dares tell artists what they can and cannot do? Sometimes, it's a lawyer, and for good reason. "There was a video artist who took footage of people and artwork inside a museum, and he asked one of our lawyers, 'Can I add music and make this into a music video?' The lawyer said, 'no.'" Lori Mason, former associate director of legal services at New York's Volunteer Lawyers for the Arts, added that what the artist did properly was to ask first before publicly exhibiting the video.

Of course, this or any other artist doesn't have to obey what some lawyer says, and none of the Volunteer Lawyers for the Arts groups (https://vlany.org/national-directory-of-volunteer-lawyers-for-the-arts/) around the country—or lawyers in private practice, for that matter—require that they do. (Some VLA

groups have arts mediation programs, which provide an alternative to more costly lawsuits.) "We advise artists what the law is, how judicial decisions are made and how a case is analyzed, and inform them of the risks they may be taking by displaying certain works," she said. The benefit of going to a Volunteer Lawyers for the Arts organization rather than to some $300-per-hour private attorney is that, if you are going to hear bad news, it might as well be for free or at a discount.

Works of art sometimes violate the law. Increasingly, it could be copyright or trademark infringement, or it might be breaking some noise ordinance, blocking a thoroughfare, or violating the rights of an individual's privacy or publicity. Any number of possible laws. Back in 1999, New York art gallery owner Mary Boone was arrested for weapons possession and unlawful distribution of ammunition as the result of a display of guns and ammunition by Tom Sachs (charges were dropped, and Boone's record was cleared after she had no further arrests over the next six months). A few years earlier, the Organized Crime & Narcotics division of the Chicago Police Department raided the Richard Feigen gallery, confiscating a sculptural work titled "10,000 Doses," by an artist named Gregory Green, which was thought to consist of twelve laboratory bottles of LSD (charges were dropped when no LSD was found, and the artwork was returned, although in somewhat damaged condition).

Somewhat less dramatic but more far-reaching, a 2008 exhibition at the Gagosian Gallery in Manhattan by appropriation artist Richard Prince brought a copyright infringement lawsuit by French photographer Patrick Cariou, whose photographs were the basis of Prince's paintings (Cariou won in district court, then lost on appeal). Until the courts come to some consensus on when borrowing is OK and when it is not—when the legal parameters of appropriation art are clarified—it may be important for artists to check with a lawyer first.

That video artist saved himself a headache by contacting the VLA. Mason noted that there were at least three major problems he faced: The first was filming inside the museum without the permission of the institution, since the museum explicitly does not allow filming or the taking of photographs. The second was making images of the artwork in the museum, without finding out who owned the

copyright to the art (probably the museum) and obtaining authorization to do so. The third was filming people who happened at the time to be in the museum galleries without their consent, thus violating their privacy. As the likelihood of obtaining permission from the museum was close to nil, and finding the strangers he filmed at the museum and getting them to sign a model release agreement was close to impossible, the lawyers at VLA could only recommend against his going forward.

A different law led Robert O'Neil, former executive director of the Thomas Jefferson Center for the Protection of Free Expression at the University of Virginia, to recommend that another artist discontinue his art project. The artist creates sculptural works using neon glass tubes, and the piece he had in mind was in the shape of a burning crucifix. "That work, regardless of the artist's intention, can be seen as a form of hate speech," O'Neil said, "and judges and juries here might find that actionable." There was discussion about creating a plaque next to the work that disclaimed any connection to Ku Klux Klan cross-burning, "but the artist just decided to back off. I don't blame him."

Not every issue is so cut-and-dried. Brooklyn, New York, feminist artist Deborah Kass exhibited a series of paintings of performer Barbra Streisand based on photographs of her in the 1983 film *Yentl* and done in multiple images in the style of Andy Warhol. "These paintings raised a number of questions," said her New Jersey lawyer Peter Skolnik. "Could she display these images without getting into trouble with Barbra Streisand, with the film studio that made *Yentl*, with the Warhol estate? Who owns the copyright to these photographs?" However, "My advice to her was to keep on exhibiting them. She had been displaying them for a decade. Streisand certainly knew of them, and the Copyright Act has a three-year statute of limitations, so I thought she was probably safe."

Another knotty legal problem arose when part-time documentary filmmaker and part-time New York City cabdriver Daniel J. Wilson began secretly recording the conversations of his passengers starting in 2011, putting together a audio montage of what was said. "When I was originally thinking of presenting this work," Wilson said, "I thought of it as being heard by a small audience—in a

gallery, for instance—and I didn't think anyone would hear about it, based on my reading of the wiretap laws." Somehow, a reporter at the *New York Times* learned of his art project and sought to write about it, "which got me really nervous. I called up lawyer friends, and they were pretty discouraging." Eventually, he contacted the Volunteer Lawyers for the Arts and was referred to one of their member attorneys, Michael Akman, who investigated the state's eavesdropping statute, finding that because Wilson was present while the backseat talk was taking place—Wilson himself kept quiet and let the passengers muse out loud—a "court is therefore unlikely to rule that you are guilty of eavesdropping under New York law." Akman recommended that Wilson avoid "the inclusion of any personal or particularly sensitive information that would make the voices in the piece more recognizable or cause them to be easily identified with any particular individual," and he concluded that the most likely violation would be of New York City's Taxi and Limousine Commission rules, possibly resulting in a fine and losing his cab license.

It is never clear how one's artwork will be received by the public or by law enforcement. Arnold Gottlieb, a lawyer with the Toledo Volunteer Lawyers and Accountants for the Arts in Ohio, noted that he helped out a photographer and local university professor who had taken nude images of his son. The photographer sent his film to a developer, who notified the police. "I spoke to the detective, explaining that they were taken by an artist, not a pedophile, and no charges were filed."

The art may be illegal, but it is the artist who gets charged. Artists need to gain an understanding what the laws are and that the laws apply to them. "There are a lot of myths out there, and just wrong information, that artists hear about or find on the internet," said Robert Pimm, director of legal services at California Lawyers for the Arts. Much of that information involves what it means to infringe on someone's copyright. "Many artists think, 'If something is posted on the internet, then it must be in the public domain.' That's simply not true. They think, 'If I give attribution, then it's OK if I use someone else's work.' That's not true. I hear artists say, 'There's a certain amount I can take from someone else's work before it becomes infringement.' The Supreme Court already has ruled that isn't true."

To help artists learn what is true, California Lawyers for the Arts holds regular seminars and workshops on legal questions and online offers webinars and podcasts to disseminate information more widely. Artists who need to speak directly to a lawyer may contact one of the group's four offices around the state (in Sacramento, San Francisco, San Jose, and Santa Monica) to set up a thirty-minute free counseling session, which can be followed up by a referral to a member volunteer lawyer who will charge a discounted rate or even offer legal services for free. The other VLA organizations around the country provide some or all of the same services for literary, performing, and visual artists. Pimm noted that "90 percent of the problems we deal with are the result of artists who didn't plan ahead"—they did something in violation of some law without first checking with legal counsel— "and it is harder for our attorneys to help them after they've gotten into trouble."

MEDIATION

An artist's work sells at a gallery, and she waits for the gallery to pay her. And waits and waits. Phone calls are made, texts and emails are sent, but no check in the mail. "Things have been a little slow of late. You'll get it, you'll get it," she is told. We all have heard that one before. But what to do? She has the gallery owner dead to rights if she wants to go to court, but she doesn't want a lawsuit or the expense of hiring a lawyer—probably paying more in fees than her artwork cost—or to spend so much time pursuing a verdict or to dissolve her relationship with the gallery. She just wants to get paid.

There is another option to either sitting around getting furious or suing the bum, called mediation, which a number of nonprofits and for-profit organizations across the country offer to those seeking dispute resolution in a manner that is faster, less expensive, and less stressful to all involved. A number of volunteer lawyers for the arts organizations throughout the United States have specific arts mediation programs that help artists (fine artists, performers, writers) settle a problem with another party, charging modest fees, and those volunteer lawyers groups that do not have established mediation programs often arrange impromptu sessions when asked. They do, because mediation is also less draining for the

lawyers who are volunteering their time and services, resolving disputes quickly and not forcing them to choose between assisting an artist and earning a living at the more profitable side of the practice of law.

"Mediation is cheap, it's private, it's fast and you don't need a lawyer," William Rattner, former executive director and now senior counsel of Lawyers for the Creative Arts, a VLA group in Chicago, Illinois, said. He added that "it makes people feel better afterward, than if they had gone through litigation or the small claims court system, and that is the whole point." That feel-better quality arises from the fact that "you get a chance to tell your story, in a more comfortable setting, just you, the other person and a mediator. It's not like litigation, where you have to answer questions. There is a great value in just venting." In addition, the other side is able to tell its version ("some people aren't fully aware that there is another side," Rattner said). Another benefit is the fact that the two sides will themselves craft a resolution and are not "reliant on a judge with a gavel."

Not every mediator at New York's Volunteer Lawyers for the Arts' MediateArts program is a lawyer, according to Amy Lehman, the organization's director of legal services, although they all have received appropriate training in mediation and have an interest in dispute resolution. For example, one mediator "is an art appraiser, and one is a musician at Lincoln Center," she said, adding that all have in-depth knowledge of practices in various arts industries.

California Lawyers for the Arts was the first VLA group to offer arts mediation, beginning its program in 1980, and currently receives over one thousand calls for the service annually, although not all calls result in a mediation session, according to Bonnie Kneitel, program director for arts arbitration and mediation services in the organization's Sacramento office. "Some things can be resolved very quickly without the need for mediation, and sometimes the problem isn't arts-related, which is a requirement for us."

In California and at other VLAs, the program works like this: Someone calls up with a problem for which they seek legal counsel, and the organization may decide that it would be best handled by the mediation staff. That staffer hears out the caller and, if the problem appears fixable by mediation, asks the person to

formally submit a request for mediation, for which there is a $25 fee to open a case. The staffer will then contact the other party to the dispute, notifying that person of the opportunity to settle the problem in mediation, explaining the process and its benefits over litigation. "The largest problem is convincing people to come to mediation," said Marci Walker, legal director at Lawyers for the Creative Arts. "It's human nature to be stubborn and to insist you are right and don't owe the other person anything or even want to discuss the matter." Not everyone can be convinced, but many are, because they do want to resolve the conflict and avoid going to court and the lingering resentments that often develop in an adversarial system of justice. As opposed to courtroom judges and even arbitrators, mediators do not render decisions but look to facilitate communication between parties to a dispute, at most offering observations and suggestions that are not binding.

Not every problem or dispute can be handled through mediation. "If the problem is an out-and-out violation, like copyright infringement, that's something we would advise taking to court," Rattner said, "but if it's a people thing, such as a gallery sold an artist's work but won't pay the artist, then we recommend going to mediation." Not paying the artist, or not doing so within a prescribed period of time, as the law requires, is a frequent problem, and mediators often recommend that a payment schedule be established.

Mediation relies upon the goodwill of each side to want to resolve the matter short of hiring lawyers, through a structured conversation they enter into voluntarily. Someone who claims that "I'm reasonable, but the other guy isn't" probably would have little faith that mediation could accomplish anything. "Sometimes, lawyers don't want to bring clients in for mediation," Rattner said, "because they don't believe in it, they want to keep the case going, they have a desire to win, win!" There are also instances when one party to a dispute wants mediation, but the other doesn't ("let him sue me"). Mediation is used, and is useful, when there is a preexisting relationship that the two sides—say, a visual artist and an art dealer—want to maintain. However, it may also be the case that "people don't want to be perceived as jerks and are willing to sit down and hear the other person out," he said. "Eighty-five percent of the time, you can get parties to mediation and, once you

establish the ground rules—no interrupting, let everyone have their say—you find that empathy kicks in. Most people want to do the right thing. People will be happy with the outcome, which you never see in court."

Mediation sessions generally last three hours, and most disputes are resolved in just one go-around, Kneitel said. Each party in a dispute pays for mediation, and the cost for one session at the California VLA is determined on a sliding scale based on one's income, starting at $25 for those with annual incomes below $25,000, $50 for those whose incomes fall between $25,000 and $50,000, ranging up to $1,000 for larger, wealthier institutions. The organization takes applicants' income levels at their word and do not ask for tax returns. "Most of the people who call the mediation program are emerging artists, and they don't have a lot of money, so we try to make the process as inexpensive as possible," Kneitel said.

Outside VLA organizations, mediation is still possible, although often more expensive. The New York Peace Institute (http://nypeace.org/), a not-for-profit agency with offices in Brooklyn and Manhattan, provides trained mediators for free dispute resolution to help "helps people get what they need, whether it's peace and quiet, family unity, a financial settlement, or just a chance to be heard." One needn't be an artist, but artists are welcome, too. On the slightly more expensive side is the New York–based Arts Mediation Group (http://www.artsmediation.com/), which charges between $150 and $250 per hour session fees for artists and between $300 and $400 for commercial enterprises, "although we use a sliding scale, so fees are often below that," said Caroline Holley, one of the group's mediators. She noted that sessions tend to last one hour at a time and that more than one session tends to be required to resolve disputes. "We find it's better to have a few sessions, with a little breathing time in between."

ARTISTS LOSE LAWSUITS

In 1987, sculptor Richard Serra launched a lawsuit against the federal government's General Services Administration for removing his *Tilted Arc*, a public artwork that same agency had commissioned several years before for New York City's Federal Building Plaza. Throughout the art world and beyond, people took sides,

some arguing along with the artist that the federal government had violated Serra's First Amendment rights (by censorship) and artistic "moral rights" (destroying the piece by taking it away from the site-specific location for which it was solely created), while others condemned the sculpture as ugly and unresponsive to the actual people who worked at the site. In the end, Serra lost his case, not because the federal district court judge decided he didn't like *Tilted Arc* but on the more straightforward fact that the contract the artist had signed with the General Services Administration contained a clause permitting the federal agency to move the piece. Much has been made of the state of public art in the United States as a result of the *Tilted Arc* controversy but, perhaps, the most important lesson for artists to draw from the outcome is that "when you sign a contract, you're bound by it," according to John Henry Merryman, a legal expert in art law.

Sometimes, it is easy for artists to forget that laws apply to them, too, such as the artist who protested when her "site-specific" public sculpture she had not been asked to create or install was removed from land she didn't own. Or the Milwaukee artist who was told by the city to remove an earthwork she fashioned on municipal property, a thirty-nine-foot-long, three-foot-high "snake"—"I thought I had permission," she said, recalling a vague conversation she had with someone she thought worked for the city. Any number of other artists have ignored municipal home occupancy ordinances that disallow businesses operated out of one's home, especially those that create considerable noise (such as metal sculpture) or traffic (selling from one's studio).

Boston-area sculptor David Phillips brought a lawsuit against Pembroke Real Estate for wanting to rearrange the placement of a series of twenty-seven small and large abstract and representational sculptures he had been commissioned to create for Eastport Park in the South Boston Waterfront District in 1999. The artist sited the individual elements where he thought they fit, but the park owners decided in 2001 to redesign the park, improving the public walkways and increasing the number of plants. The sculptures were put into storage while the changes were made and then resited where the owners thought them most appropriate. Phillips sued under the Visual Artists Rights Act, claiming that altering his

placement of the individual elements altered the entire work and that the position-ing of them was "site-specific," eventually losing in the appellate court, because that federal law "does not apply to site-specific art at all." There is no mention in the law of "site-specific," although the term is used regularly in the art field. New York City's Guggenheim Museum's website offers this definition: "Site-specific or Environmental art refers to an artist's intervention in a specific locale, creating a work that is integrated with its surroundings and that explores its relationship to the topography of its locale, whether indoors or out, urban, desert, marine, or oth-erwise." The term would appear to have all the descriptive validity as other art terms, such as "Cubist" or "mixed-media" or "assemblage," yet the validity of those words didn't get decided in court.

In another instance, sculptor Chapman Kelley brought a VARA lawsuit against the City of Chicago after the city decided to create a new bridge linking two areas of Millennium Park in 2004. That bridge diminished a wildflower arrange-ment, consisting of 66,000 square feet of plants, which the artist had created in the park in 1984 using his own money and without authorization of the city. Just as with David Phillips, Kelley won in district court but lost repeatedly in appellate court. The issue was not whether or not Kelley had been paid or commissioned to create *Wildflower Works* but, rather, the precise language of the law. The Visual Artists Rights Act defines the type of artwork covered by the statute—paintings, drawings, prints, photographs, or sculptures in a single copy or limited edition of two hundred copies or fewer (that are signed and consecutively numbered)—and the courts would not stretch the meaning of sculpture to encompass floral arrange-ments. "[G]ardens are planted and cultivated, not authored," the Seventh Circuit Court of Appeals decided in 2011.

If there is a moral to all this, it is that artists are obligated to follow the law just like everyone else. Calling something art does not make it immune from local, state, and federal statutes; claiming that a law that doesn't include the term "site-specific" still protects site-specific art doesn't make it so.

Certainly, fine artists tend to be more sinned against than sinning. Since they usually are in a weaker economic position than collectors, museum officials, and art

dealers, artists are more likely to be taken advantage of by the people on whom they are dependent. Bringing a matter to court—such as nonpayment, copyright infringement, willful destruction of artwork, or any type of breach of contract dispute—can be so expensive, time-consuming, and damaging to the very relationships artists look to cultivate and maintain that many do not fully pursue their rights. "So many artists have clear claims but can't afford to bring them," said Ann Garfinkle, a Washington, DC, lawyer who has represented visual artists.

Few of the claims that fine artists bring to any of the Volunteer Lawyers for the Arts organizations around the United States ever get to court. On occasion, a pro bono lawyer for Volunteer Lawyers for the Arts will send a threatening letter to someone infringing on the rights of an artist, which often has the desired effect. Artists with claims that can only be litigated usually are directed by the VLA attorney to outside legal counsel, who may or may not choose to pursue the matter. The main factors in that decision are, first, how much money is involved in the dispute and the likelihood of winning. "It costs a lawyer between $100,000 and $200,000 to pursue a case and an appeal," said Scott Hodes, a Chicago lawyer who has represented a wide assortment of visual artists. "If the lawyer doesn't feel he has a slam-dunk case, he won't take it," noting that too few artists have the financial resources to be able to pay if they lose.

There have been numerous instances in which artists have brought legal actions and won, which enhances the chances of other artists in similar situation to pursue their rights successfully. (Many more artists have had their lawsuits settled out of court, and sometimes the terms of the settlements include a "gag order" on publicizing the outcome, which speeds the process along for the injured artist but leaves other artists in the dark as to their rights.) As instructive as an artist winning a major case are instances in which artists do not prevail.

One lesson that artists often need to learn is "get it in writing." Artists may have understandings with their dealers—perhaps tacit or even stated, but rarely written down. When there is a dispute, however, both sides may claim very different understandings, which a written agreement would have alleviated. The costs of deposing, or having lawyers interview, parties to the dispute would be lessened

significantly. A second element is that artists should read the agreements they sign: "Artists are handed a contract, and someone tells them what it means or says that it is a standard industry contract," according to Elana Paul, former director of VLA of New York. "After there is a problem, the artists come to Volunteer Lawyers for the Arts, waving the contract and claiming that the dealer violated their agreement. We read over the contract and then have to tell the artists, 'You didn't sign what you thought you signed.'"

Some contracts, especially those in which an artist is commissioned to create a work, such as a portrait or public artwork (mural or sculpture), may need to be explicit about every possible contingency. Sculptor Howard Ben Tre, for instance, had never mentioned to the owner of a building in Baltimore, Maryland, who commissioned a glass sculpture for the lobby in the early 1990s that cracks generally appear in his pieces but would not compromise the work's structural long-term integrity. However, on seeing the eventual cracks, the building owner became upset, leading to an arbitration that forced Ben Tre to remove the work at his own expense and return the money paid to him. Similarly, in 1980, sculptor Robert Arneson was asked by the San Francisco Arts Commission to create a bust of Mayor George Moscone, who had been assassinated two years before by a member of the city's board of supervisors, whose legal defense for the shooting noted his alleged addiction to Twinkies. Arneson's maquette was approved, but the final work, when it was unveiled in late 1981, contained a variety of additional elements, such as the suggestion of bullet holes in the pedestal, bloodlike splatters of red glaze, and the inclusion of the words "Bang, Bang, Bang" and "Twinkie." The Arts Commission rejected the work and refused to pay him on the basis of a breach of contract (the bust was later purchased by an art dealer). It was common practice for Arneson to write words on, and make last-minute alterations, to his work, but the Arts Commission was unaware of the artist's practice and neither the artist nor his agent had informed Commission members in advance.

Another instance in which an additional provision or two in a contract might have precluded a legal action occurred three times with sculptor Athena Tacha. She has received numerous commissions for public artworks, but the

contracts never contained a clause requiring the commissioning bodies to provide routine maintenance or make any needed repairs. Works at the University of South Florida in Fort Myers and at Hyde Park in Cincinnati were destroyed after they had been allowed to rust and become an overall hazard to the public. A third work, in Sarasota, Florida, was similarly permitted to deteriorate, but a threatening letter from Tacha's lawyer, Ann Garfinkle, at least brought a promise to repair the piece. "Letting a work of art deteriorate to the point that the owner can declare it hazardous is a way to get around the provisions of the Visual Artists Rights Act," Garfinkle said. Because "there is no duty to maintain artwork under the Visual Artists Rights Act, you have to negotiate for that in the contract."

Like everyone else, artists cannot become overconfident about their chances of winning a lawsuit ("litigation is an uncertain process," Paul said, "where you may be confronted on the other side by a completely different set of factors, real, invented or imagined") or greedy about what they are owed. In the fall of 2005, Seattle-based glass artist Dale Chihuly brought a lawsuit for copyright and trademark infringement against Bryan Rubino, Robert Kaindl (another glass artist with whom Rubino collaborated), and a number of galleries that sold their work, claiming that the two had plagiarized his work. Eventually, he dropped the suit (a countersuit by Kaindl against Chihuly was also dropped in the agreement), stating, "If I had to do it again, I probably wouldn't." Dale Chihuly's experience proves that the old press agent's mantra—"There is no such thing as bad publicity"—is sometimes untrue. The glass artist's lawsuit brought him a great deal of unwanted attention, for his legal action, his business ethics, and generally for his place as an important leader in the glass art movement. The lawsuit itself was reviled by newspaper and online columnists as a case of bullying (the big rich artist using the law to beat down the competition).

COPYRIGHT

Alexander Calder made it clear what he thought of copyrighting works of art. Somewhere in the South of France, he constructed a large metal cow defecating

small c's with circles around them—the universal copyright symbol. Ironically, it is the only work the artist ever copyrighted, but it is hardly an endorsement.

Perhaps he came to regret his stance when one uncopyrighted sculpture, created for the city of Grand Rapids, Michigan, was reproduced as an image on government stationery and also on the side of the city's fleet of garbage trucks. Grand Rapids' city fathers were clearly proud of the work and viewed it as a civic logo, but their use of it proved embarrassing for the artist.

Many artists see copyright as a commercial issue, not something for fine artists, and don't bother finding out more. Of course, if artists ignore copyright, so do many other people. Every year, entrepreneurs make unauthorized use of artists' work in order to create prints, posters, clothing, dishes, pillows, rugs, and bath towels, even other works of fine art, with their imagery, and many artists find themselves unable to stop this or even to receive any of the money that others are making with their imagery. Furthermore, unauthorized use of imagery may reflect badly on the reputation of the artist when, for instance, colors are different from the original or shapes are distorted.

Copyright is the right to reproduce one's own work, and it comes into being as soon as the artist completes their work. However, problems may occur when the piece is "published," that is, when it leaves the studio on loan, consignment, or is sold. At this time, the copyright notice should be attached to the work, looking like this:

<div align="center">© Jane Doe 2022</div>

The spelled-out "Copyright" or abbreviated "Copr." is just as good as ©; initials or some designation by which the creator is well known ("Mark Twain" for Samuel Clemens, for instance) may be substituted for one's full name; the year, which can be spelled out (Two Thousand and Twenty-two) or written in Arabic (2022) or Roman (MMXXII) numerals, or even something more eclectic (2K+22), refers to the date the object is first published and may only be omitted when the work is a useful article, such as a postcard, dish, toy, article of clothing, stationery, or piece of jewelry.

Most artists are reluctant to deface or, at least, distract people from their work by sticking a copyright notice on it and, under the old Copyright Law of 1909, artists were obliged to put the notice in the most conspicuous place possible in order to assure the public that copyright was claimed. However, under the Copyright Law that went into effect in 1978, artists are permitted maximum discretion in placing their copyright notice, which includes the back of a canvas, frame, or mat, or the underside of a sculpture. The onus is now on the potential infringer to determine whether or not the work is copyrighted. Also, since March 1, 1989, when the United States officially joined the international Berne Copyright Convention, omission of copyright notice does not result in a loss of the copyright privileges. However, notice should still be placed on works so that maximum damages can be obtained from infringers.

The 1978 law clarified that copyright ownership and sale of the physical work of art have been separated. All a collector buys is the work itself. The reproduction rights remain with the artist. If the buyer wants the reproduction rights as well, they must now bargain for them, and smart buyers sometimes do just that.

The copyright is potentially worth money if, for instance, the image is used for prints, posters, tapestries, or whatnots that are sold to the public. A painting may sell for $5,000, but an edition of one hundred prints made from that image, each selling for $100, would bring the copyright holder $10,000. The copyright may be worth more than the original work (for which the artist received a onetime payment), and artists such as sports painter Leroy Neiman and Art Deco stylist Erté have become known more from prints than from their oil paintings.

Copyright confers several exclusive rights to an artist for the life of the creator plus seventy years: The first is the right to reproduce the copyrighted work; second is the right to make derivative works (making a motion picture from a book such as *Gone With the Wind*, for instance, or a poster from a sculpture); third is the right to control the first sale of a work (of course, a buyer of a legally made copy may resell it); the last is the right to display the copyrighted work. The owner of a work has the right to display it to people who are physically present for the display,

but people and institutions that borrow works have no right to display them without permission from the copyright owner. According to Paul Goldstein, a copyright expert at Stanford University Law School, "the copyright notice is like a no trespassing sign, reminding people that the work is protected, and that helps to take away the innocence defense."

Artists may bring legal action against infringers. If the case is decided in the artist's favor, the infringer would be stopped from continuing to produce and distribute the copies, and a federal marshal may be assigned to seize and impound the infringer's unauthorized copies; the infringer would pay the artist the actual dollar amount of damages and profits; the infringer may be ordered to pay the artist additional (statutory) damages of between $200 and $150,000 for each infringed work; and the infringer would be required to pay all attorneys fees and court costs.

There is "fair use" of a work of art, which usually refers to images that accompany a news article, parody, or critique, or to images that may be used in teaching. Fair use does not lessen an artist's ability to earn money or control the use of the image.

Artwork can be registered with the federal Copyright Office (Library of Congress, Washington, DC 20559–6000, 202-707-3000, www.copyright.gov). Registration prior to an infringement or within three months of first publication allows the artist to have all legal fees and court costs paid by the infringer at the discretion of the copyright case judge. One may download an application (http://www.copyright.gov/forms/formva.pdf), which should be filled out and returned with a check for $45 along with a copy of the work (two copies, if the work has previously been published). The Copyright Office wants online applications and the fees are much higher if paper forms are used. A cancelled check by the Copyright Office ensures that the work has been registered, and a copyright certificate will be sent out within four months. Works in a series (up to ten) may be registered as a group for a single $85 fee. Prices change periodically, and there are different fees for works that have been published prior to registration. A useful source of current information is https://www.copyright.gov/about/fees.html.

COPYRIGHT SMALL CLAIMS

As noted above, the US Copyright Office more recently has established a Copyright Claims Board, consisting of a board of three judges within the US Copyright Office to adjudicate relatively minor instances of copyright infringement—small claims. Damages would be limited to $15,000 for each infringed work and $30,000 total per claim. An alternative to the more expensive and adversarial civil litigation, these courts are more like mediation, requiring the consent of both sides to proceed, and defendants have the right to opt out of proceedings within sixty days and resolve the matter in a federal courtroom. Just as with other claims of copyright infringement, defendants would still need to have registered their artworks or have filed an application with the Copyright Office to register the work at issue either before or simultaneously with filing a claim and provide proof of that registration to the Claims Board judges.

David Steiner, a New York City lawyer who frequently represents artists on copyright claims, "including ones with relatively limited potential for damages," noted that the majority of instances of copyright infringement occur online nowadays and fit within the monetary parameters of the Copyright small claims court. Artists and photographers regularly post images online, perhaps on their own websites or on a social media site, such as Instagram, as a means of publicizing their work, and some of those who find those images assume that they are free to be downloaded and used. "For instance, a photographer logs onto Google and does an image search and finds that one of his images has been used on a fashion site. No one asked the photographer's permission or is paying that person a royalty."

The voluntary approach has its proponents and detractors. Irina Tarsis, founder and managing director of the Brooklyn–based Center for Art Law, said that "more often than not, artists do not have the courage, resources, or time to bring a suit to court, and the small claims court may provide for an alternative, more accessible forum to that end." She added that the forum "would allow all original content creators (street artists, photographers, and other visual artists) to be able to challenge unauthorized reproduction of their works by all kinds of infringers."

However, the opt-out provision has disappointed others, as it appears to take the teeth out of the enforcement mechanism. The legislation "doesn't go far enough as a defendant can opt out," Washington, DC–based attorney Joshua J. Kaufman said. "Therefore, I imagine most infringers know that, if they opt out, the artist won't be able to pursue it in regular court" because of the cost of litigation and "simply won't agree to it." Additionally, the aim of reducing costs by streamlining the process also lessens certain safeguards built into traditional litigation, such as the entitlement to discovery from the other side, the public nature of the record, and the right to appeal. That may make the small claims copyright court seem less fair to those accused of copyright infringement, resulting in their decision to opt out.

The opt-out provision of the CASE Act may well force artists once again to go through the traditional court system but, as Steiner suggested, "I would expect courts to take an infringer's opting out into account when determining damages or making other rulings, which may discourage the practice."

TRADEMARK PROTECTION FOR ARTISTS

When is imitation not flattery? When the purpose of the imitation is to confuse the public and to undermine a better-known artist's market. Some legal decisions have established a relatively new area of art law, protecting the trademark qualities of artists' work, such as the style and overall impression of the art.

Trademark law is usually associated with manufacturing, protecting a company's logo or other distinct mark, although it has been applied to the arts as rights of publicity, such as the face, name, signature, or endorsement of the artist. However, legal judgments have also extended trademark protection to "words, symbols, collections of colors and designs." Trademark infringement is different than copyright infringement, as the artwork is not copied exactly or copied with only minor changes made (those are copyright issues), as it refers to aping significant elements of another artist's unique style.

Registering a trademark with the US Patent and Trademark Office costs $250.

Artistic style itself is not copyrightable—neither, for that matter, are perspective, color, medium, use of light, and subject matter—but the "feel" of the work is subject to trademark (in legal parlance, trade dress) protections under the Lanham Act. That federal statute, a law governing unfair competition, prohibits one individual or company from offering products or services that are confusingly similar to those of a competitor.

There is no fixed point when one may claim that one artwork has been copied from another, and some judge or arbitrator will simply have to look at the two pieces for similarities that go beyond influence and conventions of the genre. In the legal cases that have been decided, compelling evidence has revealed specific intent to imitate another's work. Two of the most noted decisions have been for musical performers—Bette Midler and Tom Waits—who sued Ford Motor Company and Frito-Lay, respectively, as well as their advertising agencies for hiring singers whose voices were very similar to Midler's and Waits's to sing songs identified with the noted performers for product commercials on television. Neither performer's name was mentioned, nor were the actual singers identified. However, as neither well-known performer wanted to endorse these or any other products, the sound-alikes were found to have infringed on their trademarks, and the companies as well as their advertising agencies were ordered to pay substantial settlements and legal fees.

In the visual arts, there have been a number of decisions. One of these, in 1992, involved an Israeli artist, Itzchak Tarkay, whose painting was found to have been copied stylistically and thematically by another artist, Patricia Govezensky, at the bidding of an art distribution company, Simcha International. "At the trial," said Sondra Harris, one of the attorneys representing Tarkay, "defendant's counsel mixed up works by Tarkay and Govenzesky. They were that close." There were no awards or damages assigned, she added, as "the company basically went out of business and, when Govezensky went back to painting, her work was in a completely different style."

Another case, decided in 1994, concluded that a Florida art dealer named Philip Wasserman persuaded a Florida sculptor, Dwight Conley, to create works in

the unique "fragmentation" style of Paul Wegner. In that latter case, all of the waxes and molds for the offending Conley sculptures were ordered destroyed and the completed pieces turned over to Wegner as well as payment of costs, damages, and attorneys' fees.

"Consumer confusion" may arise when similar-looking works are exhibited to collectors who do not immediately look for the artist's signature, according to Joshua Kaufman, who represented Paul Wegner. "Within a span of one week, Wegner received calls from three of his collectors who asked him, 'What happened to your work? It looks like it deteriorated.' They had seen Conley's imitations of Wegner's work from a distance and just assumed it was Wegner's. That can affect an artist's reputation as well as sales, if people think the quality has gone downhill."

Damage awards result from the fact that imitators' work is usually priced lower than that of the better-known artist's, which also may affect sales.

Despite the degree to which artists attempt to find a unique mode of expression, similarities between artists' work, especially those working within the same genre or even at the same time, are bound to occur. Oliver Wendell Holmes once wrote that "literature is full of coincidences which some love to believe plagiarisms. There are thoughts always abroad in the air which it takes more wit to avoid than hit upon."

If so much art didn't look alike stylistically, at least to the nonexpert, there would not have been a need for the decade-long Rembrandt Project, which de-attributed 90 percent of the paintings around the world called Rembrandts. Museum labels in general tell the story of failed attempts at determining who painted which picture. This painting is the "School of" some Old Master, that picture was created by "Follower of" someone else. A designation of "Workshop of" so-and-so gets one closer—the more-famous artist may at least have seen the work or even participated in its creation in some minor way—but the creator's identity still remains unknown. Those disciples and followers were not accused of fraud, unless they intentionally attempted to sell their own paintings as the work of the better-known artists. The fact that many artists did not sign their works as well

as the practice of apprentices learning to create in the style of their master artists resulted in headaches for later art historians.

Nowadays, deciding when one contemporary artist imitates the feel and impression of the work of another is not up to art experts but to judges of the legal system. There may be some factual evidence to rely upon: Did Artist B ever see the work of Artist A? When were the respective works made? Will someone admit to being told to stylistically copy another's work? Are there certain idiosyncrasies or errors (misplaced thumbnail, for instance) in common? The strength of Paul Wegner's case rested on "sworn affidavits by three people who were on hand when Wasserman brought photographs of Wegner's work to Conley and said 'make your work as close to these as you can,'" Joshua Kaufman said. However, in less clear-cut situations, much relies upon a judge finding a striking visual similarity between two works. In the Tarkay case, according to the written decision, the court examined "the color patterns and shading of the Tarkay works, the placement of figures in each of the pictures examined, the physical attributes of his women, the depiction of women sitting and reclining, their characteristic clothing vis-a-vis those portrayed by Patricia [Govezensky]" to find that "consumer confusion is a likely result."

The courts apply two main tests for trademark cases in determining whether or not one artist may have stylistically copied another: The first is establishing that the allegedly copied work is identified by the public with the particular artist (in legal parlance, the art has acquired a "secondary meaning"); the second is proving that the imitation is likely to cause confusion in the market. "What better for showing probable confusion than actual confusion," Kaufman stated. "Three people called up Wegner in one week."

COPYRIGHTED AND TRADEMARKED SUBJECTS

An artist sets up an easel at Times Square in New York City and paints a picture. Other than a passing thought as to muggers and pickpockets, the artist believes he has found in urban bustle a safe subject matter. But legal worries enter in: Am I infringing any trademarks by including company logos and advertising slogans, of

which there are hundreds in Times Square, in the painting? Should the building owners and their architects be asked permission to include their buildings in the picture? If an image on a billboard, of which there are many in Times Square, is included in my painting, have I violated the copyright? If an individual on the street is recognizably portrayed in the picture, have that person's rights of privacy or publicity been violated? Should a lawyer have accompanied me to Times Square?

Lawyers hold differing opinions on these questions, and the issues are complicated by the way in which the finished artwork may be used and distributed and in what form. An original painting, for instance, has greater First Amendment protections of free expression than a large edition of prints or images scanned onto limitless numbers of calendars or T-shirts. Artist Andy Warhol did not seek—nor did he need to seek—permission from the Campbell's Soup Company for his famous 1962 painting of a can of Campbell's soup because it was a non-infringing use of a trademarked label, created by Warhol in an artistic medium and displayed in an art setting. "The public was unlikely to see the painting as sponsored by the soup company or representing a competing product," said Jerome Gilson, a Chicago trademark attorney. "Paintings and soup cans are not in themselves competing products."

Freedom of commercial speech, on the other hand, is more restricted than artistic speech. "If Warhol had put the soup can image on T-shirts or greeting cards, he would have had more of a problem in defending a trademark infringement lawsuit because they aren't traditional artistic media," said J. Thomas McCarthy, trademark expert at the University of San Francisco School of Law.

He added that, by virtue of the volume and distribution of the T-shirts and greeting cards, Campbell's might have argued, "what's really selling the product is the product name rather than the artist's name or image. Therefore, people might have assumed that Campbell's authorized Warhol" to make T-shirts and greeting cards.

Many images are copyrighted or trademarked, and the legal use of them by artists is a matter of considerable debate; however, specific lawsuits are resolved not by an adherence to general principles but on a case-by-case basis. In one noted lawsuit, the New York Racing Association brought a trademark infringement

lawsuit against artist Jenness Cortez, who painted horse-racing scenes, many of which take place at Saratoga Race Course in Saratoga Springs, New York. The New York Racing Association has federally registered trademarks on the words "Saratoga," "Saratoga Racecourse," "Travers," and "The Summer Place to Be," as well as for the logos for Saratoga and the racing association itself, all of which have appeared in one form or another in Cortez's work. Charging trademark infringement, the racing association demanded that she sign a licensing agreement for the use of these trademarked words and logos on the prints, greeting cards, and T-shirts or cease using them and the horse-racing scenes that suggest them.

The racing association claimed that her work gives the public the false impression that the organization sponsors or authorizes her work and undercuts the licenses signed with the fifty or so other artists and merchants selling horse-racing memorabilia. The artist countered that her work represented the free expression of her ideas, and that the words and logos used are merely descriptive—that is, indicating a time and place—rather than suggesting sponsorship. She won, although the process took years and cost tens of thousands of dollars.

If the trademark is part of a street scene, the public is more likely to be warned that the image is something other than just a product. If there are a number of different companies' trademarks in an image, such as a street scene at Times Square, the public is unlikely to associate the picture with any one company.

In another victory for artists, this in 1999, the Cleveland-based Rock & Roll Hall of Fame lost its attempt to prohibit Chuck Gentile from selling posters based on his photographs of the facility. Three years earlier, the Hall of Fame & Museum had sued the photographer for infringing its trademark by selling posters of the I. M. Pei–designed building, and Gentile was initially ordered by a district court to destroy all of the works. However, a higher court overturned that decision, later affirmed by the US District Court in Cleveland, claiming that "when we view the photograph in Gentile's poster, we do not readily recognize the design of the Museum's building as an indicator of source or sponsorship. What we see, rather, is a photograph of an accessible, well-known, public landmark."

The legal test for trademark infringement is what the "ordinary person" is likely to believe, and there is no rule of thumb concerning how much of the image may be taken up by the trademark before an artist is apt to lose an infringement lawsuit. "Is the trademark an incidental use as part of the scenery or so prominent that someone might think the trademark owner had something to do with the picture?" said William M. Borshard, a New York City trademark lawyer. "The principles of these laws are clear and easy to state, but the application of those principles to fact is not at all so clear."

Borshard added that difficulty in knowing in advance what may be deemed trademark infringement is compounded by the fact that judges generally have different beliefs as to how much protection a trademark deserves. "On one side, there is the view that trademarks help consumers distinguish between products, which is helpful in our free enterprise economy," he said. "The other view is that trademarks are anti-competitive, in that they cause consumers to behave irrationally, selecting one product over another when both are identical. Judges take one side or another on the issue of trademark. The 'ordinary person' turns out to be the judge, and you don't know what kind of judge you'll get on any given day."

Just as a trademark may find its way into an artist's work, so might a copyrighted image, such as a billboard image or someone else's artwork. In general, an artist cannot use copyrighted subject matter unless as "fair use," that is, as commentary or criticism. Just as with trademark infringement, the legal test is whether or not an ordinary person would believe that mere copying has taken place.

ARTISTS' MORAL RIGHTS

As noted above, the Visual Artists Rights Act of 1990 represented a sea change in the legal protections afforded to artists by the federal government. The law is based on legal concepts established in French law for decades, including the right to determine when a work has been completed (first brought to court by James McNeill Whistler in 1900, later tested by the heirs of Georges Rouault); the right to always have one's name credited with the work (including advertisements); and the

right to prevent one's work from being shown in a way that might harm the artist's reputation (tested in the French courts by painter Bernard Buffet in 1962).

One of the first highly publicized instances of intentional distortion of a work of art occurred in 1958 when a black-and-white mobile by Alexander Calder, displayed in a building at the Greater Pittsburgh International Airport, was turned into a stationary sculpture and painted the city's official colors, green and gold. A few years before that, sculptor David Smith condemned a purchaser of one of his painted metal sculptures for "willful vandalism" for removing the industrial green paint, and in 1980, the Bank of Tokyo outraged the art world when it removed a 1,600-pound aluminum diamond-shaped sculpture by Isamu Noguchi that hung in the bank's New York City headquarters by cutting it into pieces.

The problem hasn't been wholly confined to sculptors, as a mural by Arshile Gorky at the Newark (New Jersey) Airport was subsequently whitewashed, and a painting by Pablo Picasso was cut into numerous one-inch-square pieces to be sold through magazine advertisements as "original" Picasso works of art by a couple of entrepreneurs in Australia. One of those Australians commented at the time, "If this works, we're going to put the chop to a lot of Old Masters."

Mutilation or destruction of an artist's work (for which the artist owns the copyright) is now considered an infringement on copyright, with artists able to sue for both compensatory (out-of-pocket) and statutory (up to $20,000) damages as well as actual damages. Those actual damages refer to harm caused to an artist's professional reputation by the destruction or distorted appearance of their work.

This kind of copyright infringement would not be a criminal violation—the copyright law does include possible jail terms and fines for instances of commercial exploitation, such as bootleg films, books, or records—since the damage or destruction of artwork is seen as an area for civil litigation. An artist must hire an attorney to bring action against someone altering or destroying their creations.

The general term of copyright protection does not apply to the moral rights created in this new federal law. Instead, the moral rights last for the life of the artist, the same period of coverage for invasion of privacy, libel, slander, and defamation of character. One aspect of the law of particular interest to muralists and wall

sculptors concerns artwork that is attached to a building, and there are special rules that balance the rights of artists and property owners. The owner of a building on which artwork is attached is required to notify the artist that the work should be removed, if it can be removed. The building owner is to write to the last known address of the artist or, if there is no response, to the Copyright Office in Washington, DC. A special department within the Copyright Office has been created by the Visual Artists Rights Act for the addresses of artists, and artists are advised to send a current address there.

Once the artist is notified that the building owner wishes the artwork removed, the artist has ninety days in which to remove it (at their own expense), at which point the artist regains title to the piece. If the artist fails to collect the artwork, or it cannot be physically removed, or the artist cannot be located, all rights under the Visual Artists Rights Act are negated.

WAIVING ONE'S RIGHTS

The law in Missouri is quite clear: If an art dealer sells an artist's work, the dealer must pay the artist what is owed and not use the money for any other purpose . . . except, however, if the artist says it's OK to do so. The exception is known as waiving one's rights, and it is explicitly stated or implicit (not forbidden) in the artist-dealer consignment laws in the thirty-four states and District of Columbia that have enacted them. "An artist," according to Missouri's 1984 law, "may lawfully waive the provisions . . . if such waiver is clear, conspicuous and in writing, and signed by the artist who is the consignor."

The ability to waive one's rights is not uncommon in the law, and waivers are written into numerous municipal, state, and federal statutes, as well as private agreements. (Almost every ski resort, for instance, requires skiers to sign a document that concludes: "I have read and understood this release prior to signing it, and I am aware that by signing it I am waiving certain legal rights which I or my children or my or their heirs, next of kin, executors, administrators, assigns, and representatives may have against" the resort operators.) It might seem counterproductive for legislators to pass a law that corrects a problem, only to include a clause

that allows the law to be circumvented, if both sides agree. However, practical considerations enter in: In some cases, allowing such a clause may have been the only way that enough legislators could be brought to support the statute. Allowing certain provisions in a law to be waived may also provide greater flexibility as the two parties to an agreement negotiate.

The Visual Artists Rights Act allows artists to waive their rights under the law; in the case of public art commissions, waiving those rights is often a precondition for signing a contract with a commissioning agent. Economic pressure, therefore, is a principal reason for artists to sign away the rights that others have worked hard to give them, the result of an unequal balance of power.

Recognizing the imbalance of what is right and what is powerful, some state laws contain a clause specifically prohibiting the signing away of rights. Illinois's 1985 Consignment of Art Act gives voice to the concern for artists in standard legal parlance: "Any portion of an agreement which waives any provision of this Act is void." Still, the seemingly ironclad law provides dealers with an out: The amount due an artist after the sale of artwork "shall be paid to the artist within thirty days of receipt by the art dealer unless the parties expressly agree otherwise in writing." Other states with no-waiving clauses also appear to make allowances for what had previously been outlawed if both sides provide a written amen. "A consignor may not waive his rights under this act unless the waiver is clear, conspicuous and in writing," New Jersey's 1987 Artworks Consignment Act declares.

There are times when artists themselves look for others to sign away their rights. When artists hire someone to photograph their artwork, the photographer technically owns the copyright to the pictures taken, as well as the negatives. Regardless of how much advice and direction an artist provided in setting up the shoot, even paying for the photographer's time and materials, and despite the fact that the photographer could not have taken the pictures without the permission of the artist, all the artist has purchased is a print (or slide) for personal use. The artist continues to own the copyright to the underlying artwork but could not make duplicates of the photograph or distribute them without the permission of the

photographer, and the photographer could require the artist to license the image or set additional charges based on the use of the image.

The likelihood of artists and fine art photographers finding themselves locked in a legal contest is slim, but it would be eliminated completely if both sides signed an agreement that stipulates all of the uses the artist plans to make of the image (such as posters or prints, postcards or brochures, and T-shirts) in exchange for a negotiated payment. The artist might also seek the photographer sign away ownership of the copyright, in order that unspecified uses of the photographic image could take place without needing to renegotiate.

A similar situation arises when an artist works with a print studio or a sculpture foundry to create an edition. The studio or the foundry technically owns the copyright to the edition; even though the prints or sculptures are based wholly on an artist's copyrighted image or model, the technical know-how of the people involved in their creation has been seen by the courts as adding an element of origi-nality, establishing a separate area of copyright ownership. As copyright owners of what is called a "derivative work," the studio or foundry enjoys the traditional right to reproduce, display, and sell the works. However, as a point of law, the derivative work cannot be completely separated from the underlying art, requiring the printer to obtain permission from the artist to fully use the privileges of copyright: The studio or foundry gains a right it cannot exercise. Still, the ownership of that copyright matters. If the copyright of the derivative work were infringed and the print studio or sculpture foundry did not pursue a legal action, the image could slip into the public domain, greatly damaging the artist's economic interests. The artist would be reliant on the studio or foundry to pursue a case where it did not have its own financial interests. James Silverberg, an attorney with the Washington, DC, law firm the Intellectual Property Group, stated that the matter is clarified and simplified when the artist is the sole copyright owner for both the copies and the underlying artwork. He noted that the written agreement between the artist and studio or foundry should include a statement, such as, "The artist shall own all rights, title and interest into the copyright subsisting in the work produced for the artist by the printer."

As a practical matter, it is unlikely that a print studio or sculpture foundry would look to undercut the artists on whose patronage they rely—a bad reputation could destroy its business. More likely than a copyright dispute would be a breach of contract; for instance, if the artist orders the creation of an edition from the studio or foundry and does not pay, the studio or foundry may be permitted to sell the works that it produced in order to earn the money it is owed and, perhaps, also sue the artist for the difference, if the sales do not generate enough income.

Again, the contract between the artist and print studio or sculpture foundry should stipulate either that copyright of the derivative work is reassigned to the artist or that the technicians are employed on a work-for-hire basis. Such a clause would probably not require any additional payment, while providing clarity to the question of who owns copyright of the actual work.

A final area of remote but potential concern is in the area of joint authorship of a work of art. Many artists use assistants who participate in the creation of the actual artwork, and these helpers may have reason to think of themselves as coequal authors of the piece, even if their contribution was not equal. As such, they are also co-owners of the artwork's copyright, with the power to license and distribute it. However, a simple letter of agreement between the artist and assistant, signed by both, should clarify that the assistant is employed on a work-for-hire basis and that copyright vests with the artist.

7

From School to the Working World

What do fine artists do when they graduate from art school? Teach? Sell their art? Win state and federal grants and fellowships? Dream of better things while working in a company's mailroom? Certainly, they can keep each other company since there are so many of them. The US Department of Education identified roughly 91,000 students at private colleges and universities who earned baccalaureate degrees in 2017 in the visual arts. (The forty-three member schools of the Association of Independent Colleges of Art and Design reported approximately 27,000 graduates in 2010.) It is unlikely that the art market quickly expanded to accommodate and support this throng. It is even less likely that many, if any, of these graduates found teaching positions, since (according to the College Art Association) schools in the market for experienced artist-teachers received, on the average, 150 to 200 applications for every job opening.

What degree-holding art students do right after completing school is not documented, although there are many anecdotal stories, some happy, others less so. While in school and certainly not long after, artists should begin to think about a second career. In effect, there are two not-necessarily-related problems for the recent graduate: The first is to earn a living, which may be easier for younger people without children, spouses, or parents to support (perhaps themselves

supported by parents) than for those with dependent family members and possibly student loans to repay, and the second is to begin building a track record of exhibitions and eventual sales. The process of working at a job often takes artists away from their art, sometimes permanently.

FIRST STEPS

Art school graduates need to conduct a skills assessment for themselves, to see what they are able to do and try to find a job in it. In some instances, the work artists find has little relationship to their art interests. For instance, painter and muralist Dan Concholar's first job out of art school in 1961 was as a janitor "because there were no illustration jobs." Eventually, he began to find work as a sign painter and a display artist, later teaching courses to students at art schools.

Sooner or later, Concholar noted, artists find a type of work that suits their styles: "Sculptors tend to be macho, and many of them do sheet rocking or other physical kinds of work. It may be physically exhausting, but you can do it mechanically and it's not a drain on your creative energy. A job with set hours also gives you a steady income and time to work on your own art."

While non-art-related jobs may not impinge on an artist's personal work, they do take time, energy, and commitment if the job will be a long-term one. Can the belief in oneself as an artist first and something else second last indefinitely? Too often, within five years after graduating from art school, most people are not doing their art anymore. The commitment to a job makes Sunday painters of a lot of talented artists.

A job that does not somehow refer to one's art training may lead artists away from art permanently. Some may say that they plan to take ten years to make some money so that they can be an artist. However, the further away they get from their art, the more likely they will feel out of it or too old and not have faith in themselves to want to start again. However, even a job that is related to art—for instance, a theater scenery designer or an art therapist—will occupy time and energy, perhaps edging an artist in an unwanted stylistic direction. (Why do all my paintings look like theater backdrops?) Whether or not their jobs are related to art, artists

may drift away from their own work unless they stay in contact with other artists and the art world in general. It makes sense to join a local, state, or national artists' club or society or association, which builds a network with others. Many of these groups also send out newsletters, providing information on exhibition opportunities and other artist news. Subscribing to an arts magazine, teaching art at a local arts center on weekends, and even taking a class at a local college also helps keep one involved. Another option is to rent space in an artists' studio building, which is a built-in community of artists. Even with a paycheck job, artists still have artmaking going on around them, and that tends to push people to keep doing their own artwork. Otherwise, it can be very hard to work alone in your apartment.

Being an artist means developing careers on two tracks: The first is finding a paying job, and the other is creating a presence in the art world. In time, perhaps, the art may become the entire source of income, or art sales may supplement an income; for some, the job and the artwork may be more closely related so that the two tracks do not seem disparate activities.

WORKING AS AN ARTIST'S ASSISTANT

In the course of a normal workday, Sharela Bonfield may order supplies, supervise interns, clean up the workspace, answer the telephone, set up meetings, create PowerPoint displays, fill out and file paperwork, and administer the archives as well as the computer database and "whatever else needs to be done." It is difficult to say exactly what Bonfield's job is, because she has so many responsibilities, but her title is clear enough: Artist's assistant. A graduate of the Maryland Institute College of Art, Bonfield, a fiber artist, works three days a week for Brooklyn, New York, sculptor Lesley Dill and two days a week for installation artist Whitfield Lovell.

If her job sounds a bit all over the board, the job description doesn't offer much help. The want ad that Lesley Dill placed calls for someone who is "talented, cheerful, peaceful, and hard-working," and the only specific requirement is "strong wrists," because the assistant will be "cutting flat metal and wire." The "peaceful" part actually is pretty important, since "we work in total silence," Dill said. Big

talkers tend to dominate the room, "and I prefer a democracy." Besides, she believes, most talk is distracting and full of the woes besetting her assistants' lives. Noting that "I'm not mom, I'm not a shrink," she asks those who work for her to "leave their troubles at the door and view the studio as the focus of all their attention and energies."

Some of those troubles, of course, may be the high price of living in New York City, where a minimum wage salary for Dill's assistants is apt to lead to hardship ("I don't give raises, so people just move on"), but her assistants aren't complaining. They see being an assistant as an entry into the commercial art world, a lesson not taught at art school. "There are a lot of connections to be made with artists and dealers, and in the art field you can never have too many connections," said Kyle Holland, a graduate of the Memphis College of Art and another of Dill's part-time assistants.

A lot of the jobs that Holland and Bonfield perform as artist's assistants has relatively little to do with their academic training as artists, although it does sometimes happen that they work directly on an actual work of art. More often, their duties border on the clerical side (answering the telephone, letting visitors in, shipping packages and sorting the mail, taking things out of boxes and setting things up), but even those mundane tasks reveal the inner workings of being a professional artist: Those calling or visiting may be collectors, dealers, critics, curators, or other artists, and the setting-things-up part may be for an exhibition or installation at an art gallery or museum. Bonfield claimed that she is considering applying to a master's program, although in library science rather than in fine art, because she has been "doing archiving so much" for Dill and now sees that as her calling.

Amy Cousins, who also was an assistant to both Dill and Lovell, noted that she worked on one of Lovell's projects gluing "piles of pennies together. The thing about working for artists is that you often learn to do very specific things that may never be relevant to your work again. I got really good at gluing pennies together." However, for both artists, she performed more administrative tasks, "like handling and packaging artwork and archiving press, which are more marketable skills to have under my belt."

After leaving those artists' studios, Cousins, a printmaking major at the Maryland Institute College of Art, served an apprenticeship at the Philadelphia-based nonprofit Fabric Workshop and became a surface design intern at a wallpaper company.

There are various benefits and drawbacks to working as an artist's studio assistant, but probably the chief attraction is the potential entrée to the professional art world that it represents to younger artists. Cousins claimed that "while working for Lesley and Whitfield, I tried to ask a lot of questions about how they got to where they are, what were pivotal moments in their careers, things like that. They were both very forthcoming and open about their experiences and gave some good advice." The drawback was the low pay—or no pay when working as an intern—and nonexistent benefits (health insurance, paid sick or vacation days, retirement plans), as well as the difficulty in getting back to one's own artwork after a day spent helping other artists create theirs. "It can definitely be a challenge to have artistic energy in your own studio after spending all day working for an artist. Working for Lesley would physically tire my hands, and it was hard to want to use them when I got home."

Credit for work done on an artist's own piece is not given, and assistants with baccalaureate and master's degree in art may find it demeaning to sweep an artist's floor or fetch the mail. "Who is supposed to clean the floors?" Lovell asked. "Am I supposed to get on my hands and knees to clean the floors? I don't ask my assistants to clean my whole house, just the studio. They are here to make my life easier, and that's not negotiable."

His favorite and first studio assistant worked for him for five years, coming "in every day with a positive attitude. He'd say, 'What are we going to do today?' That brought a lot of energy into the studio and I thrived on that. I don't want negative energy in my studio, people bugging me for letters of recommendation for grad school or wanting me to mentor them or not willing to clean the floors when that needs to be done."

Over time, assistants become essential to the artists for whom they work. Stephen Knapp, a sculptor in Princeton, Massachusetts, sends out Don Collette,

one of his two longtime assistants, along with his work when it is displayed in a museum, because Collette "knows how it is supposed to look. He can spot problems in the work and in how it is installed that few other people can see," said Knapp, who noted that he arrives a day or two later, in time for the opening.

Knapp, like Dill and Lovell, looks to hire assistants (and interns) with art training, because they want people who have an eye for detail and some experience with the creative process. Because he regularly installs his work in museums, Knapp said that artists with bachelor of fine arts or master of fine arts degrees, "especially those who have worked as museum preparators, are my favorite assistants to hire." His pay scale is a bit higher than Dill's, at $16 to $22 per hour.

Collette has been a full-time assistant for Knapp for six years, having received training in photography at the Art Institute of Boston. His own artwork consists of photography and what he called mixed-media constructions, exhibiting "here and there." His income, however, came from working as a technician in a photography lab before that closed, throwing him out of work. "I had connected with Stephen a long time ago, so when the lab closed, I called Stephen to ask for a job."

He still pursues his own artwork, a process that he claimed is made easier by the fact that "what Stephen does is so different from what other artists do and certainly what I do," so those forty hours don't sap his own creativity. "You have to keep in mind that what I'm doing in Stephen's studio is not about me and that I'm there to service his needs. If he wants my input, I'll give it to him. If he doesn't, I keep my mouth shut."

Often, the pluses and minuses of being an artist's assistant get all mixed together, as do the various tasks that studio assistants are asked to do. "Tom," meaning sculptor Tom Sachs, "wants the highest skills for the lowest wage," said Liz Ensz, a fiber artist who worked for Sachs for one year (starting at $15 per hour, ending at $17 per hour), creating various components for a lunar module installation based on photographs that the artist gave her ("I got to make some really cool things"). The elements were made of fiberglass, resin, and Styrofoam. During that year, the number of assistants in the studio ranged from six to fourteen. She got the

job through another of Sachs's assistants, J.J. Peet, the boyfriend of one of her former teachers at the Minneapolis College of Art and Design. "His referral was enough," she said. "Tom trusted J.J.'s judgment, since he was his main builder." Her interview with Sachs consisted of the artist looking at online images of her work. Sachs "decided where I would fit in."

At the end of her year as a studio assistant, in 2007, the artwork was exhibited at New York's Gagosian Gallery, where Ensz and the other assistants came to the opening, but all the applause there was for Sachs. "I don't feel weird about that at all," she said. "I'm actually grateful for the experience. I learned more in Tom's studio than I did in art school."

Not every studio assistant finds the anonymity of the job as easy to swallow. "I do think about not getting credit," said Claire Taylor, an artist who worked for sculptor Tara Donovan for nine months. "It's her work, her ideas, but her work ends up becoming your whole life; it just consumes you, and it is very hard after eight hours of constant work in her studio to come home and push yourself to do your own work."

Donovan never asked to see Taylor's portfolio but gave her a daylong tryout, gluing Styrofoam cups together in a particular pattern, which in fact was one of the activities she did regularly for a large project that the artist was developing. In addition, during that nine-month period of working in her studio, Taylor repaired Mylar disco balls and rolled adhesive tape loops, connecting them and spraying it all with a sealant. Most of the five to ten other assistants in the studio were similarly aspiring artists, and Taylor claimed that an unstated element in the tryout was determining if "I could mesh with everybody. Everyone is constantly around each other, in a relatively confined space, and you don't want tensions to interfere with the work that needs to be done." In fact, she found that "people got along really well. If someone doesn't want to talk all day, no one makes you talk, no one takes it personally. Everyone knows what it's like to roll tape all day."

There are many ways to learn if an artist needs an assistant. The principal dealer for an artist is often in touch with the studio and may be a good source of

information. Other artists often know which studios are more likely to hire assistants, perhaps offering a reference or an introduction. Some artists advertise their need for assistants in the "Jobs in the Arts" section of the New York Foundation for the Arts' website or on Craigslist.com, and Stephen Knapp finds people through hireculture.org, the jobs website of the Massachusetts Cultural Council. Artists sometimes contact art schools when they need help, and these institutions also may arrange internships and assistantships for their current students and alumni. Katharine Schutta, director of career services at the School of the Art Institute of Chicago, noted that during an interview "it's important that you know and express excitement about the artist's work," as well as bringing up the skills that the would-be assistant has to offer. Much of the actual job will be administrative, such as preparing artworks for shipment, recordkeeping, developing and updating a website, researching grant opportunities, photographing art, or proofreading a press release, "and you may be just fetching things."

At other times, artists may be approached directly about taking on an assistant. Nicholas Maravell, a painter who worked for Alex Katz from 1978 to 1987, had a brief conversation with the artist during a break in a seminar at New York's School of Visual Arts. "I asked him if he needed an assistant," Maravell stated. "He took my name down on a piece of paper, but I didn't really expect to hear from him. I thought he was just being polite, but he called two days later and offered me a job."

Over the years, artists such as Alex Katz have seen scores of young assistants come and go. These assistants may have learned a lot or a little, and what they learned may have helped them develop their own professional careers as working artists or it may have been the closest they ever came to this career. Only rarely do these and other artists know what became of their former assistants, which suggests that making and using contacts to further one's career is only a slight possibility. Apprenticeship is clearly not a ticket to success; rather, artists' assistants need to both help the artist—the job they were hired for—and to learn by the artist's example, identifying which factors enable the artist to achieve success both in a work of art and in a career.

SOME BENEFITS

Those lessons may be varied. Nicholas Maravell claimed that he learned about "the process of painting more than how to paint. I saw all the steps Alex took from the initial drawing to the final painting, and I learned a professional attitude: How to concentrate on your work, putting aside other distractions." Dana Van Horn, a painter in Philadelphia who worked for Jack Beal from 1975 to 1983, stated that he was able to learn what, for an artist, makes for a good art dealer ("a long-term commitment by the dealer to the artist without worrying whether the gallery is making a profit") and what kinds of dealers to avoid ("people who whine, or don't tell you what they think of your art, or don't understand your art to begin with").

Jonathan Williams, who has worked off and on for Richard Haas beginning in 1976 and for Frank Stella from 1988 to 1991, noted that from Haas "I learned how to draw, how to drink and everything in between, including a few vices." For both him and Robert Franca, who worked for Haas from 1984 to 1989, the majority of their paying work now comes from painting scenery for television and motion pictures, a type of artwork that is not far removed from the trompe l'oeil architectural murals that Haas is commissioned to create.

Franca stated that, besides picking up a lot of mural techniques from Haas, he also learned "how to work quickly in broad areas, for commission. I learned how to meet a deadline, how to get hired." He added that working for a well-known artist also has significant résumé value, noting that, "for those who know Dick's [Haas] work, telling them that I worked on this or that piece has been very helpful in getting commissions."

The tenure of a studio assistant ranges from a few months to a few years, on the average, depending upon what a given artist needs and how long someone is willing to work in a role in which promotions, raises, and industry recognition—the rewards of other types of employment—almost never occur. In general, it is a job for the young, and those who tire of it probably have passed a certain point in their sense of who they are as artists. For many studio assistants, working for an artist is a type of postgraduate training, an introduction to the full-time artistic life. Chappaqua, New York, artist Federico Solmi claimed that most of his assistants

are twenty-two to thirty years of age, generally right out of school. "I look for a person who is trained as an artist—the person doesn't have to have a master's degree, but it helps—and wants his own art career," he said. The art training is useful, because Solmi expects to be assisted in the creation of drawings and the actual building of his sculptures. For their part, if they observe carefully, his assistants will "learn how to run a studio and the processes I use, meet the collectors and gallery people whom I deal with and how I arrange funding for my projects. To support a studio like mine is extremely expensive."

Artists' assistants may get to meet the people—collectors, critics, curators, dealers—who visit the studio, and sometimes these chance meetings turn into something else. Besides meeting important people, working as an assistant may provide an opportunity to learn how the art market operates, how to set up a studio or prepare a portfolio, how to write a grant proposal, where to purchase different kinds of art materials, and generally how to approach the business of being an artist in a professional manner.

Graduating from art school often comes as a slap in the face to young artists. Usually departing without a plan for how to pursue a career as an artist, students leave behind a world in which they had free studio space and use of expensive equipment, time to develop their art, fellow students with whom to share ideas regularly, and professional artists-instructors who paid serious attention to them. They enter a world of high rents, small apartments, and low-paying jobs that may have little relationship to their skills. Professional artists they encounter may have little interest in, or time to spare for, a mentor relationship, and fellow starting-out artists are only likely to offer their own tough-luck tales, of not knowing how to meet the right people, of wanting a better-paying job, of having little time or space in which to create their art. Frequently, an additional perk of working for a professional artist is permission to use tools and other equipment during off-hours.

On occasion, a studio assistant learns something else that helps them develop a career, although perhaps a different career than they may have assumed. Carmella Saraceno stretched canvases for Jean-Michel Basquiat, glued plates onto canvases for Julian Schnabel, and "was invited to every party and every opening," but she

discovered her real calling after she began working with sculptor Alice Aycock. "I had heard through some people that Alice Aycock needed a truck unloaded," and she came to Aycock's Manhattan studio at 8:30 the next morning, spending the day pulling out and hauling up to the artist's studio one piece of lumber after another, the one woman among several men. The lumber didn't fit easily into the freight elevator at the studio, but Saraceno took charge of directing the process of maneuvering the pieces in and out. "Alice watched me do this all day long and, at the end of the day, she asked me if I wanted to work for her."

The "work" was varied, to say the least. "I got the keys if she was locked out, I got the car before it was towed," and she offered comfort when the artist had a blowout with her then-husband. More importantly, Saraceno figured out how to put together and install the public sculptures for which Aycock provided designs. "Alice never said no to any project. Something would come up; someone would say use this space, and she'd say yes and then try to figure out how to do it. Someone would ask her to do a project that involved electrical power, and she'd say OK I can do electrical, but she knew nothing about electrical."

In 1990, Saraceno started her own business, in Chicago, called Methods and Materials that helps artists, art galleries, corporations, museums, and public arts agencies rig, assemble, install, de-install and relocate large-scale artworks. "What I do now is figure out how to do things," she said. "I wouldn't be doing this if not for having worked for Alice Aycock." Her business currently employs nine artists, who are afforded health insurance and 401(k) pension plans.

SOME DRAWBACKS

Working for an artist may also stunt one's development. One painter who has worked for Frank Stella ("mostly paperwork") over the period of a few years complained of feeling "pressure when I do my own artwork. You are so exposed to someone else's sensibility that you can become stymied. Stella's works are so supported by the art business world that my own starts to seem so insignificant." She added that "people who work with Stella have largely stopped doing their own art. It's hard knowing how to deal with these problems."

It is frequently the case that assistants learn how to assist a noted artist all too well, as their own artwork comes to resemble that of their artist-employer, and it requires a break in the relationship for the assistants to fully emerge as expressive artists in their own right. That problem is to be expected in some degree, as it is the job of the assistant who works directly on the artwork to "get into the artists' minds, figure out what the artists are after, what they mean to do, in their work," Williams noted. Walter Hatke also stated that his job was "to learn to paint in such a manner that what I did would pass, for all intents and purposes, as a Jack Beal." After a full day of adopting a specific style or approach to painting, it is likely to be difficult to settle down to one's own artwork. All artists' assistants need to keep in mind what their role is, which is not self-expression but carrying out another artist's plans.

"One of the main things I look for in an assistant is, Can I work with that person vis-à-vis his or her ego?" Richard Haas said. "If someone's ego becomes a problem, it leads to tensions and a bad experience. There have been many instances over the years where mistakes were made in hiring assistants. The person had a personality flaw that led to a conflict where parting was not sweet—sometimes, the parting involved lawyers, once a cop."

However, tensions aren't only a result of assistants who want the final artwork to look different, Haas noted. "Where the assistant's work is too close stylistically to mine, there can be tensions. I don't encourage people to copy me—the opposite is true—because someone else doing your thing isn't flattering or comfortable. What I really want is an artist whose own talents challenge me, whose ideas are fresh and interesting, not derivative."

Haas's expectations can be a very tall order: An assistant who can ultimately work in his style yet brings new ideas that can be subsumed into Haas's art without a conflict of artistic egos. Perhaps this is the reason that most assistants do not stay very long with a particular artist. "As I matured," Williams said, "I didn't want to give my ideas away anymore. I wanted to save my ideas and my techniques for my own work."

It is also the case that the more established an artist is, the less likely that they will want an ongoing turnover of assistants, each of whom stays a year or two or

less. "It takes a couple of years in order to get an assistant to do his work efficiently," Alex Katz said. "I like it when they stay around five or six years. I lose time and money with kids right out of art school who leave as soon as they're trained. The younger ones also destroy a lot of things because of their lack of experience, and that costs me money, too."

Philip Grausman, a sculptor in Washington, Connecticut, who has used apprentices since the late 1970s, noted that it is rare for an assistant to stay as long as two years. "With only a few of them have I ever gotten anything back on my investment in time and materials," he stated. He added that his expectations for his largely short-term assistants are limited. "I have to design my pieces for the skills of the particular people who work for me, breaking down each process into very small steps." The final artworks are "maybe a little different than if I had done it all myself" and, because he has lost patience with apprentices who aren't "serious or committed," Grausman has decided to rely increasingly on foundries for help in fabrication.

He added that apprentices sometimes become very "possessive of specific work they've done. I'll come in later and take it all apart, and they get very upset. They don't understand their role here."

Whether or not it is realistic to expect that young artists will be willing to devote themselves selflessly for many years to the production schedules of established artists is uncertain. However, it is likely that the interest of established artists in stability and the desire of their younger apprentices to strike out on their own will collide regularly and create tensions.

In addition, while the established artists are inevitably getting older, their short-term apprentices are forever in their early twenties, which may lessen the ability of both sides to communicate effectively. Richard Haas, for instance, noted dryly that "I have better conversations with people who are older," and Alex Katz flatly stated that "I don't talk much with my assistants." Jonathan Williams's experience of Frank Stella also did not include much conversation other than shop talk. "Everything that mattered with Stella was the work at hand, and we really didn't talk about anything else," Williams said. "I don't remember him ever asking me much about myself."

Certainly, there are risks in asking an assistant personal questions; for instance, that the action may be reciprocated, and established artists may prefer that their employees not know potentially compromising information about themselves. Perhaps a reason that relationships may not become personal is that certain jobs that may be assigned to an assistant are contrary to friendship, such as sweeping the floor. Younger artists may assume they will have a more intense, even collegial, relationship with the artists for whom they are working than in a traditional employer-employee situation, and those upset expectations may lead to tensions in the studio.

FINDING A JOB AS AN ART TEACHER

The decision of whether or not to obtain an art degree on the bachelor's or master's level is not purely an economic one. Students enter these programs with the intention of becoming professionally trained artists, developing technical and intellectual skills that will advance and inform the artwork they aspire to create. It is a fact, however, that many artists earn some or all of their income through teaching at the college level, and the master of fine arts degree is a requirement for most of these jobs. However, there is no direct path from earning an MFA to landing a college teaching position, in part because there are so many MFAs and partly because instructors are required to show some level of experience as professional artists outside academia. That experience includes exhibitions (group and one-person shows) as well as other indications of professional activity, such as curating an exhibit or published writing about art in some periodical, in addition to teaching experience. (How to get teaching experience in order to be hired to teach is one of those conundrums that college graduates face in almost every field.)

Pratt Institute in Brooklyn, New York, may truly embody the dilemma facing artists. The school gives out more MFA degrees—five hundred a year—than any other institution in the country, yet it would be unlikely to hire any teachers unless they were at least ten years out of school and had some level of success as a professional artist while gaining teaching experience somewhere along the way. Most

hires at these schools are in their later twenties or early thirties; no one goes right from graduate school to teaching.

The prospects for teaching are not wholly dire for artists. Moving away from Modernist canons of art, most schools are looking to maintain a wide range of styles and artistic ideas—from realistic to conceptual—in their departments, as well as a diverse faculty. Artists who have technical skills in more than one area, such as painting and operating a printing press or sculpture and digital media, are more apt to be hired by schools that may want the flexibility of reassigning staff as their needs and students' interests change.

The College Art Association has also found an increase in non-university teaching jobs for artists, such as at museums and nonprofit arts centers, as well as teaching opportunities at less-prestigious institutions, including junior colleges, summer retreats (art camps, cruise line art classes), senior citizen centers, Veterans Administration hospitals, and YMCAs. One finds these jobs through contacting the individual institutions, as each has its own availabilities and budgets.

Another growing area of hiring for art teachers, according to the National Art Education Association, is the nation's public schools, where twenty-nine state boards of education across the country now require high school students to take at least one art course in order to graduate—a requirement that did not exist before 1980. In addition, 58 percent of the country's elementary schools have full-time or part-time art teachers, a substantial increase since the early 1980s. There are approximately 50,700 public school art teachers working in the nation's 15,600 school districts, with a turnover rate of between 2 and 5 percent, or between four hundred and one thousand jobs a year. These jobs, however, are available only to those holding state teaching licenses or certification (or both), and requirements differ from school to school or from district to district. Nowhere is the road to relevant employment easy for artists.

Private schools, which must be contacted individually, do not have the same requirements for teachers and may be worth pursuing. Charter schools, on the other hand, while frequently emphasizing the arts more than many traditional

public schools, are still public schools and have the same state licensing mandates for their teachers. While a source of potential employment, professional artists generally do not arise out of the faculty of private and public primary or secondary schools; perhaps the reason has been that career-minded artists historically have not pursued this avenue as an art-related career option. Another factor is that K-12 art projects focus on the product—something to have finished in fifty minutes to bring home to show the parents that very day—rather than on process, the slow development of skills, and experimentation with materials. Where school art classes are more than once a week, such as at certain charter schools, there may be an opportunity for real art teaching and artmaking, but those who are committed to serious teaching or who want to be accorded respect as professional artists will likely feel more comfortable at the college or university level.

FREE EXPRESSION ISN'T ALWAYS FREE

An additional concern for artists who teach in public and private schools is the fact that they may be placed in the position of censoring the work that their students create. The National Art Education Association discourages any form of censorship in a policy statement: "The art educator should impress upon students the vital importance of freedom of expression as a basic premise in a free and democratic society and urge students to guard against any efforts to limit or curtail that freedom." However, as a practical matter, students' work is regularly censored (not hung up in the classroom, not submissible for classroom assignments and grading). Bruce Bowman, a public high school art teacher in the process of completing a doctorate in art education from the University of Georgia, conducted a formal survey of art teachers in Georgia in which he found that drug, gang, racist, or sacrilegious imagery, as well as artwork depicting sexual acts, gambling, obscene gestures, nudity, and violence were often censored by teachers. The reasons for this action ranged from "it challenged school policy," "it disturbed the class," "it offends the general public," and "it celebrated illegal actions" to "parents complained" and it was "produced just to shock." Clearly, there is a wide disparity between what the National Art Education Association claims as a right and how art

teachers must operate in the school system. Even outside the school system, K–12 art teachers who exhibit their work may realistically worry that their own potentially offensive imagery results in increased scrutiny of their classrooms or even dismissal. Faculty whose training is primarily in education rather than in studio art may find the issue of censorship far less worrisome. There is less overt censorship of students' work at the college level or even at community art schools, but it still occurs, which may place teachers in a very uncomfortable position.

Censorship also exists at the college level, more so at publicly funded universities than at private liberal arts colleges, as politicians and interest groups may use an exhibit of challenging art as an opportunity for a broad-scale attack on the institution. Freedom of expression comes into conflict with the sensitivities of certain groups, and all that school administrators and faculty may be able to do with a clear conscience is to limit the damage to the educational institution itself. When Roger Shimomura, an art professor at the University of Kansas at Lawrence, offers his annual class for performance art, students are given at the beginning of the course a list of thirteen things they may not do. These include hurting themselves or others, the use or discharge of firearms, bloodletting or the exchange of bodily fluids, harming animals, sex acts or acts of sadomasochism, use of drugs or other illicit substances, setting fires or igniting stink bombs, calling in a false alarm to the police, or intentionally vomiting. (Over the years that he has offered this class, all of these have been tried at one point or another. Vomiting took place a half a dozen times.) If students create a mess, they must clean it up; in one instance, in which a student threw food around the room, that person was required to pay for the cleaning of everyone's clothes. To a degree, the rules ensure that lives are not put in danger and property is not damaged but, to Shimomura, an equal concern is that "nothing is done that threatens the offering of this class in the future."

In large measure, artists learn how to teach from the experience of having been taught, and the rest is usually trial and error. What is an instructor supposed to do when a student's work is overtly racist or sexually explicit or physically threatening? "Some teachers believe it's their job to produce revolutionaries and to push the edge. It's all anything goes," Michael Auerbach, an art faculty member of

Vanderbilt University, said. On the other side of the free speech issue, he noted, there are teachers who attempt to moderate or disallow objectionable work. "Some teachers grade down students based on their political beliefs, forcing students to adjust their work to get the grade. I've known a teacher or two who has required psychological counseling for students." Regardless of their personal stances, art instructors need to know before they teach their first class what their school expects of them and how they plan to handle instances of possibly tasteless art produced by their students.

WEIGHING THE PROS AND CONS OF TEACHING

The benefits of college-level teaching are clear—long vacations, time and space in which to pursue their own work, and having to teach only part of the day—but they may also be overstated. Artists have not always felt at peace with the academic life, and many find themselves uncomfortable with it now. In the past, there used to be a lively tradition of artists meeting in a few central locations (at a studio or tavern, perhaps) and hashing out ideas and comparing notes. They were able both to create art and live in the world more immediately. With the growth of teaching jobs in art around the country, the result has been to separate and isolate artists in far reaches of the country, limiting their ability to converse and share ideas.

Looking at this very issue, the critic Harold Rosenberg wrote that "If good artists are needed to teach art, the situation seems irremediable. Where are art departments to obtain first-rate artists willing to spend their time teaching, especially in colleges remote from art centers. And, thus isolated, how long would these artists remain first-rate?" The result, he found, is that many artists lose their sharpness, and their students begin to get more of their inspiration and ideas from looking at art journals than by paying attention to their instructors.

The academy has become a main source of employment for artists in all disciplines, and the entire structure of art in the United States has been affected by this. When artists are spread out around the country, removed from the major art markets and critical notice, their ability to exhibit their work becomes much more limited and the desire to show their artwork grows more intense. Members of

college or university art faculties frequently find themselves at war with the directors of the institution's art gallery over whether or not their work will be exhibited.

The division between the two is obvious. Artists want to use the available space to show what they do, which is a principal way they can maintain their belief in themselves as artists first and teachers second. On the other hand, university gallery directors don't want to be simply booking agents for the faculty, but prefer to act as regular museum directors, curating their own exhibits and bringing onto the campus the work of artists (old and new) from outside the school. Each side has a point, but it is often an irreconcilable area of contention unless, as at some colleges, there is more than one gallery for art shows on campus. Some schools have galleries that are student-run or that are principally for student exhibitions, while other spaces exist for the faculty and out-of-town artists or traveling shows. When there isn't this multiplicity of art spaces, a state of war may develop at a college that embitters the artist and exhausts their time not in artmaking but in departmental infighting.

Away from the major art centers, stimulation may be lacking for artists who need things going on around them, and academia tends to have its own special set of concerns. "In the hinterlands," Robert Yarber, a painter who has taught in California and Texas, said, "all the other artists you meet are teachers, and that can be inhibiting." Bill Christenberry, a painter and photographer at the school of the Corcoran Art Gallery in Washington, DC, noted that he was offered tenure at Memphis State University and was making a good salary there, "but I thought, 'Heck, if I'm not careful, I'm going to be trapped here.' I never regretted leaving Memphis."

When there is not a community of artists but, rather, an art faculty, discussions about art become less centered within a particular group of artists and may be limited to taking place at formal settings, such as at the annual meetings of the College Art Association (where teachers otherwise convene to look for jobs) or are in the form of critical articles in specialized journals. The ascendance of theory as a starting point for artmaking over the past two or three decades may reflect the

degree to which teaching artists find each other through a discussion of ideas rather than by shared experiences and close proximity. Additionally, teaching artists are asked to both provide technical instruction, frequently offering an analytical discussion of works by the old and new masters (and by their students), and be creative artists themselves, finding the inspiration to make their own art. This is an age-old problem, one that will continue as long as artists also teach.

Another problem for artists who teach is balancing their own professional careers with what they do for their students. Artist-faculty members, as faculty members in every school department, are required to hold office hours for their students, attend staff meetings, and participate in some campus activities. This is essential for both the students and the college or university as a whole, although it does take time out of the artist's day. It is unlikely that someone would be hired for a teaching position who made their lack of interest in these activities known.

MAKING PEACE WITH THE ACADEMIC LIFE

It is said that when the Italian Renaissance artist Verrocchio saw the work of his student, Leonardo da Vinci, he decided to quit painting since he knew that his work had certainly been surpassed. The story is probably apocryphal—it is also told of Ghirlandaio when he first saw the work of Michelangelo, of the father of Pablo Picasso, and of a few other pairings of artists—but the idea of a teacher selflessly stepping aside for the superior work of a pupil makes one's jaw drop.

More likely, many artists who teach today would tend to agree with Henri Matisse, who complained during his teaching years (1907–1909), "When I had sixty students there were one or two that one could push and hold out hope for. From Monday to Saturday I would set about trying to change these lambs into lions. The following Monday one had to begin all over again, which meant I had to put a lot of energy into it. So I asked myself: Should I be a teacher or a painter? And I closed the studio."

Many, if not most, of the world's greatest artists have also been teachers. However, between the years that Verrocchio and Matisse were working and teaching, the concept of what a teaching artist is and does changed radically. Verrocchio was a highly touted fifteenth-century painter and sculptor, backed up with

commissions, who needed "pupils" to be trained in order to help him complete his work. Lorenzo di Credi, Perugino, and Leonardo all worked directly on his paintings as the final lessons of their education. It would never have occurred to Matisse to let his students touch his canvases. In the more modern style, Matisse taught basic figure drawing rather than how to work in the same style as himself.

Teaching now obliges an artist to instruct others in techniques and styles that, at times, may be wholly opposed to their own work. Even when the teaching and creating are related in method and style, instruction requires that activity be labeled with words, whereas the artist tries to work outside fixed descriptions—that's the difference between teaching, which is an externalized activity, and creating, which is inherently private and personal.

"The experience of teaching can be very detrimental to some artists," said Leonard Baskin, the sculptor and graphic artist who taught at Smith College in Massachusetts between 1953 and 1974. "The overwhelming phenomenon is that these people quit being artists and only teach, but that's the overwhelming phenomenon anyway. Most artists quit sooner or later for something else. You have to make peace with being an artist in a larger society."

Artists make peace with teaching in a variety of ways. Baskin noted that teaching had no real negative effect on his art—it "didn't impinge on my work. It didn't affect it or relate to it. It merely existed coincidentally"—and did provide a few positive benefits. "You have to rearticulate what you've long taken for granted," he said, "and you stay young being around people who are always questioning things."

A number of artists note that teaching helps clarify their own ideas simply by forcing them to put feelings into words. Some who began to feel a sense of teaching burnout have chosen to leave the academy altogether in order to pursue their own work while others bunch up their classes on two full days so as to free up the remainder of the week. Still others have developed strategies for not letting their classroom work take over their lives.

Painter Alex Katz, for instance, who taught at Yale in the early 1960s and at New York University in the mid-1980s, noted that he tried not to think about his teaching when he was out of the class—"out of sight, out of mind," he said.

Others found their teaching had so little to do with the kind of work they did that forgetting the classroom was easy. Painter Philip Pearlstein, who has taught at both Pratt Institute and Brooklyn College, stated that his secret was to keep a distance from his students.

"I never wanted to be someone's guru," he said. "I never wanted to have any psychological or spiritual involvement with my students, getting all tangled up in a student's personality or helping anyone launch a career. I call that using teaching as therapy, and, when you get into that, you're in trouble."

However, Pearlstein claimed that "having a job has led to an intensification of my work. I had to use the little time I had to paint, and it made me work all that much harder. Something had to give, so I cut down on my social life. I decided it was more important to stay home and paint."

ARTIST-IN-RESIDENCE PROGRAMS

Amid the ongoing struggle to obtain government (local, state, and federal) support for the nonprofit arts and the din of what once was called the "culture wars" has been a growing interest around the country in helping artists create more work. Some of this has been on the part of government, as one city after another has looked to use grants, loans, and tax credits to produce affordable places for artists to live and work, while other programs that financially assist artists are private, nonprofit endeavors (Center for Cultural Innovation, Creative Capital, and United States Artists, among others). Another form of help to artists that has been on the rise is residency programs, where artists are provided time and space to do their artwork.

"Most residency programs for artists have been created in the last forty years," said Caitlin Strokosch, director of the Alliance of Artists' Communities (www.artistcommunities.org), which has over 250 members around the United States. She noted that between one-quarter and one-third of the Alliance's members look principally for emerging to mid-career artists, "and most of the newer programs appear to be aimed at emerging artists."

The definition of an artist-in-residence program has been expanding with the number of programs. An artist-in-residence at Skidmore College in Saratoga

Springs, New York, for example, is one more adjunct studio faculty member, who (according to the school's website) will "teach and sit in on classes and seminars, supervise students, consult with faculty, and of course demonstrate his/her talents." The artists-in-residence at Yaddo, the renowned artist community in Saratoga Springs, on the other hand, are housed and fed three meals a day, as well as provided a stipend of varying amounts while given time and space to work on their own art. Between the two is a wide range of variations, including artist communities that one must pay to attend, others that provide housing but no food and no stipends, yet others that require twenty hours per week of community service or groundskeeping or contributing an object the artist has created, and some that are bed-and-breakfasts or resorts holding art workshops.

Approximately 12,000 artists (in literary, performing, and visual arts) are in residence at one retreat or another, and most of them are in rural areas, where the idea is to get away from all the distractions that keep artists from pursuing or completing their work. There are opportunities for fellow resident artists to socialize at Yaddo, for instance, at sit-down breakfasts and dinners in a common room, and people are free to choose their own company in the evenings. However, during the day, artists are expected to work on their own without interrupting others, and bag lunches are left at their studios so that their creativity and thought processes are not disturbed. Yaddo is, perhaps, more than the exception than the rule in the field of artist communities, where being around other artists is often as important as having time and solitude to do one's work, but in every residency program there is a focus on the work.

"In our definition," Strokosch said, "an artist-in-residence program provides dedicated time and space for an artist to do work. It's not permanent, like a live-work site, but usually for between a few weeks and a year. There are also competitive criteria for artists to be there, in that they are selected by some means, such as through jurying or a curator." Finally, the sponsoring organization need not necessarily be a nonprofit—it may charge fees—but "it is subsidizing artists, for instance by having them pay below market rate.

In-residence programs come in a variety of types. The National Park Service (1849 C Street, NW, Washington, DC 20240, 202-208-6843, www.nps.gov) has an artist-in-residence program for writers and performing and visual artists, and twenty-nine parks around the country participate. As opposed to artist communities, the National Park Service program brings in one artist at a time. Housing but no stipend is provided, and an individual residency lasts for a period of three weeks. Artists are required to donate to the Park Service's collection some piece of their art that represents their stay, and they also may be asked to hold a demonstration or a talk for park visitors. The participating parks are:

Acadia National Park
Artist-in-Residence Program
Acadia National Park
P.O. Box 177
Eagle Lake Road
Bar Harbor, ME 04609
(207) 288–3338

Amistad National Recreation Area
Artist-in-Residence Program
4121 Veterans Boulevard
Del Rio, TX 78840
(830) 775–7491, ext. 211

Badlands National Park
Artist-in-Residence Program
Badlands NP
P.O. Box 6
Interior, SD 57750
(605) 433–5245

Buffalo National River
Artist-in-Residence Program
402 N. Walnut
Harrison, AR 72601
(870) 741–5443

Cape Cod National Seashore
Provincetown Community Compact, Inc.
P.O. Box 819
Provincetown, MA 02657

Cuyahoga Valley National Park
CVEEC Artist-in-Residence Program
3675 Oak Hill Road
Peninsula, OH 44264
(440) 546–5995

Delaware Water Gap National
Recreation Area
Peters Valley Craft Education Center
19 Kuhn Road
Layton, NJ 07851
(973) 948–5200

Denali National Park and Preserve
Artist-in-Residence Program
P.O. Box 9
Denali Park, AK 99755
(907) 683–2294

Devils Tower National Monument
Wyoming, MT 82714
(307) 467–5283

Everglades National Park
Artist-in-Residence-in-Everglades
40001 State Road 9336
Homestead, FL 33034
(305) 242–7750

Glacier National Park
Artist-in-Residence Program
P.O. Box 128
West Glacier, MT 59936
(406) 888–7942

Golden Gate National Recreation Area
Residency Manager
Headlands Center for the Arts
944 Fort Barry
Sausalito, CA 94965
(415) 331–2787

Grand Canyon National Park
Artist-in-Residence Program
P.O. Box 129
Community Building
Grand Canyon, AZ 86023
(928) 638–7739

Herbert Hoover National Historical
Site
Artist-in-Residence Program
110 Parkside Drive
PO Box 607
West Branch, IA 52358
(319) 643–7855

Hot Springs National Park
Artist-in-Residence Program
101 Reserve Street
Hot Springs, AR 71901
(501) 620–6707

Indiana Dunes National Lakeshore
Artist-In-Residence Program
1100 North Mineral Springs Road
Porter, IN 46304–1299
(219) 926–7561

Isle Royale National Park
Artist-in-Residence Program
800 East Lakeshore Drive
Houghton, MI 49931–1895
(906) 487–7152

Joshua Tree National Park
Artist-in-Residence Program
74485 National Park Drive
Twenty-Nine Palms, CA 92277
(760) 367–5539

Mammoth Cave National Park
Artist-In-Residence Program
Mammoth Cave, KY 42259
(270) 785–2254

Mount Rushmore National Memorial
Artist-In-Residence Program
13000 Hwy. 244, Bldg. 31
Keystone, SD 57751
(605) 574–3182

North Cascades National Park
810 State Route 20
Sedro-Woolley, WA 98284
(360) 856–5700, ext. 365

Pictured Rocks National Lakeshore
Artist-in-Residence Program
P.O. Box 40
Munising, MI 49862
(906) 387–2607

Rocky Mountain National Park
Artist-in-Residence Program
1000 Highway 36
Estes Park, CO 80517
(970) 586–1206

Saint Gaudens National Historic Site
Artist-in-Residence Program
RR 3, Box 73
Cornish, NH 03603
(603) 675–2175, ext. 107

Sleeping Bear Dunes National
Lakeshore
Artist-in-Residence Program
9922 Front Street
Empire, MI 49630
(231) 326–5134

Voyageurs National Park
Artist-in-Residence Program
3131 Highway 53
International Falls, MN 56649–8904
(218) 283–9821

Yosemite Renaissance
P.O. Box 100
Yosemite National Park, CA 95389
(209) 372–0200

Weir Farm Trust
Artist-in-Residence Program
735 Nod Hill Road
Wilton, CT 06897
(203) 761–9945

Most residencies are not free to the participants—even the program of the National Park Service assumes that artists will provide their own food and art materials, as well as pay their rent and any other expenses at home—and finding the means to pay for them is no simple matter. A high percentage of the participants at artists' communities are faculty members on sabbatical, and summers tend to be when these facilities are most full ("They accommodate academic schedules," Strokosch said). Others seeking help paying for a residency have some options. A number of state arts agencies around the country offer career and professional development grants to individual artists, which may be used to pay for workshops, seminars, mentoring, and specialized training, as well as (in some cases) travel costs to where they will take place. Nineteen states' arts commissions permit that money to be used to pay residencies at artist communities (Alaska, Arizona, Delaware, Florida, Idaho, Kentucky, Louisiana, Minnesota, Montana, New Hampshire, Nevada, North Carolina, North Dakota, Oregon, Tennessee, Vermont, Washington State, West Virginia, and Wyoming).

Additionally, at least one local arts agency (Marin Arts Council, 555 Northgate Drive, San Rafael, CA 94903, 415-499-8350) offers Career Development Grants that help Marin County artists pursue opportunities, such as at an artist community, to further their professional artistic development. The grants go up to

$1,500. The Sponsoring Partners program of the Headlands Center for the Arts (944 Fort Barry, Sausalito, CA 94965, 415-331-2787), an artist community, also works with the North Carolina Arts Council and the Ohio Arts Council to underwrite residencies for artists in those states at Headlands.

Several nonprofit organizations allow artists to apply for funding that may be used to pay for the cost of a residency:

Jerome Foundation
400 Sibley Street Suite 125
St. Paul, MN 55101–1928
(651) 224–9431
www.jeromefdn.org
The Travel and Study Grant Program awards grants to emerging creative artists. Funds support periods of travel for the purpose of study, exploration, and growth.
(May be used for residencies when teaching or collaborative activities are involved)
Open to residents of Minnesota and New York City.

Leeway Foundation
The Philadelphia Building
1315 walnut street, suite 832
Philadelphia, PA 19107
(215) 545–4078
www.leeway.org
Specific grants are available for emerging and established women artists. There is also a Window of Opportunity Grant that help artists take advantage of unique, time-limited opportunities that could significantly benefit their work or increase its recognition.

New York Foundation for the Arts
155 Avenue of the Americas, 6th Floor
New York, NY 10013–1507
(212) 366–6900
www.nyfa.org
Strategic Opportunity Stipends (SOS), a project of the New York Foundation for the Arts, working in collaboration with arts councils and cultural organizations

across New York State, are designed to help individual artists of all disciplines take advantage of unique opportunities that will significantly benefit their work or career development. Literary, media, visual, music and performing artists may request support ranging from $100 to $600 for specific, forthcoming opportunities that are distinct from work in progress.

Another private funding source, the Herb Alpert Foundation (1414 Sixth Street, Santa Monica, CA 90401–2510, www.herbalpertfoundation.org/foundation_home. shtml), pays for residencies at a shifting group of artist communities. However, recipients of these awards are nominated, and the foundation will not accept applications.

MUSEUM ARTIST-IN-RESIDENCE PROGRAMS

Nowadays, museums seem to do everything but give visitors a room for the night: They provide food, plan vacations, organize parties, offer concerts and opportunities for shopping, help single people find a date, and teach classes. They also exhibit one thing or another, and a growing number of them have established artist-in-residence programs that allow artists to display their work (finished and in-progress) to, and interact with, the public. The result is a win-win situation for all concerned, as both artists and museums benefit from their joint efforts.

At the Coral Springs Museum of Art in Florida, which created an artist-in-residence program in 2000, for instance, artists receive a stipend of $9,000 for their one- to three-month residencies, free materials, a studio in the museum, room and board (staying either with staff or patrons of the museum), and a separate payment for the purchase of the artwork they create on-site. "What they create becomes part of the permanent collection," said Barbara O'Keefe, director of the museum. "We're a small museum, and we have no budget for acquisitions. We found that it is less expensive to have an artist-in-residence program than to raise and maintain an acquisitions budget." She added that sources of financial support—both individuals and public and private agencies—are more willing to provide money for a program that involves both an activity and acquisitions than just one or the other.

For the artists involved, the end result of their residencies is not just one more line on their résumés but "a lot of coverage in the local papers" (Hollywood, Florida, textile artist Barbara W. Watler), "a lot of calls from people interested in commissioning a piece" (South Lake Tahoe, California, mosaic artist Patricia Campau), and the actual purchase of a work by a museum patron—"I was told to bring other, completed pieces with me to the residency" (Gray, Maine, sculptor Roy Patterson). Justine Cooper, an artist living in Brooklyn, New York, who has completed residencies at both the Bellevue Art Museum in Seattle and the American Museum of Natural History in Manhattan, noted the experience has been helpful when applying to funding sources for other projects: "It gives me a proven track record or receiving money and doing something with it."

The term "artist-in-residence" is used broadly, elastically in the art world. Artist communities, such as MacDowell in New Hampshire or Villa Montalvo in California, provide a rural away-from-it-all retreat for artists in different disciplines to pursue their individual work "in-residence," while college art departments use the term to refer to short-term adjunct out-of-town faculty. A museum's artist-in-residence program exists somewhere between the two. There is often a public component, such as leading a workshop (for schoolchildren, in many instances) or giving an evening lecture (for adults), and the artist at work is on display for visitors to the museum to see. The institution usually receives something that the artist creates, but there are generally no limits set on what the artist does. "They do whatever they want. There are no restrictions," said Patricia Kernan, staff illustrator and residency coordinator at the New York State Museum in Albany, which has had an artist-in-residence program since 1996.

There is no one type of museum artist-in-residence program. In many institutions, the artist-in-residence program is run out of the museum's education department with a very specific mandate to develop and complete projects with school-age children, and there may be no studio or materials for the artists or opportunities for them to exhibit their own work. "They're brought in to be a presence in the community, more as a creative catalyst than as a maker of art," said Kelly Armor, educator coordinator at the Erie Art Museum in Pennsylvania, which brings in

artists as short-term (three days to two weeks) residents in conjunction with exhibitions the institution is staging of their work. "They are here to be teachers, reflecting not a particular technique but how they think about art and articulate that." Artists do not apply to be residents but are selected by recommendation of other artists, critics, curators and whoever else has the ear of museum staff. Good art may be enough to get an exhibition, but to be an artist-in-residence, "they have to enjoy being around other people," Armor said. "I've approached artists who didn't feel comfortable conversing or leading discussions and don't think it's the best use of their time."

Similarly, artists chosen for the artist-in-residence program at the Rockford Art Museum in Illinois "must have teaching experience," said education coordinator Mindy Nixon. The program, which began in 1996, is "structured for youths; they tour the museum and do an activity with the artist-in-residence."

The Aspen Art Museum in Colorado, on the other hand, which established its artist-in-residency back in 1979 but let it languish, restarting the program again in 2006, has no teaching or workshops required, "unless the artist feels like it," according to assistant curator Matthew Thompson. The average residency is one month, although it may be as short as two days or as long as two months. Artists are given a workspace in one of the museum's galleries (viewable by the public), and it is there that the exhibition of what the artist has created during the interim is exhibited. In addition to studio space, artists receive accommodations and an allowance for food and money for materials, equipment, and to pay assistants. Since the Aspen Art Museum is not a collecting institution, what the artist creates does not go into a permanent collection, although "if the piece is sold, we may try to recoup our costs," Thompson noted.

It is not only artist museums that have artist-in-residence programs. A number of science and natural history museums also have worked with artists, establishing more or less formalized residencies. On the less formalized side is the American Museum of Natural History, which allows artists to work at the institution on projects for which they arrange financial support and of which the museum gives approval.

Perhaps the artist holding the record for longest artist-in-residency is water-color artist Peggy Macnamara, who has been associated with the zoology depart-ment of Chicago's Field Museum since the early 1980s. "Initially, I went to the Field Museum to do drawing," she said. "It's all a still-life waiting for me; there is no other way to get a zebra to hold still." After becoming a fixture in the museum's galleries, a zoology staffer asked to display her paintings as part of a permanent display of birds, mammals, and reptiles ("I own the work," she noted. "They are on indefinite loan to the Field Museum"), and the museum's education department offered her a contract to teach a three-hour art class once a week under the newly created category of Artist in the Field. Over the years, she has been invited on the museum's scientific expeditions to Central and South America, as well as Africa. In 2005, a Field Museum book on insects of Illinois, for which Macnamara pro-vided the illustrations, was published by the University of Chicago Press.

Over time, a full artistic career emerged. She currently teaches a scientific illustration class for the School of the Art Institute of Chicago at the Field Museum and exhibits natural history paintings at Chicago's Aron Packer gallery (selling print images of those works through her website). A number of the paintings Macnamara has created at the Field Museum have been purchased by staff scien-tists, and the head of the museum's board of directors purchased a six-foot-tall and twenty-foot-long painting of sandhill cranes. "I don't rely on the Field Museum for my income, thank God, but they give me total access to the collection and to any members of the staff," she said. "It's an ideal life."

Among the museums that have artist-in-residence programs in the United States are:

CALIFORNIA
California Science Center
Exposition Park
700 State Drive
Los Angeles, CA 90037
(213) 744–7446
www.californiasciencecenter.org

Cartoon Art Museum
655 Mission Street
San Francisco, CA 94105
(415) 227–8666
www.cartoonart.org

De Young Museum
Golden Gate Park
50 Hagiwara Tea Garden Drive
San Francisco, CA
(415) 750–3614
www.thinker.org

COLORADO
Aspen Art Museum
590 North Mill Street
Aspen, CO 81611
(970) 925–8050
www.aspenartmuseum.org

FLORIDA
Coral Springs Museum of Art
2855 Coral Springs Drive
Coral Springs, FL 33065
(954) 340–5000
www.csmart.org

ILLINOIS
The Field Museum
1400 S. Lake Shore Drive
Chicago, IL 60605–2496
(312) 665–7106
www.fieldmuseum.org

Rockford Art Museum
Riverfront Museum Park
711 N. Main Street
Rockford, IL 61103
(815) 972–2880
(815) 968–2787
www.rockfordartmuseum.org

MASSACHUSETTS
The Art Complex Museum
189 Alden Street
Box 2814
Duxbury, MA 02331
(781) 934–6634
www.artcomplex.org

Fuller Craft Museum
Art Aspire
455 Oak Street
Brockton, MA 02301
(508) 588–6000, ext. 112
www.fullermuseum.org

Isabella Stewart Gardner Museum
280 The Fenway
Boston, MA 02115
(617) 566–1401
www.gardnermuseum.org

MINNESOTA
Science Museum of Minnesota
120 West Kellogg Boulevard
Saint Paul, MN 55102
(651) 221–9444
(800) 221–9444
www.smm.org

MISSOURI
Kemper Museum of Contemporary Art
4420 Warwick Boulevard.
Kansas City, MO 64111
(816) 753–5784
www.kemperart.org

MONTANA
Hockaday Museum of Art
302 Second Avenue East
Klispell, MT 59901
(406) 755–5268
www.hockadaymuseum.org

NEW JERSEY
The Newark Museum
49 Washington Street
Newark, New Jersey 07102–3176
(973) 596–6550
www.newarkmuseum.org

Noyes Museum of Art
733 Lily Lake Road
Oceanville, NJ 08231
(609) 652–8848
www.noyesmuseum.org

NEW MEXICO
Harwood Museum of Art
238 Ledoux Street
Taos, New Mexico 87571
(505) 758–9826
www.harwoodmuseum.com

NEW YORK
American Museum of Natural History
Central Park West at 79th Street
New York, NY 10024
212-769-5800
www.amnh.org

The Studio of the Corning Museum of
Glass
One Museum Way
Corning, NY 14830–2253
(607) 974–6467
www.cmog.org

New York State Museum
The Edmund Niles Huyck
Preserve,Inc.
P.O. Box 189
Rensselaerville, NY 12147
(518) 797–3440
www.nysm.nysed.gov

Roberson Museum and Science Center
30 Front Street
Binghamton, NY 13905–4779
(607) 772–0660
www.roberson.org

NORTH CAROLINA
North Carolina Museum of Natural
Sciences
11 West Jones Street
Raleigh, NC 27601–1029
(919) 733–7450
www.naturalsciences.org

Studio Museum of Harlem
144 West 125th Street
New York, New York 10027
(212) 864–4500
www.studiomuseum.org

OHIO
Taft Museum of Art
316 Pike Street
Cincinnati, OH 45202
(513) 241–0343
www.taftmuseum.org

PENNSYLVANIA
Erie Art Museum
411 State Street
Erie, PA 16501
(814) 459–5477
www.erieartmuseum.org

The Fabric Workshop and Museum
1315 Cherry Street
Philadelphia, PA 19107
(215) 568–1111
www.fabricworkshop.org

ARE WE SPEAKING ABOUT ALL ARTISTS?

There is no recipe for becoming a successful artist, but those who do achieve success—defined here as the ability to support oneself through sales of their own artwork—tend to have certain qualities. They have an understanding of their audience, or market, how to bring attention to their art and how to negotiate a sale;

they are aware of how the law pertains to the creation and sale of art; and they do not become tongue-tied when setting up a consignment arrangement with a gallery owner or resort to art school jargon when discussing their artwork with prospective buyers. Generally, the mastery of those (and, perhaps, a few other) art business skills separate the professional from the wannabe.

Books on the subject and recommendations and suggestions in career-focused columns in artists' magazines regularly stress the importance of business skills, but a nagging question remains: Is this body of information, recommendations, and suggestions relevant to all artists or primarily to white (male) artists? Is there an alternative path to recognition and sales for artists who are not white and male?

The answer, not surprisingly, is a mix of yes and no. Perhaps the ambiguity is best described by Yesenia Sanchez, a San Francisco-based professional development consultant to arts organizations and individual artists, who stated that "in terms of guidance that I offer to BIPOC [Black, Indigenous and people of color] artists, often it is the same. However, as a person of color in the arts for over twenty years, I have an awareness of how privilege, access, and representation affect the artists themselves and that they are not playing on a level playing field." Artists who come from less privileged backgrounds, she added, may lack the same level of confidence as their white counterparts and may not look at business development in the same way.

That is not to say that significant steps have not been made at a number of commercial art galleries, nonprofit arts organizations, and museums to provide greater exposure to the work of women artists, African American artists, Native American artists, Latinx artists, and others who are not white and male. In 2020, for instance, the Baltimore Museum of Art vowed that it would only acquire new works that year for its permanent collection by women artists, and the Smithsonian American Art Museum and its Renwick Gallery have pointedly looked to broaden their presentations of the history of American art and crafts with additions to their collections of works by "Black, Latinx, LBGTQ+, Indigenous, and women artists," according to a statement released by the museum.

Moves aimed at increasing the diversity of exhibitions and holdings have had an effect. The June Kelly Gallery and the Michael Rosenfeld Gallery in New York City, both of which were established in the late 1980s with the principal mission of promoting the work of historical and contemporary African American artists, have expanded their focus in more recent years to include a wider array of artists, and not as a result of any failure of the African American art to sell. The Michael Rosenfeld gallery staged an annual "African American Masterworks" show between 1992 and 2001 but "stopped, because, if we really see these artists as great American artists—and we do—then we should just do shows of American art in which African American artists are included," Halley Harrisburg, the gallery's co-owner and director, said. "Pigeon-holing artists can do more harm than good."

Some artists have long rejected the idea of predominantly African American art galleries as ghettoizing artists altogether. "The art world, like the rest of the world, is multi-racial," said Washington, DC, painter Sam Gilliam. "An African American art gallery is a kind of gimmick, but it is wrong to try to create a second nation in America."

The category of "African American art" has begun to break down as one nears the present day. On the part of individual and institutional collectors, there is no less eagerness, and in some instances far higher prices, for the work of contemporary African American artists, such as Dawoud Bey, David Hammons, Glenn Ligon, Martin Puryear, Betye Saar, Dread Scott, Any Sherald, Lorna Simpson, Hank Willis Thomas, Kara Walker, Carrie Mae Weems, and Kehinde Wiley. These artists tend to be represented by galleries that exclusively exhibit contemporary art and, as Elizabeth Sann, associate director of New York's Jack Shaiman Gallery, which represents Nick Cave, Barkley Hendricks, and Kerry James Marshall, among others, claimed, "our goal is to erase the line between contemporary and African American art."

Still, the success of a small number of stars is not necessarily indicative of a larger category. "Galleries in New York City do not reflect America," said Chattanooga, Tennessee, painter Charlie Newton. "They don't represent the larger culture." He added that the majority of his collectors are African American and

probably do not have the means to pay the kinds of prices asked in Manhattan. There is a handful of annual art fairs around the country that specifically focus on African American art, drawing Black audiences and buyers, including the National Black Arts Festival in Atlanta, the Chattanooga Festival of Black Arts & Ideas, the Colorado Black Arts Festival in Denver, and the African American Cultural Festival of Raleigh and Wake County, North Carolina; but Ricardo Morris, founder and chief executive officer of the Chattanooga Festival, stated that "artists cannot make a living just doing Black arts festivals. These festivals are where artists may get their start." In effect, there is no alternative career path for the African American artist than seeking out the same venues as their white counterparts.

It is unlikely that any African American artists are supported solely through sales to Black collectors. Howardena Pindell, a New York City artist, noted that she creates "smaller works for people with smaller budgets," as a way of developing collectors in the African American community. And according to Dean Mitchell, a painter in Tampa, Florida, "once you get past $3,000, you lose a lot of Black people. I've never sold anything to anyone who is Black for $30,000."

Exclusively exhibiting the work of African American artists has long been the goal of George N'Namdi, founder of the N'Namdi Center for Contemporary Art in Detroit and before that the owner of galleries in Chicago, Detroit, and Miami. "A large part of what I do is educate people about a group of artists they may not have heard of," N'Namdi said.

Erasing the line between contemporary and African American art is not as easy as one may hope, and many African American artists who receive recognition are frequently identified in terms of their race, rather than the quality of their work. "For my whole career, I have been 'Benny Andrews, the Black artist,'" said painter Benny Andrews, who died in 2006 at the age of seventy-six. "Everything that a Black artist does gets talked about in terms of social issues and economics by critics." He noted that, years ago, he made two paintings of nudes: "One was a white couple, and everyone said it was Adam and Eve, and the other was a Black couple, and people said, 'What are those Black people doing under that apple tree?'"

Race is unavoidable, but so is gender and age, which may affect who is interested in purchasing someone's artwork and what that person is willing to pay. Faith Ringgold, a painter and mixed-media artist in New Jersey, noted the various roadblocks to her career that she needed to overcome, adding that overcoming obstacles has been and still is "more difficult for women than for men." Looking back over a long career, she said that "it does seem to me that there is less racism now than before," but the only solution for artists is to "be prepared to stay in it for the long haul."

8

The Materials That Artists Use

As important as it is for artists to know how to create art is their understanding of the physical properties of the materials they use and the durability of the works they make. Collectors, viewers, and other artists assume that art should last a long time; pieces that fall apart or lose their color within a few years can greatly damage an artist's reputation.

But beyond consideration of the durability of a work of art, there is another imperative: Artists should have a clear understanding of the materials they are using for quite personal reasons—their own health.

SAFE ART PRACTICES IN THE STUDIO

Many people—the Association for Creative Industries counts 63 million in this country—work on arts and crafts projects as hobbies or professionally. That is roughly 20 percent of the total population busy with painting, pottery, sculpture, weaving, or some other like activity. Unfortunately, part of that vision is that many of these same people are poisoning themselves through using inappropriate materials, unaware that many of these products contain extremely toxic substances. Working on arts and crafts projects at home can be a source of both fun and chronic ailments for professional artists, amateurs, and especially children.

Knowing what's in these products is the first step. Federal and state "right-to-know" laws have made this much easier for those artists who have art-related jobs, such as in publishing or teaching. Employers of these artists are required to provide information about the hazards of the products used on the job in the form of special data sheets. These sheets are called Material Safety Data Sheets, and they include the products' manufacturers and distributors, recommendations for safe handling (protective equipment and how to handle spills), storage and disposal, the level of toxicity and recommended first aid procedures, as well as the physical properties of the product (its boiling point, flash point, melting point).

Self-employed artists also should look up the Material Safety Data Sheets for the products they are looking to buy. Manufacturers and distributors are not required to provide them, but most responsible companies will.

The data sheets are necessary because art materials labels do not list ingredients. And, until recently, only acute (immediate) hazards had to be listed, such as severe eye damage from splashes in the eyes or poisoning due to the ingestion of small amounts of a product.

In 1988, the federal government enacted a labeling law requiring art supply manufacturers to list chronic (long-term) hazards associated with the product on the label. This enables buyers to make safer choices and, if artists understand the hazards of particular chemicals, they can use the warnings to identify the contents. For example, a yellow material labeled with warnings about cancer and kidney damage is likely to contain a cadmium pigment. A material labeled with warnings about reproductive damage, birth defects, nerve, brain, or kidney damage may contain lead. (Unlike ordinary consumer paints, artists' paints are still permitted to contain lead.)

Some of the most common toxic materials found in arts and crafts materials are:

Chemical	Art Material	Major Adverse Effects
Ammonia	Most acrylic paints	Irritates the skin, eyes and lungs
Antimony	Pigments, patinas, solders, glass, plastics	Anemia, kidney, liver and reproductive damage
Arsenic	Lead enamels and glass	Skin, kidney and nerve damage, cancer
Asbestos	Some talcs and French chalks	Lung scarring and cancer
Barium	Metals, glazes, glass, pigments	Muscle spasms, heart irregularities
Cadmium	Pigment, glass and glaze colorant, solders	Kidney, liver and reproductive damage, cancer
Chromium	Pigment, glass and glaze colorant, metals	Skin and respiratory irritation, allergies, cancer
Cobalt	Pigment, glass and glaze colorant, metals	Asthma, skin allergies, heart damage, respiration
Formaldehyde	Most acrylic paints, plywood	Irritates skin, eyes, and lungs, allergies, cancer
Hexane	Rubber cement and some spray products	Nerve damage
Lead	Pigments, enamels, glazes, solders	Nerve, kidney, reproductive damage, birth defects
Manganese	Glass and ceramic colorants, pigments, metals	Nervous system damage, reproductive effects
Mercury	Lustre glazes, pigments, photochemicals	Nervous system damage, reproductive effects
Uranium Oxide	Ceramic, glass, and enamel colorant	Kidney damage, radioactive carcinogen

The federal law was clearly needed. Many chronically toxic substances are used in art materials, including heavy metals (see table above), toxic minerals such as asbestos, silica, and talc, and a barrage of solvents. Exposure to these substances in art materials has resulted in many instances of injury to artists and children. Some artists and children are especially at risk, because they work at home, where exposure is intimate and prolonged. The danger increases when art projects are pursued in living areas, presumably because when they had children they lost their art studios.

Exposure of family members to the toxic effects of art materials can occur in many ways. For example, they can breathe in dusts from pastels or clay, as well as vapors from turpentine and paints or inks containing solvents. Dusts and vapors can travel all through the house, and dusts may also be ingested when small amounts drift into kitchen areas, contaminating food. To combat this kind of exposure, parents should segregate their art activities in rooms that have a special outside entrance and that are locked to prevent small children from entering.

Worktables and studio floors should be wet-mopped regularly. Ordinary household and shop vacuums ought not to be used since their filters will pass the small toxic dust particles back into the air. Sweeping is even more hazardous, for this will cause dust to become airborne.

Running water should be available in the studio. Floors should be sealed to facilitate easy cleaning, and spills must to be wiped up immediately. Separate clothing and shoes should be worn and left in the studio in order to avoid carrying and tracking contaminants into the house.

Monona Rossol, an industrial hygienist and president of the nonprofit organization Arts, Crafts and Theater Safety in New York City, recommended that studios be properly ventilated. The ventilation should be tailored to fit the type of work done in the studio. For example, all kilns need to be vented, and there are several commercial systems that can be purchased for them. More complex equipment may require an engineer to design a proper system.

One simple system she recommends for many individual studios requires windows at opposite ends of the room. The window at one end is filled with an exhaust fan, and the window at the other end is opened to provide air to replace that which is exhausted by the fan. This system should not be used in studios where dusts are created, although it is acceptable for painting and other arts activities that produce small amounts of solvent vapors.

BECOMING MORE ENVIRONMENTALLY FRIENDLY

In many areas of life, consumers may buy products that are less harmful to the environment than other brands, such as purchasing a hybrid automobile or bathroom tissues made from recycled paper or food from farms that practice "sustainable agriculture."

Artists, too, strive to be good stewards of the environment through the purchases they make, but it is not easy as switching to a hybrid car or using recycled materials. Over the past forty years, art supply manufacturers have focused most of their attention on producing products that are safer for artists—less lead (because of the association with neurological disorders) in white paint, for instance,

or moving away from oil-based to water-soluble materials (in order to lessen the problems of fumes that may damage lungs, the liver, and the central nervous system). When products are water-soluble, however, "artists are less likely to assume that they are harmful to the environment and just pour everything down the drain," said Scott Gellatly, product manager at Gamblin Artists Colors in Portland, Oregon. "It is probably more important to inform artists how to dispose of waste in a responsible manner."

In these environmentally anxious days, when everyone is striving to be more eco-friendly and green, a growing number of artists' materials suppliers are marketing themselves as being safe to the planet and nontoxic. Some manufacturers of easels indicate whether or not the wood used comes from a plantation or sustainable forest, rather than harvested from an older-growth forest, for instance. Rex Art, an art materials supplier based in Miami, proudly claims on its website that "Here at Rex Art we do our best to be green. Our offices and warehouse are painted with low VOC paint, we use non-toxic cleaning products and we recycle shipping boxes and packing material. We've installed efficient lighting fixtures throughout our facility and programmed our thermostats so that we use less energy. We even made sure our desks were certified to have less of an impact on the environment throughout their lifecycle." (VOC stands for volatile organic compounds.) Glob Paints, in Berkeley, California (http://www.globiton.com), touts the fact that its paints in six colors (Lemon Verbena, Tangerine, Plum Purple, Berry Blue, Pomegranate, and Basil Green) "are made from fruits, vegetables, flowers and spices" and "are gluten-free, soy-free and vegan." The Earth Pigments Company in Cortaro, Arizona, for its part, makes the claim that "all of our pigments, binders, and mediums are safe, non-toxic, environmentally friendly," in large measure because they do not contain certain hazardous metals, such as arsenic, cadmium, chromium, lead, mercury, or tin. That's fine as far as it goes, but many artists want more than just earth tones. They will end up looking for metals, such as the cadmiums and cobalts, and their choice is simply to purchase it from some other supplier. It is important to note that artists' materials suppliers don't make or produce pigments themselves but purchase pounds and kilos of them from mining companies

abroad whose main buyers have industrial uses in color-making. In fact, these companies are not necessarily mining for pigments at all and instead are seeking a certain kind of ore when they happen to run across a vein of ochre or something else. This will be sorted out and sold to middlemen who are the suppliers to the makers of artist materials. The mining companies themselves operate under different national laws, which are generally strict and (one hopes) enforced.

With companies that produce artists' paints, the "green" claims principally involve how they dispose of waste. Golden Artist Colors, a manufacturer of water-based paints in New Berlin, New York, for instance, has a multistep process of treating the two thousand gallons of wastewater produced each day. The water is not dumped down the drain but put through an initial filtering process that separates the acrylic solids from the clear water, according to Ben Gavett, the company's director of regulatory affairs. Those solids form a largely dry "waste cake" that goes to a landfill, while the remaining water undergoes a reverse-osmosis filtering system that separates chemicals in one stream (sent to a waste treatment facility) and clean water in another (to be reused back in the factory). "We recycle many different things—electronic equipment, paper, printer cartridges, you name it—but our largest concern is the water we use here," he said.

Gamblin Artist Colors, whose factory is 100 percent wind-powered and seeks to "buy the materials we need as local as possible" in order to limit the transportation carbon footprint, Gellatly said, has another way of reusing what otherwise might be viewed as waste material. The company uses an air filtration system to protects employees from exposure to pigment dust. Every year, this pigment is collected and, rather than sending it to the landfull, Gamblin uses this mish-mosh to form a generally dark gray paint, which it calls Gamblin Torrit Grey (named after the company's Torrit Air Filtration system) and markets toward the end of April around Earth Day.

Like "all-natural" and "organic," "green" isn't a term regulated by governmental agencies but often is defined by whomever is using it. Because of the concern over their proprietary formulas and trade secrets, manufacturers of artists'

materials continue to be reluctant to reveal completely what is contained in the products they sell.

Monona Rossol noted that she is often skeptical about the "green" claims of many art supply companies. "You need to separate their environmental practices from what is safe for you in the studio," she said. She noted that citrus oil, which is regularly marketed as a safe substitute for turpentine, "is considered green, because it's biodegradable. However, it's every bit as toxic as turpentine for you." In general, she doesn't trust many of the artists' materials manufacturers, "because they won't tell you all the ingredients in their products" on the federal government–required Material Safety Data Sheets. "Many of the ingredients in their products have never been tested for toxicity, so how can they claim they won't harm you? But, still, most of these companies put the nontoxic label on their products."

PROPER DISPOSAL PRACTICES

Gamblin's website (www.gamblincolors.com) offers some guidance for studio practices in its "Newsletter" section, but the essential information largely boils down to one sentence: "Call your local recycling center for disposal instruction." Many other art supply manufacturers do the same or just hope that artists will know what to do. "On our tubes, we provide a very general statement, 'Dispose of appropriately,'" said Art Guerra, owner of Guerra Art Supplies in Brooklyn, New York.

Art supplies are chemicals; even watercolors and gouaches, which are more environment-friendly than many other products, have pigments that are chemicals, and you don't want these things in your body or in the environment. In other words, artists cannot just buy their way into "green-ness" but must be vigilant about what they do with all the supplies they use. Eventually, things get thrown out. Sometimes, it's a lot of things, from artworks that didn't sell to ones they have grown ashamed of, and then there are all these leftover materials: Paint scrapings, inks, clay and stone chips, cleaning rags and solvents, lacquers, varnishes and patinas, cans and tubes of this and that. In the fine arts, the fight for a greener world often takes place right in the artist's studio, specifically when it comes to taking out the trash.

Perhaps the first solution to the problem is not to have so much trash, which may mean not purchasing more of some product than one actually needs (so there is less to throw away), and a second is donating excess material to some nonprofit organization. Michael Skalka, former conservation administrator at the National Gallery of Art in Washington, DC, who chaired the artists' materials subcommittee at American Society for Testing and Materials, recommended contributing half-used paints and other materials to Habitat for Humanity, while Marc Fields, president of the New York–based sculpture supply company The Compleat Sculptor, recommended donating hardened oil-based clays to public high schools and colleges: "What isn't usable for professional artists may still be usable for schoolchildren," adding that those clays can be reconditioned with oils to become flexible again. On the other hand, professional artist-grade materials may contain metals, such as lead or cadmium, which are prohibited from use in public schools, and the Consumer Product Safety Commission prohibits the use of adult art materials by children in grade six or under.

Of course, donating excess materials only works on the margins of a larger problem, which is how to dispose of them safely, ensuring that potentially harmful ingredients in these products do not leach into the public water supply. What artists should do is not always clear, in part because there are different rules for hobbyists than for professional artists—hobbyists are assumed not to produce as much waste and are permitted to dispose of most of their art-making waste with household trash, while professionals are held to the standards of small businesses and educational institutions—and the fact that regulations for disposing of potentially hazardous wastes vary from one municipality to another. As a result, product manufacturers only recommend that buyers follow local waste treatment regulations—the Farmingdale, New Jersey–based clay manufacturer Chavant, for instance, stipulates that its clay should be disposed of "according to local ordinances"—and that requires artists to find out what the rules are.

The federal Environmental Protection Agency sets certain mandated guidelines for hazardous waste disposal, and individual states may either adopt these rules wholesale or go beyond them. Each state has a governmental department of

environmental protection that provides information for the closest recycling or transfer station relevant to the type of item needing to be disposed of, and an online source of help to find these sites is www.earth911.com. Towns and counties have landfills, administered by a local department of public works, which establish guidelines for types of trash and recyclable material that can be brought in, and they also are in charge of the collection of hazardous waste, including poisons, solvents, and aerosols, which may be collected once a month or less frequently.

Distinguishing between hobbyists and professionals is a fruitless exercise. Many retirees can be labeled as amateurs and hobbyists but work at their art forty hours a week, while school art instructors are technically professionals but may be too busy with their teaching to produce much in their studios, and their sales may be small to nonexistent. Because of this, it makes most sense to view all hobbyists and professionals simply as artists who should all follow health- and environmentally conscious studio practices when they produce trash. (It should be noted that the artwork done by school art instructors in school, and the manner in which wastes produced there are removed, does fall under the regulations of the Environmental Protection Agency, which recently redefined the term higher education "laboratory" to include "art studio.")

All painters, for instance, clean their brushes, releasing into either water or some solvent the pigments that may contain one of the heavy metals. Alan Cantara, environmental health and safety manager at the Rhode Island School of Design, recommended prewiping brushes with a cotton rag or paper towel, which "removes between 60 and 90 percent of the paint from the brush," before soaking the brush. The rag or paper towel has just become a hazardous material and should be placed in a metal bin with a cover on it. Laboratory safety supply companies sell fifty-five-gallon drums for approximately $75; the lids on them inhibit the collection of oxygen within the drum, keeping a rag covered with linseed oil from drying out, a process that generates heat and potentially spontaneous combustion. When the drum is filled, it should be taken away by some hazardous waste hauler for incineration. Incinerators burn hotter and more thoroughly than the fires individuals might set in their backyards, and the companies that incinerate also filter the

smoke and ashes in order to ensure that harmful particulates do not get into the air or groundwater.

For painters using water-based or acrylic paints, they can then wash their brushes in soapy water. Michael Skalka and Woodhall Stopford, toxicologist for the Arts and Creative Materials Institute, both claim that this soapy water can go down the drain in relative safety. The system used at the University of North Carolina's art department, on the other hand, involves three separate tubs of water used to clean brushes—the first filled with soapy water, the next two with clean water, finally placing the contents of all three tubs in a fifty-five-gallon drum—and having a hazardous waste disposal hauler remove it. Separating hazardous from nonhazardous material—or trying to guess which materials may be nonhazardous—is time-consuming and likely to lead to mistakes. Artists ought to treat all their waste products as hazardous, which makes decision-making much easier.

Those using oil-based paints, on the other hand, will use some type of solvent for completing the cleaning of their brushes. A small container of solvents can be reused for a number of times, because the pigments in the paint are heavier than the liquid and will sink to the bottom, leaving the liquid clear. Eventually, the solvent will become cloudy and need to be replaced in the container, and the contents should be dumped into a fifty-five-gallon drum; when full, a hazardous waste hauler will take it away for incineration.

Solvents should never be poured down the drain, and landfills do not want liquid waste. However, it may be possible to evaporate a solvent by putting it outside in the sun, which is not great for air quality but poses smaller risks when the amount of liquid is relatively small, leaving behind a solid "cake" of pigments. Once the solvent has evaporated and the oils have become set, they become inert although they still may be considered harmful. Landfills will accept solid artists' wastes as long as they are not toxic. If an artist is working with products that are labeled hazardous, then these should be segregated for disposal as hazardous wastes.

Unwanted painted canvases may be scraped down and reused; otherwise, because of the metals stuck on, they must be considered hazardous waste rather

than placed in a landfill. Burning canvases outdoors releases fumes into the air and doesn't completely carbonize the solid material, allowing it to seep into the groundwater supply. In most municipalities, one may discard as ordinary trash a tube or can of paint that is empty (nothing comes out when you squeeze the tube, it takes hours for a single drop to come down the side of an overturned can), regardless of what was contained in the tube or can. This is an area in which an artist might need to consult local waste disposal regulations, particularly where a requirement is that containers must be rinsed out (it is impossible to rinse a tube of paint).

Sculptors face a variety of health risks within their studios, particularly from dusts from dry clays and plasters that need to be mixed, as well as from certain types of stones that are carved, which are linked to respiratory illnesses, and from patina mixtures for metal sculpture that can contain acids. Clays, both water- and oil-based, plaster, and stones may be placed in landfills. Digital Stone Project, a computer-aided stone carving foundry in Mercerville, New Jersey, "ships dumpsters of stone to a recycling center where it is used for road paving," said Steve Flom, a staff sculptor.

Ceramic shells are not considered to be hazardous waste and may be recycled for construction projects or as filler for concrete.

The polysulfides, silicones, and urethanes that artists use to create molds for casting wax, resins, plaster, concrete, and other materials are more hazardous in the liquid forms by which they are sold. However, one purchases them in two parts (Part A and Part B), which are to be mixed together, often in one-to-one ratios, which harden to form a solid. That solid foam, plastic, or rubber may be taken directly to a landfill (the catalytic reactions generated by the combined liquids have already taken place). If a sculptor only has one part—perhaps the other part spilled or is lost—they may purchase the other part separately (for use in making a mold or just to form a solid that can be thrown out) or turn it in during a hazardous waste disposal collection.

Of greater concern are the liquids that sculptors may use, such as patinas, lacquers, and varnishes, which are hazardous materials. However, they tend to be used in small amounts—for instance, one cup—that may be left outside to

evaporate (more quickly in dry, warm environments than in more humid ones), at which point any remaining solids are inert and can be put in a landfill. For those who look to speed up the process, Marc Fields recommended pouring plaster into the liquid, "which will fix it, then dispose of it as solid waste."

Good things sometimes result from bad ones. An useful source of information for artists is an Environmental Protection Agency booklet titled "Environmental Health & Safety in the Arts: A guide for K-12, Colleges and Artisans," which was prepared by Pratt Institute (www.epa.gov/Region2/children/k12/english/art-1of5. pdf) as part of a $300,000 settlement by the school with the EPA because of improper waste disposal practices.

A PRIMER ON PAINT LABELS

What information should be on the label of a tube of paint? Presumably, prospective buyers would want to read about what is inside the tube, such as the pigment, medium (oil or acrylic, for instance), other admixtures (additives, binders, coarse particle content, extenders, preservatives), and the durability (or lightfastness) of the product. As noted above, art supply companies are also required by federal law to indicate which ingredients are known to cause either acute or chronic illnesses ("has been shown to cause cancer"), what those ailments are, and how the product should be used properly, as well as the name, address, and telephone number of the manufacturer.

Unfortunately, not all art supply makers provide all this, and many offer bits and pieces of information, often using proprietary names and terms or codes that mean different things to different manufacturers.

The hues and proprietary color descriptions are obviously one example. Most tubes of artist paints include a number that corresponds to a standardized Color Index, a nine-volume reference that is jointly produced by the Society of Dyers and Colourists in England (P.O. Box 244 Perkin House, 82 Grattan Road, Bradford West Yorkshire BD1 2JB, 011-44-1274-725138, www.sdc.org.uk) and the American Association of Textile Chemists and Colorists in the United States (One Davis Drive, P.O. Box 1215 Research Triangle Park, NC 27709–2215, 919-549-8141,

www.aatcc.org). This reference may be accessed through the payment of a subscription (www.colour-index.com), while other print editions may be found in technical and art libraries. It lists by CI (color index) the name and number of all commercially available dyes and pigments and their intermediates. One may also contact the American Society of Testing and Materials (100 Barr Harbor Drive, West Conshohocken, PA 19428, 610-832-9500, www.astm.org) for precise descriptions of pigments and the durability of pigments. For alkyds, oils and resin paints, the specifications are contained in ASTM D-4302; for watercolors, ASTM D-5067; for acrylics, ASTM D-5098. Each ASTM standard costs between $50 and $100. Artists may want to write to the manufacturers when tubes do not indicate the color index number or that number is not clear. The label for Liquitex's Cadmium Red Medium, for instance, says "Munsell 6.3 R," which is the index number (the R refers to a shift to the red).

Permanency ratings is another area in which one might contact the manufacturer for more information if the label is not clear or decipherable. The American Society of Testing and Materials rates paints I, II and III for their resistance to fading in daylight, or lightfastness, with I the most resistant. Liquitex follows the ASTM format in its lightfastness ratings, but Van Gogh ratings are +++ and ++, with +++ the highest degree of lightfastness and ++ what the company calls "normal degree of lightfastness." Rembrandt lists lightfastness, starting with the most permanent, as A, B, C and D. Winsor & Newton has two different rating systems: ++++, +++, ++ and +, and AA, A, B and C (++++ and AA are the most lightfast). The ASTM standards are quite useful in terms of understanding the actual color, performance and quality of an art product.

Part of the system established for labeling by the American Society of Testing and Materials requires manufacturers to list on the product label the enhancers used when they comprise more than two or three percent (by volume) of the material. Not all American companies, however, subscribe to the ASTM standard, and few European suppliers do.

The paint's durability as well as its color index name and number are optional for manufacturers to include on the product label, but health and safety information

is not. Since 1990, the federal Labeling of Hazardous Art Materials Act requires that all art materials sold in the United States include a conformance statement ("Conforms to ASTM D-4236") that ensures the manufacturers submitted their product formulas to a board-certified toxicologist for review. The toxicologist determines what labeling is required under the standard. Also required is a telephone number in the United States from which additional information may be obtained. There are a number of board-certified toxicologists working with art materials companies. Many companies subscribe to the labeling program of the Boston-based Arts and Crafts Materials Institute: "AP Nontoxic," "CP Nontoxic," and "Health Label" seals appear on the labels of their paints. Both "AP" and "CP" indicate that the Institute certifies the products are safe even for children ("AP" specifically refers to nontoxicity, while "CP" includes both nontoxicity and performance requirements), and "Health Label" signifies that the warning label on the product has been certified by an ACMI toxocologist and, if hazards are found, appropriate warnings are printed on the label. After review, the Institute's toxicologist can allow the product to carry one of its seals. However, the same paints may be sold by a mail order company but without the ACMI emblems to indicate their safety.

Very small tubes of paint are exempted from including most of the required federal labeling. The safety information on a tube of Windsor-Newton cadmium red watercolor paint, for instance, was condensed to three words—"Warning: Contains Cadmium." By this standard, a cigarette pack might simply inform buyers that the product contains tobacco.

The appearance of a conformance statement and a health label does not instill confidence in every art product user that all acute and chronic health risks are identified and described. According to the US Public Interest Research Group, which issued a report in October 1993 entitled "Poison Palettes: The Lack of Compliance of Toxic Art Supplies with Federal Law," the question of nontoxicity is a loophole-filled designation, and the labeling law is itself buffeted by insufficient compliance. The report found that warnings about chronic health hazards and the manufacturers' telephone numbers were frequently missing from the product labels.

"Art materials are not as safe as many people have been led to believe," said Bill Wood, a researcher for the research group and author of the report. "Many products may be labeled nontoxic if they have never been tested for toxicity. The Environmental Protection Agency has complete test data on only twenty-two of the more than seventy thousand chemicals produced by chemical manufacturers in this country. To call something nontoxic when you don't actually know is misleading."

Monona Rossol added that "a benzidine dye that hasn't been tested can still be marketed as nontoxic, even though it breaks down to free benzidine in the body, which is well known for causing bladder cancer as well as other diseases."

The "ASTM D-4236" on the label is supposed to mean that the toxicologist has reviewed the product's formula but, Rossol said, "there are mislabelers out there that just put this on the label. Artists should choose to buy paints from one of the large, reputable companies that has the proper label."

However, Woodhall Stopford, a consulting toxicologist for the Arts and Creative Materials Institute and director of the Occupational and Environmental Safety program at Duke University Medical Center, claimed that the US Public Interest Research Group report was flawed in that it made no distinctions between higher-risk, industrial uses of art materials, such as spray painting an automobile, and the more limited exposure in artmaking.

"With fine art materials," he noted, "you are dealing with amounts so small that the risks—even assuming that a child is going to be using the product, and ingesting, inhaling, or having it in contact with skin on a daily basis—are minimal."

MEDICAL TREATMENT FOR ARTISTS

Here is a medical success story: A twenty-two-year-old painting student at the Art Institute of Chicago was becoming depressed and withdrawn, delusional and paranoid, refusing to leave his apartment. Eventually, the school he attended recommended that the student see a psychiatrist. The symptoms "were not, in some ways, atypical for college students who have psychotic breaks during this period of

their lives," according to Dr. David Hinkamp, an occupational medicine specialist in Chicago who treated him. It was the psychiatrist who referred the young man to Dr. Hinkamp, believing that the student's symptoms were the result of exposure to solvents in his art materials, such as turpentine. The student painted fifty to sixty hours per week at school, taught a spray-painting class to area teenagers, and then went home where he painted some more, he said. "This really was twenty-four-hour exposure, and it was creating neurological problems."

Dr. Hinkamp gave the young man a crash course in what is in the art supplies he used, how they should be handled in a safer manner, the types of air hoods and ventilation systems needed to remove hazardous dusts and supply fresh air to his workplace and suggestions for some less toxic versions of the materials he used, such as turpenoid in place of turpentine. "He snapped back after six weeks," he said, becoming once again "bright and outgoing."

That student was lucky. "Usually, by the time you get symptoms, you have already reached a level of toxicity that is difficult, although not impossible, to treat," he said. For instance, lead, an element banned in house paints and all children's paints, the result of its potential to cause damage to the brain and nervous system, continues to be available for the professional artist, because it is highly opaque—a small amount covers a relatively large area—and keeps the paint flexible and crack-resistant for a relatively long period of time. Even those artists who have stopped using lead in their paints may not be free of the problems, because "lead gets deposited in the bones and slowly leaks back into the blood, intoxicating you." Over a longer period of time, lead is slowly filtered out of the body by the kidneys, but those who continue to use paint that contains lead won't be free of the toxins, he added.

That student also was lucky because a doctor related the symptoms to the type of artwork he was doing, rather than just prescribing antipsychotic medications. Dr. Hinkamp is one of a relatively small number of physicians who specialize in treating visual artists, but he noted that "we're a tertiary referral service. By the time a patient comes to us, that person has already seen one doctor who referred him to some other doctor, and that person made a referral to us." Most doctors "will

never ask you much about your profession. They have so many questions to ask new patients. If they ask your profession and you say 'artist,' they will say 'OK' and move on to the next question without asking what kind of art you make and the types of materials you use." The average doctor's visit is fifteen to seventeen minutes, and the goal is to fix whatever is wrong in that period of time. The likelihood of a general care doctor recognizing a link between what the patient has and what they do for a living is remote.

As a result, artists cannot rely on health-care providers to connect what they have with what they do and must become their own sources of information, he said. The presenting problems, such as numbness in one's fingers and toes or memory loss or diarrhea are not unusual disorders, but they can be associated with solvents or lead. Sculptors who do welding may be subject to the same risks of inhaling manganese fumes as professional welders, and manganese is associated with the onset of Parkinson's disease. Katherine H. Kirkland, executive director of the Washington, DC–based Association of Occupational and Environmental Clinics, noted that the difference between someone getting help early on or too late is "how alert the primary care physicians or the patients themselves are to the fact that they need expert help." The fear on the part of workers in a number of fields that reporting ailments may cause them to lose their jobs also results in treatment taking too long to get started.

Artists generally do not account for a significant percentage of the patients at these clinics, although those in New York City tend to get the greatest number— "Broadway folks, dancers and musicians," she said—which she attributed to the fact that people in the performing arts are better attuned to changes in their bodies than those in other professions and are quicker to seek help. (She noted that the least likely group to seek medical help are performers in Cirque du Soleil, "who won't admit that anything is wrong and won't take time off. They are absolute workaholics.")

The association (www.aoec.org) has approximately sixty member clinics in twenty-five states and the District of Columbia, as well as three Canadian provinces, that work with people who have work-related ailments (occupational

medicine) or who live in an area where certain types of usually industrial work is done (environmental medicine). The majority of these clinics are affiliated with teaching hospitals, Kirkland said. These clinics accept health insurance, but for artists who only may have a private plan that does not cover out-of-network referrals completely or at all, the cost becomes one more barrier to receiving timely help. She noted that many of the association's member clinics will work with people who have "limited funds, but decisions on that aren't up to the individual clinics so much as the academic institutions to which they are affiliated. Only a small number of non-reimbursable patients are permitted."

There are many more occupational medicine departments at hospitals than are members of the association, and artists who believe they have work-related ailments can go to one of these in search of help.

There are far more specialists in the treatment of physical ailments of performing artists (dancers, singers, musicians, actors) than of visual artists, and many of these practitioners are associated with teaching hospitals, such as Cleveland Clinic (Center for Performing Artists), Washington University Orthopedics (Performing Arts Program), Sinai Hospital in Baltimore (Medical Guidance and Treatment for Performing Artists), Rehabilitation Institute of Chicago (Performing Arts Medicine), Houston Methodist Hospital—Texas Medical Center (Center for Performing Arts Medicine), University of California at San Francisco Benioff Children's Hospital (Health Program for Performing Artists), Mount Sinai Beth Israel in New York City (The Louis Armstrong Center for Music & Medicine), Michigan Medicine—University of Michigan (Performing Arts Injury Clinic), University of Wisconsin Hospital (Performing Arts Medicine) and New York–Presbyterian Hospital/Weill Cornell Medical Center (The Center for the Performing Artist). There may be some overlap of the types of injuries experienced by both performing and visual artists, but Dr. Hinkamp noted that physicians at these facilities are more experienced and knowledgeable about the ailments of performers and "might not offer much help to fine artists."

Yet another source of help for artists is occupational therapists for which the national organization, the American Occupational Therapy Association (www.

aota.org), maintains a listing of these practitioners on a state-by-state basis. Additionally, occupational therapists increasingly are on the staffs of medical practices, making the process of a referral from a primary care physician potentially more expeditious. Still, according to Karen Jacobs, a professor in the department of occupational therapy at Boston University's College of Health and Rehabilitation Services, "artists must make it known to their doctors that they need this kind of care."

Occupational therapists frequently start out asking patients to write out an activity time log for the week, noting the types of work they are performing and when they are in any sort of pain. "That enables us to identify any patterns that are contributing to the problem," she said. Additionally, these practitioners will go to the individual's work site to observe and videotape, which may reveal the patient's posture, the amount of light, the air quality, and any odors, "and then we develop an intervention. It may be as simple as recommending the person take a break every thirty minutes. There's too much repetition. One time, I noticed that a sculptor was working on a table that was too high, requiring him to reach over too much, which was causing strains. Using a hydraulic system of raising and lowering the work area made a difference." Ideas for conserving an artist's energy and making modifications in how the work is done develop collaboratively between the artist and occupational therapist. She noted that, while occupational therapists are trained in general areas of workplace injuries, they are less likely to know the specific issues of toxicity in the products that artists are using, "and they would recommend bringing in an industrial hygienist, who would know what's in the air and how that should be improved," she said.

Most health insurance plans cover occupational therapy, although the out-of-pocket costs for seeing someone privately range from $75 to $125 per hour, depending upon location.

For those interested in alternative medicine, there also are options for artists with work-related ailments. Al & Malka Green Artists' Health Centre in Toronto and Green Acupuncture and Med Spa in Johns Creek, Georgia, offer programs for performing and visual artists. Dr. Sam Kim, director of Green Acupuncture, noted

that many of his artist patients had gone "to a primary care doctor first but came to see me when there was no result." He stated that work-related ailments usually reflect "an imbalance in the body system, affecting energy and blood flow," the causes including repetitive motions and ingesting toxic substances. "I listen to my patients' complaints, trying to find what has been weakened, where the imbalance is in their bodies, where the blockages are that is the cause of pain," he said, using herbal treatments and acupuncture to correct what has gone wrong.

TRANSPORTING SCULPTURE

Artwork may get panned by critics, defaced by vandals and crazy people, or just ignored by everyone, but sometimes the worst thing that can happen to a work of art is moving it. Things fall off the side of a truck and break, the prongs on a forklift impale an object packed in a crate, an object is shipped or stored upside down or on its side, affecting its balance, another object is warehoused for some period of time in a damp warehouse leading to mold or rust. Fill in the blank with your own horror story.

Perhaps even more worrisome is transporting a maquette, for instance to a foundry for enlargement and casting or to some agency or individual in order that the design is approved as part of a commission agreement. "Things come in needing to be fixed all the time," said Mitchell Meisner, president of Meisner Art Casting in Farmingdale, New York. "We try to touch it up from photographs, or we'll bring the sculptor in to try to make it right." Often, Meisner is so convinced that the maquette won't make it to the foundry in reasonable shape that he sends a moldmaker to the artist's studio to take care of that part of the job there, or he will go to the studio to pack and drive the model back to Farmingdale himself. "I'll drive like an eighty-year-old grandmother, but I'll bring it here in good condition."

Sending a maquette is one of the riskiest activities for sculptors, and they take a range of approaches to this part of their job. "I try to get clients to come to my studio," Loveland, Colorado, bronze wildlife sculptor Dan Ostermiller said, or "I try to get a client to give preliminary approval through photographs." Boaz Vaadia

of Brooklyn, New York, goes a step further, emailing Photoshop images of how a proposed sculpture will look on-site to those commissioning his work. "I'm asking people to totally trust me and to trust my creative process. If someone insists that I bring a maquette to them, I don't do it. They have to trust me."

Both Ostermiller and Vaadia make the molds for their sculptures in their studios, which they then send on to foundries, as they are reluctant to ship maquettes. "So many problems can happen," Vaadia noted. When he has transported a maquette, Ostermiller drives it himself ("a couple hundred miles at most"), taking along a companion who holds onto the crated model for the entire trip. Bathroom and meal breaks are kept to a minimum, because plasticine may melt in the heat, so "you can't leave it in a hot car for a long time—you need the air-conditioning going the whole time." (Or kept at a moderate temperature if traveling during the winter, since clay and plasticine become brittle in the cold.) No less worrisome is hitting a pothole or a curb, which can loosen the model's armature from the base. More often, if he needs to drive the maquette, Ostermiller casts it first in plaster at his studio, again hoping that the car ride is smooth so that no cracks develop in the plaster.

Vanessa Hoheb, who works with artists at Polich Tallix foundry in Rock Tavern, New York, recommended that artists "transfer their clay or wax" models into plaster or some harder material before shipping them off, calling clay and wax maquettes "an accident waiting to happen."

A lot of things can go wrong, requiring sculptors to think about how their work will be protected from the very start. That starting point is often the armature, which must be sturdy, but then comes the packing and crating. Shredded newspapers, Styrofoam "peanuts," bubble wrap, blankets, spray foam insulation, or Ethafoam all may provide protection, allowing the maquette to "float" in a crate and not touch any of the sides that can be bumped during transport. Hoheb noted that bubble wrap may leave an impression on the surface of the maquette, requiring that the artwork first be wrapped in paper, and she recommended that the density of the wrapping material increase as one moves out from the maquette toward the sides of the crate.

The larger and heavier the crate, the more expensive the shipping. John Henry, a sculptor of large-scale abstract steel pieces in Chattanooga, Tennessee, noted that he pays $150–$250 to pack, crate, and ship his maquettes to the people who commission his work for their approval ("I don't live where most people can't come by to look at the piece"). His models are made from machined aluminum, wrapped in soft blankets, and then surrounded by bubble wrap when packed in a cardboard box, which is next put in a larger wooden crate with more bubble wrap between the two boxes. Everything he has shipped out has arrived in good condition, and the only problems have arisen "when people return things to me, because they don't take as much time packing everything carefully."

Mitchell Meisner also is an advocate for double-boxing maquettes, only adding that the outer box always should be wood, because "cardboard also gets thrown around and dropped, and things get handled a lot better when they are in a wooden crate." After the artwork is placed in the crate, the top side should be fastened not with nails, since the hammering may jar the sculpture that the box is intended to protect, but with screws. It is also wise to place skids under the bottom of the crate, in order that the prongs of a forklift can get underneath the box, and write "TOP" on the crate in order that it be transported properly (placing some sort of ornament on top as well might make even clearer to movers which side is up and which down).

Another artist who regularly ships her maquettes is Philadelphia sculptor Mary Sand. Driving her models to the foundry isn't an option for her, since for reasons of lower cost she uses the Berkeley, California, foundry Artworks, although some of those savings do get eaten up by the expense of shipping, which can reach $325 and higher. She applies three layers of rubber around the model, "which keeps the clay protected and gets the process of moldmaking started," and then blows foam around the whole thing in the wooden crate.

At times, she surrounds the rubber with bubble wrap and then the blown-in insulation. There haven't been any problems but, "when it's a complicated piece, I still get worried." At that point, she flies out to California with the crated work, booking an additional seat on the airplane for the crate, although if it is a small

work "I might be able to put it in the overhead bin." The worry then transfers to airport security, which generally wants to have the maquette unwrapped in order to look at the clay and armature ("do they think I've worked this hard just to blow it up?"). That adds to the time it takes to get through the airport, but so far there haven't been any missed flights or damage during the unpacking and repacking. Airport security people just look and don't touch, knock on wood. No one ever said that being an artist is worry-free.

TRAVELING WITH ART SUPPLIES

There Daniel Greene stood, waiting to board an airplane at the Dallas airport, while a security official pawed his carry-on box of pastels, wondering if they were colored bombs. "She didn't know what pastels were and, because of that, I almost missed my plane," Greene, an artist in South Salem, New York, said. "The only satisfaction I got was that she had to wash her hands when she was done."

This odd scene actually occurred before September 11, 2001; since then, people have lost much of their sense of humor about air travel, and worries about what is being taken aboard have increased markedly. Tightened airport security since the terrorist attacks have changed the way US passengers have been accustomed to flying, from arriving two hours before departure and enduring lengthier pre-boarding searches to the elimination of curbside baggage check-in and more rigorous enforcement of luggage weight allowances. Airport security guards are now employees of the federal government, rather than the airlines or airports: Their watchfulness is greater, and their procedures are more consistent around the country. The lengthier process of boarding an aircraft has been offset by the higher level of protection that passengers now enjoy.

The tricks that used to work no longer do: Regularly flying around the United States to lead workshops in portraiture, Daniel Greene used to take three boxes with paints, pastels, paper, canvas, boards, extension cords, palette knives, brushes, stands, spotlights, turpentine, and videocassettes as his flight luggage. "I had them checked curbside," he said. "They were always considerably over the weight limit, but I tipped the baggage handlers lavishly so they wouldn't hassle me.

You can't get away with that anymore." Airline officials are much stricter in adhering to package and luggage guidelines: Passengers may take only two bags, weighing no more than fifty pounds apiece for domestic flights or up to seventy pounds for international trips. Beyond that weight limit, one may be required to pay substantial penalties or not be able to take the packages at all. These days, Greene ships these materials ahead of time by FedEx, paying between $150 and $160 each way.

In this new world, some fine artists have found seemingly harmless materials removed from their bags by airport guards. "Artists call me: They've had their paints confiscated, and they are very upset," said Joe Gyurcsak, a painter and brand manager at Utrecht, the art supply manufacturer and store. Artists have also called or emailed Robert Gamblin, president of Gamblin Colors, a paint supplier, with similar complaints, "and this is probably just the tip of the iceberg." He noted that an artist typically takes a paint box as part of carry-on luggage. "The security person asks, 'What is this?' and the artist say, 'These are my paints,' and that triggers the problem." Gamblin explained that "paint" is a hot-button word for security agents, since it is described as a hazardous, combustible material by the federal Transportation Safety Administration. "The word 'paint' never appears on our products," he said. "They are called 'Artist Colors,' which is how artists should refer to them."

Safer yet (at least from the standpoint of getting on board) is to check paint boxes and all other art materials with regular luggage. Those artists who need to keep their art supplies close at hand ("My paint box is very fragile," portrait artist Ray Kinstler said) should remove any palette knives, regardless of how dull the edge.

Regardless of hassles, artists traveling overseas or across vast distances in the United States are likely to take airplanes, and the watchword for them is to travel light and ship certain items ahead—such as by UPS or FedEx Ground (if the items are combustible, such as solvents, fixatives, or turpentine, and are not permitted on aircraft)—or to purchase needed materials where they are going. "Most of the places I go to will have an art supply store, if it's a city of any size," said New

York artist Richard Haas. "If it's a small town, there may be a problem. The secret is, don't do things in small places."

Artists, of course, may want to use the supplies and materials with which they are most familiar, rather than hope to find the same or similar wherever they are traveling. A problem with shipping materials ahead may include rough treatment, extremes of cold storage (if acrylic paints freeze and then thaw, they become difficult to use, turning stringy and not workable with a brush) or intense heat. Combustibility can be an issue for certain items, such as solvents, which spontaneously ignite if the temperature rises to 140 degrees Fahrenheit, the federal limit for transporting inflammable materials by air. Joe Gyurcsak stated that Dorland's Wax Medium, an oil paint additive, has a "flash point" of just above 100 degrees, while linseed oil is safety rated to 550 degrees.

A list of prohibited items for air travel can be found on the website of the Transportation Safety Administration (www.tsatraveltips.us, click on Air Travel and Prepare for Takeoff). Robert Gamblin suggested that artists obtain and bring with them Material Safety Data Sheets, the manufacturers' description of the product, and recommendations for safe and proper use. In general, Gamblin added, artists should "keep your cool" around airport security and "seem to know what you're doing. If there is any question about what you're bringing, show them the Material Safety Data Sheets and explain that you are going on a painting holiday."

9

Getting Ready to Handle the Pressures

Learning how to handle the pressures of creating art or of being an artist is something each creator must do for him- or herself. When painter Philip Guston wanted to obliterate all the art history he had filling his mind and forget the work of other artists in order to ready himself for something new, he would take in a double feature. Painter and sculptor Lucas Samaras claimed that "I generally clean the house a few times, go shopping, all sorts of stuff to wipe my consciousness clean of what everyone else is doing."

Other artists have been more self-destructive when responding to pressures, relieving their psychological stresses by harming their bodies. Some artists have adopted the view that such behavior enhanced their art. Alexander Calder overate; Pablo Picasso vented his anger on women; Jackson Pollock and Franz Kline both got drunk; Jean-Michel Basquiat took drugs. Some artists simply have found the pressures on their lives too great to be borne.

Some ways of handling talent and artistic pressures are clearly preferable to others. Unfortunately, stories about self-destructive artists have given the world an image of what an artist is and does, and many younger artists seek to live up to the bohemian image. The likelihood, however, is that this leads to more ruined lives than to more good art.

In *The Thirsty Muse*, literary historian Tom Dardis wrote about "what a number of . . . great talents have sought in [alcohol and] drugs: an altered state of consciousness that permits the artists a freedom they don't believe they possess in sobriety. The fact that this freedom is illusory is beside the point; many artists have convinced themselves that they obtain it in no other way."

At times, artists may set their expectations too high, at least at the outset, identifying only the most prominent art gallery as befitting their work and viewing any other venue as a disappointment, or defining success in terms of a major museum retrospective or making the cover of *Art in America* or having their work priced at some five-, six-, or seven-figure amount. Feelings of rejection and loneliness, or being marginalized and silenced, the anxiety of spending months or years producing something and then waiting for some sort of response (and being perceived as overly sensitive when that response comes)—these are common to all artists, regardless of how well their careers have gone. No discussion of the pursuit of an art career can avoid some of these emotional issues, because they are as central to the lives of artists as whether or not they produce a winning press release or say the right thing to an important dealer or collector. Clearly, it is important for artists to know what some of the potential pressures will be in their lives and careers in order that they may be prepared.

POST-EXHIBITION BLUES

Artists often think about the exhibition going up—a year or two's worth of work hung on the walls, the opportunity for praise, congratulations, reviews, sales—but not so much about the show coming down. And down they always come, after three or four weeks, to be followed by someone else's chance at attention. The exhibit recedes into memory and life goes on: time for the artist to start something new. It is not always that easy to get moving again, however, since many artists suffer a letdown, a feeling of emptiness—some psychologists liken it to postpartum depression—after the show is over.

The feeling usually does not last very long, and within a week artists are entering a regular rhythm of activity, but it is an emotionally drained state common

to artists. And it is a very worrisome feeling that often leads artists to doubt them-
selves. Do I have anything left to say? I don't feel like doing anything. All this work
for nothing—what's the point?

The letdown has a biological basis, according to Dr. Patricia Saunders, clini-
cal director of New York City's Metropolitan Center for Mental Health, which
regularly counsels fine and performing artists. "Psychologists refer to the concept
of flow, which is an altered or peak state of consciousness in which most creativity
occurs, where areas of the brain that don't usually work together do so," she said.
During the flow, the brain is highly energized. "When that ends, the brain shifts
back to the normal function, and some people experience that as less than normal."
For most, the feeling of emptiness is not long term, but those whose depression
continues may need counseling or medication to treat mood disorders, she added.

A colleague at the Metropolitan Center for Mental Health, Dr. Cheryl
Knight, noted that artists with some type of psychological disorder may feel the
letdown after the completion of a project more intensely than others, because the
project "sublimated other symptoms, and when the project is over here comes all
your issues and problems again. It can feel worse, because you have all this time on
your hands."

The prevalence of a feeling of emptiness or sadness at the conclusion of a
project among artists is great enough that psychologists suggest advance planning.
Saunders noted that this includes not putting pressure on themselves to begin a
new project when artists feel "psychologically depleted," since that only adds anxi-
ety to the mix. Some artists turn to illicit drugs and alcohol to gain control over
depression; Saunders recommended physical activity, "the best antidepressant
there is," which both is healthy and helps regulate moods.

As much as the brain may be temporarily reoriented toward the big project at
hand, so is the artist's life. The end of an exhibit or commission means that a cer-
tain regimen of activity has come to a close, requiring the artist to return to what-
ever took place before. "It is important to rely on a daily structure," said Manhattan
therapist Mary Herzog. "Human beings don't function well without structure, but
it is common for artists to forget how they've done things in the past. They start to

lose their identity." She advises artists to re-create a daily pattern of work, such as going into their studios at regular hours, perhaps using the time to read articles in art magazines or looking through a sketchbook. "Immerse yourself in the reasons you do art in the first place," she said.

The experience of activity, followed by a letdown at its conclusion, is not a once-in-a-lifetime event, but may recur with subsequent shows and commissions. Knowing the feeling from one instance may help artists prepare for it the next time. A number of psychologists involved in the arts field suggested that artists should plan a vacation, a celebratory party, or just take on activities that had been put on hold while the project was dominating their lives. Additionally, it may be valuable to take on other creative projects in which the artist does not have as large an investment, such as a portrait for a landscape painter, which may stimulate new ideas and provide fresh challenges. "Picasso took time off from painting every so often to do ceramics and sculpture. David Hockney has done prints, even stage designs for operas," said Dr. Nancy C. Andreasen, professor of psychiatry at the University of Iowa College of Medicine and the author of *The Creating Brain: The Neuroscience of Genius* (Dana Press, 2005). "Trying new and different things keeps you out of ruts."

Graham C. Jelley, a psychologist in Providence, Rhode Island, who works with both professional artists and students at the Rhode Island School of Design, stated that he talks with artists about their expectations for some project in order that they not built up unrealistic hopes that will add a sense of failure to the feeling of letdown. "You want to enter a project with your eyes open," he said. "I ask artists, 'What are you imagining about this exhibition? Are you seeing it as a breakthrough, the long-awaited chance for recognition?' Artists are creating a story in their minds about what they hope to have happen, and it is important to articulate that story to see if it is realistic."

Of course, not every artist experiences the end of an exhibit or commission with sadness; some find relief that something all-consuming is over, and others gain confidence and energy from the knowledge that they saw a major effort through from beginning to end, which may carry over into the next endeavor.

Artists are often viewed by psychologists as psychologically fragile, more prone to neurotic or psychotic tendencies than the general population. Still, artists are aware that much rides on their infrequent exhibitions and other projects; whether the issue is a chemical balancing act in the brain or the gap between art world hopes and reality, artists often experience (and sometimes talk or write about) a feeling of emptiness at the conclusion of a show. It should be noted, however, that psychologists distinguish between feelings of letdown, which tend to be transitory, and an artists' block, which is tied to anxiety and is more deep-seated.

Cheryl Knight, who in addition to training as a clinical psychologist also has worked as an actress for twenty-five years, identified three stages of post-show letdown: The first is physical exhaustion, the second is emotional exhaustion, and the third is a renewal of energy. The total recovery period may depend on how long the project was a major part of the artist's life or, possibly, it is dependent on whether the artist relies on external goals, such as a commission, or internal motivation. When other aspects of one's life are necessarily suspended for a time, there is afterwards a lack of direction.

In most cases, an artist who feels blue after an exhibition comes down may experience letdown after the next show as well but not quite as intensely. Some may plan ahead, lining up new activities or projects that eliminate or lessen the down period, while others prepare for the feeling of depletion and, while expecting it, "take down the intensity of it," Knight said. "Also, by knowing what happens, it also shortens the amount of time you feel letdown."

GETTING HELP WHEN NEEDED

"The idea that creativity is related somehow to bipolar disorder has been pretty well debunked," said New York psychologist Eric Dammann, who specializes in the treatment of fine, literary, and performing artists. This may be great news to artists who don't want to believe that what is unique about them also is what's wrong with them. That's one myth down, but then there is always another. "Many artists are fearful of therapy, oftentimes because they believe that it will make them normal and they won't be creative anymore."

It is certainly true that some psychotropic medications at higher dosing levels may make patients, including artists, feel "flat." However, the purpose of therapy "is just the opposite, which is to get obstacles—like stage fright, like creative blocks, like issues of self-esteem—out of the way so you can do what you want to do," he said.

At the Psychoanalytic Psychotherapy for Artists program of New York's William Alanson White Institute of Psychiatry, Psychoanalysis & Psychology (www.wawhite.org) where he is codirector, Dammann deals with beliefs about therapy that artists may have, as well as the underlying emotional and psychological problems that brought artists there in the first place. Another one of those beliefs is that artists' psychological problems are specific to being artists, but that is a grayer area, he claimed.

"On one level, artists are dealing with the same problems as everyone else, such as mood disorders, insecurities, trauma," he said. "Some of those problems may become magnified by the work artists do, however." Trauma, for instance, is not unique to artists, but while someone in another, nonart field of work might be able to fumble through, an artist may be "butting up against the trauma again and again through their work that deals with trauma." Economic insecurity is another area that is not peculiar to artists, but the lack of congruence between the skills that an artist may have and that person's level of achievement often seems greater than for those who aren't artists. "Someone who studied accounting and is good at accounting is likely to get a well-paying job in an accounting firm, while a highly skilled artist can end up with nothing to show for all his hard work."

Creative blocks usually are associated with fine artists and writers, yet many other people periodically or regularly find themselves stuck in a rut, doing (or not doing) the same thing and not knowing how to envision something different. "Outside of the arts, we call that 'stagnation' or 'procrastination,'" Dammann said, "and it is a very troubling feeling. In another field, you might find yourself doing the same thing over and over again, but at least you are doing something, while in the arts by definition you aren't doing anything, and that can be very traumatic."

Getting artists to come in, overcoming that fear that therapy robs them of creativity, is a challenge, he said, but some do, "because whatever has gone wrong in their lives and work has become so great that they know they have to deal with it."

The White Institute's artists program began in 1996, placing artists in various fields with area psychologists (the current roster has between twenty-five and thirty) who have experience working with this population. They may charge as little as $40 for a forty-five-minute appointment, with no set number of sessions, and roughly half of the clinicians accept insurance. "We try to match psychologists with artists in terms of specialties and payment methods."

The White Institute is not the only place where artists seeking counseling may turn. The Actors Fund (www.actorsfund.org), the International Association for Dance Medicine & Science (www.iadms.org), and the Performing Arts Medicine Association (www.artsmed.org) also offer services for artists, specifically those in the performing arts. Division 10 of the American Psychological Association (www.apa.org) focuses on the psychology of aesthetics, creativity, and the arts, but it has little to do with actual therapy with artists and more with the publication of a journal articles on the subject.

Otherwise, there is no lack of psychologists and therapists from whom artists may seek help, although the number of clinicians whose practice specializes in those working in the creative sphere is more limited, and most of them are not part of an association. Some advertise or can be found through online searches. Manhattan-based Linda Hamilton, whose private practice is 80 percent performing artists, is a wellness consultant to the New York City Ballet, which refers dancers in need of counseling to her, and she charges $250 per hour. Nancy Hillis, a psychiatrist and abstract painter in Santa Cruz, California, started out with a more general practice but then saw a few artist patients and, "through word of mouth, began to get others, and now that's my principal clientele." She charges $250 per hour and does not accept insurance. Another Californian, Eric Maisel, who describes his work as "creativity coaching," is not only found online by his patients but also conducts sessions with them online through Skype, charging $175

per hour or $100 per half-hour. "I no longer do in-person coaching," he said, adding that he also conducts group training.

He noted a large "gender division" among artists who seek his help. "My workshops are 90 percent women, because women are more willing to reach out when they are experiencing obstacles to their creativity than men." Many male artists, on the other hand, "just keep doing what hasn't been effective for them rather than look for help."

While the underlying emotional problems artists face are no different than those faced by the general population—such as mood disorders, loss and emotional trauma, anxiety, relationship issues, alcohol and drug dependency, depression, and blocks—clinicians claim that these may be heightened by the nature of their creative work. Eating disorders often are found with performers, while mood disorders and alcoholism are not uncommon with poets and writers, according to Manhattan psychotherapist Olga Gonithellis, reflecting their fears that they aren't good enough. Hamilton claimed that rock musicians are regularly linked to hard drugs, while "classical musicians take beta blockers, because that helps them control their nerves." Problems in artists' relationships frequently stem from the fact that a nonartist partner may not seem supportive of the artists' travails or shows little sympathy for an artist who isn't earning much money.

Hillis said that "one of my patients was a public school teacher, struggling to be a children's book writer, who suffered from migraines. Migraines have a physiological basis, but the psychological issues of doubting whether she should write full-time, and doubting her abilities as a writer, certainly exacerbated the pain." In time, this patient was about to overcome her self-doubt to leave behind her job to devote herself to being a children's book author. "She has published several books and gives talks at conferences. It worked out well for her." (The migraines haven't disappeared, but they seem to be less of a problem.) Another one of her self-doubting clients actually had a serious medical problem, a temporal lobe seizure disorder, "and through my medical training I was able to recognize that and get this person the help she needed." (It has been speculated that temporal lobe epileptic seizures

were behind Vincent van Gogh's action to cut off one of his ears and eventually take his own life.)

At times, psychologists go beyond attending to strictly the emotional issues that brought in their clients to more general lifestyle and career concerns. "A performing artist who is always auditioning and always being turned down can certainly get very depressed," Hamilton said. "I have to determine whether this person is doing something self-sabotaging during these auditions or if the person just isn't good enough to get the parts." She offers these clients ideas on how to take down their level of stress a notch or two. "They might need some other interests that help prevent burnout, or they might need a Plan B, a survival job. A lot of talented people won't make it, and I try to identify where someone needs work or something else to do. I direct them where I can."

Frequently, artists bring in their writings, their paintings and sculpture, their videos of their performances to counseling sessions, which creates some anxiety for their therapists. "I don't want to be put in the role of judge," Hamilton said. "If the problem is that people don't like their work and then I don't like it, I'm not being helpful." Maisel stated that "officially, I don't look at someone's work, but unofficially I sometimes do, going to the client's website. It's just for my own personal interest, but I would never tell someone that their work is bad and they should stop being an artist. That would be cruel. And, people can improve." His larger reason for not wanting to "officially" view a client's work is that "someone's artwork isn't a straightforward path to understanding their psychological state, and I don't want to look at the art in a Rorschach way."

A therapy client's artwork is yet one more step removed from the emotional issue that brought them in, although it is difficult for the psychologists to say no. The art is part of how the clients see themselves, so it is something that needs to be put up with or put to use. "I'm not in the business of analyzing an artist's work, but we can talk about how the artist sees the work, and that might lead somewhere," Dammann said. One of Jackson Pollock's psychiatrists, Joseph L. Henderson, made artwork a substantial element of his sessions with the artist, writing later that "Since he was extremely unverbal, we had great trouble in finding a common

language and I doubted I could do much to help him. Communication was, however, made possible by his bringing in a series of drawings illustrating the experiences he had been through. They seemed to demonstrate phases of his sickness." Didn't help, apparently.

CHANGING ONE'S STYLE

During the winter of 1906 and 1907, Pablo Picasso painted *Les Demoiselles d'Avignon*, a work that was a breakthrough for both figurative and cubist art. Drawing on African influences and defying Western art's tradition of visual perspective, Picasso developed a style that appears to present a clumsy relationship between parts but that actually creates its own more personal order.

For thirty years after its creation, however, the *Demoiselles* was almost more legendary than real as few people had actually seen it, although more had heard of it. Having received some initial criticism and fearing that people would misunderstand the painting, Picasso turned the canvas to the wall and very few people—artists and dealers, mostly—ever saw it until its first public exhibition at the Petit Palais gallery in Paris in 1937.

Most artists won't wait thirty years before showing their developing art but, if their work is well known and they change their style, they may easily understand Picasso's reluctance to exhibit the *Demoiselles*.

Style has become all-important to an art market where investments, high prices. and the desire by dealers and collectors to "package" an artist in a particular mode or school have been paramount. Up-and-coming artists are given major media attention early—Frank Stella was only thirty-four when the Museum of Modern Art in New York City held its 1970 retrospective of his work—and less time is permitted for an artist to develop and formulate ideas.

How an artist changes their style and to what degree are questions as significant to buyers and sellers of art as the specific content or formal qualities of a work. Most artists see changes in style as part of an evolution and not as a radical departure, with the change reflected in the form works take but not in their basic meaning. Pressures to change or not to change come from a variety of sources,

including friends and peers, critics, collectors, dealers, and, of course, from within the artists themselves.

One of the most notable examples of an artist leaving a successful style to work in a different manner is painter Philip Guston, who died in 1980 at the age of sixty-six. Originally a social realist, heavily influenced by Mexican revolutionary painters David Siqueiros and Diego Rivera (who himself started out as an orthodox cubist painter in Paris), Guston switched to an abstract expressionist style in the 1950s. Lauded for this abstract work by critics, collectors, and peers, he shocked many when in 1970 he returned to the more figurative, albeit cartoonish social realist style of his youth.

No works sold from his 1970 show at the Marlborough Gallery in New York City, and the gallery quickly dropped him from its roster. Some fellow artists were quick to register their disgust with Guston, capped by a *New York Times* review of the exhibit that concluded, "In offering us his new style of cartoon anecdotage, Mr. Guston is appealing to a taste for something funky, clumsy and demotic. We are asked to take seriously his new persona as an urban primitive, and this is asking too much."

Guston himself was "uncertain about his own works and somewhat fearful to show them," according to his dealer, David McKee. "He was worried about what people thought as no one knew what to expect." McKee noted that Guston needed "more nourishment from his own work than abstraction allowed" and looked to bridge the separation of art from social realities for his own survival as a painter and for the survival of painting as a serious activity.

Guston's two dramatic changes in style were not, however, complete breaks in the entire body of his work. There are clear similarities in the palettes for the various phases of his work, and he was always searching to revitalize painting. The differences, however, were what got pointed out, drawing the sharpest criticism. Guston was deeply affected by the negative response of many of his peers and was quite grateful that his friend of many years, fellow painter Willem de Kooning (who himself went back and forth between total abstraction and elements of figuration), liked his work, assuring him in the midst of the storm that "this is all about freedom."

Freedom is an essential ingredient of the best work, but many artists claim that their freedom is limited by outside forces influencing how they change their style and in what direction. Artists tend to point the finger at dealers.

"When you are talking about art as a commodity, dealers are mainly selling a look," said Sol Lewitt, whose own art ranged from painting to minimalist sculptures to wall drawings. "If you change your look, dealers have to resell the artist all over again. This is all about product recognition."

"Changing a style really means changing an audience," painter Alex Katz said. "If an artist has a small audience, changing a style is no problem. If he has a large audience, then many people become upset. Dealers are in the commodity business and generally are concerned with keeping the same look year after year."

The ways in which dealers may put pressure on an artist are usually quite subtle. Regular exhibitions may not materialize, for instance, or dealers may relay criticism from "potential collectors." The result is that many artists are pushed to do the same work again and again. Sol Lewitt noted that dealers said to him about his newer work, "'I like it, but I really like the work you were doing from 1967 to 1974' or something like that. What I usually tell them is, 'You'll get used to it.'"

For other artists, the greatest pressures come from peers, who often criticize each other in the form of silence. Sculptor George Segal stated that his artist friends were his toughest audience and that they have gotten the most upset over every change he has made in his work over the years. Renowned for his white plaster cast sculptures of human figures in common outdoor urban settings, Segal said that "when I began introducing color a number of years ago, friends said, 'Don't give up white!' They complained that I was changing their idea of what my sculpture was." He added that "if you have the nerve to withstand criticism from close friends, you can stand it from anyone."

Clement Greenberg is often cited by artists and dealers as the archetypal critic-strongman, emphatically promoting a certain style of work and scorning all others. Willem de Kooning claimed that he once threw Greenberg out of his studio after the critic pointed at various canvases, saying "You can't do that. You can't do that."

For his part, Greenberg stated that the influence of dealers and critics has been greatly overplayed in discussions of what artists do. Noting that nobody now worries about what critics said about Matisse or Courbet, he said that the pressures that "make artists do less than their best" come from within. These include being afraid of having their work look different than it has in the past because it will sell less, "or it may just be a fear of their own originality. Artists will change anyhow. I've never known an artist who works dishonestly."

Art collectors are no less a part of the equation, and may also react favorably or unfavorably to changes in an artist's style. Many dealers, aware that collectors frequently lag behind artists in terms of style changes, promote prints in the styles with which these buyers are more familiar, allowing their artists time to evolve and for their audience to get accustomed to the evolution.

HANDLING CRITICISM

It's the cry of every scorned artist—"The critics hated the Impressionists, too!"— but the claim is only partly true. Within a decade or so of their first major exhibitions, the critical tide had turned in the Impressionists' favor, especially as unceasing stylistic developments within the School of Paris soon made the work of Monet and company look relatively tame. By the time he was in his late seventies, Monet was lionized, an acknowledged Old Master of modernism.

For much of his career and even since his death, Andrew Wyeth was scorned by almost all the major art critics, perhaps for being the Old Master of un-modernism. Wyeth's painting, according to critic Peter Schjeldahl, is "formulaic stuff not very effective even as illustrational 'realism,'" and Robert Storr, curator of contemporary painting and sculpture at New York's Museum of Modern Art, wrote of Wyeth as "our greatest living 'kitsch-meister.'" Critic Hilton Kramer complained about Wyeth's "scatological palette," a comment echoed by critic Dave Hickey who referred to Wyeth's palette of "mud and baby poop." *Time* magazine's Robert Hughes disparagingly described Wyeth's art as suggesting "a frugal, bare-bones rectitude, glazed by nostalgia but incarnated in real objects, which millions of people look back upon as the lost marrow of American history."

For his part, Andrew Wyeth said he was not "bitter" about the quantity and intensity of negative criticism he had received "because I've been so successful in my career." However, he claimed to have read everything that is written about him, "which is nowadays absolutely negative," and that he had never "developed a thick skin. Negative criticism really knocks you flat, like a stiff haymaker to the midsection. So much of it is so unfair."

Wyeth is anomalous in the art world, vastly popular with the public and unanimously condemned by critics. Most successful, better-known artists have enjoyed a far more favorable balance of positive and negative reviews, but the example of Wyeth does point up the degree to which critics and the public are wide apart in their appreciation of artwork. Who's right is not the issue, but it is likely that a review has different meanings for readers, critics, and artists. Artists themselves have the most complicated relationship with write-ups of their artwork.

Artists, especially those who have achieved some recognition, tend to shrug off negative reviews of their work and stress how it's more important to concentrate on one's own art. "That's part of the game." "It just makes me laugh." "I don't care what they say as long as they spell my name right." However, not far below the surface, anger at some art critic or critics in general lies waiting to be tapped.

"One reviewer said about my work, and I'm paraphrasing, 'Is this art? Why did someone go to the bother to make this thing?'" sculptor Donna Dennis said. "Another time, a critic with a Marxist point of view said that the scale of my work suggested the upper classes looking down on poor people. My problem with art critics is that they often have a set point of view to which they want your work to conform, and they refuse to open their minds to see where you're coming from."

For his part, painter Leon Golub noted that negative reviews "irritate and, sometimes, depress me," while painter Larry Rivers stated that he "can be stung by something I've read about my work. I remember what was said, but I try not to let it weigh on me." When she has become angry or depressed by a review that seems "nasty or personal," sculptor Marisol has gone to the lengths of sending the critic "a letter insulting him, in order to get even." Clearly, success doesn't make an artist's anger or insecurities go away when a review is unfavorable.

In fact, success may seem to raise the stakes on whether or not the write-up is favorable or otherwise. Painter Robert Longo stated that negative reviews are "harder to deal with now than in the past" as "the quality of my work demands a certain kind of attention, which is greater than when I first started out." Donna Dennis also noted that "a poor review affects me financially now whereas, when I first started out, it only hurt my feelings."

Perhaps commercial success should compensate for criticism's version of Bronx cheers, and it may be that the critical naysaying is a result of the commercial success. *Newsweek*'s former art critic Peter Plagens noted that "critics seem to say, 'This artist already makes a lot of money and is so popular, why should I add to it?'" Perhaps negative criticism may reflect the degree to which an artist's work is unsettling to critics. Art historian Robert Rosenblum, who claimed that he neither loves nor hates Andrew Wyeth's work, said that "Wyeth is treated as an enemy by so many critics, because he represents a challenge to modern art long after the public triumph of modern art. The fact that he is such a crowd-pleaser may suggest that this triumph isn't as complete as some may have thought."

The "problem" with Andrew Wyeth is complex and doesn't even stop with the artist himself. His sister, Carolyn, also an artist, sought to be represented by the Tatistcheff Gallery in New York City in the 1970s and was told by gallery owner Peter Tatistcheff that he would need to check with every one of his other artists for their consent. "My personal feeling toward the whole Wyeth phenomenon is that I wouldn't want to participate in it," Tatistcheff said. In another example, the first show that Wyeth's painter son Jamie had in New York's James Graham Modern gallery, in September 1993, was well-attended and sold well, but there was not one write-up in any of the city's newspapers or art magazines. "I think the name Wyeth itself sends out red flags," Jamie said.

This was not Jamie Wyeth's first encounter with the name phenomenon. His first New York show, at age nineteen in 1965, at the Knoedler Gallery drew a "scathing review" from the *New York Times*, Jamie stated. "Something along the lines of, Here is another generation of the Wyeth family whose work is being trumpeted. The review went on like that without ever mentioning my artwork.

Later, other reviews came out in New York papers and magazines that attacked the *Times*' review: How could you be so harsh on a young artist? and stuff like that, again without ever mentioning my work. It was an interesting introduction to the art world for me."

Coping with criticism, both adverse and positive, is one of the most difficult tasks for any artist. Is there any truth in what someone else is saying? Does a negative review mean that the work is bad? Do misinterpretations by a critic suggest that the work isn't communicating clearly with the public? Should one just write off all art criticism as, in the words of painter Jules Olitski, "the lowest, most scurrilous area for writers to go into"?

To a certain degree, reviews and criticism serve different purposes for the writer (of the review) than for the artist (whose work is being reviewed). Critics generally like to establish their own presence in a review—as judge of art or of the ideas conveyed in the art or as a wit (Dorothy Parker: Katharine Hepburn "runs the gamut of emotions from A to B") or even to make sweeping statements about trends in art—while artists first and foremost see the write-up as a public acknowledgment of their presence in the art world. Being written up in a newspaper makes one's show an event, something that readers may want to attend regardless of the content of the review, which tends to be forgotten sooner than the fact of the exhibition. A picture of one's work next to the review has a lot longer staying power in a reader's mind than the words describing the piece, which is why press photographs are deemed so essential. "I don't care what they say about me since people don't usually read it," painter James Rosenquist said, "but they may look at the picture and remember that."

That more cynical approach to criticism does not tell the whole story, as artists often read and remember what is written about their work even if most readers do not. An art exhibition is a form of public exposure, revealing a variety of vulnerabilities. More mature artists learn to keep an open mind to potentially valuable opinions and suggestions while maintaining a steely confidence in their own work and vision. The more negative the critical reception, the more one's inner resources are tested. "If what someone writes about me affects my work, if I don't have any conviction in what I'm doing, then God help me," Andrew Wyeth said.

The critic, at their most basic level, is a conduit of information to the public that such-and-such an artist exists and whose artwork may be seen at such-and-such a place. At a more gratifying level to the artist particularly, the review indicates that the creator is being taken seriously as a professional, which may take the edge off the sting of any negative commentary.

There may be a great temptation for artists to respond to misinformation in a review, a problem creators complain of frequently. Environmental artist Christo noted that the titles of his work are frequently misspelled, as are his and his wife's names, and facts such as his nationality (Bulgarian) are often incorrect. "Some critics wrote that I am Czechoslovakian," he said. "One person wrote that I was born in Belgium." Donna Dennis pointed out that the scale of her work doesn't reflect class differences (as the Marxist critic had written) but "the scale of my own body, which a feminist critic would have understood." Most artists, however, see reasons to check the impulse to respond.

Beyond the questions of the critic's value in making public mention of the artist and of responding to potential misinterpretations is the deeper issue of whether or not criticism resonates as true. Larry Rivers suggested that criticism may prove most valuable and constructive when it parallels one's own private doubts and concerns. Criticism, whether favorable or otherwise, is often able to open up ideas and provoke discussion.

"Criticism has expanded my vision when the person has tried to make an intelligible and intelligent statement," Leon Golub said. "It's like a goad, a provocation thrown at you, and it energizes me and my work. Sometimes, I respond to criticism through my work."

Not all criticism is unfavorable, of course. Smaller circulation newspapers rarely knock artwork, and editors often try to help locals—artists or galleries. Frequently, the artist may be met with praise, which certainly makes the creator feel good but also may involve a pitfall or two. One can start believing in one's own touted "genius" too much, interfering with one's ability to work boldly.

"Artists who have been pushed around a little should know not to let praise go to their heads," Golub stated. "Sure, I'm happy when I get praise, and I get

depressed when something negative comes out. If you let it go to your head, you're a schmuck; if you let it stop you from working, you're self-destructive. You can't let either praise or damnation take over."

Artists may be able to hear criticism only from critics, from friends, peers, family members or, perhaps, from no one. Some people respond to criticism in certain ways, regardless of whether they are artists or shoemakers, but the real issue is how confident the creator is in their own work. Criticism can come too early and too hard for some artists, and James Rosenquist recommended that creators hold off displaying their art until they feel secure in what they have made—secure enough to make it public and, as a child, let it go off into the world. Once a work of art leaves the studio, it no longer belongs exclusively to the artist; rather, it belongs to the world. It is liked and understood according to the tastes and knowledge of the people who see it, and the creator becomes just one more person in this chain. Sometimes, criticism opens an artist's eyes to facets of the work that they hadn't before realized. The artist learns to step back, watch the processes of the art world, pick up what good can be gleaned, and go on to the next creation.

THE BENEFITS AND PITFALLS OF CENSORSHIP AND CONTROVERSY

"I've refused to become a prisoner of *Piss Christ*," said photographer Andres Serrano, referring to his photograph of a crucifix submerged into a glass filled with urine, but the fact remains that he has become a very wealthy prisoner of that work. The picture, created while a recipient of a $15,000 grant from the Southeastern Center for Contemporary Art in Winston-Salem, North Carolina, which itself had received a grant from the National Endowment for the Arts in fiscal year 1987–1988, drew fiery condemnation from religious groups around the United States and members of Congress, including North Carolina senator Jesse Helms. Coming at the same time as the controversy over the indirectly government-sponsored exhibition of the work of photographer Robert Mapplethorpe, the outcry came close to abolishing the federal arts agency.

The dispute over *Piss Christ* has proven to be a "double-edged sword," the artist said. "Collectors rushed to support me. I've sold a lot of work, and I wouldn't have sold anywhere near that much if the controversy hadn't occurred." The other side is that the flap broke up the artist's marriage ("I was a little paranoid for about nine months") and made Serrano a symbol, represented by this one work that colors all he has ever done or will do. "*Piss Christ* has been over for me for a long time; for other people, it may never be over."

Great public controversies or instances of censorship can't help but affect an artist in a significant way. For certain artists, there is a clear upside. "I like to think that my career would have reached this level without the help of the FBI," said photographer Jock Sturges, whose San Francisco studio was raided in 1990 by the Federal Bureau of Investigation, which confiscated and destroyed many of the artist's prints and negatives of nude children before a federal grand jury failed to indict Sturges. "Certainly, the feds pushed my career ahead by ten years."

David Hammons gained considerable publicity and new collectors when his sculpture of a blond and blue-eyed version of Jesse Jackson (titled *How Ya Like Me Now?*) was attacked in 1989 during an outdoor exhibit in Washington, DC, with sledgehammers by a group of Black men who felt the work disparaged Jackson. The artist repaired the piece in time for a more recent retrospective, adding to the work sledgehammers and the logo of the cigarette maker Lucky Strike, since "it was lucky for me that those men struck the piece with sledgehammers, because that got everyone to notice me."

However, for most artists, the sword is not double-edged. The controversy elevates an artist's name and face long enough for the individual to become the focus of death threats and hate mail, snubs from collectors, dealers, and curators, with little but a tarnished reputation to show for it.

"Controversy hasn't been a fast track to success for me in the art world," said Kate Millett, whose 1970 *The American Dream Goes to Pot* featuring an American flag partially stuffed into a toilet behind prison bars has been picketed by veterans groups and others whenever it has been displayed. The work was most recently exhibited as part of an "Old Glory" show at the Phoenix Art Museum in Arizona

in 1996, where it was met with protests and condemnations from Senator Jesse Helms, House of Representatives Speaker Newt Gingrich, and then–presidential candidate Bob Dole. "I've gotten a sort of notoriety because of that piece and some others I've done but, in another way, the controversy hasn't affected me a lot because I've never been able to sell my sculpture. All my life, collectors and curators have backed away from me. No dealer has come to me for any purpose whatsoever. I think I've sold only a couple of works to friends, for $350 apiece."

Controversy worked in her favor, after her 1971 book *Sexual Politics* was published, which became an instant classic among feminists, but her artwork has never benefited. Why one artist's career is aided by controversy but another's is not may not be easily understood. Senator Helms denounced both Serrano and Millett, both of whom produced work that cause viewer discomfort; collectors, critics, curators, and dealers rallied around Serrano but avoided Millett.

The studio of photographer Marilyn Zimmerman, a tenured professor at Wayne State University in Michigan, was raided in 1993 by police who confiscated prints and negatives in a manner similar to the FBI raid on Jock Sturges. She, like Sturges, took photographs of a nude child—her own daughter, in fact—and the district attorney decided to drop all charges in the face of protests. However, "there was no great surge of interest from collectors in buying my work or from dealers who might show my work," she said. The fear that this raid created in her life "did stop me from photographing the nude. I use other, appropriated images instead. Frankly, for a long while, I lost the heart to make images." She also lost her daughter as her ex-husband used the photograph controversy to gain primary custody in court.

Instances of censorship effectively ended the art aspirations of two young artists, David Swim in Austin, Texas, and David Nelson in Chicago. Swim's figurative plaster sculpture of a nude man was removed in 1993 from a public art show. His lawsuit against the city, the mayor, and the head of the local Art in Public Places program was supported by the Art Censorship Project of the American Civil Liberties Union and the National Campaign for Freedom of Expression, but "support for me in Austin was pretty nonexistent. The Austin Visual Arts

Association, which receives money from the city, tacitly supported the city's decision." In addition, the area galleries in which Swim had been showing his work became "concerned about the work I did, and no other dealers came to pick me up."

The controversy and lawsuit (eventually dropped after a trial, several appeals, and an overturned conviction) proved too distracting for him to get back to work. "I wasn't in an emotional place where I could create any art," he said, and he stopped producing art altogether, taking a job as a computer technical support representative for Apple.

David Nelson was an art student at the School of the Art Institute of Chicago in 1988 when he placed in a student show a portrait of the late Chicago Mayor Harold Washington dressed in frilly lingerie. Several Black aldermen came into the museum's gallery and took the picture away, inciting an ACLU-sponsored lawsuit and several protests on both sides. According to the registrar's office at the School of the Art Institute, Nelson lives "somewhere in the Midwest and doesn't pursue art anymore, to our knowledge."

Controversy invariably requires that an artist take time away from their work, to speak with police, the press, lawyers, other artists, and even groups that ask the artist to give a public talk. It also takes an emotional toll. Dread Scott Tyler, whose 1989 work in an exhibition in Chicago, *What is the Proper Way to Display the U.S. Flag?* requires viewers to walk on a flag in order to read from a book, noted that he has received death threats in the mail, his mother has received death threats at her home and office, and that other Black artists have received these same threats. "People don't know what I look like," he said. "They see Black artists and assume they're me."

Millett also noted that she felt frightened when Speaker Gingrich "denounced me on the floor of Congress. In another society, I would be arrested and jailed or worse that day. There is something about being the target of all this animus. It's different than just a bad review when the government is attacking you. It has the power of social force behind it."

Artists are sometimes accused of deliberately seeking publicity by courting the outrageous, then taking advantage of the notoriety in order to sell their work,

but "would you trade what Sturges went through just to get your name out there?" said David Mendoza, former executive director of the Washington, DC–based National Campaign for Freedom of Expression. Within the first five weeks of the FBI raid on his studio, Sturges said that he had spent $80,000 on legal fees, "lost forty pounds, I couldn't sleep; I was anxious all the time. If I had been convicted, the sentencing was ten years. I thought I was going to prison. I had read that child pornographers were usually raped and brutalized in jail, and I would get AIDS. I thought I was under a death sentence." He sought psychiatric help.

In the relatively small art world, artists have a large measure of control over the context in which their work is placed through the exhibition of that art. Public controversies bring artwork into a far larger realm—photographs of Dread Scott's piece appeared on the front pages of the *Chicago Tribune, New York Daily News*, and *Village Voice*, among others—where artists have little to no control. Serrano is the *Piss Christ* artist, Sturges a child pornographer. Karen Finley, the performance artist for whom a grant from the National Endowment for the Arts was recommended by a peer review panel but denied by the agency's advisory council in 1990, has been labeled the "chocolate lady" for some much-debated performances years ago in which she smeared chocolate on her body. Their entire careers have been reduced to one or more images that encapsulate the public controversy generated. At other times, their work has been cited by their opponents in order to make points about something else.

"I saw a picture of my flag-in-the-toilet reproduced in a newspaper, accompanying an article on why the NEA should be abolished," Millett said. "I've never received a cent from the NEA, but that didn't apparently matter to this newspaper or to the person who wrote the article. I feel horrible about being used in this way."

IN AND OUT OF THE SPOTLIGHT

In 1949, *Life* magazine published an article whose title asked the question, "Is Jackson Pollock the Greatest Living Painter in the United States?" Although the article's tone seemed to ask readers to answer in the negative—which, based on the letters to the editor that were published, they did—it heralded a new attitude by the

media toward art. Despite a portrayal of Pollock as an oddity whose work and mode of artmaking defied comprehension, the art was described in terms of his success in selling his works. If he sells, it is assumed, the rest is OK.

Money talks, and in the art world it publicizes. Publicity has become a staple of the art world, affecting how artists see themselves and how dealers work. On its good side, this publicity has attracted increasing numbers of people to museums and galleries to see what all the hullabaloo is about and, consequently, expanded the market for works of art. More artists are able to live off their work and be socially accepted for what they are and do.

On the other hand, it has made the appreciation of art a bit shallower by seeming to equate financial success with artistic importance. At times, publicity becomes the art itself, with the public knowing that it should appreciate some work because "it's famous" rather than because it's good, distorting the entire experience of art. Seeing the touted works of art may be anticlimatic, especially when—as in the case of Georgia O'Keeffe—the poster images of an artist's paintings are often larger than the originals.

Certain artists, artworks, and art collectors have become celebrities in the same way that the latest supermodel, the Hope Diamond, and society page figures turn ordinary occasions into notable events by their very presence. One must not forget the essential irony of Andy Warhol's comment about everyone's fifteen minutes of fame—that this type of notoriety is hollow, more to be watched in a detached manner than taken to heart.

Then, the fifteen minutes are over. Most people tend to limit their memories to either what is personally important to them or what is currently being talked about. It is always with a sense of astonishment that anyone thumbs through a ten- or twenty-year-old art magazine and remembers the artists who were being lauded right and left. The obvious question is, "Whatever happened to . . . ?"

The language used to describe these artists' then-current work is learned, partisan, and enthusiastic. This artist's work is a "significant contribution," that artist is having a "major show," while another is the "leading spokesman for his generation." So many of them never seemed to get written up again and, years later,

one wonders, what happened to them. Did they die? Did they stop working? Was their subsequent work so bad that everyone thought it best just not to mention it ever again?

They largely continued to live and do work of the same quality, but they all learned how uneven attention can be in the art world. They also learned what it is to go out of fashion. "America is a consumption society," Marisol, a folk–Pop art sculptor who was the toast of the art world during the mid-1960s, said. "They take you and they use you and then they throw you away."

Marisol was in all the art and fashion magazines, and her opinions on fashion, culture, and cuisine were meticulously noted. People hungering for her pronouncements have had little sustenance since the late 1960s when she seemed to disappear—at least from the periodicals. Exhibitions of her work became fewer, and her name fell into that area of consciousness that includes the name of President Eisenhower's secretary of agriculture and the first movie one ever saw.

"The people who count don't forget," she said, "but you do wonder, when all the noise dies down, what all the attention was about. Was all that excitement really about your work or just excitement about being in" fashion. She added that she never stopped working—"but now I just do it more privately."

All art is created privately, anyway. An artist goes into their studio to commune with the muse, not with the art magazines, in order to produce a work of art. But creating art is not just a form of self-therapy, and artists need some way of gauging their audience. Most artists want to project themselves and get more than an echo.

The feedback they receive is often short-lived and not without some drawbacks. Historically, since Impressionism, no single art movement has dominated the art world for as long as ten years. By the time one group of artists begins to receive recognition, a new generation has grown up and starts to express itself. The old group recedes, having made its mark on history, but no one wants to be historical in one's lifetime—one might as well be dead.

Painter Ray Parker claimed that he had been through the popularity-neglect mill several times now: "Taste changes very rapidly," he stated. "One day, everyone

loves you, the next day no one remembers you. But the changes are fast enough and cyclical enough that, at least in my case, people come back. Then, they go away again. You learn to get used to it."

By now, most artists in the public eye know that some day they will be replaced, and they must prepare themselves for that eventuality, investing their money now, producing as much as possible while they're hot, and attempting to change their style with the turns of the market. One of the unwritten credos of today's art world is that a young artist (just as a young rock star) may well be considered through by the time they are forty, and one should rush to strike while the iron is hot. Isn't that what hype is all about? Commitment by an artist means persevering even when recognition is not there.

GETTING SUGGESTIONS FOR WHAT TO CREATE NEXT

The director of the Creation Museum in Petersburg, Kentucky, had a suggestion for sculptor Mark Hopkins, but it was a bit odd. "He wanted me to do a sculpture of Noah's Ark, including a dinosaur or two," he said. (The Creation Museum "brings the pages of the Bible to life," according to its website.) "I thought, 'that's ridiculous.' I told him, 'it will look like *Dinotopia*.' It just wouldn't make any sense, so I rejected the idea." But he said it nicely, diplomatically, "something like, 'Let me think about that for a while,' because you don't want to hurt someone's feelings."

Many, perhaps most, artists get suggestions from people—their dealers, their collectors, their (artist) friends and spouses, someone who shows up at an exhibition opening—for new subjects. "People say to me, 'I know an interesting person you'd want to paint,'" said Jamie Wyeth. "Well, I'm not interested in paint-ing interesting people, thank you very much. I don't say that to them. I say some-thing like 'fine' or 'Oh, great!' and just forget about it." He doesn't want to be rude, either.

Sometimes, the recommendation isn't for new things but old ones. Dealers have told Northampton, Massachusetts, artist Scott Prior, "'this painting I could have sold ten times,' and I guess the suggestion is to keep doing the same thing." Other people come up with ideas for him, based on other interior or exterior views

he has done at some point in his career: "You should paint my summer place. You'd love the view from the deck." Things like that. Prior takes a deep breath, also wanting to be agreeable, and says "something like 'Oh, that's interesting' or 'I'll have to check that out,'" hoping that the subject gets changed.

Where do an artist's ideas come from? From dreams or their own experiences or someone else's art? Quite often all of the above, no doubt. Sculptor Petah Coyne claimed that "travel gives me so many ideas. The world is full of amazing visuals." Julian Opie, a British painter and sculptor, claimed that "I get loads of ideas from past artists, from history." Painter Tula Telfair stated that she isn't particularly interested in other people's ideas because she has so many of her own, based on themes she has pursued in earlier imagined landscapes. New ideas have to get in line. Still, the suggestions from other people keep on coming and, at times, they get taken up. Painter Eric Fischl noted that a dealer of his work in Germany "suggested I should explore making paintings based on the bullfight." He liked the idea and pursued it.

Fischl isn't a sports or animal artist, but the subject allowed him to explore a long-standing theme in his work, the rituals of masculinity, but this time seen from a different vantage point: The toreador faces down the brute force in himself.

A different type of suggestion occurs with painter and sculptor Alan Magee, who has incorporated old dolls and household objects into his work as though these were archaeological finds. "People who know my work have given me gifts of metal objects and other things they have dug up in a field," he said. Fellow artist Lois Dodd "gave me a rusted metal cup she found under her barn, because she knows I like these kinds of things." And he does like these things. "They act as a provocation to me. They seem to be saying, 'What do I remind you of? What can you do with me?'"

Most suggestions are meant well and reflect the fact that these viewers are connecting to the art in some positive way, something that triggers their own ideas or memories. Al Agnew, a wildlife artist in Sainte Genevieve, Missouri, tells those who offer suggestions to him that "'it's an interesting idea,' and let it go at that," and it usually ends at that. "I can't remember anybody seriously

following up and checking to see if I painted it." At times, it can get a bit awkward. "I once had a dealer who kept telling me what I should do," Telfair said. "He seemed like a frustrated artist." Taking someone else's ideas and opinions is more difficult for some than for others. Painter and critic Peter Plagens noted that "sometimes an art world friend, my dealer or a critic (and I do read reviews of my work) will say something, usually in passing, about something I've painted that'll cause me to think and maybe change course just a bit." More often, however, the comment is "'Oh, I like this better than that,' and I end up determined to do more of *that*."

LOVE AND MARRIAGE

There are a number of reasons that people marry or divorce and, sometimes, it is because they are both artists. Another artist will understand the art one is attempting to create, will accept the lifestyle and serve as an in-house supporter as well as an experienced eye. Another artist may also be in-house competition and one's fiercest critic, resentful of one's success and scornful of their own.

It is not infrequent that artists marry each other, as the people they tend to meet in their art studies, at gallery openings, or through their professional associations often are involved in the art world. Leon Golub and Jack Beal, for instance, met their wives (Nancy Spero and Sondra Freckelton, respectively) while attending the school of the Art Institute of Chicago.

Despite the real benefits for an artist of marrying (or living with) another artist, the identical careers—regardless of how dissimilar their respective artwork may be—create tensions for the two of them. Being an artist requires an ego of considerable size; two such people may find themselves clashing frequently, even if their disputes have nothing to do with their art or careers. Strong, unbending wills have destroyed more marriages than anything else.

Some artists approach these issues in advance by talking out a list of potential concerns. Jack Beal proposed to Sondra Freckelton three times before she finally accepted. "At first, he had the idea that I might be Madame Matisse, but I said 'no' to that. I didn't study art in order not to have a career on my own," she said.

The back of their 1953 marriage certificate includes a written "agreement of partnership" establishing that they are equal partners.

"Artists have to outline what the dangers are, could be, might have been," said Miriam Schapiro, a painter who has been married to another painter, Paul Brach, for over forty years. "You have to discuss whether or not to have the same or separate friends, whether you want to be treated as a couple or as individuals, whether your careers allow you to have a family, where you want to live, whether you want to be in the same gallery or not. They're all difficult subjects, but married couples—especially those with the same career—have to be able to communicate."

Other artists attempt to resolve the tensions of both spouses being artists through establishing separate studios (sometimes never even visiting each other's studios), using different dealers, and generally staying out of each other's careers. One example of this was the house that Mexican muralist Diego Rivera had built for himself and his painter wife Frida Kahlo. There were two separate buildings, containing two separate living units and art studios, connected by a bridge on the second-floor level.

Having two distinct studios, one for her in the garage and one for him away from the house, is "a physical manifestation of what is already going on," said Scott Prior, who is married to Nanette Vonnegut, both painters. "If we are too close, we sort of step on each other's toes. We do talk about each other's work, but there are times when Nanny would just as soon that I not say anything about her work because I can be disruptive."

It is relatively seldom that both artists in a marriage receive the same degree of attention and success in selling their work. At times, one artist's career is clearly on the rise while the other's has peaked, a scenario played out in the film *A Star Is Born*. Collectors, critics, and dealers may come visit one artist's studio and not the other's, which can be especially painful when the two artists share the same space. Competition and anger may enter a relationship.

"When my wife's career is doing better than mine," Leon Golub stated, "I don't feel as good about myself and may develop resentment." Golub added,

however, that he directs that resentment elsewhere—at limited thinking in the art world, for instance—and not at his wife.

The tension and sense of competition may be too great for some marriages. The wives of Edward Hopper and Philip Pearlstein gave up their art careers, for instance, believing that there could only be one "genius" in the family. Sally Avery said that her "career has flourished over the past twenty years" after her husband, Milton Avery, died. While he was alive, "I wasn't trying to promote my own work. I tried to promote his work, because I thought he was a better artist than me."

Problems are not necessarily lessened when an artist marries a nonartist. Janet Fish, a painter who first married and divorced an artist, then married and divorced a nonartist, and currently lives with another artist, noted that "problems about being an artist are really symptomatic of other problems in the relationship. Men simply have more problems than women with competition. There is something in their upbringing that requires them to be the breadwinner. The bad relationships I've had have been when the man's ego has been too tender."

She added that "I know some women artists who say their husbands never come to their openings or to see their shows, as though they are trying to deny these careers exist."

While artists marrying artists has a certain logic, the history of art reveals many examples of artists preferring a caretaker. Almost the entire abstract expressionist movement of the 1940s and 1950s, for instance, was supported by the wives of the major artists. Barnett Newman's wife, Anna Lee, for example, was a typing instructor; Mark Rothko's wife worked as a model, and Adolph Gottlieb's wife, Esther, taught school. In Europe, it was a tradition for artists to marry "working girls." Goethe married his housekeeper, as did Pierre Bonnard and Marc Chagall—when his first wife left him, Chagall married his next housekeeper. This kind of marriage (and this kind of support for male artists in general) has largely disappeared with the advent of the women's liberation movement.

Marriage, of course, isn't a professional decision but a personal one. The success rate of marriages is not necessarily improved when artists marry critics or dealers and, in many respects, the marriages of artists are no different than those

of everyone else. Some artists get along well enough both personally and profes-
sionally that they, like Claes Oldenburg and Coosjie van Bruggen or Edward and
Nancy Reddin Kienholz, are able to collaborate on art projects. Others, whose
artistic ideas are not easily compatible, keep their marriage out of their careers as
best they can.

"I think it's hard to be an artist married to an artist. I think it's generally hard
to be married and be an artist," painter Lois Dodd, who was once married to sculp-
tor William King, said. "When you're married, you have to think of another person,
and art is a very selfish activity."

DIVORCE

How much more enjoyable it is to speak of love and marriage than of splitting up,
but divorce happens, and it happens to artists at probably the same rate as for
everyone else. Marital property—everything acquired during the marriage—
needs to be divided in some way: the cars, the house, the bank account, the furni-
ture. So, too, the artwork created by the artist-spouse, and along with the physical
objects are current and future revenues from licensing as well as the copyright.

Does any of this come as a surprise? "Artists tend not to think of the artwork
they create as property, marital or otherwise," said Barbara J. Gislason, a lawyer in
Minneapolis who specializes in both family law and intellectual property. Artists often
look at their unsold creations, which may be placed in storage, stacked somewhere in
the studio, decorating the house, or on consignment to a gallery, as theirs by right. The
courts, however, view any artwork created during a marriage as community or marital
property, to which the nonartist spouse has an equal claim. (That extends to copyright,
which a 1987 ruling from the California Court of Appeals determined belongs not
"only to the author" but "must be considered community property.")

Not everything is up for grabs. Artworks created prior to the marriage and
those produced after the couple has separated or filed for divorce (depending upon
the jurisdiction) are not counted as marital property. Payments agreed upon before
the marriage, such as for an art commission or licensing agreement, that arrive
after the wedding also are excluded from the marital assets.

The first requirement for an artist in the midst of a divorce is "to develop an inventory, a detailed list of all the artworks that have been made, which were made before the marriage, which were made during the marriage, which have been sold and at what price, and which haven't been sold," said Raoul Felder, a divorce attorney in New York City. The location of unsold pieces created during the marriage needs to be identified, and hiding artworks or failure to disclose licensing documents could be a source of future lawsuits. "Half or even 100 percent of any undisclosed and unallocated assets may be awarded to the other spouse, depending upon if the failure to disclose is determined to be the result of fraud by the nondisclosing spouse," warned Valerie L. Patten, a family and art law practitioner in Palo Alto, California.

In addition, some value must be assigned these artworks. That evaluation might be done by a professional appraiser or even a gallery owner—a dealer may be the only source of pricing information in the event that no secondary market exists for the artist's work. Preferably, the spouses will agree on a single appraiser or dealer to determine values, but both sides are entitled to pick their own experts, with final estimates negotiated by lawyers or by a judge in a court of law. "You want to avoid the vagaries of separate appraisals," said Manhattan attorney Malcolm Taub, and separate appraisals also double the legal costs. However, spouses may determine their own valuations, without needing to bring in other people. Past sales, or the lack of sales, are a central part of the discussion, as is a sense of realism. If an artist has had an exhibition of twenty works, and only two of them sold, for $3,000 apiece, it could be argued that the other eighteen also are worth $3,000 or that those works have little to no value (or something in-between). Most states' divorce laws are based on what is called "equitable distribution," which refers to roughly comparable values for each partner on a marital balance sheet, and the goal of the judiciary is for the spouses to find ways to divvy up assets and property that each side finds acceptable.

More complicated is determining a value for artworks that have not been exhibited or even completed: What is the value of a clay model or maquette? When the piece is brought to a foundry, how many will be cast in an edition, and what will

be the price of each? Taub stated that unfinished artworks might be assessed at some fraction of their value when completed. In these instances, the division of artistic property might be structured in terms of future earnings. The clay model in the studio may not have any value in itself but, if cast in an edition, could generate revenues in the future. "Unsold works of art have a speculative value, but it is still a value," said Amy L. Beauchaine, a lawyer in Orlando, Florida, whose practice includes both entertainment and family law. "I've seen agreements where an ex-spouse will be paid less than 50 percent, say 20 percent, if a work produced during a marriage is sold within three years' time after the divorce." Additionally, the nonartist spouse might agree to cede future earnings in exchange for being freed from responsibility for a current foundry bill, since debts accrued during the marriage also belong to both spouses.

"Judges don't want to take away property from the person who created it," said Gislason. They also don't want to be in the position of assigning market value to artworks in a marital estate, recognizing that the art market may be in turmoil and that individual pieces might be sold only as conditions permit. Putting a large number of artworks on the market at one time is apt to result in lower prices and, perhaps, few or no sales, which complicates the divorce settlement and damages the artist's market. Because of this, judges prefer artists in the midst of a divorce to devise some means of assigning values to art property that is agreeable to their spouses without the intercession of the courts. Most family law cases are settled without going to trial, leaving a judge with no further responsibility than to sign off on an agreement.

In the end, a divorcing couple is supposed to derive equal value in marital assets on a final balance sheet. Therefore, "artists need to be realistic about the value of their own work," she stated. "If the artist is inflating values, the lawyer for the spouse is likely to recommend that the artist keep it at the crazy price, and the spouse will get more on their side of the balance sheet."

During a marriage, an artist may make gifts to their spouse of some work of art, but that gift still is part of marital property. If the spouses wishes to retain the gift, something of equal value is to go to the artist's side of the balance sheet.

The fact of incorporating themselves as a business would not separate artists' earnings and artwork from marital property. According to Brett Ward, a lawyer in New York City who has handled the divorces of numerous artists, performers, and writers, "the court would determine the value of the corporation and require, say, half to be paid to the spouse."

Until the property division has been settled in a divorce decree, artwork may not be loaned, sold, or destroyed without the consent of the other spouse. It is unlikely that the nonartist spouse would object to sales at a gallery exhibition, since that may lead to money that can be shared, although a sell-off of one or more artworks at below established prices might be objected to for depressing the market.

Divorce negotiations are a time of considerable horse-trading. Ward noted that "more established artists generally have a wealth of other assets, such as real estate and investments, which can be traded for works of art that the artists especially want to retain, while less established artists may only have the works of art." Emerging artists may view their artwork as more valuable than their spouses who hadn't seen it selling and are willing to trade their interest in it for something more immediate, such as the computer or the car.

"Things I made I kept," said painter and printmaker Janet Fish, who married and divorced painter Rackstraw Downes. "If you're making these things, it seems that they should stay with you." (Downes kept his own paintings after the divorce, too.) That point of view might have been a point of contention but for the fact that neither artist was experiencing sales at the time of their divorce, and dividing up their accumulation of artworks only would have been for sentimental reasons. When painter Lois Dodd divorced sculptor William King, on the other hand, he took some of her paintings and she some of his sculpture. "We didn't argue about it," Dodd said. "It was more like, 'Do you like this piece?' 'Can I have that one of yours?' We wanted things to be as amicable as possible."

The value of any licensing contracts or the creation of multiples and derivative works, known as copyright, similarly is a matter of negotiation, with money changing hands as part of the divorce settlement or by an agreement to share

profits after the divorce. When Charles M. Schulz, creator of the long-running *Peanuts* comic strip, divorced his wife of twenty-four years, he agreed to share future revenues from his work at the initial rate of 27 percent, decreasing over a ten-year period to 15 percent. Similarly, when comedian Jerry Lewis divorced his wife, Patti, after thirty-five years, they agreed that he would retain ownership rights to the films he had made during that time, but she would have a half-interest in the royalties from them.

With copyright, spouses may decide that one will own the physical object while the other owns the copyright (that ensures an ongoing business relationship between the two), or one side might buy out the other's copyright interests. For the artist, but just as much for the spouse—particularly if there are ongoing financial interests between the two or children who will need to be supported—the goal must be to maintain the art career with as little interruption as possible.

10

End Stages

The end of a famous artist's life might be thought of as a time of tributes and celebration, but not for Robert Indiana, who is best known for his 1965 image of the stacked letters L-O-V-E. He died at his island home in Vinalhaven, Maine, in 2018, a few months short of his ninetieth birthday. Just a day before his death, however, a lawsuit was filed by the artist's agent, the Morgan Art Foundation, against his studio manager, Jamie L. Thomas, and against another company, the New York–based American Art Image, which Thomas allowed to produce allegedly unauthorized editions of the artist's work. American Art Image was accused of copyright and trademark infringement. Indiana, described in the lawsuit as "bedridden and infirm," and intentionally isolated by Thomas, had a new will drawn up in 2016, superseding his 2013 will, which turned over power of attorney to Thomas. "It is our contention that Indiana was in poor health, and he had a difficult time reading," said Luke Nikas, one of the lawyers representing the Morgan Art Foundation. "He was not aware that he had assigned power of attorney and not mentally competent" to provide informed consent to what was being done in his name. Fraud? Forgery? Shortly after the artist's death, an FBI agent arrived on the island to investigate Indiana's death, ordering an autopsy, and Maine's attorney general then brought a case claiming that the estate

paid excessive legal fees during litigation. Lots of charges and counter-charges. It took three years to conclude most of the lawsuits, but what a mess.

No less so for multimedia artist Nam June Paik (1932–2006), who in 1996 suffered a stroke that largely curtailed his ability to create new installations, but his career was far from over. Exhibitions of his work were being planned, new pieces were still being fabricated, and existing works continued to be put up for sale at galleries. What's more, a series of sculptures purportedly by Paik, but which the artist denied were his, were put up for sale, leading to two lawsuits against Paik, which his lawyers chose to settle, because Paik was not deemed mentally competent to testify at trial. "You can see this as people taking advantage of a senile artist," said Paik's nephew and estate executor, Ken Hakuta. "He was sick."

The lawsuits were eventually resolved out of court. Had Paik maintained a documentary record for all his work—"So-and-So Gallery or studio assistant is authorized to produce this many pieces, to be titled this, this, and that and sold for these prices," signed and initialed by all parties involved—the confusion might have been resolved more quickly and with less expense. Good recordkeeping, unfortunately, is not one of the characteristics of highly successful artists. Diminished brain function, however, may prove catastrophic for an artist whose business is run completely out of their head. "Just getting old is hard," said Dr. John Zeisel, director of the Woburn, Massachusetts–based organization Artists for Alzheimer's. "Bills don't get paid; things don't get put away. Most creative types have things lying around anyway and, when they develop dementia, it becomes much harder to organize."

Among the problems that may occur are:

- Artworks that have been loaned to a gallery, collector, or museum and are forgotten. The recipients may construe the loans as gifts, sometimes selling the works.
- Artworks consigned to a gallery and forgotten. Galleries, too, sometimes forget to pay artists.
- Images that are licensed for commercial use, also forgotten. "Postmortem royalties, with few exceptions, tend to taper off," said Elliot Hoffman, a

lawyer with an arts practice in New York City, "but sometimes royalty payers forget to pay the artist or the artist's estate or heirs. Sometimes, they just stop paying and wait to see if anyone complains."

- Elements involved in the process of creating a multiples edition, such as mock-ups, proofs, maquettes, molds, or drawings, are overlooked by the artist but are subsequently used or sold by the publisher, fabricator, or foundry.

- Artworks that are not documented with photographs or written information (title, size, year, medium), which may pose later problems of attribution. Artists are generally thought to be the best judges of their own work (although there are instances where some have been less than truthful, denying early pieces they now dislike or, in the case of Giorgio di Chirico, intentionally misdating works) but, when the artist suffers memory loss (as in the case of Nam June Paik) or dies, the problem of attribution is magnified. Determining when a work was created and by whom becomes a more drawn-out and expensive process.

"Artists, by definition, are not business-minded," Hoffman said, which is neither true nor a definition, but there have been numerous instances of artists neglecting to keep good records on their artwork, loans, licenses, and consignments, leading to headaches and lawsuits during an artist's lifetime and beyond.

Life can be messy and chaotic before you die, and death doesn't do any tidying up. Pablo Picasso, for instance, did not leave a will, but he did leave behind a crazy-quilt assortment of children, grandchildren, and ex-lovers who spent a combined $30 million and the next six years after he died in 1973 settling the issue of who got what. Tens of thousands of artworks waited for the courts to straighten things out. Painter Thomas Kinkade, on the other hand, appeared to leave behind two wills when he died unexpectedly in 2012 after overdosing on alcohol and Valium. One will appeared to favor his estranged wife and children and another, handwritten and signed shortly before his death, favored his current girlfriend. Each will identified who would get his mansion and control over his paintings. More work for lawyers.

A will identifies what the deceased person intended with their assets, making the disposition of property orderly and often with an eye toward reducing or eliminating the payment of estate taxes. When someone dies intestate—without a will—state intestacy laws take over, determining how one's property, which includes all securities, bank accounts, and real estate, is distributed and to whom. Whatever intentions the dead person might have had for these belongings (you should get this, I don't want him to get anything, donate all these) become secondary. "A will doesn't solve everything," Nikas said, noting that the issue of the amount of money paid to estate executors brought lawsuits with the estates of both Andy Warhol and Robert Rauschenberg, "but it ensures that the intentions of the person who dies are carried out."

Intentions matter. Sculptor Harry Bertoia, who died in 1978, did leave a will—just one—the traditional type that left everything to his wife and three children. However, according to his daughter Celia, her father "talked about what he wanted done with his works with me, my brother and sister, and with friends," and much of what he reportedly talked about concerned where he wanted his work exhibited and donated, and that certain pieces be kept together. All of those people "remember things differently. People just did what they wanted. There was a lot of selfishness and greed." In 2013, Celia Bertoia started both the Harry Bertoia Foundation and what turned out to be a three-year lawsuit against her brother, who had kept a large number of the artist's works in a barn in Pennsylvania, to recover pieces in order that their father's wishes be carried out. "Those were three miserable years of my life that I won't get back," she said, but Celia did prevail, and much of the Harry Bertoia estate currently sits in Bozeman, Montana.

The moral, to Celia Bertoia, is for artists to put their intentions in writing so that there will be no disputes about what they wanted. That works sometimes, not all the time. Saul Ostrow, a critic and partner in the company, Art Legacy Planning, which provides estate management services to artists and art collectors, noted that one artist wrote in his will that paintings from his estate would be gifted to the Metropolitan Museum, Museum of Modern Art, and the Whitney Museum. "Each of these museums had one drawing by the artist in their collections, and he thought

that since they each had a drawing they would want his paintings, too," he said. The artist was wrong. "The museums didn't want the paintings, and the executors of the estate had to go to court to break the will" in order that something else could be done with these artworks.

A good starting point is for artists or their assistants to keep good records of their work and careers, which would lessen later confusion. Toward that goal, the Joan Mitchell Foundation established a grant program, named Creating a Living Legacy or CALL, enabling artists to document their work. The foundation underwrites this process by hiring an archivist and paying for a computer (if need be) and the creation of an image and text database rather than providing money to an artist directly. "If you just give artists money, they might not spend it on archives," said Carolyn Somers, executive director of the foundation. "While they are alive, artists can do their own catalogue raisonné."

Another (possible) moral is to create a trust or foundation, during the artist's lifetime or upon their death, to which all or most of that person's artwork and archives will be donated. Usually, some cash will also be given to the foundation in order to cover the costs of legally setting up the entity, as well as the ongoing expenses of storing and insuring the artwork. The foundation (some morph into a private museum) keeps the art together as a collection, rather than sold or divided among heirs or cherry-picked by a museum curators or dealers, and the living artist or the estate gets the benefits of a charitable deduction and the opportunity to promote the artist's legacy and market through exhibitions, controlled gifts, and sales.

Dozens of artists have set up foundations during their lives or upon their deaths, most of them acting to promote their legacy. "I knew I had to do something or there would be less interest in my work and ideas after I died," said Chicago-based environmental artist Chapman Kelley, who died in 2020. "I could have left everything to my son, but he wouldn't have known how to manage things." As a result, in 2015, he set up a foundation to promote his work and ideas, and he views the foundation as making "a difference between whether things are preserved and seen or put in someone relative's attic or, worse, put out with the trash."

 · · That brings up the next issue for artists: Whom do you trust with your legacy—the continuing presence of your artwork and establishing a place for yourself in art history? Perhaps, by default, a relative: Celia Bertoia has been busy arranging exhibitions of her father's work at various museums, scanning her father's documentary archives, and arranging with a publisher to locate an art historian to write a book about the artist. Ostrow noted that family members may be quite protective and fiercely loyal to an artist, but some family members hold resentments against the artist (the estranged husband of the late sculptor Anne Chu crammed much of her work into an uninsulated and leaky shipping container in Long Island, which led to some of those artworks being ruined—the artist's sister is suing her ex-brother-in-law for $500,000) or just may not be "insightful" about the artwork, "knowledgeable" about how the art trade operates, and "capable" of promoting that relative's work. One of Art Legacy Planning's first clients was the widow of David Craven, a painter who died in 2016 at the age of seventy. "Craven left his wife four hundred paintings," Ostrow said. "But she had spent her entire career working in a genetic lab in Canada and didn't know the first thing about the art world. She was afraid that, when she died, the works would end up in a dumpster."

 Kelley noted that his son did not have a role in his foundation—"he lives in a big house on a hill in California and is happy there"—and has placed on the organization's board two longtime supporters of his career, a retired professor and a local businessman. His lawyer, Scott Hodes, who helped him set up the foundation, is a co-executor of the artist's will.

 There is no ideal executor of an artist's estate or foundation. "Dealers might take charge, since they usually have the best understanding of the art market and how to promote an artist's work," Hodes said. "They have an interest in the future." But they may also just want to pick and choose among an artist's most sellable works and show little interest in the rest. And, since most artists' markets die when they do, dealers often are apt to drop an artist upon their death. He also claimed that lawyers make good executors ("they know that a legacy is adversely affected by lawsuits") and that "bankers would be the least self-interested" of all potential

executors. All true, but he added that they may have less knowledge about how to promote an artist's work posthumously than those who are insiders.

Of course, the most notorious case of art world insiders doing wrong by an artist involved the estate of painter Mark Rothko. Two years before taking his life in 1970, Rothko had drawn up a will, naming three executors who would create a foundation that would receive the bulk of his paintings: Bernard Reis, an art collector and accountant; Morton Levine, an anthropology professor at Fordham University, who was also named guardian of the artist's youngest child, Christopher Rothko; and Theodoros Stamos, a painter and younger member of the New York School of abstract expressionism who was a good friend of the artist. (Rothko's wife died of heart failure six months after her husband's passing.) One of the executors' first actions was to sell 798 of Rothko's paintings to New York's Marlborough Gallery for $1.8 million and consign to the same gallery 698 more at a fifty percent commission. Rothko's children sued, accusing the three executors of conspiracy to defraud the estate and waste its assets: Frank Lloyd, the owner of Marlborough Gallery, had purchased a huge quantity of artwork by a major American artist for far below its actual value, and some quick sales that he made on a number of those paintings realized profits of 800 percent for him. Reis was charged with self-dealing for being the accountant to both the Rothko family and the Marlborough Gallery at the time of these contracts, while Stamos was accused of going along with the deal in order to be taken on as a Marlborough artist. In fact, in 1971, Stamos became part of Marlborough's stable, and his first exhibition at the gallery was held the following year. His friendship with Rothko came to be seen as partly mercenary.

In a ruling handed down in 1975, the three executors were removed from the Rothko estate and the contracts they made selling and consigning the 798 paintings to Marlborough were canceled. Stamos and Reis, jointly with Frank Lloyd of Marlborough, were deemed liable for the present value of the paintings sold by Lloyd, or $9.3 million.

Living artists are rightly more interested in their next creation than in preparing for the world without them, said Jason Andrew, independent curator and

founding partner in Artist Estate Studios, an organization that serves artists and the estates of artists (including those of painters Jack Tworkov and Elizabeth Murray) in the management and cataloguing of their art, as well as the promotion of their legacy. Still, maintaining good records of their works and sales, and picking the right someone to manage the inventory of artwork, is a key decision for an artist. The main qualifications for that person are that they be "organized and intimately familiar with the artist and their work." Relying on a gallery's record-keeping is not sufficient, he stated, adding that artists should make it integral to their studio practice to maintain for themselves a written or computerized system of documenting the titles, dates, and descriptions of all their work, as well as an up-to-date listing of where and when their pieces have been consigned, loaned, or sold. No less important are what he called "ephemera," or contextual information about the artist's work and career, such as announcements, reviews, articles, and publications, which may provide useful information if and when research is done on the artist by scholars.

Finally, he said, "an artist should have a will and one that is up-to-date. Nothing in our judicial system will prevent heirs, family members, or invested individuals from pushing against this important document, but it is very difficult for a court to go back on explicit directions expressed in this legal document."

PROBATING THE ARTIST'S ESTATE

This story begins where most end: The artist dies. Unless that artist has sold every piece they ever created, there is likely to be a potentially sizable inventory of artwork that must be valued as part of the artist's estate for tax purposes. How to value that art can be tricky, as it involves speculating about the market for an artist's work when that artist is dead.

It was no easy matter when sculptor David Smith died in a automobile accident in 1965. The fifty-nine-year-old artist had only begun to receive major art world recognition and appreciation late in life. Between 1940 and 1965, he had sold but seventy-five works, only five in the last two years of his life. Part of the reason for this was the fact that Smith deliberately kept prices high, with the result that

425 sizable sculptures were in his estate when he died. Within two years of his death, sixty-eight works were sold for just under $1 million. The remaining body of work in his estate, with each piece appraised at the fair market value, was originally valued at $4,284,000, ensuring that a hefty tax payment was due to the Internal Revenue Service within the standard nine-month period. After a hearing before Tax Court and some complicated negotiations between the IRS and lawyers for the Smith estate, the entire estate was discounted to 37 percent of the fair market value, greatly decreasing the amount of tax money due the federal government.

The Smith case developed in the field of artists' estates what is called the "blockage rule" or "blockage discount," which previously had only been applied to securities and recognizes that forcing an artist's heirs to sell most or all the art in the estate for the purpose of paying death duties would result in fire sale or "distressed" prices that are likely to be well below fair market value. Expected fair market prices are more readily obtained when individual works are sold gradually.

Over the years, this principle has been applied to such artists as Jean-Michel Basquiat (who received a 70 percent blockage discount), Alexander Calder (60 percent), and Georgia O'Keeffe (50 percent). There is no rule of thumb for determining the percentage discount, which clearly is elastic. "Different discount percentages reflect different judges, different jurisdictions and different lawyers representing the estate, and some lawyers are better and more persuasive than others," said Bernard Rosen, a New York City attorney with a number of artist clients. Additionally, a number of other considerations are taken into account in determining the discount, such as the subject of the works, the period in the artist's career in which works were created, and the medium.

For instance, there were 1,292 gouache paintings in the estate of sculptor Alexander Calder. As these gouaches were not the artist's principal medium as well as the fact that Calder's estate executors claimed that it would take the art market twenty-five years to absorb this number of his paintings (at fifty-two per year), the IRS permitted the estate to discount these works by almost 68 percent.

Predicting what art is worth after the artist dies cannot be scientifically measured, and a number of factors may apply. "The death of the artist may sabotage the market," Karen Carolan, former head of art evaluation at the IRS, said. "If the artist doesn't have a regular dealer, his death may have a very negative impact on prices." She added that having "a ready market, being a well-known artist, being represented by dealers, selling work all over the country" makes valuing artwork in an artist's estate considerably easier. Artists without one or all of those elements produce work that is far more difficult to appraise after they are dead.

Complicating variables are frequently found in these kinds of valuations: There may be a record of sales in a nondepressed art market but, when the market goes down, formerly sellable works have no prospective buyers. Some artists sell very well, but their success may be dependent upon their presence to actually sell the work—without the benefits of the artist's personality, works may not sell at all. Artists without a gallery connection may be the least likely to have works sell after they are dead. The IRS combs through auction records in order to see what prices were paid for an artist's work, but most contemporary art is not resold at auction (if it is resold at all). Another way in which the IRS often looks to determine the value of artworks is by examining an insurance policy, which requires an expert appraisal, but this is more applicable to collectors than to artists who rarely insure their own work.

Basquiat, Calder, O'Keeffe, and Smith, of course, were all renowned artists who supported themselves exclusively from the sale of their artwork. Many more artists hold teaching positions or other jobs (arts-related or otherwise) from which they receive their main income. These artists may also sell their work; however, the market is limited, perhaps almost nonexistent. What the deceased artist's work is worth is a question on which lawyers and the IRS sometimes disagree. "A lot of people teach or do something else and sell one painting every three years to a cousin," James R. Cohen, an estate attorney in New York City, said. "The IRS couldn't really demonstrate that the art has any value. You don't get into the discount issue because no one is really buying their art in the first place."

New York lawyer Susan Duke Biederman agreed, noting that "you don't want someone who paints 16" × 24" oils, and only sells one painting a year for $1,000 and has a backlog of five hundred pictures when he dies, to have the art in his estate valued at $500,000. My interest would be to say the art is worth zero. If the IRS said that people have bought this work in the past, I'd say, 'You go find me five hundred people who want to spend $1,000 on each work.'"

Certainly, the IRS is in the business of collecting money, not selling artworks. Still, Karen Carolan stated, "you can't say that art has no value if the artist has sold during his lifetime. You have to place a value on all the property in the estate." The IRS has no rule-of-thumb cutoff for the amount of money earned through sales, or the percentage of one's income derived from sales, of art in order to determine whether a deceased artist's work has market value at all or if a blockage discount (and the amount of that discount) applies.

These artists may have just as many works in inventory as David Smith or Alexander Calder but, with a far less reliable market than either Calder or Smith, estate executors face a far greater challenge when determining value and any potential discount on that amount.

The problem is not necessarily an immediate one for all artists. The entire estate goes tax-free to the surviving spouse, and the first $12.06 million of the estate is tax-free to each heir (as of 2022), $24,120,000 if the heirs are a couple. There is no need to individually appraise works of art in an estate if the entire estate is worth less than $12,060,000. In fact, if the rest of the estate is small, it behooves the heirs to value the art high enough to get as close to that $12.06 million number as they can. This protects the heirs if they someday sell the art. For instance, if an heir values a work at $10,000 and sells it for $15,000, they only pay a tax on the $5,000. However, if the heir claimed that the art was worth nothing and sells it for $15,000, the heir pays a tax on the entire $15,000.

The problem with that planning, however, is that "reasonable men may disagree, and the IRS may come in and value the art higher, moving the heirs above that $12.06 million tax-free limit and then taxing the heir at 40 percent," Cohan

said. That might happen when an heir begins to claim that the art has some value and tries to sell.

Complicating the process is estate taxes in twelve states across the country (Connecticut, Hawai'i, Illinois, Maine, Maryland, Massachusetts, Minnesota, New York, Oregon, Rhode Island, Vermont, and Washington), as well as the District of Columbia, each with its own exemption amounts. Massachusetts and Oregon are on the lower side, with $1 million exemptions, while New York State is $5,930,000 and Connecticut is $9.1 million. There may be no federal estate tax for heirs of a deceased Boston, Massachusetts, artist, but the Commonwealth of Massachusetts may apply a death tax for estates valued above $1 million. (If the estate is valued above $12,060.000, the state's estate tax could be deducted from the amount owed to the federal government.)

Certainly, some heirs may expect to eventually sell these artworks and earn a considerable amount of money from them. Sales during an artist's lifetime are no absolute indication of future value—the art of Vincent van Gogh is a clear example. During his life, van Gogh only sold one painting, but his work became far more popular and earned record prices at auctions years later.

Competing values are involved in this issue: On the one hand, heirs look to minimize the value of an estate in order to lower inheritance taxes; yet, if they plan to sell works from that estate later on, heirs would hope to limit the tax burden on those sales. Many well-known artists, such as Adolph Gottlieb, Lee Krasner, Robert Mapplethorpe, and Andy Warhol, have resolved this problem in a third way, establishing a trust or charitable foundation for their art through their wills and using the periodic sale of artwork to create and replenish the foundation's endowment. Yet others, including photographer Ansel Adams and painter Hans Hofman, donated a large number of their works to educational institutions. Artists who are concerned with keeping their inventory of works intact for their heirs might also plan for money, such as through a life insurance policy, that would pay the inheritance tax. Any of these choices is preferable to the decision by an Arizona artist in the early 1980s to publicly incinerate all of his paintings in order to spare his heirs the burden of paying taxes on them. Artists, their attorneys, and their

heirs need to examine what they reasonably expect to do with the artwork after the creator dies and plan accordingly.

A JOB FOR THE FAMILIES OF DECEASED ARTISTS

A problem for anyone friends with, or related to, a now-deceased artist. Not a famous artist, not someone with a long exhibition and sales history, but an artist all the same—someone who created works of art, which heirs believe have merit and that should not just disappear. In fact, the less this person sold during their lifetime, the more stuff that friends and relatives will have on their hands. It could be hundreds or thousands of drawings, paintings, photographs, prints, sculptures, or something else.

What to do with it all? Put it all in a storage unit or the garage? Try to sell it or donate it to some museum? Fill up a dumpster, or leave the problem to one's children or grandchildren (so that they can put it in the dumpster)?

"The choices often are extremely painful," said Jack Flam, president of the Dedalus Foundation, which was set up by painter Robert Motherwell to promote his own work and to support modern art in general. Heirs often believe that the artworks may be worth something, but commercial art galleries and private dealers are unlikely to want to exhibit or try to sell them. "Most of the time, the work can't be placed anywhere. One has to understand that the destruction of works of art is part of the natural order of things."

That may be the final solution, but heirs have other options when they believe that the artwork and the artist's memory are worth preserving, if they have the time and money.

Some deceased artists are more fortunate than others. In 2019, art book publisher Rizzoli released a $65 coffee-table book, *ROBERT DE NIRO, SR.: Paintings, Drawings, and Writings: 1942–1993*, which displayed his artwork and appreciative essays by a variety of critics and artists (and even an essay by his son, actor Robert De Niro Jr.), in time for an exhibition of works by the artist (1922–1993) at New York's DC Moore Gallery. Also keeping the artist's memory alive is an annual awards program of $25,000 to mid-career artists that was set up through his estate by his son.

That's a lot of attention paid to an artist who hasn't been on anyone's radar for quite a while, which includes the last years of his life. "De Niro Senior's early work was seen as stronger than the later work," said Sarah King, editor-in-chief of SNAP Editions, which editorially designed and produced the book for Rizzoli. King noted that she worked with the artist's estate on the development of this book, as she previously has worked with a number of other artists' families and foundations on books celebrating those artists' careers and artwork. It is not at all uncommon, she noted, "for foundations and families to subsidize the publications."

"It helps to be wealthy," said Christine Vincent, project director of the Artist-Endowed Foundations Initiative of the Aspen Institute, noting that preserving an artist's legacy or trying to promote the deceased artist's work to buyers, dealers, and curators frequently involves hiring someone to perform "collections management," which involves identifying where all the artwork is located, then having all the pieces photographed, dated, numbered, described (medium, subject matter, techniques employed), and contextualized (when and where it was created, as well as what was on the artist's mind or taking place at the time of its creation), then digitized and put in a databank. The next step may be hiring an art historian, such as a critic or university art professor, to prepare a scholarly essay about the artist and that individual's historical importance. Amid all this, a nonprofit foundation may be created that needs to be endowed and is in charge of storing and physically caring for the artwork and whose charitable mission—such as making the artwork accessible to the public through promoting exhibitions at museums—all involve spending thousands or tens of thousands of dollars.

Another estate that brought on board a scholar to help promote a lesser-known artist's work is that of Judith Rothschild. Rothschild, who died in 1993 at the age of seventy-two, was a relatively obscure painter whose most critically acclaimed work was done in the last six years of her life. The daughter of a wealthy furniture manufacturer and whose parents collected School of Paris artists that were left to her when they died, Rothschild established a foundation at the time of her death that aimed to help pay for the costs of conservation, documentation, publication, museum acquisition, and exhibition of artists who were

under-recognized as she thought herself to be. The foundation also hired Jack Flam to curate several exhibitions of Rothschild's own work. "I knew Judith casually through occasional dinner parties and other social gatherings, and I thought her art was worth examining," Flam said. In addition to his curatorial efforts, he also contacted museum officials to take a look at the artist's work, which they did, because of his own prominence. "You need contacts," he said. A major art gallery eventually came to represent her work. Years later, Rothschild "is a recognized artist of note."

A growing number of aging artists or the heirs of artists have come to recognize the need for developing some sort of plan to ensure that the artist's life and work is not forgotten and, Christine Vincent noted, "services increasingly are available."

Some families of an artist do try to take on the job of promoting that individual's career and legacy, and they find the work time-consuming and exhausting. Dara Gottfried took on the job of managing the posthumous career of her sister-in-law Arlene Gottfried, a street photographer who died in 2017 at the age of sixty-seven. That has involved maintaining relationships with the galleries that have exhibited Arlene's work and operating a website for the artist that sells her books and images, as well as placing the ten thousand or so inherited prints that the artist created over a forty-year career in storage and maintaining a database for the photographs. "I haven't hired anyone to help me," she said, adding that doing all this is "a little overwhelming for me." Her husband and Arlene's brother, comedian Gilbert Gottfried, "doesn't know anything about how to do this. I'm the more capable of the two of us." At least, she gets some help from a collections management database, a cloud-based system operated by Artwork Archive, which makes the process of uploading, storing, and retrieving information more manageable.

Another helping organization in this area, Art Legacy Planning, works with artists and their family members to establish realistic goals—such as to place works in public institutions or put an estate collection in a presentable state so that it could be displayed to museum curators or art gallery directors—and some of that work consists of helping clients "get real," said Many Dinaburg, one of the

organization's partners. "More often than not, people expect us to produce sales. We can build and enhance a reputation, and we can organize a collection in a way that galleries might take works to show, but we're not dealers. We can't guarantee that the money people spend on our services they will make back."

Planning ahead and understanding a likely outcome is a challenge for some artists and their families, which sometimes brings out the irrational in some clients, she said. There may be sibling rivalries, the inability to part with anything, fantasies about how important the artist or the artwork is, and resentments by the children of artists toward their parents. "We've sent some clients to a therapist. We offer that, but it's not taken up very much."

THE ROAD AHEAD FOR HEIRS IS NOT EASY

As any number of artists can attest, it is rarely easy to find a gallery owner who will actively promote one's work and produce sales. However, while alive, an artist continues to hold the promise of creating something new of significant interest, and some artists have big personalities that are part of the marketing and sales of their work. Once dead, that promise is gone and the artist is now reassessed in terms of a "legacy," that person's place in art history and their influence on other artists of that time or subsequently. The artists Chaim Gross, David Levine, and Raphael Soyer were all well-regarded during their lives but, according to Robert Fishko, owner of New York's Forum Gallery, which represents the three artists' estates, their deaths occasioned a "50 percent drop in prices. The saleability of their art diminished." At present, the verdict appears to be that these three were all minor artists.

Retaining half their previous value may be considered good fortune. When most artists pass away, the market for their work dies with them. When that market was small or close to nonexistent to begin with, those in charge of the artist's estate must make the case that the work of So-and-So should have been appreciated more during their lifetime but certainly needs to be evaluated now. A tall order.

Keeping alive the memory and work of a deceased artist can be a tall order, but not impossible task when the stars align. Connections and money help. For

example, William N. Copley, a sometime journalist, sometime art dealer, and lifelong painter, had sold some paintings in Europe where he lived for a number of years, but there was close to no market for his Surrealist canvases in his homeland of the United States when he died in 1996 at the age of seventy-seven. His children (William Jr., Claire, and Theodora), however, were not content to just divide up their parent's paintings among themselves and let his memory fade. "We decided to take over the direction of the estate and represent the work ourselves," his son said. "We sold a couple of my father's paintings to a German dealer and a German collector at very low prices," which provided them with sufficient money to pay a storage fee for the artwork they controlled, hire a conservator to provide condition reports on the paintings, and set up a limited liability corporation from which they could begin the process of promoting the artist's work. They also used the money to hire a full-time researcher who identified the dates and locations where paintings were created, as well as the artistic influences evident in the artworks. Additionally, the researcher also had each and every artwork photographed and filed electronically, which were uploaded onto a website that was created for the purpose of allowing browsers to learn about the artist's life and see images of his work.

Armed with this coordinated set of facts, images, and other research, Copley's heirs began contacting prospective art dealers to represent the estate, and it helped that William Jr.'s wife, Patty Brundage, had worked for the Leo Castelli Gallery for twenty years before striking out as a private art adviser. Who you know (or, at least, who will give you the time of day) matters. "David Zwirner was not interested, although his father had shown the work some decades before," William Jr. said. Another New York dealer, Michael Rosenfelt, expressed interest, but the heirs went with the Manhattan-based Paul Kasmin Gallery, as the dealer "had known about my father's work and knew many of the same artist friends of my father." Kasmin has promoted Copley's work to museums around the country, including the Menil Collection in Houston, Texas, which in 2016 organized a retrospective, "William N. Copley: The World According to CPLY," the largest showing of its kind of the artist's work.

Perhaps the most notable example of an artist who had little to no sales during their lifetime is black-and-white photographer Francesca Woodman (1958–1981), and it was partly her lack of success that led to her suicide. It was her mother, ceramic sculptor Betty Woodman, who made it her mission to promote her daughter's work, archiving the "vintage" prints that her daughter had produced during her lifetime and identifying a group of approximately fifty images that would be printed in editions posthumously. She also established information about each image, such as when the photograph was made, who was in the picture, and the context of the image, in order that those looking at Francesca's work had a better understanding of what they were seeing. "In effect, Betty curated the work of her daughter before making them public," said Jeanne Greenberg Rohatyn, a Manhattan gallery owner who represented Betty Woodman and, more recently, her estate. Betty Woodman did not need to hire a renowned art authority to reach out to important dealers and curators, because she herself had those contacts, exhibiting her Matisse-influenced ceramics in art galleries in New York and elsewhere and having her work acquired by such as institutions as the Metropolitan Museum of Art, the Los Angeles County Museum of Art, the Stedelijk Museum in Amsterdam, Holland, and at the Victoria & Albert Museum in London. In 2006, the Metropolitan organized a retrospective of Betty's work, the first time the museum held a show for a living woman artist.

The process of bringing attention to Francesca's work was not rapid and involved a step-by-step effort to acquaint the world of critics, curators, dealers, and finally collectors with the work that she had created during her short life. From 1986 to 1988, an exhibition of Francesca's photographs toured a variety of college galleries and museums in the United States, and between 1992 and 2010 a variety of exhibitions traveled to galleries, museums, and cultural centers in Europe. In 2011, the San Francisco Museum of Modern Art organized a retrospective of the artist's work, which also was exhibited at New York's Guggenheim Museum. Perhaps not coincidentally, Francesca's parents (Betty Woodman died in early 2018, while her husband George died the year before) donated an untitled 1979–1980 photograph by the artist to the San Francisco Museum of Modern Art.

Still, sorting through thousands of negatives to determine the ones that best represented her daughter's feminist vision was a lot of work for Francesca's parents, who hired a part-time curator to help with the process. In 2004, they selected the prominent New York gallery owner Marian Goodman to represent their daughter's estate, and that dealer has done much to promote the forever-young artist's work around the world.

The occasional success story cannot make up for the fact that looking for gallery representation for a parent's work may make heirs feel both frustrated and guilty, and it is easy to just throw in the towel. Loretta Wurtenberger, a partner at the Institute for Artists Estates in Berlin, Germany, and author of *The Artist Estate: a Handbook for Artists, Executors, and Heirs* (Hatje Cantz Verlag), stated that "burnout is a very real possibility. "It is very tough to name a deadline here. But if you have not been able to find any kind of support within one or two years, you should consider pausing for some years and focus on internal tasks, such as developing an online inventory database, if the motivation is not gone entirely."

Setting up gallery representation of an estate and establishing a market may not be the final result of promoting a lesser-known artist's work. Finding collectors to purchase pieces is not always possible, but that doesn't mean that unbought works of art are destined for the dumpster. New York art lawyer Herb Nass stated that one of his clients, a childless sculptor named Mary Lincoln Bonnell who died in 2013 at the age of eighty-four, was willing to donate her work to a variety of schools and museums. "There were no illusions that we could find a dealer to sell her work," he said. "Still, she wanted her work to have good homes, and I offered $10,000 to each school and museum that accepted her sculptures, incentivizing them to take the work."

At some point, heirs may decide to treat a parent's artworks in the same way as other property in the estate, like the furniture: You take this, I always liked that. Still, Wurtenberger said, "before you divide artworks among family members, you should document the works according to the newest standards and ideally keep track of them as far as possible. This at least maintains the chance that later generations can pick up the work when they have time or means to do it. They might be able to find new intercessors in their environments and times."

Acknowledgments

S ome books are said to write themselves, which refers to the rush of words that an author feels and the effortlessness of the writing. In truth, a book requires far more than an author with an idea or two in his or her head. For my part, it involved a number of advisors who read the manuscript and offered guidance, suggestions and occasional fact-checking. Among these were Amelia Brankov, Tom Brock, Alan Cantara, John Cahill, Jack Flam, Scott Hodes, Megan Noh, Christine Vincent and Judith Wallace. Thanks also to Tad Crawford, who has put his trust in me for many years now.

Index

Books from Allworth Press

The Artist-Gallery Partnership, Third Edition: A Practical Guide to Consigning Art
by Tad Crawford and Susan Mellon (6 × 9, 224 pages, paperback, $19.95)

The Business of Being an Artist, Fourth Edition
by Daniel Grant (6 × 9, 408 pages, paperback, $27.50)

Business and Legal Forms for Fine Artists, Third Edition
by Tad Crawford (8 ½ × 11, 176 pages, paperback, $24.95)

Business and Legal Forms for Photographers, Fourth Edition
by Tad Crawford (8 ½ × 11, 208 pages, paperback, $29.95)

Business and Legal Forms for Graphic Designers, Third Edition
by Tad Crawford (8 ½ × 11, 160 pages, paperback, $29.95)

Business and Legal Forms for Illustrators, Third Edition
by Tad Crawford (8 ½ × 11, 160 pages, paperback, $29.95)

Business and Legal Forms for Crafts, Second Edition
by Tad Crawford (8 ½ × 11, 144 pages, paperback, $29.95)

The Law (in Plain English)* for Photographers, Third Edition
by Leonard D. DuBoff and Christy O. King (6 × 9, 256 pages, paperback, $24.95)

Art Without Compromise*
by Wendy Richmond (6 × 9, 256 pages, paperback, $24.95)

Artist's Guide to Public Art: How to Find and Win Commissions
by Lynn Basa (6 × 9, 256 pages, paperback, $19.95)

Selling Art Without Galleries: Toward Making a Living From Your Art
by Daniel Grant (6 × 9, 288 pages, paperback, $24.95)

How to Start and Run a Commercial Art Gallery
by Edward Winkleman (6 × 9, 256 pages, paperback, $24.95)

Inside the Business of Illustration
by Steven Heller and Marshall Arisman (6 × 9, 240 pages, paperback, $19.95)

Guide to Getting Arts Grants
by Ellen Liberatori (6 × 9, 272 pages, paperback, $19.95)

Fine Art Publicity: The Complete Guide for Galleries and Artists, Second Edition
by Susan Abbott (6 × 9, 192 pages, paperback, $19.95)

The Artist's Complete Health and Safety Guide, Third Edition
by Monona Rossol (6 × 9, 416 pages, paperback, $24.95)

Caring for Your Art: A Guide for Artists, Collectors, Galleries, and Art Institutions
by Jill Snyder (6 × 9, 192 pages, paperback, $19.95)

Artists Communities: A Directory of Residences that Offer Time and Space for Creativity
by Alliance of Artists Communities (6 × 9, 336 pages, paperback, $24.95)

AIGA Professional Practices in Graphic Design, Second Edition
edited by Tad Crawford (6 ¾ × 10, 325 pages, paperback, $29.95)

Marketing Illustration: New Venues, New *Styles*, New Methods
by Steven Heller and Marshall Arisman (6 × 9, 240 pages, paperback, $24.95)

ASMP Professional Business Practices in Photography, Seventh Edition
by American Society of Media Photographers (6 × 9, 480 pages, paperback, $35.00)

The Photographer's Guide to Marketing and Self-Promotion, Fourth Edition
by Maria Piscopo (6 × 9, 256 pages, paperback, $24.95)